FRONT LINES *to* HEADLINES

The World War I Overseas
Dispatches of Otto P. Higgins

JAMES J. HEIMAN

WOODNEATH
PRESS

Kansas City

Published by Woodneath Press
8900 NE Flintlock Rd.
Kansas City, MO 64157

Cover design: Amber Noll

Publisher's Cataloguing-in-Publication
(Provided by Woodneath Press: A Program of Mid-Continent Public Library)

Heiman, James J.
 Front Lines to Headlines: The World War I Overseas Dispatches of Otto P. Higgins / James J. Heiman
 p. cm.
ISBN-13: 978-1-942337-10-2

 I. History / Military / World War I
 II. Photography / Photojournalism
 III. History / Military / Wars & Conflict (Other)

To Molly Elizabeth –

– Your great great grandfather
was greeted by his wife,
Elizabeth, – your great great
grandmother – when
he arrived home
one hundred years
ago – April 1919, and
– you will meet them too –
here
in this
book,

For Otto P. and Higgi

[signature]

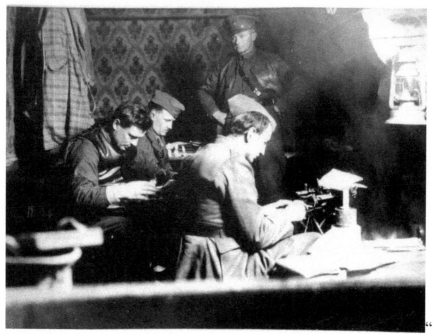

"The one remaining room of a house in Brandeville, France, on the march into Germany. November 20, 1918"

Left to Right: William Slavens McNutt of Colliers, *Raymond S. Tompkins of the* Baltimore Sun, *Bernard S. O'Donnell of the* Cincinnati Enquirer, *and foreground, Otto P. Higgins of the* Kansas City Star.

("That Job of Writing Up the War," the Kansas City Star, June 8, 1919, 15C.)

This photograph was taken on November 20, 1918. OPH is pictured in the foreground to the right. He is typing a letter to his wife, Elizabeth, and in the letter OPH indicated that the photo had been "staged" for effect.

"The fact of the matter is, the War Department wants a picture of newspaper correspondents at work," OPH wrote, "and so four of us gathered around the fire working, while they took a flashlight of us. So you see this page is only just a joke, but I thought I would write it to you so you would know that I was thinking about you, even though I was having my picture taken with a lot of highbrow correspondents and magazine writers. Now that the picture is finished I am going to tell you good night, and

tomorrow, maybe if we can get a place to stay, I will write some more."

Although the photo itself was staged, still it represented the reality of the conditions under which the stories were written. OPH explains and comments about the setting: "Only using one candle tonight. Have it sitting on a bench, then a roll of toilet paper, then a tin can, and then the candle, so I can see the keys on my machine. But we don't mind little things like that over here anymore. Don't know what I would do with electric lights. Candles furnish mighty good power, and I always carry two or three in my musette bag."

"We are going to move early in the morning to Montmedy. I don't know why it is that I have been thinking of you so much lately, unless that it is that we are living in what was once a French home, but now is only two rooms, one of which we use for a bedroom and the other for an office and workroom. We have a wonderful fireplace in it, but no windows, and as a result it is hot on one side and cold on the other. When the wood runs low we just tear a timber loose from the roof and throw it on the fire, or else rustle a table leg or a bedstead, or something like that. It makes a wonderful fire and a beautiful thing to look at, but it smokes like the devil and makes you as sleepy as can be."

[Letter from collection of Sheila Scott, personal communication August 28, 2011].

A Note on OPH's Text

Wherever possible, I have tried to maintain the text and formatting of articles as they were published in the *Star*. However, if spelling, punctuation, or sentence structure in the original would confuse or otherwise distract today's reader from the content of the article, I modernized original text conventions to accommodate meaning. Occasionally, while attempting to document the service record or biographical details of a subject OPH mentions, I discovered that the spelling of the name was inconsistent. Given the oral nature of newspaper reporting, especially in a war zone, the reporter or re-write editors at the *Star* offices, often relied on a phonetic spelling. In those situations, I maintained the spelling as it appeared in print, and I indicated the alternate spelling and source in an endnote.

Table of Contents

Foreword

America's entry into the Great War launched an unprecedented movement from the new world to the old. Over a million American men and women would cross the U-boat filled Atlantic headed for the titanic struggle in Europe. These soldiers and sailors took with them all the necessary tools of war—everything from rifles, horses, aircraft, food, fuel, paperwork, and all the many other implements necessary for fighting the crusade "over there".

The still young and brash United States watched with anticipation and unease as its youth sailed overseas. Yielding to the demand for information about the troops, General John J. Pershing reluctantly accredited a select group of war correspondents. Initially their number was small, but over time Pershing came to recognize their value to the war effort. More eager journalists would be given an army uniform and inserted into the epic supply chain to Europe.

As accredited reporters, they hoped for greater access than the freelance journalists who would also find their way to France. One of those accredited correspondents was 27-year-old Otto Higgins, representing *The Kansas City Star*. When he and the others arrived at the front lines, they would see first hand that this was a new kind of war. Their newspaper dispatches would describe a modern conflict where technology and mass production combined to produce horrific casualties in numbers never seen before. They would struggle to overcome the wartime censors, and to convey the full magnitude of their experience while balancing patriotism with objectivity. Without TV, smartphones, internet, or even radio as a mass medium, it is hard for us today to imagine the importance of their dispatches. They had a solemn responsibility to millions of readers around the world.

Although the Great War raged from 1914 to 1918, the US was a late entry, declaring war in April 1917. By the time the guns

fell silent on the eleventh day of the eleventh month of 1918, the world, and journalism, would never be the same. As Otto Higgins and his colleagues headed home, they must have felt certain they had just covered the story of the century. They could not know that the war to end all wars would be followed by another world war roughly two decades later. The rush of history is relentless. Over time, the World War I reports of correspondents like Higgins would be too often forgotten. Fortunately for posterity, Higgins' wife Elizabeth had collected clippings of his dispatches, storing them in an old steamer trunk. After he returned home from Europe, Higgins would add his field notes, photographs, military passes and other materials.

As the decades after the war rolled by, Higgins got on with his busy life. By 1959, he and his wife Elizabeth began to spend less time at their Kansas City home at 5424 Harrison Street, in favor of a trailer in Phoenix, Arizona, to be nearer to their daughter, Eleanor. Otto rented out the home on Harrison Street, but kept the old steamer trunk in the vault of a locked storage cage in the basement. The trunk faced an uncertain future. Would it ever see the light of day again?

When in the early 1960's Higgins relocated permanently to Phoenix, the old trunk, along with other miscellaneous household paraphernalia not shipped to Arizona, ended up in the care of daughter, Carol Larkin. Carol took it to her farm just outside of Pierce City, Missouri, where it lay year after year on a dirt floor in a detached garage. At some point in the late 1980's, the old trunk itself was given away to a handyman on the farm. Its historic contents, now suddenly more vulnerable, were emptied into cardboard boxes, unprotected from the four-legged creatures which naturally tend to inhabit a detached garage in rural Missouri. After Carol died in 1997, Otto's dispatches, photos and other material, could easily have ended up in an estate sale or worse.

Fortunately, Carol's daughter, Otto's granddaughter, Sheila Scott, took up their cause, and removed the cardboard boxes to her home, transferring them to a large, clear plastic storage tub. No doubt Sheila and her siblings wondered what best to do with such a collection of decomposing papers. Ultimately, Sheila donated the materials to the National World War I Museum on November 11, 2010, just 4 years shy of the Great War's centennial.

While 100 years is easily within the consecutive lifespans of two people, the technological and social changes which have occurred since the Armistice make the world of the Great War reporters seem older in time. Even so, repercussions from that cataclysm shape us still.

Now through the meticulous research of James Heiman, an insightful new chapter of the Great War has been written. Heiman has compiled the Higgins' dispatches and added much historical context, to take us back to that early part of the 20th century when armies clashed, and empires fell. Somewhere in heaven, Higgins and his fellow correspondents must be gratified with their new readership. Like the young doughboys they covered, their rallying cry must surely be, "remember us", and the ideals for which America fought the war to end all wars.

J. Bradley Pace
Jackson County Historical Society

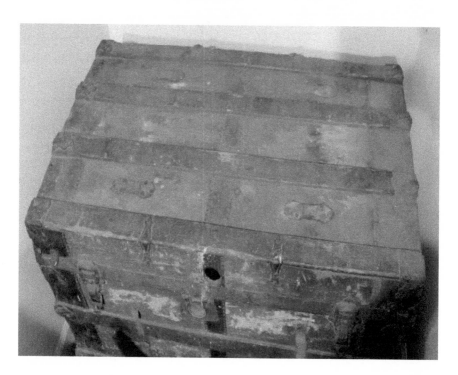

One of Otto's steamer trunks—similar to the one in which he kept his WWI material.

Otto's WWI material in Sheila Scott's plastic storage tub.

Author's Notes

Here is the story of an embedded WWI journalist for a major American newspaper told from the perspective of the complete body of his published overseas war reports. *Kansas City Star* reporter, Otto P. Higgins wrote 218 dispatches, beginning in the cemetery where the *Lusitania* victims are buried in Ireland; continuing on to the headquarters of the American Navy in London; and ending with the fight in France and the occupation in Germany.

Behind the lines, Higgins reported from the salvage, supply, transport and repair operations in support of American doughboys on their way to the "quiet sectors" of the front lines for advanced infantry training by the French and British. Along with other journalists headquartered in Paris, Higgins ventured forth to provide his readers at home with a sure sense of the support their boys were receiving "Over There."

Once American troops engaged in the fight, Higgins and Adam Breede of the Hastings, Nebraska *Daily Tribune*, secured a "special dispensation" signed by General MacArthur, 42nd Division Chief of Staff, and were the first to witness and report decisive American action at Belleau Wood. There US marines delivered their first great blow to the German juggernaut. During and immediately following the battle, Higgins took a number of photographs, four of which were published in the *Star*, and four others which are published here for the first time.

Higgins then joined the 117th Missouri and Kansas battalions deployed to provide the signal and ammunition support for the 42nd "Rainbow" Division. He accompanied and described in vivid detail night raids through the wire, lived in trenches and dugouts and told the stories of 35th Division field ambulance, engineers, infantry, artillery and YMCA men. Higgins also wrote about the 89th Division in the St. Mihiel-Verdun drive and the 35th and 89th Divisions in the Argonne—stories delayed by the censorship until they finally appeared in the paper nearly a month later.

Finally, Higgins described in detail and with previously unpublished pictures what he witnessed at the end of the war. Now that the censorship had eased, Higgins could tell the rest of the story, and he narrated the tragedies and triumphs, humor and pathos, his as well as those of the Missouri and Kansas men of the 35th, 42nd and 89th Divisions as they remembered the fight, mourned their fallen comrades and prepared to come home.

March 2, 2018

Introduction

Writing a history of a body of overseas war reports a century after their original appearance in print presents daunting challenges as well as intriguing opportunities. I discovered the opportunities through the challenges, the most daunting of which was that as the project neared completion, I was forced to take on more of the role of a reporter than I had ever been prepared to do at the outset. I discovered myself reporting on a reporter. The effect of that metaphorical transformation is left to the contemporary reader to determine—much as it was left for the reader of a hundred years ago to determine the effect of the original war reporting Otto Higgins did in 1918-1919. We are both re-presenting an experience whose proportions and significance are ultimately beyond us.

His work is done—approximately 218 dispatches totaling 198,665 words composed and published in the fourteen months between May 1, 1918 and July 2, 1919. Added to that are 74 photos, most of which were published, but some appearing here for the first time after remaining in a steamer trunk for over ninety years. His subjects were men and women with the 35th, 42nd, and 89th Divisions, who served in trenches, dugouts, shell holes, tunnels, YMCA huts, hospitals, aid stations, airdromes, artillery positions, and supply lines. Most of his subjects returned to the States after the war and are buried here, but some lie still in cemeteries in Ireland and England, France and Germany. His readers, too, are gone by now, but one hundred years ago, they were the audience for the *Kansas City Star*, a regional newspaper with morning and multiple evening editions distributed throughout seven states in the middle of America.

The original work, however, remains—on archival microfilm and here in a print summary of dispatches, along with a selection of articles, the total a little under 97,500 words gathered and edited over a period of five years. Added to that are a selection of the

photos Higgins took, additional pictures appearing in contemporary unit histories he read, maps and postcards of the areas he describes, and extensive annotations of the allusions he makes to the areas he visited on the battlefields and the ones he remembered for references at home. The subject is now the body of his overseas work and the challenge of adequately re-presenting it in a limited amount of space to an audience a century removed from its original appearance in print.

To address that challenge I had to discover principles of selection, the criteria for which evolved as the story of Higgins' writing emerged. After locating the original articles on microfilm, I transcribed them into electronic form and organized them into a database that tracked dates and places of composition, subjects, and date of publication. From those and additional biographical information from the Higgins family and resources at the Edward Jones Research Center at the National World War I Museum and Memorial in Kansas City, Missouri, U.S.A., I constructed a timeline, and from the timeline, a sequence by which the articles would be presented. Organizing the dispatches by day and month, in the order of their composition, rather than grouping the dispatches by subjects or military units, enabled me to focus on the writing and how it evolved for both Higgins and his readers.

Events in the larger context of the war do, of course, largely determine the correspondent's location and his subject matter, but the integrity of the writing is best preserved and represented by the story of its evolution into print. Higgins, too, was interested in his work as it finally appeared in print, and he asked his wife to send him clippings. He also received feedback from officers, enlisted men, former colleagues at the *Star,* and readers back home. He interacted with fellow correspondents and dealt with the changing rules of censorship. As his consciousness of the work grew, so did his confidence, and as his writing evolved, he relied even more

directly on first-person point-of-view and allusions to places and events at home. His awareness of audience seemed to grow with the intimacy of a familiar and sometimes even a profoundly personal narrative.

My audience is different from his, of course, but the feedback he received at the time, the confidence he gained as he wrote, and the familiarity he developed in the allusions he used make a great difference in how I approach the work of re-presenting his work to my audience a hundred years later. The unwritten but on-going conversation between Higgins and his audience at home, for instance, is represented in the increasingly familiar allusions Higgins makes to Kansas City, to the work the boys did in civilian life and to where the women he meets in the Red Cross stations or the YMCA huts trained or went to school. It is here that the needs of my audience come to the fore. Added to the allusions Higgins makes are word usages, slang, technical terms, military contexts, and topical references no longer a part of the assumptions the contemporary reader brings to text a century old. Consequently, the end-notes and chapter commentaries included here become a significant part of the text for which I must account in selecting which of Higgins' dispatches to retain in full, which to summarize and which to reference in passing. The accessibility my audience has to the work limits the amount of original work I can include.

As I became increasingly aware of my audience, I also became increasingly aware of Higgins' own emerging sense of audience, and I developed article selection criteria that combined audiences past and present with writers' purposes past and present. I retained intact those articles most representative of the themes that emerged in the writing that month, or of the unique circumstances that presented themselves to Higgins and revealed the personal experience shaping his narratives. The presence of other journalists, the sense of audience that entered into his stories, and his own

distinctively developing style emerged as major considerations in my selection criteria. However, my ultimate goal was to present an accessible study of the overseas war reports of a correspondent for a major Midwestern American newspaper as an integrated whole, a treatment not otherwise available in the literature of World War I journalism. I wanted to tell the story of the stories.

The result is that this holistic approach is grounded in a local context that draws purposes and audiences together. Because the army divisions and marine regiments that fought the land war in Europe were largely comprised of units drawn from particular regions of the United States, embedded correspondents were, in effect, local reporters, like Higgins, already experienced with years of reporting on the local scene. The reports he sent home during the war were as much about the folks at home as they were about the boys "over there." Higgins' purpose in writing had merged with his awareness of audience, and so have mine. Consequently, reading the war reports one hundred years later, in the context of the whole and in the order of their composition, today's reader can experience something of how a local newspaper audience one hundred years ago made a uniquely local connection to the Great War. Separated from that context, individual war reports lose the dimensions of expectation and familiarity that the writer and his audience brought to them at the time.

There were errors, of course. Higgins' original typescript was sometimes coded for cable; usually transmitted by mail, wireless or telephone and always transcribed and re-typed at the *Star*. In the process, names were sometimes misspelled, information became garbled, and censorship cut holes in the copy. In addition, as events evolved, available information was often limited or outright mistaken. However, as more time elapsed, the censorship lifted, additional information became available, errors were often

corrected in subsequent articles, and the story gained accuracy. In the re-telling here, however, any other errors are entirely my own.

—Independence, Missouri
 July 2018

Prologue: The Style Sheet, The *Star* Man, and The Censor

The Style Sheet

Like its founder and editor, William Rockhill Nelson (1841-1915), the *Kansas City Star* had its own style that grew out of the context of its character and the parameters of its production. Clean, open-face type, columns wide and packed with news, sentences crisp and concise, the *Star* both informed and entertained, as its founder wanted it to do. Its newsroom reflected its pages—packed with reporters with no cubicles, Nelson's desk completely visible and accessible. Embodied in the production elements as well as in the conventions of reading, style was the very essence of *Star* writing.

In the most general sense, style is that element of a written piece distinguishing it as unique.[1] The style of any particular piece of extended writing, for example, could allow an experienced reader to identify an experienced author even without a by-line because the developed writer's "personal style signature" is embedded in the piece itself.

In its most specific sense, however, the elements of journalistic "style" are themselves much more mundane, a set of print conventions required by a publisher and practiced by reporters. These practices are summarized in a "style sheet," or "stylebook," a succinct list of rules specifying usage preferences and standard practice in the craft of writing. Included are standard "spelling, punctuation, capitalization, the use of abbreviations and italics, the expression of numbers, and many details of typographical form and practice."[2] In this sense, style

i

establishes the uniformity shared by all the reports in a particular newspaper.

Given the general and the specific senses, then, style is as much accommodating to the reader as it is revealing of the writer. From the very outset, the reader was the focus of the *Kansas City Star*.

Publisher William Rockhill Nelson encouraged young men like Ernest Hemingway and Otto Higgins by first engaging their sense of the reader's interest. From the very beginning of the paper, Nelson had "brought to his work the viewpoint of the reader rather than that of the technical newspaper man. 'Believe in the people,' he would say. 'No man with even ordinary judgment ever went wrong in assuming that the people will support the best that is furnished them.'"[3]

Nelson understood that furnishing the best for readers depended on finding the most creative reporters. "They are the fellows whose work determines whether the paper shall be dull or interesting; whether it will attract readers or will repel them. What is needed in reporting," Nelson continued, "is initiative and imagination. The man who has the imagination to see a real story in an apparently commonplace happening, and the initiative to go after it and develop the story, is the sort of man every newspaper is looking for." Writing ability, as important as what it was, came secondary. "If in addition to those abilities comes a knack of writing, so much the better," Nelson said. "The fortunate possessor

of this combination is on the way to fame. But the ability to write is common and less valuable than the ability to dig out the news."[4]

"The essential, then is the 'nose for news'—the instinct to recognize the real story in an event or situation. This is, I presume, inborn," said Nelson. "If a man hasn't it, let him forsake the newspaper field. He will never make a success of it. With this news instinct must come industry. Often a good pair of legs makes a good reporter. The newspaper man must always be on the job, always hustling, always ready to go to any inconvenience or suffer any fatigue to get the news."[5]

Combining the "nose for news" with the "knack of writing" found its best expression in *The Star Copy Style*, codified by 1915 into 110 rules in short paragraphs, filling three columns of a single-sheet. "'Those were the best rules I ever learned for the business of writing,'" Ernest Hemingway said in 1940, "I've never forgotten them. No man with any talent, who feels and writes truly about the thing he is trying to say, can fail to write well if he abides with them."[6]

The rules Hemingway remembered and practiced so well were handed to him on an October morning in 1917, when he joined the *Kansas City Star* as a cub reporter.[7] Reporters studied *The Star Copy Style* as they went to work, and "after that," Hemingway remembered, "you were just as responsible for having learned it as after you've had the articles of war read to you."[8] The figure of speech proved apt. Hemingway remained on the *Star* from October to the end of April 1918, when he left for the war. As early as

February, he had submitted an application to the Red Cross to become an Ambulance driver in the Italian army.[9] After some delay, his application was accepted, he shipped to France, then to Italy, where he joined an ambulance section in Schio, became bored with the lack of action, and volunteered in late June to help run emergency canteen service for men in the thick of fighting at the Piave front. It was there on the night of July 8 that Hemingway was seriously wounded in the line of duty.[10] In less than two and a half months, he had gone from writing articles about accidents and crimes of violence in the city to witnessing and actually experiencing first-hand the violence in the front lines of the war. Now he would tell the story of war with the tools he had developed in the city. From his experience at the *Star,* he had already begun to develop his own signature style of terse declarative sentences, where action occurs between rather than within the lines.

The rules he followed at the *Star* had been shot at him in bullet-like fashion: "Use short sentences. Use short first paragraphs. Use vigorous English. Be positive, not negative. Eliminate every superfluous word. Don't split infinitives. Avoid the use of adjectives, especially such extravagant ones as 'splendid,' 'gorgeous,' 'grand,' 'magnificent, etc,'" *The Star Copy Style* commanded. And then came summary banishment: "The words 'donate' and 'donation' are barred from the columns of the *Kansas City Star.* Use 'give' or 'contribute.' The use of 'raise' in the sense of obtaining money, has been forced into usage where no other word seems to do as well," the rules explained. "But 'raise' is not a noun," it concluded, and after that, presumably, few reporters had the temerity to ask for one.[11]

The *Star* Man

The Star's Present Home, Grand Avenue to McGee Street between Seventeenth and Eighteenth Streets

But the reporters didn't feel the need to ask; the reward was the writing itself. Jim Fisher, a columnist at the *Star* for years, observed that in addition to the craftsmanship prescribed in the style sheet, the encouragement offered by the *Star's* assistant city editor, C. G. "Pete" Wellington, "instilled a sense of greatness into a group of young men eager to believe themselves great. The *Star* encouraged its reporters to write with absolute freedom," Fisher explained, "unhampered save by the truth as they saw it. The result was exceptional newspaper writing in a day when some reporters on other papers made up stories with small regard to truth, caring little for the craft of writing. The freedom had an added bonus—staff loyalty. Despite the meager wages, a *Star* man cherished his creative freedom. It is little wonder so many of them would develop into smooth storytellers later at other papers across the nation, in the writers' wings of Hollywood studios and at the major magazines."[12] Echoing William Rockhill Nelson, one reporter put it this way: "'We must think of the *Kansas City Star* in off-hours and show up for work whenever necessary, without extra pay. After all, what was money? Something transitory. But the fame of being a *Kansas City Star* man would last forever. And we believed it.'"[13]

For Otto Higgins, being a *Kansas City Star* man began seven years before Hemingway arrived at the newspaper. Higgins had

been schooled orally in what later was codified in *The Star Copy Style* sheet. He honed his skills of observation and intelligence-gathering so well that he captured the attention not only of his own editors but also that of J. B. Hipple, the editor of *The Press*, a smaller local paper published in Kansas City, Kansas, and in competition with the *Star*. Although Higgins worked for the bigger newspaper, he was still a local man, at least in Hipple's eyes. Higgins was the *Star's* reporter "on the branch staff" of the "Kansas side," as that beat was known, and on Saturday, June 3, 1911, Otto Higgins became part of the news himself when he "scooped" the *Star's* main staff reporters on the Missouri side. Higgins discovered and then reported the appointment of Ford Harvey of Kansas City, president of the Fred Harvey chain of restaurants, and R. J. Dunham of Chicago, chair of the Kansas City Metropolitan Railway Board of Directors, as receivers for the financially troubled Kansas City Metropolitan Street Railway Company, which ran the city's streetcars.[14]

An editorial appearing in *The Press* the following Friday, June 9, 1911, took advantage of the Higgins "scoop" to tout the advantages of the local man and the local newspaper over the bigger newspaper.[15] "The *Star* told the story about the Metropolitan Street Railway Company going into the hands of a receiver Saturday night [June 3, 1911] in the special sport edition," the rival local paper said.[16] "This important scoop is due to the ever-alert Otto Higgins. It does seem strange that a reporter on the branch staff should beat the main guys."[17] In praising Higgins by name and pointing out his "local" ("branch") status, the rival paper was certainly touting its own advantages as a local newspaper, but the qualities that give the local its advantage in gathering news are exactly the qualities that make a bigger newspaper successful. The reporter was the key.

Being "ever alert" meant that OPH fit exactly what William Rockhill Nelson wanted in a reporter. Higgins had the "nose for

news"; he had the "initiative and imagination," the "inborn instinct" that made a good reporter. Because of his "nose for news," Higgins knew the territory, was constantly on watch, and had positioned himself in the right place at the right time to get the story, just as if—as actually happened later on in France—he had set out on a clandestine scouting mission, penetrating enemy territory to gather intelligence on how men gather intelligence on enemy movements.[18] Higgins had "the legs."

Like Hemingway, Higgins' beat included police reports and stories of military recruitment and training.[19] In addition, over time, Higgins was developing a network of military men; he wrote about the old 3rd Regiment, Missouri National Guard, some of whom were lawyers, engineers and other professionals, whose military activities were becoming more serious from 1914 on, as they formed military units of colleagues and began to train for the eventual U.S. involvement in war. In the spring of 1917, shortly after the U.S. declared war on Germany and a few months before Hemingway arrived at the *Kansas City Star*, managing editor Ralph Stout extended Higgins's assignment to following the Missouri National Guard units then federalized and training at Camp Doniphan, Fort Sill, Oklahoma, and the national army of draftees then training at Camp Funston on the Fort Riley, Kansas, reservation.

Although both Higgins and Hemingway worked at the *Star* at the same time and their names appeared on the same assignment sheets,[20] given the physical distance between their work sites, it is unlikely that Higgins knew Hemingway very well—if at all— beyond a casual and certainly infrequent contact at the newspaper's main office. What the two reporters did have in common, however, was the skill of basing their reporting on the kind of intelligent observation that mattered most. And both men had put their observation, intelligence—and their legs—into writing honed by the *Kansas City Star's* style sheet.

In addition, as in Hemingway's case, it wasn't long before Higgins developed his own distinctive style. The entertaining and informative elements of the Higgins style might be summarized by the following examples that enabled readers familiar with his writing to recognize an OPH article even without the signature "OPH" monogram that typically appeared at the end of one of his pieces.

"Examples of an OPH Copy Style"

<u>Master of the Idiom</u>: "'Gimme some more ammunition,' I can remember hearing some farmer boy from Southern Missouri say, in his slow, drawling speech. 'I kain't shoot without no shells.'" ("The Old Third in a Raid," *Kansas City Star*, September 29, 1918, 2B.)

<u>Use of Slang, Especially Military</u>: "Aunt Jemima," "Archies" ("Sweets Lighten the Pack," *Kansas City Star*, September 22, 1918, 1B). "Snappy" in "The record of the 130th at the front isn't very long, but it certainly is snappy." ("When the Mobile Docked," *Kansas City Times,* April 24, 1919, 1-2). "Snapper" and "scrap" in "That was all the order. But it was enough. It had a snapper on the end of it that made it one of the most interesting orders of the day, interesting to the one sergeant and eight men who were to take part. For it meant a scrap in the night, a scrap in the enemy lines, with the probabilities that someone would not return." ("The Old Third in a Raid," *Kansas City Star,* September 29, 1918, 2B). *The Star Copy Style* permitted slang as long as it was current. "Never use old slang," *The Star Copy Style* decreed. "Such words as "stunt," "cut out," "got his goat," "come across," "sit up and take notice," and "put one over" have no place after their use becomes common. Slang to be enjoyable must be fresh."

<u>Conversational Tone, Replete with Current Slang and Use of Nicknames</u>: "And 'Skim' Campbell, now a sergeant, but in the old school days a wrestler, football player, boxer, and occasionally when he played hooky from school, a shark with a pool cue." ("When the Mobile Docked," *Kansas City Times,* April 24, 1919, 1-2).

<u>Quick-witted, Often Facetious and Usually Very Lively Repartee:</u> "Where do you get that stuff?" I shot back at them. You better save that for Pittsburg [Kansas]." ("When the Mobile Docked," *Kansas City Times,* April 24, 1919, 1-2).

"In the Moment" Description: "How my fingers itched for a rifle or an automatic so that I could take part. But I was a non-combatant." ("The Old Third in a Raid," *Kansas City Star*, September 29, 1918, 2B.)

Emphasis on the Immediate Moment, With No Attempt to Search For a Cause: "Just why, no one knew, nor did the men care." ("Paid on French Fete Day," *Kansas City Star*, August 18, 1918, 4A); "Just why it is, I don't know, but I do know that the authorities, both civil and military, and both American and French, scrutinize everyone." ("Strict Rules in France," *Kansas City Times*, September 18, 1918, 9).

The Added Comment became a distinctive mark of the OPH style, especially when he emphasized an action, such as compulsive movement: "There each man went, and he went in a hurry." ("Ask D.S.C. For 66 In 140th," *Kansas City Star*, April 28, 1919, 6:30 Edition, 1).

Use of the Tag Line, "and plenty of it," (or its opposite, "there wasn't any too much of it") to describe the availability of food or the appetites of the men ("Call Peck Report Unfair," *Kansas City Star*, June 4, 1919, 3); "They had mighty good food and plenty of it." ("Garret's Men In," *Kansas City Times*, April 28, 1919, 1); "The food was excellent, much better than either the men or officers had been accustomed to in France, and there was plenty of it." ("But This Is Home," *Kansas City Times,* April 21, 1919, 1).

Use of original Metaphor and Simile: "rumors as thick as hairs on a dog's back" ("Garrett's Men In," *Kansas City Times*, April 28, 1919, 2). "It was so quiet that you could have heard a fly walk on a velvet carpet." ("The Old Third in a Raid," *Kansas City Star*, September 29, 1918, Editorial Section, 2B).

Food and Eating as Primary Metaphors: "Men were eating their way through the famous Hindenburg line" ("Winning the DSC and Her," *Kansas City Star*, April 27, 1919, 28C-30C); "This will

give them an opportunity to strut about town and exhibit their tail feathers and be entertained from soup to fish." ("Home Towns to See 35th," *Kansas City Times*, April 25, 1919, 8).

Sports Metaphors and Comparisons: "Usually, I am sure-footed, but I wasn't then. I remember wondering why I couldn't keep my feet better, for in the old days, many a time I ran the gauntlet on the football field when it took a mighty good tackler to throw me." "I am not much on the high jump, but I cleared that wire and the boy underneath it." ("The Old Third in a Raid," *Kansas City Star*, September 29, 1918, Editorial Section, 2B.).

Use of Game Analogy and Game Metaphor Throughout Articles: "This was what some of the war correspondents were expected to do, to report daily on the progress of the biggest game that was ever played during the history of the world, a game where lives counted as naught; where a few thousand dead in one day was to be expected, where the ground gained or lost was in kilometers and not in yards—a game being played with the entire world sitting on the sidelines, eagerly awaiting every word." ("That Job of 'Writing Up' the War: O.P.H. Tells How Correspondents Worked in France," *Kansas City Star,* June 8, 1919, 6C).

Sense of Irony: French and Americans at a listening post— French couldn't speak English, nor Americans French, but both could speak German and in the language of the enemy they could understand each other and at the same time overhear what the Germans were saying to one another ("Blood is Fighting Blood," *Kansas City Star,* September 10, 1918, 3).

Oxymoron: "The sergeant picked out a nice, soft steel rod for me to sit on." "When Battery B Moved In," *Kansas City Star*, October 13, 1918, 13A).

Comparison to Familiar Kansas City Places and experiences to enhance the connection to his Kansas City readers: "It was just as light, thanks to Fritz's flares, as it is at Twelfth and Grand any bright

sunny day at noon." ("The Old Third in a Raid," *Kansas City Star*, September 29, 1918, 2B).

Humorous Personification: "At first, they came over in pairs, those shells, whistling and screaming as they passed over heads to explode in the valley below us. After that, they seemed to come in threes and fours, and it sounded like they were arguing with each other on the way over to determine which shell was going to have the pleasure of finishing us." ("When Battery B Moved In," *Kansas City Star,* October 13, 1918, 13A).

Use of Literary Contrasts to Create Metaphoric Meaning: "The ocean they had left during the early hours of the morning was more like their existence the past years—uncertain, rough, treacherous, claiming all that it can lay its fingers on. The river was more like their existence before the life they are returning to—quiet, calm, placid and loving in its embrace. It acted as a sort of a welcome, a forerunner of what is before them. And they were glad. They have had enough of the rougher side of life. They want peace and quiet and the loving hands of their women." ("Garrett's Men In," *Kansas City Times*, April 28, 1919, 1-3).

1st Person Authenticity—Occasional use of 1st person to lend authenticity and veracity to the piece: "When death is stalking about all the time a man's thoughts turn back to the days of his youth, and his mother and his God. I know." ("Sweets Lighten the Pack," *Kansas City Star*, Sept 22, 1918, 1B); "I mention that because I happened to be there." ("Broke Up a Boche Raid," *Kansas City Star*, September 15, 1918, 1B); "The St. Mihiel salient had to be wiped out and consolidated. Wiping it out wasn't so bad, but consolidating it was tough. I know. I was there through both performances." ("Garrett's Men In," *The Kansas City Times*, April 28, 1919, pp. 1-3).

Use of Onomatopoeia: "I could hear the bullets whizzing all about me. I could hear them splatter as they struck ("The Old Third in a Raid," *Kansas City Star*, September 29, 1918, 2B).

About Soldier Use of Hyperbole in Story-telling: "It won't be long until the rest of them will have the same kind of stories to tell with probably a few more thrills added for good measure." ("Get First Taste of War," *Kansas City Star*, August 6, 1918); "I must have fallen forty times. I couldn't count them, but, from what I can recall, I was up and down, up and down, all the time." ("The Old Third in a Raid," *Kansas City Star*, September 29, 1918, 2B.)

Hyperbole and Understatement (Litotes) Simultaneously: "But the boche knew every blade of grass in the salient and was acquainted with every speck of dust on the roads, and they renewed their acquaintance every day and night with artillery, which made life anything but pleasant." ("Garrett's Men In," *Kansas City Times*, April 28, 1919, 2).

Emphasis by Incredulity: "How the boys managed to take it, I don't know. But they did." ("The Silent Heroes There," *Kansas City Times*, May 31, 1919, 3). "How I ever got over the fifteen yards of wire in front of our lines I'll never know. But I did. In the daytime, a hundred miles back of the lines, I would never attempt it. But somehow, I got over." ("The Old Third in a Raid," *Kansas City Star*, Sep 29, 1918, 2B).

Transitional Routine: "And so it continued day after day." "And so it goes." ("The Home Boys in Camp," *Kansas City Star*, July 17, 1918, 3).

The Individual Soldier's Point of View: OPH narrates the history of the 35th Division juxtaposed with the story of Sgt. "Skinny" Johnson, a farm boy from Nemaha County, Kansas, whose particular objective is to win the heart of his girl over the "Hated Rival," a tailored lieutenant and later captain, who, like "Skinny," has been wounded in the war. OPH uses the Stock Story Elements

of Romance to narrate "Skinny's" story. ("Winning the D. S. C. and 'Her,'" *Kansas City Star*, April 27, 1919, 28C-30C).

The Censor

Higgins developed his own distinctive style within the parameters of *The Star's* style sheet, but as a war correspondent, he also had to adapt his writing to the demands of the censor, and these demands changed constantly as the war progressed and as General Pershing himself began to see the value of the press in influencing public opinion to support the military mission of the A.E.F. Following is Higgins' copy of the official statement of censorship rules in force when he arrived in France in April 1918.

RULES OF CENSORSHIP[21]

April 2, 1918.

Principle of Censorship: All information which is not helpful to the enemy may be given to the public.

A. GENERAL CONDITIONS. Under the foregoing basic principle, all articles must meet four conditions.
 1. THEY MUST BE ACCURATE IN STATEMENT AND IMPLICATION.
 2. THEY MUST NOT SUPPLY MILITARY INFORMATION TO THE ENEMY.
 3. THEY MUST NOT INJURE MORALE IN OUR FORCES HERE, OR AT HOME, OR AMONG OUR ALLIES.
 4. THEY MUST NOT EMBARRASS THE UNITED STATES OR HER ALLIES IN NEUTRAL COUNTRIES.

The foregoing conditions apply to every article which is written. The specific rules which follow are intended to explain them but never to be considered as permitting the publication of anything which conflicts with those four conditions.

B. IDENTIFICATION OF PERSONNEL. There will never be identification by numbers or organization.
 1. Concerning TROOPS IN THE LINE identification will be only as announced in the Official communiqué

2. Concerning TROOPS IN TRAINING. There will be no identification by sections, i.e. "New York Troops", "Ohio Troops", etc. in cable dispatches. When it is obvious to the censor that in consideration of time element no military information will be given to the enemy by articles which will be sent by MAIL, there can be identification of small groups, as "New England Troops", "New York Troops", etc.

3. With reference to MAGAZINE ARTICLES OR COPY FOR BOOKS, time element becomes a still stronger factor in lessening the value of the eventual publication to the enemy's information service and is to be taken cognizance of by the censor.

4. Reference cannot be made to troops, as "NATIONAL GUARD", or "NATIONAL ARMY", or "REGULAR" organizations. During this war, we have only one army, the United States Army.

5. As to INDIVIDUALS, a name can be used whenever the story is materially and obviously helped by using the name. The determination of this is in the hands of the censor and not the writer.

6. Officers of the A.E.F. are not be to be quoted, directly or indirectly or anonymously in regard to military matters (tactics, strategy, etc.) except as specifically authorized.

C. IDENTIFICATION OF PLACES. Places can be mentioned only to a limited extent.

1. Within the Advance Zone, no sector shall be said to have any American troops in it until the enemy has established this as a fact by taking prisoners.

2. No town in the Advance Zone shall be identified as holding troops of the A.E.F. or Allied Forces except as an essential part of a story of an engagement and AFTER the fact.

3. No base port shall be mentioned by name or description as having anything to do with Allied Forces' activities of any character.

4. No point in the Intermediate Zone shall be mentioned so as to form by inference a link between a specific base port and any part of the front line.

5. There is no objection to stating the location of schools in the Intermediate Zone, except for special reasons, which will arise under special conditions. There is, however, a prohibition of identifying the location of the main regulating station and large supply depots.

D. SHIP MOVEMENTS, real or possible, will not be discussed.

E. PLANS OF THE ARMY, real or possible, will not be discussed.

F. NUMBERS OF TROOPS. As a total or as classes, will not be discussed except by special authority of G.H.Q.

G. TROOP MOVEMENTS will not be discussed except by communiqué.

H. EFFECTS OF ENEMY FIRE will not be discussed except by communiqué.

I. ARTICLES FOR PUBLICATION IN EUROPE will be scrutinized carefully to make sure that they do not hold possibilities of dangers which the same stories printed in the United States would not hold. This applies not only to military information which would thus be in the hands of the enemy within a day after writing, but also to an emphasis on small exploits which it may be extremely desirable to print in the United States but quite undesirable to print in Europe.

J. EXAGGERATION of our activities, accomplished or contemplated, will be studiously avoided, because of the bad effect that this will have on the respect which our Allies have for our promises.

K. CASUALTIES as to numbers will be passed only as indicated in communiqués.

 1. Individual dead or wounded will be mentioned by name only when it is reasonably manifest to the censor that the facts are correct and that some definite good end, such as offering examples of heroism etc. will be served by printing them.

 2. In the main, it is desirable to print no names of dead or wounded until the Department has had time to notify the families, and, as this notification comes only through the hospital report, it is apparent that there will be delays.

 3. Under no circumstances are there to be reports as, for example, "that a major general was killed while, etc." Either the man's name should be given or this event should not be mentioned at all, whether for military reasons for because such a vague statement would uselessly alarm the families of all other Majors-General in France.

L. DECORATIONS: A Board at G.H.Q., A.E.F., considers all recommendations for the Medal of Honor, the Distinguished Service Medal and the Distinguished Service Cross. In cases of the first two, the honor is given at Washington on recommendation from G.H.Q., A.E.F.

 1. The fact that this recommendation is given will be considered as news, exactly as is the actual granting of the Distinguished Service Cross, which is within the power of the Commander-in-Chief of the A.E.F. These will be announced through the Press Section at G.H.Q., through the Field Headquarters of the Press Section, without awaiting final action in Washington.

 2. The recommendations for such honors by brigade or division commanders, will NOT be considered as constituting news, inasmuch as in the event that such recommendations are not approved, premature publication would do an injury to the

man recommended but not by higher authority deemed worthy of the honor.

3. In the case of Allied Army decorations, a different rule applies, where citation alone is considered as news. Such a citation can be published by the American correspondents as long as they observe strictly the rules of the Allied Authorities with reference to such cases. This news will not originate officially with the American G.H.Q. but if it comes to the attention of the Press Officer at G.H.Q. will be promptly communicated to the Field Headquarters of the Press Section.

M. AMERICAN CENSORSHIP is final on articles concerning American troops. Three cases present themselves and are disposed of as follows:

(a) If American troops are operating in a STRICTLY AMERICAN SECTOR, news of them will be submitted only at American G.H.Q.

(b) If Allied troops are operating in a STRICTLY ALLIED SECTOR, news of them will be submitted only at the G.H.Q. of the Allied Army concerned.

(c) If American Troops are operating IN CONJUNCTION WITH an Allied Force, news of these joint operations will be submitted to censorship at EITHER the Field Headquarters of the A.E.F. or the Field Headquarters of the Allied army concerned. In such a case, the American Officer designated as Field Censor with the Allied Army G.H.Q. will examine every mention of American troops in such a story and his written O.K. and addition of "*Controle Americain*" will be essential to the passage of that portion of such a story. In the same way, the officer of the Allied Army concerned designated as Field Censor with the American troops G.H.Q. will examine every mention of Allied Forces in such a story

and this O.K. will be essential to the passage of that portion of such a story.

N. The American Censor at the Bourse in Paris is not authorized to censor stories concerning the field operations of American troops in France. He is, as always, authorized to examine such stories, and in the event that he finds a story concerning American troops which has not in it a notation that the passage concerning American troops has been censored by the competent field censor of the A.E.F., he is authorized to hold up such a cable or mail story until he can communicate with the competent field censor and ascertain why the story did not include a notation of his having examined the article.

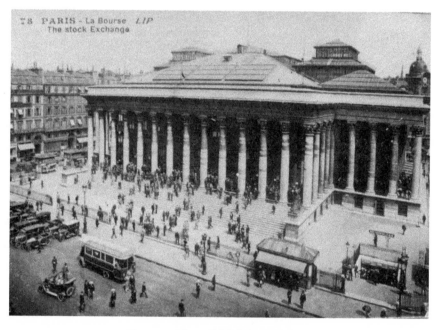

Censorship of OPH's Work

Once in a while, censorship itself became an element in OPH's writing. Sometimes OPH himself explained why information he would normally include as a good reporter could not be printed because the censorship would not allow it or information he would not normally be able to reveal because of the censorship

was now permitted. A good example of the later occurred in an article OPH wrote on November 8, 1918, and sent by cable to the *Star*. "Complete details are now released by the censor, showing the progress of the 89th Division in its last drive and the towns and villages freed by this division," Higgins wrote.[22]

At other times, the *Star* itself felt compelled to illustrate the work of the censor. For example, the *Star* might allow gaps where the censor had cut out portions of the text, or the editors in Kansas City might explain in parenthesis or in a box preceding the article that the censor had excised the information before it had been received at the *Star*. The later was the case in the first few days of the fighting in the Meuse-Argonne at the end of September, 1918: "Reports have been coming into Kansas City from many sources about the hard fighting, the heroic gallantry and the great suffering and losses of the 35th Division in the Argonne Forest battle the last days in September," The *Star* noted on November 1, 1918. "Only the barest facts of that great struggle have seeped through the fingers of the military censors, and so far the casualties suffered there have not appeared in the official lists. Incomplete cable dispatches received shortly after the stirring days of the last week of September, when the 35th was going up the Aire River on the east side of the Argonne Forest told of terrific fighting and heavy losses and the capture of Cheppy, Exermont, Very, Charpentry and Vauquois Hill, but names and units were rigidly cut out by the censor. The censor has been slightly more lenient with the present article."[23]

The article referenced by the *Star* was written by OPH on October 3 and printed on November 1 in the *Star*'s main edition. When it finally arrived at the *Star*, almost a month after it was written, the censor had already made seven cuts, totaling 165 words out of the 2,040 OPH wrote. The censorship in this instance represented 8% of the article's content. Even with what did get

through, OPH had to use his own code. For example, "a regiment of Kansas City infantry" referred to the 140th Infantry. "The Kansas City regiment of engineers" referred to the 110th Engineers. "The khaki-clad men from Missouri and Kansas" referred to the 35th Division. "Kansas City artillery" referred to the 129th Field Artillery. The editors at the *Star* added further details so readers could identify the units in terms with which they were familiar: "The 140th Regiment of the division is made up of the old 3rd Regiment of Kansas City and the 6th Regiment, recruited in Missouri towns, and both members of the old National Guard," the editors explained. "The 129th Field Artillery is also a part of the 35th Division. It includes old Battery B of Kansas City and other batteries from Independence and from Kansas [City]."

Of all the references to censorship, however, the best review of its effect on OPH's writing came from Higgins himself, some seven months after the fighting stopped in November 1918. On June 22, 1919, as his writing about the war was drawing to a close, OPH was finally able to explain to his readers how he and his fellow reporters had dealt with the issues of censorship. His article, "'Getting By' the Censor," appeared among the series of articles published in a regularly appearing column entitled, "From the Notebook of O.P.H." Not from the "notebook" series itself, his piece on censorship was a new article and explained from his own perspective how the censorship to which he was first introduced in March 1917 with an update in April 1918 worked throughout his reporting, both stateside and overseas.

"GETTING BY" THE CENSOR
CORRESPONDENTS WITH THE A. E. F.
WERE IN MANY CLASHES

However, by Changing a Few Words
Stories Were Permitted Transmission
To Newspapers—Ruses Some Men Used.

By O. P. H.[24]

While America was at war what news was proper to tell the people at home and at the same time take a chance of giving information valuable to the enemy?

Time after time "copy" submitted to censors by American war correspondents on the front clashed with the rules and regulations of the censorship. In nearly all cases the censors were victorious. Occasionally the correspondents got the best of the game, but not often.

Never at any time did the correspondents at the front dare evade the censorship. But time after time they cut corners, argued the censor around to their point of view, appealed to general headquarters, and had the rules changed so that stories could be allowed to pass.

As a result of this, the rules were being changed continuously, and unless a correspondent visited press headquarters from time to time he would be writing "copy" leaving out essential facts that would be possible to print. An effort was always made to notify us, of course, of changes in the rulings, but mail was one of the things in France that was very uncertain and at times letters required months to deliver.

The censorship was divided into two classes, the combat area and the rear area. The office of the rear area was in Paris. Here all matter to be sent by mail or cable, referring to work back of the lines, was censored. The combat area was of everything that had to

do with the troops along the front. Never at any time did the work of one section conflict with the other. For instance, a story concerning front lines events could not be written in Paris and passed by the Paris censor. Should the story be given to that office, it would be sent immediately to the advance section. This made it impossible for correspondents to write stories about the front while they were in Paris, without suffering from two to three days' delay in having the articles passed by the censor. This rule was iron clad because censors in the advance section always were informed fully on action at the front, and those at Paris were not.

An intermediate office was maintained at Neufchateau, which occasionally handled mail and cable stories that affected the extreme north end of the American line, a sector that usually was quiet.

HOW A CORRESPONDENT EVADED.

Some of the rules were peculiar to us. For instance, I couldn't say that the 35th Division had done something, but I was allowed to say "troops from Missouri and Kansas." Of course, everyone in Missouri and Kansas knew the 35th was composed of men from Missouri and Kansas, and the boche knew it also. But then there were other troops from these states, and the news never was definite. Now, with Frank Sibley of the *Boston Globe* it was different. Sibley covered the 26th Division alone, known as the Yankee Division. He could refer to them as "Yankee troops," and everyone knew just what was meant. Yet he couldn't say "26th Division."

During the early stages of America's participation in the war last summer[25] I lived in the line with the 35th, and was writing exclusively about that division. But I couldn't say so in my "copy." I had to head it "On the American Front" or "With the American Army at the Front," which meant nothing to the people at home, and I could not mention names above the rank of captain.

Correspondents who cabled daily matter regarding the progress of the war seldom paid any attention to individual units. It made a big difference in this way, however. Everyone in the United States was interested in knowing whether their relatives or friends were fighting. They knew what units their persons were in. Judging from the papers from early in June, one would have thought the Marines were fighting the war alone. This was because the name "Marines" was permitted, while no other units could be named.

The casualty rule was one that made things hard for all concerned. The Central Records Bureau was organized on a small basis. Consequently, when the fighting became heavy, it was snowed under with reports. The condition of the records still is shown in that casualty reports are yet being published, several hundred a day. Before any casualty had been reported the name had to be verified by the bureau. This took weeks, and sometimes never was verified. Yet men and officers in the line were permitted to write and cable home about these things, while the correspondents did not dare. Many a hero went to his death unsung because of this rule, and many a heroic deed of valor by a soldier wounded in action never was recorded. Yet if a man did something unusual and came through without a scratch it could be printed. The soldier who suffered for what he did received nothing.

THE BALTIMORE SUN'S RUSE.

Beginning with the St. Mihiel drive[26] the official communiqué mentioned names of divisions occasionally. We were permitted to write what these divisions had done up to the time of mention in the communiqué. This helped some, providing you were interested in the divisions mentioned. For a long time we were permitted to write mail stories using the name and location of the division with this provision:

The story was marked "Hold for cable release," and was supposed to be held in the newspaper office until permission to print

it had been received from France. The release depended upon the identification of the division by the boche, or the movement of the division to another part of the line. Raymond S. Tompkins of the *Baltimore Sun*, as well as others of us, had lots of good "copy" held up this way. The *Sun*, however, became tired of holding the "copy" in the office, sent it to Washington, where the military authorities after examining it said they could see no reason why it shouldn't be printed at the time. They passed it. Thereafter, whenever the *Sun* received "copy" marked "hold for cable release," it went to Washington and was released. The rest of us knew nothing about this scheme, however, and many times our stories were printed two and three months after the action occurred.

Edwin L. James of the *New York Times* had a peculiar way of getting "copy" through. James usually would begin talking a day in advance. If he desired to present one side of a case, he would begin talking about the other side. The censor usually would take the opposite side. In that way James would get an expression from him and the next day present his story. Wilbur Forrest of the *New York Tribune*, too, had a way all his own. If the censor would blue pencil an important paragraph or an idea, Forrest would calmly tell him to throw the entire story away, that it was ruined forever and ever, that the entire heart was out of it, and without that one paragraph it would be useless to print the story. Censors knew a story usually represented hours and hours of work, and finally the story would be passed with a changing here and there of a few words.

VISITING MEN WERE FAVORED.

After the Armistice, conditions were harder on frontline correspondents than before. While they could mention the names of units, locations, and the names of officers, and men up to the rank of colonel, yet there were many other things that had to do with policy that the censor would not pass. Yet visiting correspondents could

make flying trips all through the occupied territory, return to Paris, write what they pleased and drop it in the mail, where it would be examined only by the French postal censor, and he probably never saw it. The censorship section connected with the A. E. F. in Paris had been abolished, yet it was maintained at the front and regularly accredited correspondents could not write nearly so freely as the visitors could.

Now and then the French and English would hold up "copy" intended for American newspapers, "copy" that had been passed by the American censor. This happened quite frequently in Paris, where the French were concerned, even though they were bound by agreement not to do so.

But, taking it all in all, the American censorship was much more lenient than that of the British or the French, and if the war had continued another year a system would have been worked out that would have allowed a larger amount of news to be passed. The censors were learning and becoming more lenient all the time.

Chapter 1: OPH: The *Star's* "Own Correspondent" —April 1918

By 1917, Otto Paul Higgins had been working as a police reporter for the *Kansas City Star* for seven years. His regular beat took him to police headquarters and to those parts of the city's north end, where crime had its own zone of combat and violence exacted an almost daily toll in human life. Then, on April 2, 1917, President Woodrow Wilson read before a joint session of Congress the declaration that would finally put the United States at war with Germany. That announcement at the national level, along with other unique circumstances locally, was the catalyst making Otto P. Higgins, or "O.P.H." as he became known, the *Star's* choice for its "Own Correspondent" to report on the training and deployment of Missouri and Kansas troops for war. Higgins's experience as a reporter, his sense of humor and his popularity and social networking, combined with his writing ability and fluency in German, prepared him for telling the war stories of many of the friends he later saw "over there" in England, France and Germany.

Higgins already knew the territory "over here." In addition to his police beat, Higgins had also regularly reported on the activities of the 3rd Regiment, a Missouri National Guard unit, most of whom, with the exception of Company B from Boonville, MO, and Company H from Liberty, MO, were boys from Kansas City. Higgins himself recalled that he "began with the old Third Regiment, when it was first called out, was with it at Camp Nichols, later at Fort Riley, Camp Funston, Camp Doniphan, Fort Leavenworth, Fort Sheridan, and thence to France."[1]

The "Third Missouri was among the first of Missouri regiments to enter national service. Having received the call three weeks before war was actually declared, the Third Missouri drilled regularly on training grounds at the old armory at 39th and Main in Kansas City.[2]

Among the re-activated unit's first assignments was the order to guard the bridges over the Missouri River; field headquarters was organized in a roundhouse in North Kansas City for the posting of reliefs. "It was a service," Captain Stephen O. Slaughter wrote,"the major duty of which was to warn sightseeing passengers on the observation platforms of trains about to cross the bridge that they must, for some reason not clear to them and somewhat vague to the guard, go into the car while it crossed. Occasionally the monotony was varied by the arrest of some tramp suspected of being an I.W.W,and pulling him heartily from a boxcar. Anyway, the bridges were not blown up, whether due to the vigilance of the Third Regiment will never be known."[3]

Otto Paul Higgins , 1909
(Photo courtesy of Eleanor
Carter family).

Toward the end of May 1917, the regiment's Third Battalion detrained near Fort Riley, Kansas, and headquartered on the Pawnee Flats "near the place where the first loads of lumber were being dumped from trains" for the construction of Camp Funston. From then until the autumn of 1917, the battalion "mounted guard, two complete companies at a time" and drilled on the premises. By October 1917, the Third Battalion and the remaining part of the outfit at Camp Nichols[4] in Kansas City "were in what the men considered to be creditable shape" until they were "soon to be undeceived on that point" upon their deployment to Camp Doniphan, Fort Sill, Oklahoma, where Higgins followed them as they were consolidated with the Sixth Missouri and began intensive training with the 35th Division as the 140th Infantry, A. E. F."[5]

Throughout his reporting, Higgins would refer to the 140th Infantry as "the Kansas City Infantry."

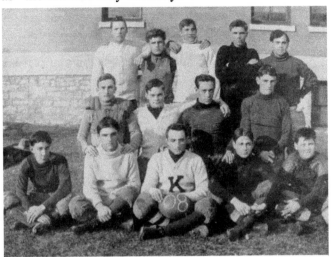

Kansas City Kansas High School football team, Fall 1908.
The Jayhawker 1909 (Photo courtesy Kansas City Kansas
Public Library).

Besides his familiarity with the 3rd Missouri and the rigors of his police beat, Higgins possessed another quality that made him especially effective as a reporter—a convivial nature. His penchant for repartee-in-print appeared as early as 1909 in the Kansas City

Kansas High School annual, where he served as an "assistant local editor" and submitted for the "Gossip" page the following notice about his friends: "STOLEN—The addresses of my affinities. If the list of old ones cannot be returned, let the finder make me out a list of new affinities. He may take the old ones for himself. No questions.—Otto Higgins."

The repartee may well have been in response to the *Annual's* treatment of Otto's role as team captain during the 1908 "Foot Ball" season. The scores for games with Leavenworth, Lawrence, and Central were listed first as ties, 5-5, 0-0, and 0-0, respectively. Then came second encounters, with Lawrence winning by 27-0,

3

Leavenworth winning by 17-0, and Central winning by 22-4. For good measure, there was the game against "K.C.U." (Kansas City University?) with the amazing outcome of Kansas City (KCK High School)—40 and K.C.U.—0. The total points for the season tallied 49 for the Kansas City High School and 71 for its opponents. So what appeared to begin evenly enough did not end particularly well at all, and the season was less than a complete success. Otto was apparently more successful in other fields, and the other editors of the high school annual were not at all reluctant to point that out, either.

In the team picture above the scores, Higgins is pictured as team captain in the front row center of his 14 teammates, wearing a letterman's sweater and holding in his lap the '"08" season football. A later page, humorously devoted to misinterpreted initials, dubbed the "O.P.H." of Otto Paul Higgins as "Old Pigskin Higgins". The joke continued on the page displaying his senior picture, where his oval portrait appears once more in the very center, encircled this time not by football teammates but by the oval portraits of six quite attractive young ladies. Also centered in the brief vignettes appearing under the block of pictures is the following double entendre in reference to Otto's role as football captain: "Otto Paul Higgins. 'I luv'd em, squir'd, em, druv'em.' 'Cap' is there with the goods in speaking and athletics. And in the picture above he is the center of a throng he admires."

The class prophecy carries on the subtleties of the vignette: "'What's Higgins doing?' O, he's knocking cattle at Armour's," a reference to the unsavory task of rendering livestock unconscious just prior to their slaughter and processing at the Armour meat-packing plant, not far from the school. Apparently, his classmates were not about to let Otto or posterity dismiss the improbabilities of the 1908 football season or, for that matter, Otto's regard for the fair

sex. True to form, Otto wasn't about to let them forget his regard for their recognition, either.

Otto P. Higgins (center) in The Jayhawker 1909. (Photo courtesy Kansas City Kansas Public Library).[6]

Not only did his sense of humor and convivial nature prepare Higgins for telling the stories of many of the friends he saw later in France, but his fluency in German gave him a particular advantage. He acquired German at home, where he served as interpreter for both grandmothers, one of whom spoke only German and the other only English, and both of whom lived with the family at 718 Homer in Kansas City, Kansas. Later, Otto attended St. Anthony's Catholic Grade School in Kansas City, Kansas, a parish school for German-speaking immigrant children, where his fluency was reinforced. And later still at Kansas City, Kansas High School, he took up the academic Modern Language Course of studies and pursued that curriculum until graduation.[7] In addition to his being captain of the football team and assistant editor of the *Jayhawker* annual, he was also a member of the Gavel Club, the school's debate

squad. His graduating class of May 1909 consisted of 162 students, the largest to date in the 23-year old history of the school[8] that later became Wyandotte High School.

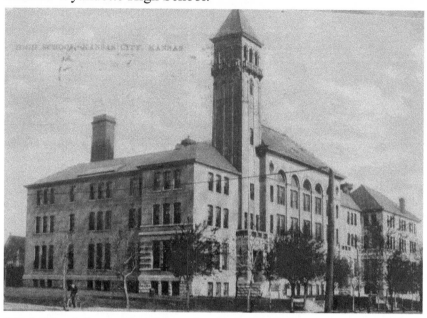

"High School, Kansas City, Kansas," published by Webb Freyschlag, Co., Kansas City, MO." Sent August 22, 1909. (Author's collection).

Besides his proficiency with oral language, Higgins also possessed excellent writing skills. Like Ernest Hemingway at the *Star* at about the same time, Higgins had been trained in the elements of writing later codified in *The Star Copy Style*, to which Hemingway attributed much of his own success as a writer.[9] In addition, Higgins's appreciation of irony, his penchant for storytelling, his gourmet appetite, and his tendency to take risks in a good poker game made him a character in his own right, keenly observant of his audience.

Emmet Crozier, another *Kansas City Star* reporter, who began at the *Star* two years after Higgins, recognized him as a character who enjoyed playing to the audience.[10] Crozier described Higgins as a "big bear-like man who had learned newspaper work as a police reporter in Kansas City's Northside, had a strong desire to

bet against the dice in all crap games and was full of conviviality. Higgins smoked home-made cigarettes, which he rolled himself from a ten-cent package of Bull Durham. In distinguished company, Higgins invariably attracted attention when he poured out the Bull Durham, shaped the flimsy cylinder in his huge paws, and licked the paper to seal it."

OPH practices with pipe in hand.
(Photo courtesy of Sheila Scott).

"As he finished the ritual, Higgins would invariably ask whoever was watching, 'Would you like a cigarette?' Before the confused onlookers could think of a safe reply, Higgins would thrust the home-made tissue twist in his mouth and, reaching in his back pocket, pull out a gold cigarette case from which he would offer the others his own private brand with gold monogram 'OPH,' a special blend of Turkish and Greek tobacco. He carried a swagger stick with a silver handle, which was hollow and always held a small drink or two of brandy."[11]

So at the age of 27, Higgins's experience on the *Star*, his personality and his skill with language convinced managing editor, Ralph Stout, to offer him the job as the *Star's* "Own Correspondent," and the "OPH" monogram became the brand for his writing just as it was the trademark for his cigarettes. From the day war was declared and the mobilization of troops began in earnest, Higgins began reporting the drill and training not only at Camp Nichols within the city limits of Kansas City, MO, itself, but at the larger installations of Camp Funston at Fort Riley, Kansas, and Camp Doniphan at Fort Sill, Oklahoma. In his own words,

"while the home boys were doing the training and fighting, [I] was telling the home folks just how they did it." [12]

He knew his local audience well. Up to this point, Higgins had spent most of his life in Kansas City, Kansas, but was equally familiar with the Missouri side of the state line and had travelled a good deal across the country. Originally from Streater, Illinois, he was born January 19, 1890, the only child of James J. Higgins and Delia Schosser Higgins, who moved to Kansas City, Kansas, in 1891, when Otto was barely a year old. His mother was also born in Streater, but his father had immigrated to the U.S. from Ireland and worked as a boilermaker for the Union Pacific Railroad. Otto lived with his parents at 718 Homer Avenue in Kansas City, Kansas, where his parents continued to reside during the war and for the rest of their lives. While attending the University in Lawrence in 1910, Otto roomed at 1041 Vermont Street. During the summers he held a variety of jobs, including the Kansas wheat harvest. When the sweat ran down into his eyes during a raid into No Man's Land later in the war, he recalled working in the heat of the Kansas harvest: "I have worked in the Kansas harvest fields in summer time when we had to rub axle grease across our foreheads to keep the salty perspiration from running down into our eyes," he said, "but it didn't run any faster than it did last night, and the mountain air was extremely chilly."[13]

He also wandered about the country. Burris Jenkins, a minister of the Community Church in Kansas City for over thirty years, a war correspondent and editor of the *Kansas City Post*, recalled a conversation with Otto during a trip the two made together by rail through Nebraska. At one point in the conversation, Otto looked under the railway car to examine the rods leading back to the brakes. He then recounted a story of riding the rods under the trains or on top of the coaches. "Every spring during his boyhood," Jenkins recalled Otto saying, "as soon as school was out he would

jump out the window some night when the family were all asleep and beat it for the railroad yards, and then beat his way to various parts of the country. He would work awhile in the harvest fields, or at road building, as a mule skinner, or any old job, and then resume his journey across the continent. Year after year he lived as a hobo and visited nearly every state in the union."

"'How did you ever get it out of your blood?'" Jenkins asked.

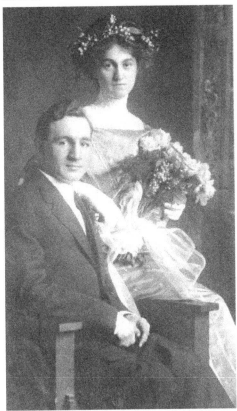

Otto P. and Elizabeth Higgins, January 24, 1911. (Photo courtesy of Eleanor Carter family).

"'I never did,'" Higgins admitted. "'I'm a hobo yet, by irresistible impulse. Every few weeks I have to get away or die. In the summer I take my family and we motor all over the country, camping out and sleeping on the ground. In the winter I go to lakes and streams and camp. I have to go!'"[14]

Although *die wanderlust* never left him, Higgins did put down roots in Kansas City. On January 24, 1911, he married 21 year-old Elizabeth Loschke, who was working at the time as a stenographer.[15] Elizabeth was the second daughter of Louis Loschke, who emigrated from Austria in 1885, lived at 3rd and Ann (1909) in the Croatian and German neighborhoods in Kansas City, Kansas, and at various times served as a ticket agent, ran a saloon,

and sold cigars. By 1918, Elizabeth and Otto had established a permanent residence on the Missouri side in Kansas City at 3221 East 32nd Street, a block north of Linwood and a block east of Indiana, not far from Kansas City, Missouri's Central High School. There they raised three children: Carol, Eleanor and Louis James, who died in 1939, a young man of 25.

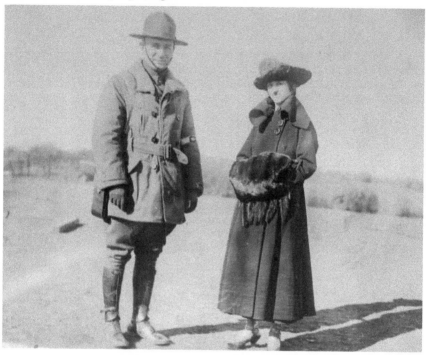

Otto P.& Elizabeth Higgins, winter 1917. Note "C" correspondent brassard on OPH's Left arm. (Photo courtesy Eleanor Carter family).

Higgins' journalism career began before his marriage. After spending some time in college, Higgins took a reporting job at the *Globe* and from there went to the old *Kansas City Post* and then to the *Kansas City Star* in 1910.[16] By May of 1917, the mobilization had begun to transform the National Guard units of Missouri and Kansas as they became federalized to become the 35th Division. In addition, the First Battalion of Kansas City Field Signal men became the 117th Field Signal Battalion. They were joined by the 117th

Ammunition Train, raised in Rosedale, Kansas, and both units became part of the 42nd "Rainbow" Division. The draftees for the National Army were sent to Camp Funston at Fort Riley and became the 89th "Midwest" Division. Meanwhile, at the age of 27, Higgins completed his own registration on the first registration day, June 5, 1917. One of 1,544 men between the ages of 21 and 30 who registered with Kansas City Draft Board 14, he reported having a wife and three children under 12 as dependents, but claimed no exemption from service. His registration also indicated that he had had no prior military service and was currently a newspaper reporter for the *Kansas City Star*. It is likely that the local board was notified later of his assignment as a war correspondent and recognizing that circumstance, the local board did not call him to active military duty.[17]

On Tuesday, September 4, 1917, Higgins sent his first dispatch from Camp Funston, Kansas, under the by-line of "The *Star's* Correspondent."[18] For the next seven months he alternated between his accommodations at Camp Funston, Kansas, and his hotel room in Lawton, Oklahoma, filing dispatches on the 35th Division training at Camp Doniphan and the 89th Division training at Camp Funston. After their training, the 35th and 89th Divisions traveled by rail from their cantonments to the Hoboken, New Jersey, point of embarkation. Higgins left with the troops early on April 6, 1918, aboard the *S.S. Lapland*[19] to spend fourteen months overseas.[20] Once out to sea, the adventure began, and Higgins described the trip in his own words:

"In the early part of April, 1918, when I crossed the Atlantic, the submarine menace was at its height. The first day out of New York boat drills began. Passengers, troops and crew were obliged to take their places on deck for roll call, while the ship's officers saw that life belts were adjusted properly. The few timorous persons on board began to worry, helped by the many rumors that were afloat.

When we put into Halifax for two days, everyone was certain the Atlantic was full of submarines waiting for us.

"On the same deck with me was a tall, gray-haired man and his short, broad, heavy wife, going back to England, their native soil. Of this world's goods they had plenty, and before leaving New York each had invested in a non-sinkable rubber suit, something like those worn by divers, but guaranteed to remain upright and keep afloat. The suits were of one size. The tall man managed his very well, but his wife needed help.

"Lieutenant Shay, commander of a British mine sweeper for two years, returning from leave to Canada, and I were called in to assist at the first trial. With much effort we got the short, broad woman inside the rubber suit and properly adjusted it. She paraded up and down in the stateroom, dragging behind her the heavy, lead-filled things that encased her feet, like a crippled dog dragging an injured hind foot.

"On the front of the suit was a pocket, just below the chin. In this we placed a carton of crackers, a flask of brandy and a flask of water so that in case she did have an opportunity to float around in the Atlantic head up, she would not die of starvation or thirst. A hoop around the waist held the main part of the rubber suit away from her body so that it was nice and wide and would hold plenty of air for floating. The hoop caused the short, wide woman to resemble a hogshead. But she was very proud of her suit and always talked of submarines and how safe she felt.

"We struck the submarine zone about three days out of Liverpool. We were required to wear our life belts all hours of the day, to sleep in our clothing at night with our life belts at hand, and the doors of our cabins half open so they wouldn't jam in case we did start sinking.

"Two mornings out of Liverpool a nervous young man came running down the companionway at 4 o'clock yelling at the top of his voice:

'We're hit! We're hit!'

"Then came the blasts of bugles in various parts of the ship, the signal for 'abandon ship.' Never before had we had a drill before 10 o'clock in the morning. Moreover, it was dawn, an ideal time for submarines to work.

"A hasty scurrying of feet, a slamming of doors, a few frightened shrieks from the women, followed by the calm voices of the men who were with them, as everyone hastened to their positions on the upper decks, immediately followed the bugles. While automatically reaching for my clothing, I remembered that one of the ship's officers had whispered confidentially to me the night before that we would have a boat drill at 5 o'clock in the morning. Reassured, I rolled over, extinguished my light and fell asleep.

"But not for long. A wild shrieking from forward awakened me. I jumped out and listened again. I thought some woman had been struck by a torpedo. Shriek after shriek arose as I hastily dressed. Each cry was more rending, heart-breaking. They all seemed to come from the same place, and I thought I recognized the voice as the same. Bundled up in my sweaters, overcoat, woolen socks and carrying a grip filled with papers, a camera, and typewriter, I dashed out of my stateroom and down the companionway towards the screams.

"I didn't get far, however. For there wedged tightly in the doorway of her stateroom, was the short, wide woman, completely dressed in her non-sinkable waterproof, undersea suit, unable to move an inch either way and screaming as though she were giving up the ghost. Her husband had abandoned his suit and had run for the upper deck. She wasn't going without her suit, however, and

there she was. The hoop had been her undoing. She tried to go through the door and the hoop was too large. The harder she pushed and the more she screamed the tighter she became wedged. With the cold sweat popping out all over me, I endeavored to calm her and dislodge the jam. It seemed an hour, but it wasn't more than two or three minutes, when the people began running downstairs from the deck to learn the cause of the excitement. We freed her."[21]

A few days later, Higgins wrote to his wife, Elizabeth, describing the trip and making a slight allusion to the submarine scare, but otherwise re-assuring her that there was nothing to worry about.

April 17
Somewhere in the Atlantic

Dear Little Honey—

Everything is running along just as smooth and nice as a new sewing machine. We have had lovely weather all the way across, except just after leaving [censored]. There the sea was a bit rough and things looked kind of funny to me for a day or two. But after that things settled down and the sea was as calm as the creek that flows through Mother's farm. It made the trip very enjoyable, albeit a little lonesome. But I got plenty of sleep, usually all night and all afternoon. The last few nights, however, it has been different. We have been in the danger zone and a few nuts had to sit up all night, waiting to be hit by a sub, I suppose.

This morning I was startled out of my wits. Shortly after 6 a.m. I heard a man who talked like my steward calling to the passengers in the next cabin to get up quick, that we were liable to be hit any moment. I raised up in bed, and then commenced to laugh, for I remembered the soldiers were to have an unexpected boat drill at 6:20. Those passengers who were awake thought a sub had been sighted, and were very much frightened.

14

From the dope I can get we will land about Friday, unless something happens. I will mail your letter on board. It passes through the censor, probably at [censored] and then is immediately sent back. In the meantime, however, you will have heard that I landed safely.

Now don't worry about anything, for everything is lovely. Having a nice time, not doing any work, & feeling fine. Take good care of yourself and the kiddies, and please do as I said about Regina. I will try and get something for the kids when I hit London.

Lots & lots of love and kisses from

Daddy"[22]

Before Higgins hit London, he docked in Liverpool and there he, along with correspondents Adam Breede and Webb Miller, became themselves the object of a typically good war story.[23] Crozier tells it this way. "As these three arrived in England, Webb Miller explained that under War Department regulations they would not be permitted to send long messages home or tell where they were. The customary thing, he said, was just to send a three-word message—ARRIVED SAFELY, LOVE. But American newspapermen rarely do the customary thing. Breede and Higgins held a parley at the Liverpool dock. Breede, uncertain whether he would wear the Army uniform in France, had brought over only one pair of pants, which were getting a little baggy. He wanted to send back to Hastings for another pair, but was uncertain, in view of Miller's warning whether the message would be too long. Higgins suggested that he dispense with the 'Arrived Safely, Love' and send merely a brief request for the pants. That message, Higgins contended, would assure the folks at Hastings of his safe arrival and would also conform to the Allied demand for brevity.

"That night British intelligence, puzzled over a cryptic cable message—SEND OTHER PANTS PRONTO, ADAM BREEDE—

assigned one of its operatives to check on the Nebraska editor. Obviously, this was code. He located Breede and Higgins at the Strand Palace Hotel in London and kept them under fairly continuous surveillance for several days. They were trailed across the channel. G-2 in Paris picked up the scent. For nearly a month the combined resources of British, French, and American secret services endeavored to learn what Adam Breede meant by his mysterious cable. Eventually, when he had become well known at 10 rue Ste. Anne [press headquarters], a casual question disclosed that there was nothing secret or sinister about his message from Liverpool to Hastings, Nebraska: he simply wanted another pair of pants."[24]

After joining the other reporters in residence at their Paris hotel, 10 rue Ste. Anne, Higgins and Breede "soon learned the shortest distance between there and Harry's New York Bar in the rue Danou."[25] "In May, with other recent arrivals, they were given special passes and sent on a tour of airfields and bases—Blois, Tours, Saumur, St. Nazaire, Coetquidan, Gièvre, Issoudun, Nevers, Dijon, Is-sur-Tille."[26]

At first, hesitant about permitting troop access to journalists because of the potential for the enemy to gather intelligence through their newspaper reports, the U.S. military had accredited only twenty-five correspondents, each one to be assigned to an A.E.F. division. General Pershing's order of June 8, 1918, mentions "Higgins, *Kansas City Times*" as one of eight non-accredited correspondents then in France and interested in writing about troops from particular sections of the U.S.[27]

Besides these "division men," as they were known, Higgins identified other categories of war correspondents in an article he wrote about being a war correspondent. The correspondents known as "'specials' made Paris their headquarters and came out once in a while for special articles on certain phases of the war; the 'mail

men' wrote only mail stories; the 'feature men' wrote only feature stories to be sent either by mail or cable, according to the news value of the story; the 'magazine men' wrote an article maybe once or twice a month and the 'cable men,' whose publications paid the cable fees, cabled their stories on a daily basis. "At one time," OPH wrote, "there were some forty-two American correspondents on the various fronts, and most of these on the American front. And those on the American front, while they didn't have all the privileges they believed they should have, they had more than the correspondents on any of the other fronts."[28]

"The cable men had the hardest time of all," Higgins noted, "especially those who were playing a lone hand. Their work meant that they had to be out in an open car from ten to fifteen or twenty hours a day, and regardless of what happened they had to be back at press headquarters before 11 o'clock at night to write their stories, have them censored and filed with the telegraph. During a drive I have seen these men go day after day with a few hours' sleep, maybe none at all, and perhaps a hot meal occasionally. Men like Junius Wood of the *Chicago Daily News*, Freddie Smith of the *Chicago Tribune*, Edwin L. James of the *New York Times*, Wilbur Forrest of the *New York Tribune*, Burr Price of the *New York Herald*, Raymond G. Carroll of the *Philadelphia Public Ledger*, Martin Green of the *New York World*, Clair Kenamore of the *St. Louis Post-Dispatch*, Henry Wales of the *Chicago Tribune*, Lincoln Eyre of the *Evening World*, all cable men, were those who performed the hardest work."[29]

As a "mail man' and a 'division man," Higgins himself was originally assigned to the Midwest's 89th Division. Pershing's June 8 order provided no transportation, conducting officer or cable facility to these correspondents, and they were not permitted to circulate except within each correspondent's own division. Only mail correspondence was allowed and subject to the military

censors.[30] As a result, many of Higgins' first postings to the *Star* were days and sometimes even weeks old, slowed up by having to go through the censors first and then by boat and rail to the *Star's* offices on 18th and Grand Avenue in Kansas City.

Later, once General Pershing and his staff began to realize the importance of public support for the war, restrictions eased. More freedom of movement was allowed, daily briefings were provided, and passes and identity cards were issued. With the order of May 22, 1918, correspondents had already been permitted to wear the distinctive Sam Browne belt and on their arm a brassard with the letter "C" indicating their official status as war correspondents. While stateside, Higgins wore a white brassard with the letter "C," signifying an unaccredited correspondent. Once overseas, he donned the green brassard with the red "C" and joined with elements of the 89th and the 35th divisions. Lt. Col. Ruby D. Garrett commander of the 117th Field Signal Battalion of the 42nd "Rainbow Division," introduced Higgins to the colonel's commander, Brigadier General Douglas MacArthur, who extended reporting privileges to OPH for units of the Rainbow Division under MacArthur's authority.[31] Primarily, those units consisted of the 117th Field Signal Battalion raised for the most part in Kansas City, Missouri, and the 117th Ammunition Train, organized in Rosedale, Kansas, with volunteers from eastern Kansas. In addition to the 42nd Division's 117th battalions, Kansas and Missouri boys populated the rosters of the 89th Division and the 35th Division; many of the boys came from Kansas City itself.

Embedded correspondents like OPH followed certain routines to file their stories. "The war correspondents always were near the front line, and in many, many cases they were under enemy fire," Higgins wrote. "What was known as field headquarters of the press section always followed the battles and always was situated in the town nearest the fight where telegraph facilities could be

obtained. When the first American divisions went into the line in the Lorraine sector, press headquarters was at Neufchateau. When the Château-Thierry and Bois de Bellau fights were on, it was moved to Meaux. The night before the St. Mihiel salient was wiped out, it was moved to Nancy. The night before the Argonne drive began, the war correspondents were loaded in motor cars and sent to Bar-le-Duc, where they remained until the Armistice was signed. From these towns they would work in and out of the lines, sending cablegrams every day or writing mail stories. Of a necessity, the men were under fire occasionally, for if they hadn't been, they wouldn't have been capable of writing the things about the war which they did." Higgins himself was under fire on numerous occasions and was forced to snatch his typewriter, camera, and field notes and move into a more secured area to resume his work.[32] Since he was a newspaperman and a non-combatant, the only weapon he was allowed to carry was his Alpine walking stick, a cane with a heavy steel point.[33]

While the fighting continued, Higgins moved back and forth among the 35th, the 89th and the 42nd Divisions. After the Armistice was signed on November 11, 1918, the 35th Division was withdrawn, but the 89th and 42nd were assigned to remain as part of the Army of Occupation. OPH remained with them, too. "In going into Germany," OPH commented, "the press section moved with the troops. Headquarters, after the Armistice, moved from Bar-le-Duc to Verdun, from Verdun to Luxembourg, then to Trier, and from there to Coblenz. They were at Trier only about two days, however."[34]

Although the correspondents operated under certain military restrictions, they had their own rules to ensure the operational continuity of the work. Accredited correspondents had to pay for transportation and for the cost of cables. OPH observed: "Although the accredited correspondents paid $60 a week to the government

for use of motor cars, there was a rule that no car could go out unless at least two men were in it. This was because of the shortage of transportation. And two 'cable men' seldom went out together. For instance, the Associated Press maintained three correspondents on the American front all the time. Every day two of these would take a car and go out, leaving one man behind to rest, write his story and handle whatever came up at press headquarters. The other cable men were not so fortunate. The United Press kept two men at the front, but one was in every day while the other was out scouring the lines. He seldom would take a cable man with him. He always would prefer a "mail man," a "feature man" or a "magazine man," so that whatever live news he found belonged to him exclusively. Once in a while, two cable men would form a combination and work together.

"Men like Frank Sibley of the *Boston Globe*, Raymond Tompkins of the *Baltimore Sun*, Joe Timmons of California and myself spent our time with certain divisions to which we were assigned, coming in, sometimes when our passes expired, but ordinarily to write or have censored what we already had written. Herbert Corey and men who wrote feature stuff alone sometimes would spend a week with a unit and then for a while make daily trips to the front."[35]

The cost was not cheap. OPH reported that "some of the press associations and syndicates spent thousands of dollars on the American front alone each month. Besides motor cars at $60 a week for each accredited correspondent, and the Associated Press had three, the United Press two, the cable tolls cost twelve to seventy-five cents a word."[36]

Realizing the importance of the journalists' work, however, the military did provide support. "The press section always carried one or two signal corps telegraph operators, men who had handled newspaper copy in the States. These men would go into the French

telegraph offices and handle most of the 'copy,' for the French operators were not accustomed to sending thousands of words daily."[37]

Additionally, "General Headquarters always kept the correspondents fully informed in advance of all the offensives. For instance, the night before the St. Mihiel drive, General Noland, then head of the press section, called the men in and described to them just what was going to happen, when it would happen and how. He knew, and G. H. Q. knew, the correspondents could be trusted implicitly, or they wouldn't have been there. While G. H. Q. knew this, a large number of other officers didn't. Many of them looked upon correspondents as spies because they always were asking pointed questions until a letter from G. H. Q. stated they were entitled to know what was going on and could be trusted with the knowledge."[38]

Field officers weren't the only ones who mistrusted war correspondents and had to be set straight. OPH himself was asked on numerous occasions about the veracity of what the correspondents wrote, and he set the record straight, too. "Since I have returned to America," OPH wrote, persons have asked me:

'Isn't a lot of this stuff we read in the newspapers and magazines about the war a lot of bunk?'

'Did you ever see a war correspondent near the front line or under fire?'

"Taking the questions in the order in which they come, I will say 'no,' and 'yes'. Everything that appeared in the newspapers from the American front was as true as it humanly was possible to make it. The majority of the magazine stories were the same. Now and then, however, an editor or a magazine writer would manage to get to the front for a week or so, and upon his return to his favorite haunts, write some things about which his knowledge was a trifle vague, but this seldom happened in France. It couldn't, because of

the strict censorship observed in all matter written for publication. The men and women who were classed as war correspondents never dared to write fiction. They were held strictly along truthful lines, and when they wrote a story they knew it to be true, and the army officers who acted as censors knew it to be true."[39]

War correspondents weren't just male, either. Women wrote about the war, too, and they were not afraid to experience combat at close range. Maude Radford Warren was a prime example. "Maude Radford Warren of the *Saturday Evening Post* probably saw more actual war than any other American woman in France," Higgins wrote, "just so she could write intelligently about it."[40]

"Writing intelligently" about the war required a thorough knowledge of the context, first-hand observation of the scene and personal contact with the men and women who supported and participated in the fight. Intelligent writing required a professional, who could navigate the checkpoints of the censor's rules, was privy to official briefings and practiced in the art of sorting out truth from rumor.

Besides being professional, and an embedded war correspondent, Higgins also took a personal approach to his dispatches. He wrote in the first person and described the action as it was actually occurring. From the perspective of his readers, Higgins may have known their boys' commanding officers and might even have known the boys themselves or maybe have talked to them in the routine of daily duties. As part of a daily routine at home, readers recognized OPH's by-line, and were familiar with his conversation. Readers may even have known him personally and talked with him on his daily beat before he went overseas. Because readers had come to know Higgins, they knew they could trust him, and looked forward to what he had to say. After all, Higgins was right there where their boys were, and it was his job to tell it like it

really was, so readers, too, could feel that much closer to where their boys really were.

For the boys, the first direct experience of the war was at sea, as American merchant ships and troop transports confronted the threat of German submarines. And so it was during the first half of May, 1918, that Higgins' first overseas articles focused on the German U-boat menace, beginning with an article referencing the sinking of the Lusitania and moving on to a series of articles describing the work of the American destroyers, subchasers based in the British port of Queenstown, Ireland.

Chapter 2: In British Ports—May 1918

From May 1 through May 19, 1918, OPH wrote a series of seven articles from Ireland and England. These articles appeared in the *Kansas City Times* and *Kansas City Star* three to four weeks later, from May 20 to June 4, 1918.

Fittingly enough, the first of all of the overseas articles OPH wrote was the piece he did from Clon Mell, the Old Church Graveyard in the hills in back of Queenstown, Ireland. Here the bodies of the victims of the *RMS Lusitania* had been laid to rest three years earlier, after that ship was sunk by German Submarine U20 on May 7, 1915. Of the 1,198 who died that day, 124 were Americans; the fate of the Lusitania became a symbol for the inhumanity of the Hun and served as a catalyst for turning American public opinion against the Germans.

Sun on Lusitania Graves:
Clon Mell One of the Highest Spots Near Queenstown
(From the Star's Own Correspondent)
[Otto P. Higgins]

QUEENSTOWN, IRELAND, May 1.—

Every evening as the sun slowly descends into the Atlantic, its last rays seem to linger lovingly upon a little spot on one of the highest hills back of Queenstown, where lie the bodies of the Lusitania victims. Here the sun shines the first thing in the morning and the last thing at night.

Clon Mell or the Old Church Graveyard, as it is more familiarly known, overlooks the River Lee and is one of the most beautiful spots in Ireland. It is almost three hundred years old, and the historic ruins of an old church still stand at one end of the burying ground, the vine-covered walls sheltering the graves on the inside from the wind and sleet. The grass is green the year round,

and the evergreens keep the cemetery almost as pretty in December as it is in June.

Three large plots were set aside for the victims of the Lusitania, and these contain most of the bodies. A few others are buried in private plots.

It was almost three years to a day when I stepped from a quaint little Irish jaunting cart into the cemetery, and the tulips and forget-me-nots on the well-tended graves were in blossom. The wall flowers were just in bud and the evergreens that surround the plots were as green as the grass underfoot.

Wreaths under glass, placed there by loving hands, were all untouched, and not a glass broken. The graves are looked after by Robert Jones, caretaker of the cemetery, at the expense of the Cunard Line, owners of the ill-fated Lusitania.

Only one grave, a private one, contains an epitaph that clearly and concisely tells the story of the disaster. Carved on the headstone is the following:

...

A Victim of the Lusitania
Foully Murdered by Germany
May 7, 1915

...

And as long as the sun rises and sets, its first rays in the morning will creep slowly over the spot that contains the victims of a Hun's foul act, and its last rays at night will linger lovingly and caressingly on the quiet, silent graves in Ireland.[1]

The next two days, May 2 and May 3, OPH was in London, where he filed two reports. One article, written from the headquarters of the American Navy, described an American woman from Boston whose brother had been killed in the war and who had volunteered the use of her car and her service as a chauffeur with no

compensation. British women, OPH noted, were doing the work of men in a variety of other capacities.

"No. 4" An American Girl
Brother of Boston Woman Killed in France
Elsie Chapin Gives Car She Repairs and Drives Without Pay at U.S.
Naval Headquarters in London

(By the Star's Own Correspondent)

LONDON, May 3. A visitor in the American naval headquarters in London on a cold rainy morning, trying to "thaw out" in front of the grate. An Orderly, one of the marines, stepped to the door and called.

"Number Four, front, please."

A young woman dressed in raincoat, rain hat and heavy boots, who had been sitting at a table looking at a magazine stepped forward, drawing on a pair of driving gloves.

The orderly spoke to her, and she left. A day or two later the visitor was at the same place again. The same girl was there, and I asked her what "Number Four" meant.

"I'm an American, from Boston," she said. "I was here when the war broke out. My brother joined the British forces and was killed, so I am trying to do my share. I drive my own car and work like the rest of the chauffeurs. We are known by our numbers."

It took a little questioning to get the details. The girl, an author, has given up her profession, gave her car free to the use of the naval officers, and drives it herself. She doesn't get any pay and doesn't ask any. She is Elsie Chapin, daughter of Mrs. Alice Chapin, an American writer. She takes her turn with the men, is just as efficient as they are and looks after her own car. She is doing her bit.

It all seemed very unusual at first, but the newness gradually is wearing off.

On every hand women are doing men's work, side by side with the men. They are driving motor cars, trucks, working as conductors on trains, street cars and busses, handling baggage, washing windows, working in factories and every place else. About all you see is either women or old men, boys or crippled men doing the work. Nearly all the restaurants have girl waitresses.

The other day it was raining, as usual, and a stiff wind was blowing. A man was riding a bus when his hat blew off. The conductor, a mere girl, pushed the button and immediately swung off, just like a switchman back home swings off a moving freight car. The pavement was slippery and she fell. She jumped right up, however, ran back about fifty feet, picked up the hat, caught up with her bus, pushed the button and handed the man back his hat as she went on collecting fares.

A conductoress can be just as polite and obliging as a conductor should be and they don't make half the fuss about it.[2]

OPH's second article from London compared the restrictive English system of rationing with the more liberal Irish fare.

Erin the Land of Plenty
Unlimited Consumption of Juicy Steaks and other Food the Rule
In England the Consumption of Meat for the Individual is 8 Ounces a Week and Limit is Strictly Enforced

(From the Star's Own Correspondent)

LONDON, May 2. Once more my craving for good food and plenty of it has been appeased. For I have been to Ireland, and I have returned fat as a shoat ready for market.

Food restrictions in England are enforced rigidly. It is pretty tough on a stranger until he gets onto the ropes. The first three days I spent in the British Isles I didn't have anything to eat

but fish. I reached the point where I was dreaming about fish. I was afraid I never would be able to go down in the Ozarks on vacation time again and wrestle with the bass. I never wanted to look another fish in the face.

Peter Clark Macfarlane, the author, and Mrs. Macfarlane were with us. They hadn't seen a piece of meat for a week. But that was because they couldn't smell it out like I could. I finally got on my regular ration, two ounces of steak four times a week.

All Changed in Ireland

But things are different now. The minute we struck Ireland everything changed. The food restrictions were negligible. Nothing was scarce but sugar, and I had a pocketful of that. The first morning in Ireland we had ham and eggs for breakfast, regular fried ham and regular chicken eggs. That night I had a steak smothered in onions—the kind we used to get in a certain buffet on Walnut Street with French fried potatoes, coffee with cream in it, and cake—real old-fashioned cake made with white flour. And it was a meatless day, too.

This may sound foolish, going into raptures over a piece of steak smothered in onions and a piece of cake, but it was a mighty serious thing. If you had been eating fish as long as I had you never would have left Ireland. Almost every meal I had there contained a great, big, juicy steak or ham and eggs at a reasonable price. Living was so good in Ireland I wanted to stay there and "cover" the war from one of the most beautiful and quaint little spots in the world.

England Petting the Irish

The English are sort of petting the Irish, and the food restrictions are not enforced. The only bread or cake made out of white flour I have had since setting foot on British soil I had in Ireland.

And everything else is plentiful there. The bars are open all the time. In England they are open only a few hours each day, and then they have very little in the iceboxes. Most of the grain is being used for food instead of liquor.

You couldn't guess in a thousand years what we brought back from Ireland. A pound of cheese and a pound of chocolates, both of which are scarcer in England than whisky in Kansas.

England Grins and Bears It

No matter how strict the food regulations or how scarce the supply, the English take it with a smile and a joke, a thing Americans will have to learn. Here a shortage of food is more to be laughed about than taken seriously, especially when there are plenty of substitutes.

Food cards are necessary to obtain meat, butter and sugar, and the English get as much fun out of their food cards as Americans do out of clowns at a circus. Now and then, of course, there are exceptions, but very seldom.

When the restrictions were placed upon sugar, the English women made it a fad to carry a fancy little bag containing a lump or two. The men carried theirs in a pocket. None of the hotels or restaurants serve sugar. They give you instead a little saccharine tablet for sweetening your coffee or tea. Persons living in hotels can secure a small sack of sugar each morning by signing for it. Each person is allowed eight ounces of sugar a week.

Twenty Ounces of Meat a Week

Meat is on the same basis. Each person is allowed twenty ounces of meat a week, but only eight ounces can be what is called "butcher's" meat, which includes steaks and chops. The rest must be taken out in sausage, heart, kidneys, livers and such. Butter and margarine are restricted to four ounces a week.

Beating the Butcher--a Game

Here is where the English sporting instinct comes in. Everybody tries to beat the butcher. The other afternoon, in a tea room, a bevy of women were discussing the war. One of them remarked she had been able to obtain three pounds of beef that day by a certain method, and she was the heroine of the party.

The English take the food restrictions as a game and they always are ready to play. If they can beat it and get a little more than they are entitled to, they are happy and tell their friends. If they can't they are just as happy and well pleased, but don't tell their friends.

There was the shortage of matches. It was almost impossible to obtain matches in London at any price, and they still are very scarce. English men and women are great smokers. Whenever a man or woman wanted to smoke and didn't have a match, they borrowed a light from their nearest neighbor who had one, regardless of sex or station in life. It was all part of the game.

Crowds Happy in the Dark

It is the same with the lighting and fuel proposition. The theaters start about 7:30 or 7:45 o'clock and close early. The restaurants close early. Very few street lights burn, and all windows are dark. That is done to save fuel and fool the Zeps.[3] The crowds on the streets are just as large as they ever were, and people jostle and crowd and step on each other and stumble along in the darkness, always with a joke, never seeming to mind who steps on their toes or stumbles over their heels. They take it as a matter of course.

The few Americans here kick more than all the English. The difference being the English are at war and know it, and the Americans haven't begun to realize it as yet.

O. P. H.[4]

Higgins did his part to change the perception of the Americans towards the war in the four articles he wrote during the two weeks from May 5 to May 19, 1918. OPH sent the articles to the *Star* by mail from "a British port, with the American Destroyers." The censorship did not permit OPH to identify where the American destroyers were, so his dateline is purposefully vague. However, because he refers to four American officers "traveling through a certain British possession the other day in the neighborhood of the destroyer base," the port in question was likely Queenstown (Cobh), Ireland.[5] Here the American Base 6 Submarine Chaser Detachment operated 30 subchasers that had been transferred from the 66 originally deployed at Plymouth, England.[6]

Two of the four articles describe the Americans in their off-duty hours, and the other two describe the men at war: the ships themselves and the shared operations of the British and the American crews. Primarily, the articles focus on the work of the American subchasers or "little American destroyers,"—OPH seems to use the terms interchangeably—sometimes at sea for over a week, on patrols for German U-Boats or assigned close-in to escort convoys of American troops safely into port, a priority for American naval forces. Larger American destroyers were also based at Queenstown and assisted in the escort and anti-submarine work of the sub chasers. Higgins was, however, interested in the little sub chasers, which were as compact, he says, "as a box of sardines."[7]

EYES OF DESTROYERS OPEN

THE U.S. SUBCHASERS ABROAD TENSELY AWAIT THE ENEMY.

Built Compactly, with Provisions for
Every Emergency, the Little
Fighting Boats are Agile
Athletes of the Sea.

(From the Star's Own Correspondent.)

A BRITISH PORT, WITH THE AMERICAN DESTROYERS, May 10. If the man who designed the little American destroyers had desired to add another hair he would have been compelled to hang it on a smoke stack. For Uncle Sam's sub chasers are as compact as a box of sardines.

Each destroyer has almost everything a sailor needs. Then it is duplicated in another part of the ship, triplicated somewhere else, and quadrupled still another place. For the chasers were built with the idea they possibly would be either torpedoed or shot full of holes and in any event they must keep going, regardless of where a hole is ripped into them.

EQUIPPED WITH EMERGENCY ENGINES.

Each boat has several engines. They can be worked together, or separately, or one with the other, or several at a time; so if one or even two should be put out of commission, the boat would "carry on," as the English say. There are steering gears or wheels in almost every place imaginable; back end, front and, top, bottom and center. Although struck, if one of the boats has a leg to stand on, literally speaking, it somehow will manage to limp into port.

When heavy seas are encountered, every man on board is comfortable, unless on watch. Then he must be outside on deck and

go through it all. But the hatches can be sealed so tightly not even a pinch of salt water can creep in. Ventilators continually pump fresh air into the compartments, and electric fans keep the air in circulation. Plenty of fresh air is needed, for every bit of space not occupied with material is filled with men.

PREFER HAMMOCKS TO BUNKS.

The bunks are placed in tiers and fold back against the walls during the day, or when not in use. Straps are provided which hook from one side of the bunks to the wall to keep the bluejackets from rolling out. And when there aren't enough bunks, hammocks are swung from the ceiling. Most of the men prefer hammocks because they sway with the boat and are comfortable, especially in rough weather.

A sailor has to be sure-footed and agile if he enjoys life on a destroyer. There are no wide, spacious stairways on the little fighters. The men must climb iron ladders, go out through small holes and down more ladders.

GUNS ALWAYS IN READINESS.

The destroyers all are equipped with several guns of various sizes, placed at advantageous points, always ready to take a shot at anything that looks as if it might need shooting. Anti-aircraft guns always are pointing towards the stars, ready to take Fritz on the fly, while depth charges always are at hand to drop or hurl at a submarine. The bluejackets call the depth bombs "ash cans." Each charge contains a large amount of amotol and T.N.T., high explosives. Let an "ash can" explode near a submarine and there is one less to deal with. Each boat is equipped with "chutes" where the "ash cans" are released and dropped into the water, all set and ready to explode at the required depth.

MUST EXCEL IN AGILITY.

Everything on a destroyer always is set and ready to go, for a submarine can dive in almost the wink of an eye, and the men on a destroyer must act just a little bit more quickly if they are to get results.

Life on a destroyer is strenuous at the most, but the men enjoy it after they grow accustomed, for there always is a chance for a brush with Fritz.[8]

COMBINE TO FIGHT U-BOATS.

A Mutual Admiration Held by British
and U. S. Destroyer Crews.

(From the Star's Own Correspondent.)

A BRITISH PORT, WITH THE AMERICAN DESTROYERS, *May 17. American and British destroyers slip out of port side by side to search out submarines, convoy ships or do patrol duty. Sometimes the boats are under the command of a British captain and at other times an American captain. The senior officer present always takes command.*

The destroyer fleet work entirely under the direction of a British admiral. American destroyers have their own director, but both American and British destroyers must do as they are told by the admiralty. The two forces work together, each admiring the ability of the other and both proud to do all in their power against the common enemy.

"If I am in command and need help I pick up whatever British ships I need, no matter where they are, and they do as I tell them," an American commander said the other day. "The scheme works both ways. The British have excellent officers here, men of rare judgment and ability, and they return the compliment. So there isn't any argument."

The same feeling exists throughout the entire personnel of the two destroyer fleets, even among the bluejackets, either on sea or shore. The Americans mingle with the British, the British with the Americans. Both form one big unit with one purpose and a combined effort to carry it out.

Instead of receiving exaggerated reports of the submarine campaign in official bulletins, they are toned down. In the early stages of the war, statements were given out that certain submarines were destroyed at various places, and later the submarines turned

35

up at their home ports. That does not happen anymore. No one will admit a submarine has been destroyed until the destroyer can produce actual evidence from the inside of the boat that the depth charge was effective.[9]

A Bit of Home for the Navy

U.S. Sailors and Officers Maintain Club in British Port

Serves as Loafing Place for Men from Destroyers with Shore-Leave
Cashier a Kansas City Boy

(By a Staff Correspondent)

A BRITISH PORT, WITH THE AMERICAN DESTROYERS, May 5 (by mail). It was just like a little bit of home. On every hand the old familiar tongue could be heard, and it was like unto food to a starved stomach.

One big room was filled with dining tables and most of the seats were occupied. The kitchen was a big open affair, where all the cooking was done in plain sight and everybody could see his food as it went on the fire. From another room came the click of pool and billiard balls. The rear part of it was filled with books and magazines.

THEATER HOLDS 1,000 MEN.

A large sign bearing the single word "Canteen" conveyed a world of meaning to the visitor, for he knew that there he would find American tobacco and other things American on sale at American prices, something that is very scarce in Great Britain. Another large room, equipped with a stage, a moving picture machine, a piano and a large screen upon which pictures are exhibited at least three times a week, and capable of holding nine hundred or a thousand men, was at the far end of the series of buildings.

36

It was "The Men's Club," in a British port out of which the American destroyers are working, equipped and maintained almost exclusively by the American sailors and officers. The club is for anyone in uniform, be he British, American, seaman or soldier, officer or private. Real American meals, with real American steaks, cooked in the old home way, are served to the men on shore leave at moderate prices. Here you can draw out your little package of papers, your little sack of tobacco, and "roll your own" without attracting the attention of everyone within hearing distance. Here the sailors drop in and take whatever books or magazines they want without having to sign their lives away, for it is a matter of honor that they be returned in good condition—and they always are. Here the boys on shore leave spend most of their evening, for they can read, smoke, eat, play pool or billiards, watch the movies, or do as they please, for almost nothing.

EXCELLENT TALENT IN NAVY.

The big night is always on Saturday. Most of the boats try to make port Saturday and then the fun begins. The men always furnish their own entertainment that night, and some of the finest talent in America can be found there sometimes, either professional or amateur. For there are men from the theatrical profession in the Navy as well as from other professions. And Saturday night always finds the club crowded to capacity.

Some months the club fails to pay expenses, and the deficit must be made up by popular subscription. A regular American soda fountain will be installed before long, the gift of a friend in the States. It is now on its way over. Nearly all the supplies are purchased through the Navy. And the cashier? He was once a Kansas City newsboy and sold the Star *on downtown streets.*

O.P.H.[10]

"One Sack of 'Makin's'"

The camaraderie of the British and American officers and bluejackets is reflected in an especially poignant piece OPH wrote about the sociability of rolling one's own cigarettes. From the time OPH was aboard the *SS Lapland* on the trip to Liverpool through his reporting from the British and American destroyer base, the familiar drawstring extending from the tiny sack of tobacco stuffed into the shirt or tunic pocket served as a "password to good fellowship," the invitation to the kind of conversation that nearly always leads a good reporter to a good story.[11]

To The Kansas City Star

From Otto P. Higgins, Staff Correspondent

London, May [1918], Dear Bill: Someone said, sometime, that "one touch of nature makes the whole world kin."[12] They might have changed it a trifle, and made it read "one sack of 'makin's'[13] makes all America kin."

Sounds kind of foolish, doesn't it? But it's true. A little sack of "makin's" seems to have a wonderful drawing power among Americans away from home, and it is a password that they all recognize the world over.

It was said of the French people that when the first American soldiers landed there the French all thought that the little familiar tag hanging from the pockets of the men's blouses was a part of the uniform. It wasn't, they soon learned, but it was the password to good fellowship, new acquaintances, and it has helped while many an otherwise vacant evening with pleasant companions.

You know I always smoked a certain brand of tobacco, and being a married man with a family, I always "rolled my own" instead of buying the "tailor-made" ones. Knowing that American tobacco was scarce on this side of the water I took quite a supply with me.

The first good results came on the ship. The second day out I was rolling myself one, when an American naval officer came up to me and introduced himself. I couldn't quite understand, until he explained about seeing me have a sack of "makin's" and asked if he couldn't roll one. That was the beginning of a mighty fine friendship. The word soon got about, and it wasn't long until nearly all the Americans on board would rally round me after dinner for a little bit of my "makin's".

You don't roll your own in England. You always buy them rolled, made out of some kind of leaves that I cannot seem to

become accustomed to. It is very unusual to see anyone take a little sack of "makin's" from his pocket, pour a little of the fine grain into a slip of paper, and twist one up in a second, and it was always a source of amusement for the English to see it done, and it never failed to attract attention. The English are great smokers, both men and women, and they are always interested in novel smokers.

I have had men approach me in dining rooms, in hotels, restaurants, busses, tubes, on trains and in the streets, and introduce themselves, stating that they too, were Americans, and wouldn't I please give them just a little bit of my "makin's"? One of the happiest men I have met in a long time is an American who lives and works in London. He always used to call on me just to borrow a few whiffs. Now he doesn't come quite so frequently, for he has discovered a tobacconist in Soho who carries a small supply of the "makin's" and who retails it for twenty-five cents a package. At home it was a nickel.

But when I visited the American destroyer base, I was right at home. For every place I went, I saw the little familiar tag hanging from pockets, and the little red book sticking out, and I was again among friends. For no one but an American carries that paraphernalia in a foreign country, and a little sack of "makin's" is always good for a password.

So it may truly be said "that one sack of 'makin's' makes all America kin."

Chapter 3: From Paris—May-June 1918

From May 16 to June 3, 1918, OPH spent almost three weeks in constant travel, visiting ten different U.S. Army camps throughout France: Blois, Tours, Saumur, St. Nazaire, Coetquidan, Gièvres , Issoudun, Nevers, Dijon, and Is-sur-Tille.[1] His visits took him to the rear areas behind American lines, where U.S. forces were establishing salvage, supply, transport, and repair operations to support Allied efforts at the front. From those experiences, between May 22 and June 3, 1918, OPH wrote a series of eight articles focusing on salvage clothing depots, warehouse facilities, railroad terminals, motor transport repair shops, the largest and only American aviation training center, and even fields in rural France, where he discovered American soldiers cultivating gardens and farms. The *Star* published the articles a month later, between June 20 and July 5, 1918.

Each day, OPH and his follow correspondent, Adam Breede of the *Hastings Daily Tribune*, Hastings, Nebraska,—along with other newly arrived war correspondents—checked in to press headquarters at 10 Rue St. Anne in Paris. There, G-2-D, the press section of the A.E.F, issued passes and organized tours of the ten Army camps, "all for the ostensible purpose of keeping the American public informed." [2]

The U.S. Army camps the journalists visited were part of a life-line supplying American troops with the materiale and logistical support needed for the survival and fighting effectiveness of the A.E.F. Located at the mouth of the Loire River in the middle of the western coast of France, St. Nazaire's facilities housed and loaded supplies from ships onto railcars for the A.E.F. Intermediate storage facilities were established further along at Gièvres, on the main rail line from St. Nazaire through Tours and towards Dijon. Even further along, Is-sur-Tille became the advance storage facility because the French had already established a

regulating station there, and it was near the area that had been designated for training American troops.[3] Other facilities the journalists visited—Nevers, Bois, Tours—were either directly along the rail line or close to it. North of St. Nazaire, Coetquidan was about halfway along another rail line between the port of Brest on the northwest coastal tip of France and Tours, which was inland along the line from St. Nazaire to Dijon and Is-sur-Tille.[4]

At Bois, the journalists saw laundries and a replacement depot for the Services of Supply. In addition to laundries, journalists observed a bakery company facility and a clothing salvage depot near Tours that by August 1918 was turning out nearly $3.4 million of refurbished clothing per month.[5] The Salvage Depot No. 1 near Tours was just one of almost twenty other salvage depots, operating in one million square feet of space, "the first systematic salvage operation in war."[6]

Another clothing salvage depot was located at Is-sur-Tille, along with storage space and Quartermaster Depot #6. Quartermaster Depot #8 was located at Dijon. Coetquidan was the site for a remount depot for horses, a bakery company, and a temporary laundry. The larger facilities located at St. Nazaire and Nevers housed laundries, bakery companies and storage space. In addition, St. Nazaire had a remount depot, and Nevers was the site for both Quartermaster Depot #1 and the Quartermaster Casual Depot, where Quartermaster military personnel were temporarily housed in transit to other facilities. Quartermaster Depot #5 was located at Issoudun, with another bakery company and storage space.[7]

Also at Issoudun was the 3rd Aviation Instruction Center (A.I.C.), "the largest of Uncle Sam's aviation training centers," OPH noted, "where pilots are turned out almost every day, ready to go to the front."[8] Although the censorship precluded OPH from identifying the name or exact location of the camp, he did note that

it was "located far back of the lines, somewhere around the center of France, several miles from the quaint little French town where the railroad station is located."

It was here at Issoudun that the U.S. Army Air Service conducted all of its fighter pursuit training, except for instruction in aerial gunnery, which was conducted at Cazeau in southern France.[9] After being trained to fly the French Nieuports, students at Issoudun advanced to acrobatics, formation flying and the use of camera guns mounted on their planes. The fatality rate during training was high—one per each 9.2 graduates as compared to one in 50 graduates trained in observation and bombardment. Almost all of the 766 pilots trained at Issoudun were sent to squadrons already operating in the front-line areas known as the "Zone of Advance."[10]

On May 25, 1918, OPH wrote about the Red Cross camp canteen at Issoudun. "The women work from very early in the morning until 9 o'clock at night, and work steadily," OPH wrote. "For they not only serve meals at regular hours, but hot coffee, tea, chocolate, sandwiches and cakes are served at all hours. Aviators are nearly always in the cheery dining room shortly after they return from their flights, for there is nothing better than a hot chocolate or coffee to warm a person after having been chilled through." The canteen was under the management of "Miss Givenwilson, an American girl from the East,"[11] and "among the women working at the canteen are two Kansas Citians," OPH was careful to mention, "Miss Lois Cornforth, a former welfare worker,[12] and Mrs. Alice Appo, a magazine writer.[13] Both women have been assisting at the canteen nearly six months."

The story of the Red Cross women is in many ways typical of the dedication of the men and women who became the subjects of OPH's stories. Taken as a whole, the eight articles OPH wrote from Paris in the late spring of 1918 focused on the physical conditions and even moral protections and support that the boys were receiving

as they went about the work of war, but there is also about the articles a sense of immediacy for the here and now. Written in the present tense, the articles place the reader with the boys and reassure the folks at home that their boys are being cared for properly. The boys themselves behave in an exemplary manner, and their work is, in turn, an example to the folks back home.

Ever mindful of his audience, OPH continuously reassures the home front of its virtual presence with the boys in France. Comfort and familiarity are frequent themes throughout the articles, and OPH finds ironic humor in noting, as a matter of fact, how much of home the troops have actually brought with them to France. Powerful are the forces of habit and routine, once the novelty of French customs and culture wear off. For example, working for the first time beside the French in their railroad shops, U.S. troops were at first thrilled by the free ration of two bottles of wine per day, but the wine proved relatively low in alcoholic content and hardly quenched the men's thirst, so the men petitioned for and received barrels filled with fresh water instead.[14] In another article, OPH assures the mothers at home that "in three weeks of constant traveling in France, in communities where Americans were just as common a sight as the French, not one intoxicated American was seen."[15]

Even when the boys are allowed the rare opportunity to visit a French village, the hours the French bistros are allowed to serve them are strictly limited, and proprietors risk being blacklisted if they don't comply. Military police keep constant vigilance. In some places, OPH assures his readers, the surveillance is so strict that soldiers "are forbidden to even talk to the women."[16]

Such carefulness is also reflected in the conservation of physical resources. Higgins describes the work of the American transport facility to replace truck and car cushions that have been "appropriated" by the men for beds. He describes the efforts to

44

replace canvas, re-use salvaged parts, and repair and return to service 95% of the trucks and cars sent to the rear to be refurbished. He reports on the work of salvaging parties and separate salvage facilities at Tours and Is-sur-Tille that recycle clothing, while other depots salvage steel and iron articles such as field ranges, stove pipes, steel helmets, stoves, periscopes, and similar articles. "Everything found in the pockets of the soldiers' clothing is sent to the salvage depot," OPH observes. The salvage depot savings amount to $700,000 a month with more anticipated in the future. Like the behavior of the soldiers themselves, the salvage operation serves as another example to the folks back home of the need for self-discipline in a time of war. "Uncle Sam is setting an example in thrift and saving with the American Expeditionary Forces in France that it would be well for the folk back home to imitate," OPH concludes.[17]

Not only do the boys serve as examples to the home front and carry with them the wholesome values, thriftiness, and work ethic of the home front, but they also carry from home notions of status, comfort, familiarity and privilege that reflect the racism of the time. A large number of segregated black servicemen, in unequal proportions to the smaller numbers of white servicemen, saw duty in the "Services of Supply." Only about 10% of Black soldiers saw combat, the remainder being "employed as stevedores, porters, cooks, waiters, and ditch diggers or in the construction and repair of cantonments, roads, and railroads, either abroad or at military facilities back home."[18] Black soldiers weren't alone in being assigned to labor: Chinese coolies supplied much of the labor in American railroad facilities, OPH observes, much as they did fifty years earlier in the U.S.

The racism of the time was especially reflected in the attitudes towards the service of black porters. OPH notes a special "delight" to both the Negro soldier-porters and the other soldiers and

officers, all presumably white, who rode the "American Special." "There is a passenger train, called the 'American Special,'" OPH observed in an article he wrote from Paris on May 23, 1918, "operated exclusively for the movement of officers and men. Not only are the men who patronize the road delighted with it, but part of the trainmen wouldn't trade jobs with the Queen of Sheba. They are the Negro porters, taken from a Negro regiment. There isn't another job in France that delights them more. And there isn't anything that delights the soldiers and officers more than to have the Negro porters on the trains." For an audience 100 years later, the words "American Special," "patronize," and "delight" carry a bitter irony they likely did not possess for a significant portion of the audience in 1918.[19]

By the time the audience in Kansas City had read the eight reports from Paris, OPH had already moved on to the front, writing from the Luneville Sector, the Vosges Mountains, Alsace, the Lorraine, and Belleau Wood. OPH's eight articles from Paris prepared his readers for the combat articles that followed in much the same way that the support facilities themselves prepared and sustained the troops for the struggle that lay ahead.

U.S. MEN THRIFTY ABROAD

Salvage Depots for Army Equipment
Save Thousands of Dollars

(From the Star's Own Correspondent.)

Paris. May 22. Uncle Sam is setting an example in thrift and saving with the American Expeditionary Forces in France that it would be well for the folk back home to imitate. With shells bursting everywhere, bullets flying in every direction, materials and equipment suffer as well as men. The men who are wounded are sent to hospitals and treated and most of them saved. Practically all the equipment is saved.

There are salvaging parties all along the lines, who gather up every piece of equipment or clothing, no matter in what condition it is found. Carload after carload, filled with nothing but "junk" of every description, is received every day at salvage depots, where it is rejuvenated and sent back. At the largest American salvaging plant in France, the estimated saving effected this way the first two months the plant was in operation was ¼ million dollars. In April this was increased to $450,000, and in May the total value of articles reclaimed will exceed $700,000. Each month the values will mount higher, as more American troops participate at the front.

All clothing repair work is done by French women and girls employed at the plant. They are so expert with needles that whole sections can be replaced in uniforms. Not the smallest bit of cloth is wasted.

Another small plant is operating in connection with the main salvage plant, where steel and iron articles are salvaged, such as field ranges, stove pipes, steel helmets, stoves, periscopes, and articles of that kind. Everything found in pockets of the soldiers' clothing is sent to the salvage depot. These souvenirs, as they are

47

called, are kept in a large drawer. Of the whole conglomeration, small prayer books are in the majority.[20]

PEP UPSET A SLEEPY TOWN

A French Port Fell Before American Industry

Our Army Transformed a Fishing Village
Into a Railroad Terminal—
Natives Said It Couldn't Be Done

(By the Star's Own Correspondent.)

Paris. May 23. There is a certain little coast town in France where the inhabitants worship the Americans and look upon them as wonder workers and miracle performers.

Before the Americans came, this was a dirty little fishing village. Nothing unusual ever happened. It was so sleepy that every shop and business house closed for two hours at noonday so the people could eat. But that was before the Americans came.

A DIFFERENT PLACE NOW

Now some of the places never close, and the French have been so imbibed with the spirit of American hustle that some of them even work on Sundays. Since the Americans took over the port, the docks have been enlarged and improved. There are fifteen of them in use now, capable of unloading from twenty-six to thirty ships at once. Sixteen more docks are under construction and before long the capacity of the port will be more than doubled. American ships are being unloaded in from three days to a week, whereas in the old days it required five and six weeks to do the work. But the Americans sometimes work three shifts, and they use modern materials. The docks and storehouses have been so interwoven with switch-in tracks that often ships are unloaded and the goods transferred to the waiting railway cars.

Some trouble was encountered at first in building the numerous switch-tracks. The French authorities said it would be impossible. But the Americans went right ahead, and if a building happened to be in the way, they built right through it, until now they have a system of handling freight that is equal to any in the world.

In fact, if the present plans are carried out, this will be the largest port in France, and it will handle nothing but American troops and supplies.

AMERICANS BUILT A CITY

Just a few miles away is a fair-sized city, built entirely by the Americans. It contains storehouses of all varieties, with thousands of square feet of storage space. At present, thirty-three warehouses, each with a capacity of twenty-one thousand square feet of storage space, are being used. More are being erected. One warehouse, now almost completed, is said to be the largest of its kind in either England or France. It will have a storage capacity of two hundred thousand square feet.

Most of the freight is unloaded from ships directly onto the freight cars, and the average number handled is between seven and eight hundred a day. The cars are much smaller than the American freight cars, however. The supplies are immediately sent to the warehouses a few miles distant, sorted and sent to their destination. Sometimes the freight goes to training camps, sometimes to the front, sometimes to other storage plants, and some of it is stored at the base. Each department has its own warehouses and handles its own supplies.

ALL DONE BY THE ARMY

All of the work is being done by the army with the exception of some of the labor. A large part of this is being done by the Chinese coolies. All the buildings are being erected by the engineers. The railroads are being constructed and operated by

them, while the signal corps has constructed the six hundred miles of telephone and telegraph lines necessary to maintain the lines of communication with the front.[21]

U.S. RAILWAY WORK HUGE

Throughout France Americans
Are Building Tracks and Yards

French Officials Are Not Convinced as
To Capacity of Large Locomotives,
And so Demonstration
Trip is Arranged.

(From the Star's Own Correspondent.)

Paris, May 23. It doesn't take much traveling in France to learn why all the railroad regiments were recruited back home shortly after the States entered the war. No matter where you travel, you find American soldiers operating trains and switch yards.

This is true not only near the front. The system begins at the base ports. American soldiers can be found along most any French railroad. Usually they operate the funny little French engines, but the big American locomotives are coming in now and are being put into service as fast as they arrive. In some places, rejuvenated Belgian engines are used. Those, for the most part, have been put into shape by American workmen and turned over to the French.

French a Little Skeptical.

American railroad men so far have failed to impress French railroad officials with the immense power of an American locomotive. The French will not be convinced. A trial trip has been arranged from one of the French ports to the American locomotive shops. An American engine will draw forty-seven of the little French freight cars. The American officers insisted on running a real train, but the French have refused to permit more than forty-

seven cars. A special train to carry the French railroad men will follow the train on its trial trip. The ordinary French locomotives are about half the size of the American engines.

Not only are Americans helping to operate the French roads, but are building roads of their own. Miles and miles of track are under construction at present and miles and miles already have been built. Construction work, however, in the rear of the lines at least, is chiefly in the various camps and depots.

Switching yards that will exceed anything seen before in France are under construction. Every foot of track will be needed o handle the immense quantity of supplies and materials arriving from across the ocean in a steadily increasing stream.

Crews Want Active Service.

All the construction work is done by American engineers. The trains are operated by Americans, and some of the engines and cars bear only the label, "U.S.A." painted in large letters on each side. Many a young man who felt a thrill when he volunteered for service in France now is far behind the lines building railroads or switching boxcars, the while itching to get up to the front. But all realize the system of supplies is one of the most important things in a great war, and that it constantly must be maintained. So they are content for the time being to remain where they are.

There is a passenger train, called the "American Special," operated exclusively for the movement of officers and men. Not only are the men who patronize the road delighted with it, but part of the trainmen wouldn't trade jobs with the Queen of Sheba. They are the Negro porters, taken from a Negro regiment. There isn't another job in France that delights them more. And there isn't anything that delights the soldiers and officers more than to have the Negro porters on the trains.

O.P.H.[22]

A RAIL ARMY OF YANKS

American Experts Handle all U.S.
Railroad Work in France.

Soldiers Till Camp Gardens With
Tractors, Repair Shell-Racked Motor
Transports and Are Contented—
On Water Wagon from Choice.

(From the Star's Own Correspondent).

PARIS, June 1. You might find railroad yards and shops somewhere in the States to compare with it, but it is very doubtful. From a distance it looks like a group of exposition buildings, for the plans were all made before the war, and the building stopped when the government confiscated all the steel. But when Uncle Sam took a hand in the great struggle, the railroad center was taken over and the work now is fast nearing completion. In fact, it is so nearly finished Uncle Sam's men have been doing railroad work there for some time.

Nearly all the men in the unit were recruited from one of the big Eastern railroad companies, and they are all experts in their own lines, whether it be switching, engineering, repairing boilers, doing machine work, or whatever else is necessary. The men were all picked for their superior technical knowledge from the lowest buck private to the commanding officer, who formerly was a master mechanic at one of the biggest railroad shops in the States.

Working French Hours—11½ a Day

At present, the men are working in all parts of France. Wherever technical railroad men were needed in a hurry, whether in the shops, the yards or on the road, they were sent. They are working side by side with the French, working French hours, and eating French meals. They don't work nine hours a day, either, but

eleven and one-half hours, and they receive only soldiers' pay, but they are content, for they are doing their bit where it is needed most.

All the important American railroad work will be performed at the big shops now under construction shortly. Some of it is being done now, but equipment is scare at present. By the time this story is printed, the shops will be going full blast.

All the American locomotives and cars are sent direct to the shops to be tested and for their trial trips. All American trains will be made up and dispatched from there, for the shops are ideally located at one of the big French railroad centers, about midway between the American base and the American lines, in a place air raids and long range guns never reach.

Tired of Wine, Demanded Water.

When the American mechanics first went into the French shops they began inquiring for water to drink. Water was a thing unheard of by the French workmen for each is given two bottles of light wine a day and that is sufficient. This pleased the Americans immensely, for free wine twice a day was something new to them, and they were looking for thrills. The arrangement went along nicely for a week or more. But that was enough. Soon the men began writing to their commanding officers, asking for water. The wine was mighty good, they said, but they preferred water. So a conference was held with the French officials and now the Americans have their fresh water barrels, where they can get all the water they desire.

"That is the way it is with our boys," one of the officers remarked. "Everything was new to them at first, and they took to it like a duck takes to water. But their old habits soon reasserted themselves and they now are all on the water wagon, merely because they prefer to be there and because they are very fond of water."

OUR MEN'S MORALS GOOD

Conduct Overseas Dispels Any
Fears the Mothers May Have.

Not One Intoxicated American is Seen—Aviators Enjoy a Canteen
Where Red Cross Women
Serve Food

(From the Star's Own Correspondent.)

PARIS, June 3. American boys may be closely watched at home to see that their morals are not corrupted, but they are watched more closely in France.

In a visit to ten different American camps in various parts of France, a general idea of how closely the American are guarded and how carefully their behavior is watched is very easily obtained. Nearly all of the camps are situated several miles from a village, usually in a beautiful, rolling country where nothing but green trees, grass and cultivated fields can be found. The men are seldom allowed to visit the neighboring towns.

Drinks Only at Certain Hours.

In all of the cities were American soldiers are stationed military police abound, and they are always on the job. In some places the soldiers are forbidden to even talk to the women, and they can purchase drinks only between certain hours, and then only light wines and beers. Any place found selling alcoholic liquors to soldiers is placarded by the authorities, and no soldiers are allowed to go there while the place is under the ban. If they sell anything to the men out of hours, the same thing happens. So, consequently, the order is obeyed to the letter, for everyone wants to get a share of the American trade.

Not Much Alcohol Is Used.

The beers and wines are very, very light. The percentage of alcohol used in their manufacture is very small, judging from the effect on the men, for in three weeks of constant traveling in France, in communities where Americans were just as common a sight as the French, not one intoxicated American was seen.

PARIS, May 25. You could very easily tell that a woman's hand had at least been there some time, for the little windows of the long, low, narrow building were hung with freshly ironed chintz curtains. Vines, almost full grown had worked their way up the little strings, partly shading the windows from the sunlight. The sidewalks were bordered with flowers, all in bloom. No one but a woman would take such pains with a building in an army camp.

It was far back of the lines, somewhere around the center of France, several miles from the quaint little French town where the railroad station is located. The camp was the largest of Uncle Sam's aviation training centers, where pilots are turned out almost every day, ready to go to the front.

The Only Place of Its Kind.

Once inside, you could easily see why the one building was so beautifully kept. For hurrying here and there, their arms filled with trays containing real American food, were American women, Red Cross workers, wearing their long blue denim aprons and their white flowing headdresses. They had taken it upon themselves to see that the officers and men of the aviation camp were well fed and well cared for. It required special arrangement, for that is the only place of its kind in the American army, either in the United States or in France.

The women work from very early in the morning until 9 o'clock at night, and work steadily. For they not only serve meals at regular hours, but hot coffee, tea, chocolate, sandwiches and cakes

55

are served at all hours. Aviators are nearly always in the cheery dining room shortly after they return from their flights, for there is nothing better than a hot chocolate or coffee to warm a person after having been chilled through. No liquors of any kind are allowed in the American camps, and the men are very glad to be able to get something hot to drink.

A Room For Enlisted Men.

Another large room in the opposite end of the building is operated entirely for the enlisted men. No meals are served, but hot lunches and hot drinks are served at cost all day and all evening.

The place is in the charge of Miss Given-Wilson, an American girl from the East, and American Red Cross women do all the work, except the cooking.[23] This is done by French women. The women receive no salary and pay their own expenses. Everything is served at cost.

Among the women working at the canteen are two Kansas Citians, Miss Lois Cornforth, a former welfare worker, and Mrs. Alice Appo, a magazine writer. Both women have been assisting at the canteen nearly six months.[24]

Women Do a Wonderful Work.

"I don't know how we could have managed during the winter and early spring without the canteen," one of the men remarked. "This was, in my mind, the coldest, wettest, and muddiest place in the world, but we always had a nice warm place to come to, and we could always get plenty of hot things to eat and drink. The Red Cross women are doing a wonderful work. The Red Cross has a staunch friend in every man in this camp. For they not only keep up the canteen, but they built a big bathhouse when we didn't have any, and now they are going to install a laundry so we can get our clothing washed here in camp."

O.P.H.[25]

Chapter 4: Behind the Lines and at Belleau Wood—June 1918

On June 6, just west of Château-Thierry, the U.S. 2nd Division commanded by General Omar Bundy faced the equivalent of four German divisions at Belleau Wood. The 2[nd,] Division's Marine Brigade and its 3rd Infantry Brigade led the attack to clear the woods in three weeks of fighting.[1] Bundy suffered 1,800 killed and 7,000 wounded.[2]

While that action was going on in the field, the visiting American war correspondents, fresh from their tour of support operations behind the lines, were receiving considerable help in their attempt to report the work of the troops in the lines. On June 8, because of great delays in reports of divisional actions reaching headquarters for distribution to newspapers back home, General Pershing sent a cable to Chief of Staff in Washington changing the policy that, up until that point, had limited the number of American war correspondents. Pershing now wanted to attach twenty-five accredited correspondents to American divisions and provide the correspondents with automobiles and cable facilities. "'There are a number of correspondents now in France,'" Pershing wrote, "'who are interested solely in particular sections of the United States. Of these, eight are not accredited, and for your information these eight are: Hazen, *Portland Evening Telegram*; Higgins, *Kansas City Times*; Hunt, *Red Cross Magazine*; Kenamore, *St. Louis Post Dispatch*; Sibley, *Boston Globe*; Timmons, *Los Angeles Examiner*; Tompkins, *Baltimore Sun*; Williams, *Los Angeles Times*. I recommend that war department select, accredit, and assign one correspondent to each division; selection of correspondents reference paper or combination of papers to be represented by each to be made under such regulations as it determines. Advise combination of papers for news distribution as well as for expenses of correspondents representing territory from which division comes. These correspondents to be placed under bond, given same status as

other accredited correspondents, but to understand thoroughly and sign agreement in accordance with conditions outlined herein. *Pershing.*'"[3]

As a result, "the visiting correspondents received their division credentials . . . and joined the outfits whose training in the U.S. they had already reported. Clare Kenamore of the *St. Louis Post Dispatch* went with the 35th Division, already in the line. Otto Higgins of the *Kansas City Star* joined the 89th (he would go with the 35th later); Joe Timmons of the *Los Angeles Examiner* and Harry A. Williams of the *Los Angeles Times* both went to the 91st; Raymond S. Tompkins of the *Baltimore Sun* went to the 29th. Slowly, the news coverage of the American Expeditionary Forces developed and grew. The journalistic Old Guard at Meaux handled the big battle stories, the daily cables, and urgent flashes. From the training camps and the quiet sectors came the mail stories, simple homey feature stuff, certainly harmless so far as military information was concerned, but immensely comforting to the people in the United States."[4]

Such were the stories that OPH wrote before he received his credentials for the 89th and 35th Divisions. In the first few days of June, 1918, OPH was with the Kansas City 117th Field Signal Battalion of the 42nd "Rainbow," a Division comprised of units from twenty-six different states. Missouri's contribution to the 42nd, the Field Signal Battalion, had been the first of the Kansas City units to be sent into the conflict, and OPH wrote three articles, one each on June 3, 4, and 5, from Baccarat, where the 117th was stationed at the time. The articles were published on July 17, 1918, the first of the articles to mention the hometown boys.

By early June, Higgins had already secured a pass that had authorized travel to "Chaumont, Langres, Neufchateau, Toul, Baccarat via train and return to Paris from June 6, 1918, to June 10, 1918." He had also secured a "special dispensation," signed by

General MacArthur, 42nd Division Chief of Staff, to extend that pass until June 16.[5] During that time, OPH and correspondent Adam Breede of the Hastings, Nebraska, *Hastings Daily Tribune*, were "the first to witness and report decisive American action at Belleau Wood, where U.S. marines delivered the first great blow toward the offensive which culminated in the Armistice. Their position here was a perilous one and the correspondents were under shell fire most of the time."[6] During and immediately following the battle, OPH took a number of photographs, four of which were published in the *Star* and four others which are published here for the first time.

By June 13, Higgins had located the "Old Third" Missouri National Guard Regiment of Kansas City Infantry, now the 140th Infantry, 35th Division, at Gamasches, Normandy, France. Three days later, he returned to American Headquarters at Chaumont, where he reported on Major John F. Carmack, who had been wounded in both legs on May 20, while participating with French troops in a raid. Besides Lt. William T. Fitzsimons, the first American officer and first Kansas City native to be killed in action, Major Carmack was the first officer of the Missouri home units to be wounded in combat.[7] From June 22-24, OPH was back with the 42nd Division, but this time with the 117th Ammunition Train, the Kansas contribution to the 42nd. While with the Ammunition Train, OPH took a number of photographs which were published in Sunday edition of the *Star* on July 28, 1918. Pictures of the 140th Infantry taken on June 13 appeared in the *Star* on August 1 and August 6, 1918.

In all, throughout June, 1918, OPH had written twelve articles that appeared in the *Star*, and during that month the paper published twenty-two of his photographs. OPH had visited the 117th Field Signal Battalion, the 117th Ammunition Train, and the 140th Infantry. He had been recommended by General Pershing to the War Department for credentialing as an embedded correspondent,

and with his friend Adam Breede, he had been the first correspondent to witness action at Belleau Wood. It had been a very busy month for the 28-year-old journalist from Kansas City.

O. P. H. with the 117th Field Signal Battalion

OPH wrote the following three articles about Kansas City men in the 117th Field Signal Battalion, the 117th Ammunition Train, and the hospital and ambulance trains supporting them. The articles appeared in the *Kansas City Star* five weeks later, on July 17, 1918. Part of the 42nd "Rainbow" Division drawn from 26 states and the District of Columbia, the 117th Field Signal Battalion was the first of the Kansas City units to deploy overseas. On October 18, 1917, the 117th left Hoboken, New Jersey, bound for Liverpool, England, where they arrived on November 18th under the command of Major Ruby D. Garrett. After further deployment in France at Vaucouleurs, Challannes, St. Blin, Orquevaux, and the Rolampont area, the unit came under fire at Luneville, and on March 3 with the rest of the 42nd, took over a sector near Baccarat. "Here the Signal Corps made extensive improvements in the old communication system," recalled Lt. Col. Ruby D. Garrett after the war. "New lines were built and old lines salvaged. Several miles of buried cable were installed. While there, many signal officers from other commands were assigned to the 117th for instruction. On June 21, 1918, the Division was relieved from the Baccarat sector by the 77th Division and the 61st French Division and re-assembled in the Châtel-sur-Moselle area. From June 23-29, the 42nd Division moved to St. Germain."[8] "Baccarat" is the "Somewhere in France" to which OPH refers as he begins his reports, but the place he remembers is home.

The Home Boys in Camp

Familiar Faces Greet A Star Man in France

Motor Dispatch Rider is One of the Chaps
Who was Third in a Missouri River Marathon—
More Mature Now

(From the Star's Own Correspondent). Somewhere in France. June 3. Dropping in the midst of (deleted) [the 117th] signal corps battalion was like getting a letter from home. After traveling for two months through England, Ireland, and France, it was better than a Croatian wedding to drive into a little French town right back of the front lines and find familiar faces. The first man to open the door, the man who was in charge of the office, spent several years handling news for the Associated Press in Kansas City. The Chauffeur who drove the major's car formerly was a motor car demonstrator on Grand Avenue. A soldier who brought a report on some wires that he had mended after they had been broken by shell fire was a former office boy in the Kansas side office of the *Star*. Two of the men who were operating the wireless machines formerly were telegraphers in the Kansas City Associated Press office.

And so it continued day after day. Always more familiar faces. Some of them had been mere boys before they enlisted, while others had been men. But now they are all men, every one of them, and it is doubtful if even their mothers would recognize them for a moment or two.

A motor dispatch rider came in to deliver some letters. He was covered with dust and little rivulets of perspiration trickling down from his forehead from a 50-mile ride on the motorcycle over the French roads. He was tall, lithe, and his face was so brown it almost corresponded with his olive drab uniform. He took third in the marathon swimming race in the Missouri River last summer. The telephone rang. On the other end of it a former Kansas City

newspaperman was waiting to speak to his commanding officer. He was stationed somewhere in the hills with a battery of artillery, and almost every night he exchanged compliments with the Germans a few hills distant. Another man came in to report that certain radio sets near the front lines were now in perfect working order. He was the troubleshooter for the wireless outfit, and it was his duty to keep all the radio outfits in repair, regardless of where they happened to be stationed, whether near the frontline trenches or in the rear at division headquarters. Back home he was a student at the Northeast High School, and his recreation consisted in building and working an amateur wireless outfit in his back yard.

Even the man who cooked the meals for the officers' mess every day was an old acquaintance. He formerly had charge of the dining room and the kitchen at one of the Grand Avenue hotels.

But there is a change in every one of them. Somehow they look older and more mature than they did back home in civil life, for all of them have faced the numerous times they have all been under fire; they have walked all day in the snow and slept in cold barns all night; they have lived and worked day after day in mud and rain; they have seen their comrades die from injuries inflicted by the boche; they have worked twenty hours a day and worked like they never have back home. It has all had its affect on them. Yet today they are happy and contented and eagerly awaiting the day when they can have some real battles with the enemy, for the occasional fights that take place most every night, the few hundred shells that are exchanged nightly and a little of the poisonous gas now and then has only served to make them more anxious than ever to take a real fall out of the German hordes.

Somewhere in France. June 4. You can never tell what may happen to them once they get into the army. They may go up, they

may go down, they may drag down a few medals or they may end up in the guardhouse. Take the army cooks, for instance.

Contrary to public opinion, the fine hotel chef doesn't always make the best army cook. He may come from almost any walk of life, and generally he does. They say that cooks are born and not made, but in the army they are made.

For instance, the cooks in the signal corps battalion which left Kansas City almost a year ago[9] range from a peddler of catfish on the streets of Kansas City to the chef at the Hotel Muehlebach. Back home "Catfish Charley" drove a small wagon through the streets selling fish, and when he wasn't selling he was fishing. But now "Catfish Charley" can turn out a strawberry shortcake that melts in your mouth. Not only that, but he can prepare a stew that never fails to reach the spot.

One of the other cooks formerly was a Kansas City lineman. The extreme cold and snow last winter injured his feet a little, so he turned from climbing telephone poles to cooking and he has qualified as an expert in buckwheat cakes and biscuits.[10] Another one was a sheet metal worker in the West Bottoms. No one, at any time, or at any place has ever connected the sheet metal trade with a cook book, yet this sheet metal worker has done so well in his adopted line that he shortly will be promoted to the rank of corporal.

And so it goes. Working side by side with another well known Kansas City hotel chef is a boilermaker, one who formerly constructed and repaired boilers in a shop on West Fifth Street. Between the two, the boilermaker makes the better cook, according to his commanding officer. Both the chef and the boilermaker are privates, and between them they manage to turn out a meal that helps the battalion maintain its reputation of being one of the best fed units in the division.

Over in the ammunition train unit,[11] recruited in Greater Kansas City and the state of Kansas, one of the best cooks turned

out to be the son of a Kansas banker. Before the war, his education consisted of going to school, in addition to which he was an expert on the mandolin and guitar. No one had ever heard of him doing any cooking, and that was the last thing he ever dreamed of doing himself. Yet today he is an army cook, and a good one. How or why he doesn't know. Neither does anyone else, but he is.

The old 1st Missouri Ambulance Company[12] has two cooks that are so good at their jobs that they were appropriated by a general officers' mess. One of them formerly was a brakeman on the Katy and the other was studying to be a grand opera singer. But they could put out bacon and eggs, coffee, lyonnaise potatoes[13] and other things just as well as if they had been born with a cook book in their arms.

This doesn't extend only to the cooks, but to other lines of duty as well. Chaplain James Small, a Kansas City minister now attached to the hospital trains of the division, has an assistant who formerly operated a switch engine in the Frisco yards.[14]

"We have a large amount of work to do," the chaplain explained the other day, "and some of it is very aggravating. I needed an assistant, so I decided I had better get one who could swear. No man in the world can beat a railroad man at the cussing game, so I picked an engineer for my assistant, and let me tell you he is a good one. He never swears unless it is absolutely necessary, and when he swears, he swears. I always have been fond of a man who does his work thoroughly."

O.P.H.[15]

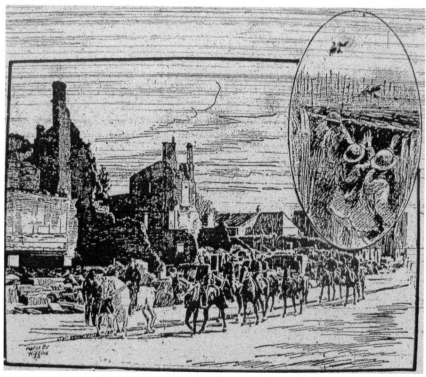

A Kansas City Signal Corps Staff in a Ruined French Village. Signal Corps men releasing carrier pigeons in the front trenches.

Photos by Higgins[16]

KANSAS CITY MEN IN FRANCE

* * *

O.P.H. with the 140th Infantry

Comprised of the old Missouri 3rd and 6th National Guard Infantry Regiments, the 140th Infantry landed at Le Havre, France, on May 9, 1918, from aboard the *Archangel* and marched out to British Rest Camp No. 1. While they were in the rest camp, a German U-boat entered the harbor and blew up a ship at anchor. Destroyers were deployed to chase the U-boat, but it escaped. As a result of the attack, "the dangers we had passed through on the

Behind the Lines and at Belleau Wood—June 1918

voyage over became very real to us," regimental chaplain Cpt. Evan Edwards observed[17].

After turning in their barracks bags and being outfitted with British Enfield rifles and gas masks, the 140th Regiment boarded French trains for Eu, Normandy, where 35th Division Headquarters had been established. The 140th detrained there on May 13 and marched ten miles to Gamasches, where regimental headquarters was set up. The regiment was also billeted at Monchaux, Longroy, Guerville and Château le Hays[18]. The British Expeditionary Forces had deployed a company of Argyle and Sutherland Highlander British soldiers as well as the 17th Manchesters under Major Pompfrey to begin the "polish" training to which OPH refers in the following articles.

[Untitled; Reference to "Old Third," Now 140th Infantry, 35th Division][19]

SOMEWHERE IN FRANCE, [Gamasches, Normandy] June 13.—Not too very long ago he was employed in a bank in the neighborhood of Tenth and Walnut streets as assistant teller.[20] He and some of the other young men in the neighborhood in which he lived, joined one of the infantry companies of the old Third Regiment because they liked the exercise gained while drilling at night and they enjoyed the long hikes out into the country on Sundays.

No one thought of a war at that time, but when the call came they were all ready and today they are in France doing their bit.

Not even his best friend could have recognized him had he seen him in the little French village where he was billeted. He had been riding in boxcars and marching for several days, and ended up by sleeping in an old barn, something he never dreamed of doing at home. But here he was glad the barn didn't have any cracks in the roof, and was tickled to death because he was fortunate enough to

67

get a bunk equipped with chicken wire as springs. He had arrived only the night before, and hadn't had a chance to do any washing for several days.

ALL HAPPY AND SMILING

There he was standing alongside the town watering trough, his sleeves rolled up above his elbows doing his washing. Standing beside him were several French women, each with their little bundles of laundry at hand, performing the same duty the former assistant teller was doing. They were all apparently happy, and all smiling. The soldier couldn't understand what they were saying and they couldn't understand what he was saying. Yet every now and then they would raise up from their work speak to each other, laugh, and start working again.[21]

All French villages are equipped with a town wash trough, usually near the center of the village, where all the women bring their washing. When the men first landed in France it seemed more like a joke than a reality, but it didn't take them long to appreciate the results that could be obtained at the town trough. And it was there we found the former assistant teller, busily engaged in doing his week's washing.

THINGS WERE DIFFERENT NOW

Back home he would have blushed a rosy hue away back behind his ears if anyone would have suggested that he do even a portion of his washing. But now things were different. He was a soldier, ready to fight.

He didn't even look up when a motor car drove up and stopped behind him. He was trying to get a grease spot off a woolen shirt and was rubbing industriously not knowing that plain ordinary French water wasn't made to remove grease spots from woolen shirts.

No. 4—It didn't take the boys from home very long to acquaint themselves with French methods. In fact, they were very glad to find such a thing as a village wash trough, one that was always ready for instant use. Here the men mingle with the French women and they all do their washing together. It doesn't matter whether they can talk to each other or not, they get along just the same. The photograph was taken the second day after a Kansas City regiment of infantry arrived at its camp in a French village. [Note: likely Col. Albert Linxweiler's 140th Infantry, see story 13 June 1918].[22]

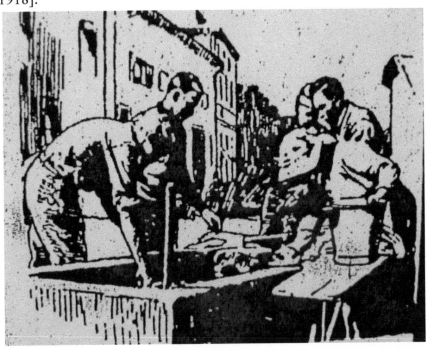

When his commanding officer called to him he turned around, saluted and stood at attention, the soap suds dripping from his arms and hands. The shirt had accidentally dropped in the trough. He recognized us when called over to the car, wiped his hands on the section of his uniform farthest away, shook hands and started talking. His face suddenly clouded and took on a perplexed expression.

"Pardon me, just a moment," he explained. "I've dropped my shirt in the trough, and I'm afraid the cold water will cause it to shrink."

We waited while he rescued the shirt. And back home he was assistant to the paying teller.

O. P. H.[23]

With Our Own Boys In France

(From Photographs Made by The Star's Correspondent).

No. 1—As long as the wheels hold out, and as long as there is anything to cook, the Kansas City infantry isn't going to go hungry in France. No matter where or how fast the unit moves, the kitchens will follow right along behind. In the field, rolling kitchens are used wherever possible and the coffee and stew can be cooking on the fire while the kitchen is traveling along the road. There is nothing like a rolling kitchen when the troops are moving.

No. 2—It is in "Sunny France," only it rains the greater part of the time, so a top is kept on the mail wagon for safety's sake. If the mail man should happen to ruin his delivery because of any inattention on his part he would be shot at sunrise by his comrades or torn to pieces by the angry mob, for letters are the most valuable things the men receive and they must be cared for like a 10-million dollar baby.

No. 3—It was a long trip overland, but the trucks all made it, and they arrived in camp the same time the men did. The men rode part of the way on the train and marched a small part of the way, but the trucks all went under their own power, carrying supplies for the men from Missouri and Kansas. The photograph shows the first of the trains arriving in a French village, where some of the men are quartered.

As a war correspondent, OPH carried no weapons, but he did have his walking stick, his musette bag, a leather case for his field notes, a portable typewriter, and his camera. The following photos and their cutlines carry on the theme of the daily routines in the life of a soldier. The "Kansas City Battalion of the Signal Corps" is the 117th Field Signal Battalion, and "the first ambulance organized in Kansas City" is likely the 1st Missouri Ambulance Company which was organized on January 2, 1912. Kansas City doctor Major William L. Gist, OPH's friend and family physician, was the commanding officer. The ambulance company served on the Mexican Border July 8 to December 26, 1916, and was again called into Federal service on June 3, 1917, and sent to Camp Doniphan where Cpt. Gist was promoted to Major and the unit became part of the 110th Sanitary Train, serving with the 35th Division in France from June 1, 1918 to April 15, 1919. The unit was assigned to the Gerardmer Sector (Vosges Mountains), in reserve for the Battle of St. Mihiel, in combat during the Meuse-Argonne Offensive, and afterwards withdrawn to the Sommedieue Sector.[24] The Kansas City infantry company pictured in the last photo is most likely the 140th Infantry Regiment, which arrived in France still wearing their "Baden-Powell" campaign hats.

With Our Own Boys In France

(From Photographs Made by The Star's Correspondent June 20-22).

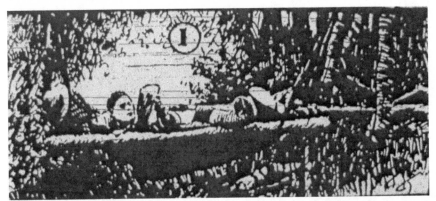

No. 1—Life in the trenches can be made very comfortable when the fighting isn't very severe. When the topography of the terrain permits, the men many times have very comfortable surroundings. The photograph shows an enlisted man of the Kansas City Battalion of the signal corps reading a magazine three months old, after working all night on the telephone lines. The hammock is constructed out of chicken wire. The spot is in the foothills of the Vosges Mountains. The picture was taken between the first and second line trenches, and artillery shells were passing overhead at the time, but they were directed at objects several miles distant.

No. 2—The men who belong to the 1st Missouri Ambulance Company organized in Kansas City, the one that served on the border, have become very fond of the French children. The photograph shows the men unloading the trucks on their first day in a certain French village where they are camped for training purposes. While waiting for the trucks to arrive they have made friends with the little French children, and they all feel right at home, even though they cannot talk to each other. But speech isn't necessary when hearts are in the right place, and besides, the soldiers nearly always carry chewing gum in their pockets, and the children are inordinately fond of it. The company arrived in camp without a mishap, and the men are all in excellent condition. They had to start work immediately, for a number of cases of mumps broke out in the unit en route to camp.

No. 3—A company of Kansas City infantry taking their first exercise after having arrived in the French village near the front, where they were stationed for training purposes. The men were still wearing their campaign hats, although they are taboo in France. They had just arrived in camp and had not had time to have the overseas cap issued to them.

Observation Box in "No Man's Land."[25]

No. 4—A close watch must always be kept on the enemy at all times. If it isn't possible to watch him from the trenches, then he must be watched from other points. So a steel box has been devised, which is placed on a partly concealed position and is usually subject to fire from snipers, where the observers must remain. The box is constructed of two layers of heavy steel, with a vacuum between the layers. Here the observer must sit by the hour and keep a close watch on the opposing trenches and No Man's Land. This post is situated out in No Mans Land, and many times the boche snipers take a few cracks at the men as they crawl up to the post to go on duty.[26]

In the cutlines for the following photos, the ammunition train to which OPH refers is the 117th Ammunition Train of the 42nd Division. The train was "a unit responsible for stockpiling and delivering the ammunition necessary for artillery and infantry units engaged in combat. They were the lifeline for the fight."[27] The 117th Ammunition Train was raised by Iola, Kansas, native, Lt. Col. Frank Travis, in June 1917 and sworn in on Mount Marty, where the Rosedale Arch now stands in Kansas City, Kansas. Captain William K. Herndon is the adjutant to which OPH refers.[28] The cemetery in the Lorraine, France, holds graves of the 42nd Division.

With Our Own Boys in France

(From Photographs Taken by The Star's Correspondent June 22-24).

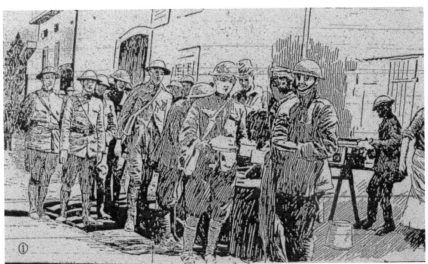

No. 1—The work of the ammunition train organized in Greater Kansas City and Eastern Kansas is very dangerous for they must deliver munitions to the batteries and advance positions at all times. Most of their work is done at night and frequently they must drive over shell swept roads, so they must wear their steel helmets and gas masks all the time, whether at work or at play, for they never can tell when shrapnel or shell splinters will strike them, or when the gas will be sent over by Fritz. The photographs shows the lieutenant colonel from Iola, Kas, who commands the train, standing on the extreme left The adjutant, a former Kansas City Insurance man, is standing at his left. They were inspecting the mess when the photograph was taken. The smile of satisfaction in front comes from Rosedale.

No. 2—At present, at least when this picture was taken, the boys from home were not making their own bread. They have been moving too fast to establish a bakery, so their bread is being shipped to them from other field bakeries. Some idea of the size of the loaves may be gained from the pictures of the loaf being held by a Kansas City captain in charge of a supply company. The bread is made of white flour and is of very good quality.

No. 3—The very best of care is being given the American graves in France wherever possible. Many times the exigencies of war compel burials to take place wherever the men happen to fall, but if there is an opportunity they are placed in graveyards. The Lorraine graveyard shown in the photograph is filled with men from the most famous of the National Guard Units sent to France. The cross above each grave bears a lithograph engraving showing the name of the soldier, the cause of death, the date of death, and the name of his division. The emblem was suggested by Maj. Ruby D. Garrett who formerly commanded the signal corps battalion raised in Kansas City.

No. 4—Ammunition must be delivered at all times, regardless of artillery fire, machine gun fire, gas attacks or any other kind of attacks. The gas attacks are very frequent. Consequently, the horses must wear gas masks as well as the men. It takes some little training to teach a horse to breathe through a gas mask, but they will do it and they can weather a gas attack as well as any soldier. Each horse carries his mask hanging under his neck and in case of an attack it takes only a moment to adjust it. The photograph was taken of a team belonging to a Kansas ammunition train that was one of the first units in France.[29]

No. 2—Soldiers must sleep as well as fight. Sometimes they are able to sleep very comfortably, like the lieutenant in the photograph, and sometimes they are not. But the night before, the lieutenant led a raid on the German lines, and the next morning the camera caught him asleep. The tent is in the front line trenches of an American division and the roof must be kept green all the time so that German airmen cannot distinguish it from the surrounding foliage. The hammock is made out of chicken wire.

No. 3—One of the duties of the commanding officer of an ammunition train is to see that all the transportation is kept in good shape all the time, so Lieut. Col. Frank L. Travis of Iola, Kas., goes around occasionally inspecting the work to see that it is being done properly.

No. 4—When the boys from home come marching into a French village where they were going to camp they passed one of their sources of supply on the road. For during the day the family cow works in the field and morning and night it gives milk, which is retailed to the soldiers. The photograph was taken in the main street of the village where two Kansas City ambulance companies are quartered and where other Missouri and Kansas troops are stationed for training purposes.[30]

O. P. H. at Belleau Wood

Otto P. Higgins took the four photographs which appear below on June 18, 1918, immediately following action by the 5th Marines in the Bois de Belleau, "Belleau Wood." The photographs did not appear in the *Star* until September 22, 1918, accompanying an article OPH wrote on August 12, 1918, "Sweets Lighten the Pack," (*Kansas City Star*, Sunday, September 22, 1918, 1B). The four photographs are the originals, bearing some water damage, with OPH's original cut lines written in his handwriting on the back.[31]

WITH OUR BOYS IN FRANCE

(From a photograph taken by The Star's Correspondent.)

AFTER THE AMERICAN TROOPS HAD TAKEN BELLEAU WOOD

"39 Higgins. A boche position. The two men who were shooting the rifles seen on the parapet were lying dead in the dugout when this picture was taken. The short sticks on the right are hand grenades. Top Line—an abandoned boche position. 2 col."

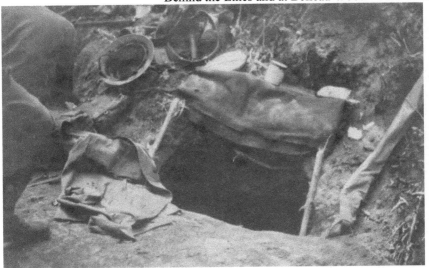

"40 Higgins 44 Spread. Cutline—Fox hole, German, Belleau Woods. This is their home, just big enough to sleep in or to sit up."

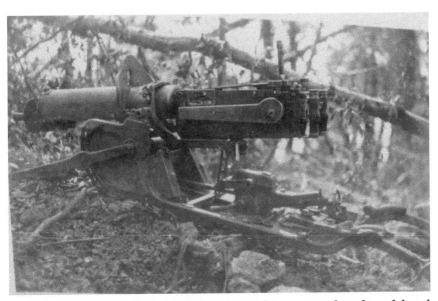

"41 Higgins. Cut line—2 col. A machine gun abandoned by the boche in their retreat. It is standing just as it was left."

"47 Higgins. The remains of a boche machine gun crew. Bois de Belleau."

Unpublished Photographs by OPH taken in Belleau Wood, June 18, 1918, Accompanied by His Original Cut Lines.[32]

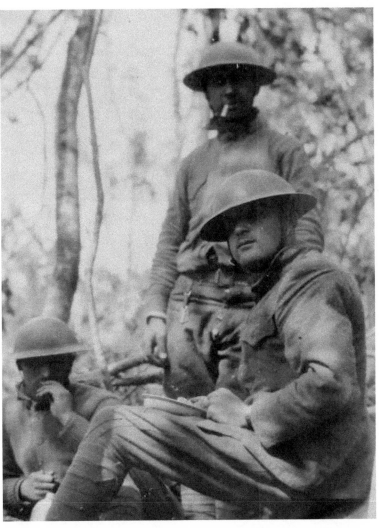

"44 Higgins. 5ᵗʰ Marines. Belleau Wood. June 18—18."

"These three men are camped on the edge of the Bois de Belleau where they can easily see the boche positions."

"Top Line—Eating supper while watching the boche."

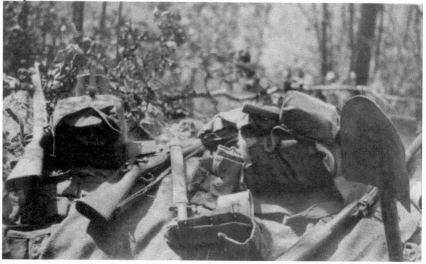

"46 Higgins. Boche equipment—left behind in the (rush) retreat. Belleau Woods." Passed AEF censor A 27 in France on 1 Juilet 1918.

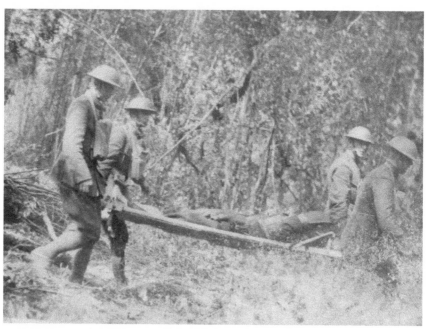

"48 Higgins Cutline—2 col. Carrying wounded out of the Bois de Belleau." Passed AEF censor A 27 in France on 1 Juilet 1918.

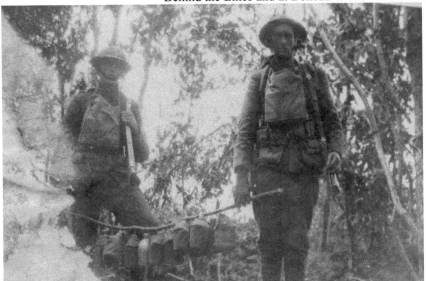

"49 Higgins Top line—Carrying water to the advance lines Bois de Belleau. It takes a three hours hike to reach the edge of the woods from regimental H.Q. The boche occupied the entire wood and were driven out."

Chapter 5: In the Vosges—July 1918

On July 2,1918, President Wilson announced that nearly one million American troops had been deployed to Europe.[1] They had their work cut out for them. By the middle of the month, German General Erich Von Ludendorff initiated the final phase of "the Great German Spring," the "Friedensturm", the assault that was supposed to bring German victory and peace. The Friedensturm did prove to be the turning point of the war, but not for the Germans. Known to the Allies as the Second Battle of the Marne, the front stretched fifty miles, east and west of Rheims.[2] Along 27 miles of the front from Fontenoy to Belleau, the Allied counterattack proved so successful that the Germans retreated to the Hindenburg line Meanwhile, in Russia, Bolsheviks executed Russian Czar Nicholas II and his family. Royal power in Europe was beginning to crack, in the east, and soon in the west.

While these events were taking place during the month of July, OPH was spending most of his time with the Kansas City boys of the 35th Division high up in the Vosges Mountains overlooking the valley of the German Rhine, but OPH began the month with a piece he wrote about Mary Louise Blodell, a 14-year old French girl, who endeared herself to officers of the 117th Field Signal Battalion by teaching them French. Higgins then turned his attention to the 140th Infantry. He followed Major Murray Davis's men as they hiked up the mountain at night to take their positions in the trenches. He observed a raid into "No Man's Land," reported on the unique strategy of Kansas City boys to prompt the Germans into wasting their ammunition by throwing rocks at them, observed the effectiveness of scouting parties, and recorded details of the soldiers' daily routine—eating from the rolling kitchens, trying to keep warm in the cold rain, enjoying the arrival of the YMCA hut, learning French, and eagerly devouring letters and clippings from home. During the month, the Americans and French celebrated their

respective independence days, cementing once more the historical ties that bound the two countries together and that joined them now in a common cause to preserve the freedoms won by revolution.

On July 30, OPH returned briefly to Paris,[3] where he visited 117th Field Signal Battalion commander, Lieutenant Colonel Ruby D. Garrett, who had been hospitalized with appendicitis after the Battle of St. Mihiel. While in Paris, Higgins got a call from Joe Ware, a former *Kansas City Star* reporter and now a 1st Lieutenant with the 150th Machine Gun Battalion, 42nd Division,[4] who had been at Fere-en-Tardenois arranging the sight on a machine gun when a German shell exploded in front of him, killing the man standing next to him, breaking Ware's eardrum, and sending him to the hospital with a severe case of shell shock.

Throughout his travel from unit to unit, OPH continued to run into former colleagues from the *Star*, former classmates from Kansas City Kansas High School, and various acquaintances, who recognized Higgins from his days on the police beat in Kansas City. Throughout the sixteen articles he wrote for the *Star* during July, OPH mentioned by name nearly thirty men whom he knew or who recognized him.

"The world after all is a mighty small place," OPH observed, "and France itself sometimes doesn't seem much larger than Kansas City. But it is amusing, and interesting, as well, where and under what conditions you sometimes find your friends."[5] The familiarity in his writing brought a little bit of Kansas City to the war, and as OPH wrote about those familiar Kansas City faces, he brought the war back home to Kansas City.

THEIR "PROFESSOR" AT 14
KANSAS CITY OFFICERS INSTRUCTED IN FRENCH BY A LITTLE GIRl.

An Incident of the Signal Corp's Stay
In a FrenchVillage—
When Orders Came, the Little "Professor" Was in Tears.

(From The Star's Own Correspondent.)

WITH THE KANSAS CITY SIGNAL CORPS IN THE LUNEVILLE SECTOR, July 1.[6] Every American soldier and officer with scarcely an exception, wishes to learn French when he comes to France. It isn't the easiest thing in the world, however, because sometimes the men scarcely ever see a Frenchman except at long range.

But now and then a few of them will have an opportunity to get together and do a little studying. It so happened that a group of Kansas City officers was stationed in a little French village which happened to be close to the lines. Their work took them along the front both day and night, but they were always around about dinner time, for even soldiers must eat occasionally.

"And Mary Louise stood in the doorway of her home as the men filed past." Photo in the Star.

Across the street from the mess hall lived a pretty little French girl, Mary Louise, 14 years old. She and her mother and little brother lived there together and somehow they managed to get along, for Mary Louise's father had been a prisoner in Germany for three and one-half years; for like all other Frenchmen he had joined when the war first started, and he was what the French call an "*adjudant*."[7]

One of the officers got into the habit of dropping in on Mary Louise and her mother after dinner, studying French out of a little French-English grammar that Mary Louise had. He made such rapid progress in French, and Mary Louise absorbed the English so fast, that before long all the officers began dropping in on the little French girl after dinner each night, and Mary Louise became a "professor" to a class of fourteen grown men at the tender age of 14 years. After that, Mary Louise, her little brother and mother never wanted for anything.

OPH's original photo of Mary Louise Blodell.[8]

But all good things have an end. One day the order came that the division was going to move. Where, no one knew. The order read: "Be ready to move at a moment's notice."

So the little French class had to end, and when the final parting came, little Mary Louise cried like a child of 14 can cry. Yet she felt no worse than the officers. It isn't in the calendar that big grownup men should cry, yet many a tear rolled down tanned and weather-beaten cheeks early on the morning when the men departed.

And Mary Louise stood at attention in the doorway of her home as the men filed past, and each raised his right hand on a level with his eyes as a token of farewell to the little French "professor" they all had grown to love so well.

O.P.H.[9]

WHEN OUR BOYS "WENT IN"

"O.P.H." TELLS OF KANSAS CITY
LADS IN FRANCE

It was 9 O'Clock at Night When The Order Came to Fall In,
And the 14 Mile March in the Mountains Began

(From The Star's Own Correspondent.)

WITH THE MISSOURI AND KANSAS TROOPS IN THE VOSGES MOUNTAINS July 15 – It was around 9 o'clock at night when an order came to "fall in." All of the company commanders, who had been absent for the last two days familiarizing themselves with the details of the sector which we were going to take over, had returned to lead their men up the tortuous, winding road of the mountain.

Canteens had been hurriedly filled, packs carefully adjusted to backs, and rifles slung over shoulders. It was to be a long, hard, grueling march, and the men knew it. Although it was only about fourteen miles, it was almost straight up all the way, and there is nothing that gets a fellow more than continuous climbing hour after hour.

"Fall in," commanded the major, a former Kansas City lawyer, from down at the head of the column.[10]

"Fall in," came the echo, as each company commander repeated it to his platoon commanders.

"Huh," came the next command, which means most anything, but the men always do the right thing. This time it meant to march forward—and upward.

The first two miles was along practically level country, a beautiful winding road that anyone could travel and enjoy. The packs were still not very heavy, everyone was happy and feeling good. Someone struck up a marching song, which was carried up

and down the line of eleven hundred men. And after it was finished, someone struck up another, and so it went, nearly everyone joining in, regardless of the quality of his voice, until the foot of the mountain was reached. Here the order to rest was given. A few sat down, but most of the men leaned on their guns, for they weren't tired as yet, and no one felt the effects of the march. The ten minutes passed very quickly, however.

THE MEN BEGIN TO CLIMB.

Again came the order to "fall in" and to march. The men started the climb, every back bent forward so as to rest the heavy pack on the shoulders as much as possible. The road was one of those snake-like affairs that climb right up the face of a mountain, something like a stepladder. Straight up, it wasn't so far. But nothing except a mountain burro or a bird could go straight up. If you wanted to get there at all, you had to follow the road.

On each side of the road was a profusion of the tall pine trees so common to the mountain forests of France. They grew close together and fought their way upward to two hundred feet as straight and tall as an arrow. On one side of the road the mountain went straight up, and on the other it went straight down. The trees came so close together, however, that their branches almost touched one another across the small, narrow winding pathway, shutting out all the light from the new moon and the wealth of stars that shone like jewels through the overhanging branches. It was so dark that the men could only see a dim outline of one another even though their eyes were accustomed to the darkness, and in most cases they plodded along, each holding close to the almost totally obscured object in front of him.

AFTER TWO HOURS CLIMB.

A halt was called every fifteen minutes to give the men breathing space. For the first two hours, hardly any of them fell out

of ranks. They were well trained, these men, and the strain hadn't begun to tell on them. But after that, when the major called back: "Fall out," they literally fell out, and enjoyed the rest to the full.

"I used to think it was some job to make the old Ninth Street hill," one fellow sung out. "but now I could make it on high and think I was going down hill."

"Grab me quick!" someone else yelled out. "I'm sliding backwards and my brake won't work. It's burnt out."

"If some blankety-blank blank don't quit stepping on my heels I'm going to put my gondola in the middle of his map," came from up the line.

"For God's sake, bartender, if you can't give me more beer and less foam I'm going to spend all my nickels with Joe Donnegan after this," someone else popped.[11]

"Well, I wonder who's kissing her now?" somebody sung out and then stopped suddenly, as his foot slipped, stumbled, his heavy pack became over-balanced, and head foremost he went over the side of the mountain.

OVER THE SIDE HE WENT.

"Hold her, Deacon," a soldier just behind him called out at the disappearing figure.

Half a dozen packs slipped to the ground, and over the side went the boys, feeling their way down the mountain in the wake of the rolling, rumbling figure, that finally lodged twenty-five feet below against the foot of a tree. The marching men had halted, glad of the breathing space, but not for long. Ten minutes later the unfortunate and his rescuers had again "fallen in," and the winding, puffing column continued upward.

So it went, all up and down the line, all night long. If the Starbeam[12] writer could have been there, he could have garnered enough Starbeams to have lasted a month, for every man there

seemed to be a humorist, and all they had to do was to think, climb, puff, utter an occasional curse and then pull something good, regardless of whether anyone heard it or not.

The first streaks of dawn were visible through the thick foliage shortly after 3 o'clock. By 5 the sun was peeping over the top of the mountain, which could be plainly seen—the mountain, I mean, for the trees were beginning to thin out.

At 6 a level spot was reached and the major called a halt while an orderly ran back to the rolling kitchens to see if breakfast— "slum"[13] and coffee—was ready. It was. There is nearly always something cooking in a rolling kitchen. The company commanders drew their papers out of their dispatch cases and called the roll.

A THOUSAND FROM KANSAS CITY.

There wasn't a man missing out of the entire eleven hundred, and one thousand of them were from Kansas City.

The major only had to say "fall out" once. That was enough. Packs and rifles slid to the ground, mess kits appeared like lightning and there was a scurrying of heavily shod feet for the kitchens, for the rule, "first come, first served," was in vogue.

Thirty minutes later, the ground was covered with tired, worn-out figures, wrapped in their blankets and propped up on the downhill side by trees and stones, fast asleep. The toughest part of the hike was over.

O.P.H.[14]

KANSANS OVER TOP

The Star's Correspondent With the 35th Division
Writes of a Thrilling Day in France

BARRAGE THEN A RAID

When the American Artillery Had Established a Zone,
232 Kansans Went Over the Trenches.

Five Prisoners Fell into Our Boys' Range and
All Hands Were Satisfied

KANSAS CITY MEN GO IN

"O.P.H." Gives a Picture of the Home Town
Boys Entering the Vosges Trenches.

(From The Star's Own Correspondent.)

WITH THE MISSOURI AND KANSAS TROOPS IN THE VOSGES MOUNTAINS. July 20. The Kansas troops early this morning underwent their first baptism of real fire when 232 picked men went over the top and brought back five German prisoners.

Eighteen German dead were counted on the field, while bits of others were picked up here and there

Several men, including two officers, probably will be awarded medals for deeds of heroism performed by them while under fire.

Lieut. Thomas H. Hopkins, Company G _____ [137th Infantry] of Wichita was killed when he went out on the battlefield to rescue one of the men who had been wounded. A sergeant, whose name was not learned [Sergeant Jackson Walker], then went out under intense fire and brought back both the body of the lieutenant and the wounded soldier. Late in the afternoon, after the fight was finished, Capt. Roy Perkins, Company G, _____ [137th

Infantry] of Salina, found, in checking over his men, that two of them were missing. Without a word to anyone he went alone across No Man's Land, entered the German lines and two hours later came back with the bodies of his two men. He found them lying in a boche dugout.[15]

MOUNTAIN IS COLD AND CLEAR.

It was one of those clear, cold, bright, snappy nights that occur frequently in the Vosges Mountains, the kind where each and every star stands out like a lighthouse on a foggy morning. The moon had dropped behind the mountains shortly after midnight, leaving the stars the lone duty of illuminating the valleys and mountains.

No one knew just when the attack would begin. Most of the men were taken from one Western Kansas company and the rest especially selected from volunteers from the other Kansas companies. They had been training for three days in the method of attack, and the night before had filtered into the front lines in small squads, so as not to alarm the boche outposts, stationed less than fifty yards away.

The night wasn't much different from any other night in the Vosges, except that to those who were waiting for the raid to take place, the occasional shells overhead seemed much louder than usual. There wasn't much laughing or joking or singing going on, or sleeping, for that matter. Each man was lying in a dugout or trench, alone with his own thoughts, for no one dared talk or even smoke.

REPORTER FOR *THE STAR* LOOKED ON.

Knowing in advance of the details of the raid, the colonel of the adjoining sector invited me to accompany him to the top of the nearby mountain overlooking the valley below, where the raid was to take place and where we could plainly see the details. We arrived

at our observation point at 3 o'clock in the morning, after crawling some distance through the tall grass so we wouldn't appear on the skyline. There we remained shaking and shivering in the damp grass.

The stars seemed to melt away before the advancing sun, which came up from the east, spreading a hue of gold which seemed to melt into red, just as if the dawn sensed what was waiting for it. Now and then a cannon would drop a shell across the valley, as if the gunners were testing out their instruments of death. The sound would echo and re-echo up and down the valleys, and it wasn't at all reassuring. Now and then some nervous "doughboy" on guard would let fly a hand grenade at some imaginary object, or a rifle would let go with two or three shots, or a machine gun cut loose with a burst or two of shells. Here and there a star shell would go up, and the many illuminating sparks would light up the ground underneath. Each side wanted to be sure no one was slipping up.

THE AMERICAN ARTILLERY OPENS UP.

It was just 4 o'clock. A colored light went up from some unseen place. Every hill on our left seemed to burst forth in fire. I thought I was familiar with much of the country and knew the location of the artillery. But I didn't. Shells seemed to be coming from every conceivable place.

They came from our left front, from our side, and from behind us. The flashes of exploding powder from the cannon were constant. The ground shook. Each battery had its objective, and each was doing all the program called for. Four minutes later the boche artillery began replying. Shells were bursting everywhere. Earth, fragments of trees, and barb wire were flying in every direction. There was one battery just to our left that had been firing over us. The boche were trying to locate it, but their shells were falling short, and every time a shell hit the opposite side of our little

mountain—and they were dropping just over the hill from us—the ground would shake so we couldn't hold our glasses steady.

MACHINE GUNS IN, TOO.

The firing was general for fifteen minutes, everybody shooting anything he could find to shoot at. The steady hum of the machine guns could be heard very plainly above the roar of the big guns. The boche signals began to go up. The red flares evidently meant they needed help. They were sending up red flares all up and down the valley, and we thought that they certainly needed them. The fire seemed to concentrate in one point, where we knew the raid was to take place. The object was to tear up the barb wire, destroy the machine gun nests and make things as easy as possible for our men who were going over.

"Bringing Home the Bacon." Five boche prisoners captured by the boys from Kansas in a trench raid. Photo by Otto P. Higgins, France, Kansas City Star, *September 8, 1918, 1B.*

In a few minutes you could see a small bare spot in the shape of a parallelogram. The artillery had established its box barrage, and it was exceptionally plain, for most of the valley was filled with heavy smoke. Here the men went over at two points, right through

the boche barrage and shell fire, cleaned up No Man's Land, scoured what was left of the boche lines, cleaned out their dugouts, investigated all the cellars of a village held by the boche, and came back bringing five prisoners they found in a dugout.

ALL DONE IN AN HOUR.

It was all over in an hour. The men had all returned, the wounded attended to, the prisoners started on their way to the rear to get a good hot breakfast and then to be thoroughly questioned . By half past 5 the shelling had become desultory, and by 7 o'clock both sides had settled down into their regular routine of watchful waiting and occasional shooting.

"A Group of Kansas Soldiers Who Went Over the Top." One has a boche helmet he brought back with him and a boche knife. Another has a boche bayonet.
Photo by Otto P. Higgins, France, Kansas City Star, *September 8, 1918, 1B.*

It was a happy, tired and ragged group that came back from the raid. I met the escort bringing in the prisoners just around the hill from where the battle took place, each man walking stiffly erect, rifle over his shoulder and the sun glinting on the fixed bayonets. But every man wore a smile, even the prisoners, for they were glad to be alive.

Nearly all the men had torn their clothing on the barb wire, some had been skinned up by falling into trenches, shell holes and dugouts, some had bullet holes through their clothing, and several exhibited long jagged rips which they treasured very highly because they were made by boche bayonets making last thrusts.

I found one boy, a Kansas City, Kas., lad, sitting on the roadside crying. He was a most woebegone figure. He was dirty, his clothing was torn to shreds, and he was tired. He held his rifle in one hand and a wicked-looking trench knife in the other. Just why, I don't know and neither did he.

HE DIDN'T GET A BOCHE.

"I didn't get a boche," he told me. "I swore I would kill every one I found, but someone always beat me to it. We were lying on the parapet all ready to go, when a piece of shrapnel struck the hand grenades my partner carried in his belt, exploding one of them. He was killed right beside me. His blood on my back here isn't dry yet. I swore I'd never leave a boche alive, and here I chased all over the place and couldn't even find one to kill. But I'll get them the next time, or else they will have to get me first."

More than half the men brought back souvenirs of some kind. One would come running back carrying a boche rifle, one a helmet, one a cap, one a pistol, one a piece of a machine gun or anything else that could be picked up. One man had a handful of buttons he cut off the body of a dead boche, and nearly everyone had something. He who came out without a souvenir to send home to the folks was singularly unfortunate, and he who killed his first boche was the most envied of men. For that is the ambition of every man here, to get a boche.

By the time the prisoners reached regimental headquarters they were stripped of everything except their bare necessities. Everyone had traded belts with the Kansas boys. They willingly

offered all the buttons off their clothing, and anything else they had that was loose. In return the men gave them cigarettes, money and a good hot breakfast. You couldn't have told that the men were prisoners. They were treated more like guests. Every soldier insisted on giving them a little more to eat and those who could talk German gathered around and were the pride and joy of their friends because they could talk to the boche and then disseminate the information thus gained to the other men. The boche were satisfied to be prisoners and they had just as much fun out of it as the boys from Kansas, who had seen their first real warfare.[16]

FEAST FOR HOME BOYS

DESPITE FOOD SHORTAGE, SUMPTUOUS MEAL WAS CONTRIVED.

With Supplies Almost Unobtainable
Near Front, Kansas City Cook
Served Steak, Mushrooms, Salads, Pie and Everything.

(From The Star's Own Correspondent.)

WITH THE MISSOURI AND KANSAS TROOPS IN THE VOSGES MOUNTAINS. July 24.[17] The mess at battalion headquarters had been faring badly. Supplies had been slow in coming. Occasionally, a day passed when one arrived. What there was had to go to the men holding the front lines because they didn't understand the situation as we did, and always had powerful appetites.

We had been living about half the time on bully beef, canned salmon, sardines and coffee. Sometimes we had potatoes and bread and sometimes we didn't. Everybody was busy day and night, for the sector was a large one, and it took more than two days to cover it. So the men were in and out at all hours, and the meals were served accordingly, with the exception of dinner, which was at 7 o'clock prompt. Everyone tried to be there.

EXPECTED REGULAR MEAL.

Somehow, it got noised around that "Doc" Hanson, the mess officer, had scraped together a regular meal.[18] "Doc" didn't have much to say, but someone learned one of the orderlies had disappeared with a mule the day before to a town on the other side of the mountain about eighteen miles away. "Red" Lawson, the cook—and, by the way, "Red" used to be an expert pool player in Kansas City—and "Mac," his first assistant, had nothing to say.

Both were quiet as clams. The mysterious air around the place caused everyone to be there promptly.

Nobody was disappointed. We all squeezed into the dining room and stood around admiring the table, waiting for the major to take his seat. The table was built of pine boards, and the seats were wooden benches. The service consisted of chinaware, tin, aluminum, and enamel ware. The knives, forks, and spoons were of all sizes, shapes, breeds and patterns. But we were glad to have any kind.

Major Ernest W. Slusher, DSC

Someone had cut some branches from the pine trees and fastened them to the wall. Bunches of wild violets that grow in profusion along the tiny mountain streams were on the table.

WAITED EXPECTANTLY.

We sat around the table and waited. There was Murray Davis, who formerly practiced law in the Commerce Building,[19] "Doc" Hanson, who operated a dental office back home;[20] "Doc" Howell, proprietor of a drug store across from Cas Welch's[21] courtroom;[22] Steve Slaughter, who was always recruiting for the old Third;[23] Russell Throckmorton, who was in the brokerage business, Vic, I forget his last name, but he is short and fat and hasn't got much blonde hair on his head and wears gasses, who worked for the Metropolitan.[24] "Fergie," his right name is Ferguson, who comes from where they make corn whisky, down in Missouri, one or two others and myself. The door opened and in walked Ralph Truman and Bill Gordon from regimental headquarters.[25] Both used to be on the Kansas City police force. Then came "Doc" Slusher.[26]

Three more places had to be set, more dishes borrowed, extra boxes brought in for chairs. Then "Red" and "Mack" came with the meal.

First there was potato soup. Next came steak, smothered with mushrooms. Then there was mashed potatoes and lettuce salad and salmon salad, canned corn, stewed tomatoes and real French peas. Along with that was white bread and butter, coffee with cream and sugar, blackberry jam, Roquefort cheese and peach pie. Where it all came from only two or three knew, and they wouldn't tell.

WHERE IT CAME FROM.

Most of it came from tin cans, such as the mushrooms, tomatoes, milk and jam. The butter fame from some family goat, but it was butter. But the flour and some of the other things--no one knew that they could be found within miles.

Outside, the boche were dropping the usual number of shells, and the 75's were returning fire. A battery of 1-pounders was blazing away. In front, a rifle would pop. The bursting of hand grenades and the rat-a-tat-tat of the machine guns could be heard. But it was dinner time.

O.P.H.[27]

HOME BOYS SMOKED ROPE

BUT RED TRIANGLE SINCE HAS PROVIDED REAL
"BACCY."

O.P.H. Tells How "Y" Trucks Sent by
Henry J. Allen Carried "Makin's" Into Vosges, Ending
A Critical Shortage.

(From The Star's Own Correspondent.)

WITH THE MISSOURI AND KANSAS TROOPS IN THE VOSGES MOUNTAINS, July 28. They have come at last. Everyone now is happy, glad, are free, devil-may-care, and all the rest of it. The good news came today, and it spread like wildfire.

The Red Triangle,[28] the Y.M.C.A., at last had found us, and a little less than two miles by the road and paths from here we can buy tobacco—regular good old American tobacco—and chocolate and cigarettes and writing paper and envelopes. Two miles isn't far. I have seen men walk five and six miles up and down these mountains many a day because someone told them somebody else had said at a certain little French canteen over in a certain general direction they could buy French cigarettes, and when a man will walk five miles for a French cigarette he will walk ten for a package of regular good old American tobacco.

HENRY J. ALLEN IN CHARGE.

We had heard for some time that Henry J. Allen of Kansas was with us and that the Red Triangle would establish ten huts within the division. But the men have been in France so long and have heard so many stories and had seen so few Y.M.C.A. huts that they wouldn't really believe until they actually saw.

The division had been on the move continuously until this sector was reached. So the men have missed out on most of the little conveniences modern warfare allows. They have been going so fast even the mail couldn't catch up and the government issue of tobacco was weeks late. The only stationery they could get was at the "*Foyer de Soldat,*" the French Red Triangle, when one could be found, at the little French canteens, or when passing through some village. American tobacco was nil.

I have seen the men smoking coffee grounds, dried leaves, tea leaves and pieces of rope. I saw a soldier pay five francs fifty, equivalent to $1, for one little 5-cent package of tobacco.

TOBACCO AVAILABLE NOW.

Now things are different. The Red Triangle has brought in a supply, and the issue of tobacco is coming regularly. The price dropped to about normal. The other night I happened to be at regimental headquarters when word came three wagons were bringing in Red Triangle supplies and a secretary. Everybody ran down the road to greet them and help unload. Shop opened right there. Someone found an ax and the secretary smashed open the nearest box. It was chocolate, good old milk chocolate from home. He sold it right out of the packing box as fast as he could make change.

The next box contained cigarettes. They went just as fast. They were the first American "tailor-mades" the men had seen for weeks.[29] The box empty, the store closed down for a time.

"I want to get this stuff inside and up on the shelves," the secretary announced.

ALL HELPED "Y" SECRETARY.

He might just as well have announced he was going to start giving away $100 bills. Everybody who could get near a box or a crate seized it. The stuff was inside in a jiffy. Then all helped break open the boxes and willing hands shoved the supplies at the secretary so fast he didn't have time to arrange the stuff on the shelves. That secretary worked harder that night than he ever worked in his life, but he was happy. He couldn't help it, because everyone around him was happy.

"Where do I sleep tonight? The secretary asked.

Half a dozen hospital cots were offered, also several dozen blankets. Everyone wanted to make his stay as pleasant and comfortable as possible. He had been a long time coming, and no one was taking a chance on letting him go.

RED TRIANGLE CHEERS.

When Mr. Allen resigned from the Red Cross, it was announced that he was to have charge of the Red Triangle work with the home boys. He came right down here into Alsace, bringing numerous secretaries with him, and sending five carloads of supplies at the same time. But transportation is slow here at the front, and it is a long way from Paris. So it was quite a long time before the supplies came. While waiting, Mr. Allen established his headquarters, located the buildings he was to use as supply depots and personally went over all the surrounding country, both in the mountains along the front and in the valleys, to select the best spots for the Red Triangle huts.

By the time the supplies arrived, everything was ready for them. The huts had been located, just back of the front lines, as well as in the valleys where the troops were at rest. The supplies were

loaded on Wagons and trucks, whichever available, and shot right out to the troops.

From now on, the folks back home can expect more letters than they have been getting. The Red Triangle furnishes stationery free and usually has a large supply. Also, the men will be as happy and contented as possible, because they will be getting those comforts fighting men need, and that is furnished by no agency except the Y.M.C.A.

O.P.H.[30]

Chapter 6: Through Alsatian Days—August 1918

Once back in the Vosges Mountains with the 35th Division, 140th Infantry, Higgins described the longest hand of cards he ever played, while gas and artillery came uninvited into a poker game with a few officers of the 140th. Then, on August 3, 1918, OPH wrote about the first attack he witnessed of Germans attempting to overtake a listening post that jutted out into No Man's Land from the front lines of Kansas City's 140th Infantry.

That raid, which occurred on July 31, 1918, in an exposed sector near Wesserling in the Alsace, became the subject of two other articles, which detailed the action and identified the men of the Kansas City regiment who took part. To personalize the involvement of the Kansas City boys for its readers, the *Star* published pictures of some of the men involved in the action. For the Kansas City boys themselves, the raid had served to boost morale, the men confident now that they could measure up to the challenge of trench warfare in the Vosges Mountains.

Following the articles about the July 31st raid are a series of articles describing the positive effects which the Y.M.C.A., the Red Cross, and, Father William L. Hart—the Knights of Columbus chaplain—played in boosting the morale of the men. OPH observed that the morale received a big boost when Henry J. Allen, formerly the editor of the Wichita *Eagle*, joined the Y.M.C.A. and took over its work with the 35th Division. He joined the 140th at Saulxures, France.[1] Later, Higgins traveled to Kruth, a small town in the Alsace, to interview Allen as he recuperated from a serious bout of diphtheria with the able assistance of Topeka's Field Hospital 139 stationed there. Allen had just been nominated *in absentia* to be governor of Kansas, but it was more important to him to be sending Y.M.C.A. stringers out into the trenches with cigarettes, newspapers, magazines and the newly published *Stars and Stripes*. And OPH acknowledged that service. "The clouds haven't been so

dense, or the mud so deep, or the weather so cold, or the shells so deathlike, since they have joined us and become one of us," Higgins wrote.[2]

OPH also wrote about the opposite effect, too—how the morale of the boys was compromised by complaints of conditions at home. One of the boys of the 140th shared with OPH a letter he had received from his wife, who carried on about the increased costs of street car fares, gas, coal, electricity, ice, and food; the children's and her need for new clothes; the washerwoman's demands for more pay; the tax bill; and the wife's lack of funds for her annual trip to the Ozarks. "They can't seem to appreciate back home we are at war," her soldier-husband observed, "and that all the little pleasures and luxuries of life should be forgotten." "I can't do anything about it," he admitted to OPH, "but I wish you would do what you could, because I know lots of other boys receive the same kind of letters," he concluded. So OPH turned the tables on the home front, and, speaking for the boys, wrote an article contrasting the harsh living conditions they had to endure in the trenches with the ordinary way of life they had enjoyed at home before they were forced to go to war. OPH repeated the soldier's observation: "I marveled at how little the folks back home appreciate the hardships of this war," OPH wrote.[3]

Just one example of those hardships was graphically demonstrated by Higgins himself. While writing one of the Y.M.C.A. articles, OPH suddenly stopped and inserted a note admitting that his hands "are trembling so much that they couldn't strike the correct keys" of his typewriter. He was working during a bombardment by the light of a candle stuck in the neck of a champagne bottle and wondered if what he was writing would ever be passed by the censor. It did pass the censor and was published in the *Star,* giving his readers at home a real sense of what it was like

to be telling a story about morale and be interrupted by the very thing most threatening that morale—artillery shells.[4]

OPH later noted that the situation works in reverse, as well. He described sitting next to a lieutenant working a machine gun when the lieutenant received a rare letter from his wife narrating a story about their five-year old son and his playmates enjoying an outing at Electric Park in Kansas City. "The lieutenant was back in Kansas City then, out in the Country Club District, playing in the yard with 'sonny,'" OPH wrote. "A little thing like machine gun bullets, boche airplanes and shrapnel breaking all around couldn't bring him out of the reverie." The effect of the lieutenant's letter from home was in sharp contrast with the complaint letter the soldier had received from his home.[5]

Such abrupt juxtapositions only emphasize the ironic unreality of war. OPH noted a similar irony when he wrote about coming upon a listening post staffed by French and American soldiers, neither of whom understood the other's native language, but both of whom understood German, could communicate with one another in the language of the enemy, and were perfectly able to understand what they overheard from the German trenches nearby. Later on, German prisoners behind the American lines were utterly shocked when an American soldier by the name of Heinrich Schmidt stopped and engaged them in casual conversation. "So it is that the 'Heinies,' and the 'Augusts' and the 'Carls' and the 'Pauls' of German parentage from Missouri and Kansas are doing more than their share toward winning the war," OPH observed.[6] So it was with Higgins himself, who had learned German as a boy from his maternal grandmother, Cresence Schosser, but did his best work writing in English about American boys fighting Germans in France.

OPH was doing his share toward winning the war by re-presenting to the audience at home the Kansas City boys in the trenches (35th & 89th Infantry Division Regiments), behind the

artillery (129th Field Artillery), in the ammunition trucks (117th Ammunition Train) and ahead of the spools of telephone wire that tied the rest of them together (117th Field Signal Battalion). Higgins lived in the same dugouts they did, ate the same food, endured the same night marches, suffered the same bombardments and volunteered for the same missions. He took the same risks as they took. He told their story.

One night in mid-August, he accompanied nine men of the 140th in a night raid to bring back prisoners for interrogation. In just over 5,600 words, the third longest of the overseas articles, OPH takes the reader through a harrowing, minute-by-minute re-play of the experience, through the wire, out into No Man's Land, while flares expose their position and bullets whiz through the air around them. Because he was a non-combatant, OPH could carry no weapons; he had only his walking stick to clutch as he crawled along the ground. He thought of his family at home: "Dinner was just about over, back home, as I figured the time from my watch," he recalled. "I could see the children leaving the table, washing their little hands at the kitchen sink and running out into the yard to play with the neighbor children. I could see the family sitting out in the porch swing, sprinkling the lawn from the porch, as we used to do, and then enjoying the cool, damp air that arose from the moist grass, and I wondered if they were thinking of me as I was thinking of them."[7]

The eight men and Higgins returned from the raid safely, with no casualties, but they had failed to achieve their objective. "The raid was over. It had failed in its object, that of taking prisoners. But every raid isn't always a success," OPH concluded, and, as he writes, another patrol goes out a following night, and OPH is with them in spirit. "I'm wondering, as I finish this article by candlelight," OPH writes, "whether they will all return? Or whether they will be as fortunate as we were, even if we didn't bring

back any prisoners? And what they are thinking about, as they are crawling across No Man's Land towards the enemy wire, for there's where they are now at 11 o'clock, with the moon shining down on their prostrate forms."[8]

Higgins's chronicle of the Missouri and Kansas troops in the Vosges Mountains included other topics—troop movements at night, a man's fear of the dark that persisted into the front lines, air raids, snipers, a visit with Company B of the 129th Field Artillery—with the result that in the seventeen articles he had written during the month of August, 1918, he had achieved his objective. Beginning the month by witnessing and writing about a raid on the 140th Infantry, OPH ended the month by writing about a raid on the enemy, a raid in which he had himself participated, and, by the power of his own vivid description, allowed his readers to experience, quite as keenly, as well.

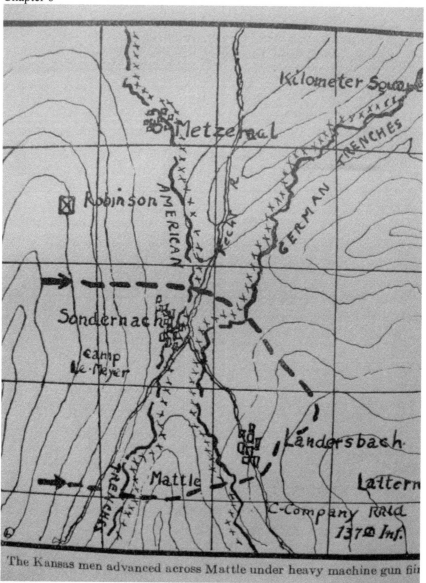

"The Kansas men advanced across Mattle under heavy machine gun fire."[9]

THE OLD THIRD IN A RAID
O. P. H. GOES ALONG TO BRING BACK PRISONERS

Sergeant Robinson's Squad Has a
Thrilling but Commonplace Ad-
Venture on the Boche Wire—A
Tribute to City-Bred Boys.

(From the Star's Own Correspondent.)

WITH THE 35TH DIVISION OF MISSOURI AND KANSAS TROOPS IN THE VOSGES MOUNTAINS, Aug 21.

A patrol of eight men in charge of Sergeant Robinson, will leave G. C. A. P. Y. at 11:30 o'clock for the enemy lines, returning to the same place by 3 o'clock.[10]

Object: To bring back prisoners for identification purposes.

That was all the order. But it was enough. It had a snapper on the end of it that made it one of the most interesting orders of the day, interesting to the one sergeant and eight men who were to take part. For it meant a scrap in the night, a scrap in the enemy lines, with the probabilities that someone would not return.

But those are the patrols the boys like to go out on, patrols where there is a likelihood of a fight. None of them ever stops to think of not coming back. Every man knows that he can whip any boche that ever shouldered a gun, and he is always ready and willing to take a chance on proving his superiority. So when it was noised around that the patrol was going out, applications began to come in to Sergeant Robinson of the scout platoon, it didn't take him long to select his eight men for the sergeant had some of his squad go out into No Man's Land almost every night. He needed men he could trust this time, men who were brave, cool-headed, husky and strong, and crack shots. For it is dangerous work to crawl through the enemy wire and bring back prisoners. The men would have to fight

in the open while the enemy had the cover of their trenches, and the getaway had to be made under a heavy fire.

"O. P. H." ASKS TO GO ALONG.

I had expressed a desire several times to go out on a patrol, but something had always interfered with my plans. The sergeant knew that I was eager, or at least I appeared to be eager, to visit No Man's Land at night.

"We're going to have some real sport tonight," he whispered to me in the afternoon. "We're going out after prisoners. I've been over the ground already, and if you want to have a good scare, come along."

I told him I would, if I could get the major's permission, and he was just as pleased as I was.

"Sure," said the major.[11] "You are going out with some of the best men in the battalion, and if they can't show you a good time no one can."

So it was settled.

SERGEANT EXPLAINS ATTACK.

We met at battalion headquarters at 11:00 o'clock. The moon was shining. In the cleared spaces in the mountains it was so light that you could almost read a newspaper. We all gathered around the sergeant there in the road in front of the little dugout office, while he carefully explained the plan of attack. We were to leave our outpost in single file and crawl along the lower side of a road that connected the two lines. We were to follow him to within twenty-five yards of the boche trenches and lie there concealed in the weeds along the lower side of the road. The sergeant and five men were to go on through the wire until they could see the two boche outposts. They were to lie there for an hour waiting for a relief to be made. If it wasn't made within that time they were to crawl along a few yards to the connecting trench, where two of the

122

men were to be left to guard the rear. The other three were to crawl along the trench and get the prisoners. The "covering party" was to remain where it was until the fight started, and then it was to open fire along the enemy trenches in an effort to keep the boche heads below the parapet and to draw the boche fire while the sergeant and his men were bringing back the prisoners.

It looks very simple on paper. But this was a game of life and death. And the chances of all of us returning unscathed were against us. The order read to "bring in prisoners," and prisoners were what Sergeant Robinson was after.

VOLUNTEERS DROP IN.

As we walked down the road from the line of dugouts wherein is stationed battalion headquarters, a silent form would step out from behind a shadow and quietly join us. Before we were out of the headquarters limits three such figures joined us, boys who were not selected to go on the party, but who couldn't bear to remain behind asleep in their bunks while there was a chance of some excitement. No one said a word to them, and no one objected to their coming, for they had the nerve or they wouldn't be there and that's what it took—nerve.

When we reached our final outpost we stopped for a last word of instruction and a load of hand grenades. Each man was traveling light, carrying only such weapons as he could use to advantage. All of us had emptied our pockets of everything we carried, so that if we shouldn't come back, it would be impossible for the boche to identify either us or the units from which we came. Each man wore his full uniform, including a leather vest over his blouse, held close to his body by the heavy army belt. Suspended to this was a wicked looking trench knife on one side, a .45 caliber automatic revolver on the other, a canteen cover filled with various kinds of hand grenades and smoke bombs, round after round of both

revolver and rifle ammunition, and a first aid kit. Only men in the covering party carried rifles, but the others would need their hands for their work. These men carried their bayonets, not fixed to their rifles, but back down through the clips that hold the shoulder sling, for a rifle is a hard thing to get through barbed wire entanglements and a bayonet on the end makes it more difficult. Tied to his breast, like a bib on a child, each man carried his gas mask, and on his head was a steel helmet. Most of the helmets were covered with burlap so that the scratching on the wire and bushes wouldn't give us away. Stuck in the burlap were small branches of pine trees for purposes of camouflage. I, as a non-combatant, dared not carry any arms of any kind, so I took only my alpine stock, or heavy, steel pointed cane. This, and a pair of moleskin gloves to protect my hands as much as possible from the stones and barbed wire, were my only equipment.

TIME TO JOKE A BIT.

As we stood grouped around the sergeant at the outpost there in the moonlight, all the men who were holding the post came up. For they, too, would have to take part in the entertainment. It was their duty to help keep the enemy heads down below the parapet as much as possible.

"Is there any word you fellows want to send home?" some wag asked.

"Your name may be Coffin, but you'll never see one," someone else told Charley Coffin, a son of C. Z. Coffin, secretary of the Retail Merchants' Association in Kansas City.[12]

"Always carry your Bible and your girl's picture over your heart," someone else whispered. "And when it saves your life, tell her about it. That always saves the hero's life in the books, you know," he added.

"Don't start any crap games out there," someone else chipped in. "The colonel won't stand for it."

So it went, for about fifteen minutes. Every one kidding and laughing, all in whispers, for the boche lines were close here. I don't think the joking was necessary to keep up their spirits. For my part, I had an empty sort of sensation in my stomach, the kind you get when an elevator in one of the downtown office buildings drops five or six stories without stopping, only more so. If anyone was nervous or afraid, he didn't show it.

SERGEANT'S PLEASANT WORDS.

"We are all coming back," the sergeant added after giving his final instructions. "Some of us may be dead or wounded, but no one will be left behind. Now is there anyone who doesn't want to go?"

Silence.

"Any questions?" he asked. Again silence.

Then.

"Follow me."

And we were off.

First, there was the sergeant, Albert E. Robinson, an illustrator for a Kansas City lithographing company;[13] behind him was Corp. Kamp Oliver, from the stock yards,[14] then Odo Van Brunt, an 18 year-old schoolboy from the Kansas side, and all steel nerves;[15] next was William J. Nevins[16] and Sidney Rice, also from Kansas City;[17] then myself; Sergt Henry H. ("Chick") Hoover, from the business department of *The Star*;[18] Privates Ralph Charles[19] and Charles W[esley] Coffin[20] were next; then came Sergt. Joseph Roche, a former railroad clerk back home.[21] Sergt. Jack Pride, a clothing salesman,[22] and Corp. Jack Helmick.[23] Some place in the line was Private John Kelly, known sometimes as "Long John" because he is long and slim. "Long John" was the oldest one of the outfit for he is in his thirties, and a Missouri farmer. But he is one

of "the boys" because he has plenty of nerve, is cool-headed and a crack shot. "Long John" can always be found up in front.[24]

CRAWLED OUT ON STOMACHS.

The sergeant led the way down a small trench that connected the outpost with a night position. From there we crawled out under the wire, chicken wire, barbed wire and every other kind of wire. Every man was flat on his stomach, crawling slowly, quietly, but surely. We were on the side of a hill, below a road that led directly to the enemy lines, and the ground was covered with weeds, underbrush, prickly berry bushes, shell holes and wire. We had to move with the greatest caution, and test out each piece of ground before we let down our weight. The snap of a twig might give us away. Now and then we would strike a patch of ground without any covering, where the moonlight seemed to spread its beams like an arc light. Here we had to just barely move, inch by inch.

For some reason the perspiration seemed to break out on me, and it was rolling in streams down my face, while little rivulets of water seemed to find their way down my spine. I have worked in the Kansas harvest fields in summer time when we had to rub axle grease across our foreheads to keep the salty perspiration from running down into our eyes, but it didn't run any faster than it did last night, and the mountain air was extremely chilly.

FORTY-FIVE MINUTES, TWO HUNDRED YARDS.

Every few minutes the sergeant would stop and hold up his hand. This meant for us all to stop, to give those in the rear a chance to catch up and to rest a moment while we listened for a possible enemy ambush. It took us twenty minutes to crawl through our own wire, and forty-five minutes to reach the edge of the enemy wire, although it was only two hundred yards from the point where we started.

Here the sergeant and his four men were to leave us. That left Sergeant Hoover, a volunteer, and me, a spectator, right up in front. The rest were strung along behind us. We were to wait without making a sound until the show started and the sergeant and his men were on the way back. Then we were to open up and give the boche all we had, so as to cover the sergeant and his men in their "get-away." It reads easily, doesn't it? It sounds like a simple matter, doesn't it? Yes, and it was. It meant that the flash of our guns was to be the boche target, and there was nothing between us and the boche lines except a few blades of grass and some bushes. The prisoners were to be turned over to two of the men, who would take them back through our wire, while the rest of us would give battle to the enemy and cover the slow retreat.

Without a word, the sergeant and his men left us. Quietly, slowly, without making a sound, they crawled away on their stomachs. The moon, instead of going down seemed to grow brighter. The stars that before seemed to be slightly dimmed by the brilliancy of the moon now stood out, each and every one of them like an undimmed headlight on a big motor car. I rolled over on my back and lay there, looking at them. Every star seemed to point a finger of light at me and say:

"There he is. Down in those weeds. Now you can pick him off."

SOMEONE COUGHED.

Some place down the line someone had to cough. He stuffed his handkerchief down his throat to smother it, yet to me it sounded like an explosion in a munitions factory. We were all on the alert, but not a sound followed.

Quiet reigned again. It was so still that the silence was oppressive. Now and then a battery on either side would send over a shell singing and humming its way above us. Down the valley some

machine gunner would let go a strip just to see if his gun was working. The sharp crack of some frightened sentry's rifle would snap out through the air like the crack of a mule skinner's whip.[25] There was nothing for us to do except to wait, and think, and wonder, for the sergeant said it would be at least an hour and maybe longer, before they attacked the post.

Dinner was just about over, back home, as I figured the time from my watch. I could see the children leaving the table, washing their little hands at the kitchen sink and running out into the yard to play with the neighbor children. I could see the family sitting out in the porch swing, sprinkling the lawn from the porch, as we used to do, and then enjoying the cool, damp air that arose from the moist grass, and I wondered if they were thinking of me as I was thinking of them.

I could see the young men and their sweethearts walking down the sidewalk to the car line, ready for an evening at the park. I could see the men dressed in their Palm Beach suits and their straw hats, and their white canvas shoes, and I smiled as I shuddered from the cold perspiration that had dried on my body, and thought of the steel hats these boys here wore, the hobnailed shoes, the woolen socks, the heavy woolen clothing and the wool-lined leather vest and gas mask. I wondered if those boys at home, during their evening's enjoyment, were thinking of the boys in the front lines "Somewhere in France" and of those who were lying out in No Man's Land as we were, and of those who were pumping the big guns, and the machine guns, and the automatic rifles along the lines, boys who worked with never a thought of life or death or rest or food but who fought and died because it was for their country.

AND IT WAS LIKE IT, AFTER ALL.

I thought of a full-page Red Cross ad that I read in The Star one day during one of the campaigns for funds and of how the writer

pictured No Man's Land with a mother's son lying out there bleeding and dying for his country, and how the Red Cross needed money to help him. I remembered how we had all congratulated the writer, for the "punch" he put in the ad, for it all arose from his imagination, he being a good ad writer. And I thought after all how clearly he penned the picture, for here we were, and before the night was over some one of us might be lying here, bleeding and dying.

I thought of some young men I knew back home, plumbers and machinists, who were making a hundred dollars a week when I saw them last, because of the war emergency, and I thought of the high class men who were lying out there ready to die and give up their lives for $33 a month, less insurance, allotments and Liberty bond payments. And I knew right away to which class I would hitch my star if it ever came my turn to choose.

AND FELL ASLEEP OUT THERE.

I wondered if the same number of lights were burning at Electric Park,[26] and if the same concessions were there this year, and if Joe Donnegan had closed the "Edwards" for the summer as he usually did.[27] And then—merciful heavens!—I fell asleep, but I didn't know it until I heard a twig snap with a noise that resembled a cannon shot.

"It's all over now," I thought as I turned over and dug my toes in the ground, ready to leave.

A LOUD EXPLOSION.

It seemed an hour, but it was only a second or two until a loud explosion occurred, a hand grenade thrown from the boche post. I could hear the "safeties" click as the boys down the line made ready with their automatics and rifles. It was so quiet that you could have heard a fly walk on a velvet carpet. I forgot about being cold and stiff.

Never a sound followed. What happened? Had one of the boys let his weight down on a twig and broken it and aroused Fritz? Had any of them been killed? Were they through the wire? Was the fight about to start? Those and a thousand other queries chased each other through my head in less time than it takes to turn around. The others were thinking the same things, but we were not to have them answered until later.

ANOTHER HAND GRENADE.

Nothing followed the report of the grenade, and in a few minutes we all settled down into the little holes our bodies had made in the earth and rocks. I looked at my watch. The appointed hour was up. Yet no action. So I again resumed my dreaming, and again I dozed off. A sharp crack, like the explosion of a French 155 going off right over your head when you weren't expecting it, brought me back in a hurry.[28] It was another hand grenade thrown from the enemy line. Again my thoughts jumped to the sergeant and his little squad. In times like these thoughts have a habit of flitting through your mind faster than chain lightning and just as clear and distinct. I could somehow feel the tenseness in the atmosphere, as I knew that every man lying there in No Man's Land was ready to kill or be killed, as the case might be, without a whimper.

But once more it appeared to be a false alarm, a result of Fritz's nervousness, for no sound followed the explosion. I looked at my watch. It was 2 o'clock, thirty minutes late for the show to begin.

Once more we settled down into the depressions we had created in the ground, but this time on the alert, every nerve alive, for we felt, somehow, that something would follow shortly. And it did.

A FLASH OF FLAME.

It sounded like tons and tons of earth and rock sliding down the mountainside. I could hear the boys moving into position. For a second there wasn't a sound. It seemed like an hour. Then three explosions occurred, one right after the other. Hand grenades. A sharp whistle pierced the air. It was time for us to open up!

Jerry too thought it was time for him to do the same. The side of the mountain seemed to be one flash of fire. Bullets were spattering all about us. Hand grenades were popping off in front of us, each sounding as loud as a cannon explosion. Jerry was sending up rocket after rocket that made No Man's Land as light as day. You could pick out the automatic rifles along the enemy trenches by their continuous flash of fire and the pouring noise they made.

In front of me "Chick" Hoover was on one knee, a grenade in his left hand and his automatic resting on his left wrist blazing away. Behind me I could see the flash of the automatics and the rifles as the rest of the "covering party" opened up on Fritz. Some of them were lying on their stomachs, shooting. Others were resting on one knee, pumping lead and steel as fast as their guns would work. It was just as light, thanks to Fritz's flares, as it is at Twelfth and Grand any bright sunny day at noon.[29]

"What are you shooting at?" I called to "Chick."

DRAWING THEIR FIRE.

"I'm shooting at their flashes and trying to draw their fire," he answered, as he gave his automatic a little more pressure and released a steady flow of steel and fire.

"You sure are doing it," I told him. "They're mowing down the weeds here."

A flaming rocket dropped right beside me, and I flopped in the weeds and dirt like an ostrich, face down. I don't know why, but instinctively when in a tight place I always duck my head. I was

sure my time had come. My mind was a blank. I wasn't thinking of anything. I was just waiting for the "ping" of a bullet. The light burned only an instant, but to me it seemed a lifetime. It went out. I sat up again.

The old Indian fighters and the renowned bandits of the past generation never had anything on this, I thought. Here was a bunch of city boys, well cared for, well educated, most of them accustomed to the good things of life out here in No Man's Land, under the German wire pumping steel at the enemy to draw the enemy's fire upon them so that their comrades might have a better chance to escape. How my fingers itched for a rifle or an automatic so that I could take part. But I was a non-combatant.

It takes time to read this, and longer to write it. But it all happened in just about two minutes, although I didn't time it by the watch. Many things can happen in an instant at a time like this.

THE SERGEANT GETS BACK.

"Are you men ready to follow me down the road?"

I looked up, for I had been fascinated by the flash form the boche rifles and automatics. It was Sergeant Robinson standing there in the light of the moon and the flares, his automatic in one hand and a grenade in the other.

"Where are the prisoners?" "Chick" asked, as I saw him slip another clip into his automatic.

"Hit the road, men, and we'll cover your retreat," the sergeant called, failing to answer the question.

Some of the firing ceased as the men reached the road, but it wasn't noticeable. I hadn't taken more than three steps until I stumbled and fell, my "tin" hat going one direction and my stick another. Looking back I saw a rifle grenade burst in the air, and one of the boys fall on his face. One of them gone, I thought. I gathered up my stick and hat and wanted to go back, but my legs wouldn't

obey the impulse. They insisted on going the other direction. A flare went up and down. I fell again. Behind me two of the boys were coming through the light, one dragging the other hatless and gun-less by the hand. I saw "Chick" and the sergeant, each on one knee, pouring steel at Fritz.

The fight had spread by this time. I seemed to see flashes from guns coming from every direction. I mistook the explosion of hand grenades for the shooting of flares and every time I heard one explode I dropped and lay still for an instant. Once I passed a boy, his rifle barrel resting in the hollow of his hand, and his elbows on one knee pumping steel towards Fritz. Another time I jumped over one sitting in my path, who was fixing his legging, which had become unwrapped.[30] I hit some barbed wire and went down again. I wondered where "Chick" and the sergeant were, but I didn't have time to go back. I had my helmet clutched tightly in one hand and my stick in the other, because I didn't want to lose them. I must have fallen forty times, I couldn't count them, but, from what I can recall, I was up and down, up and down, all the time. My legs, somehow, wouldn't hold me up all the time. Usually, I am sure-footed, but I wasn't then. I remember wondering why I couldn't keep my feet better, for in the old days, many a time I ran the gauntlet on the football field when it took a mighty good tackler to throw me. But my legs wouldn't. They just wouldn't stand up.

CLEARED THE FIRST WIRE.

I saw the form of one of the boys stretched full length under some barbed wire. Ordinarily I am not much on the high jump, but I cleared that wire and the boy underneath it.

I could hear the bullets whizzing all about me. I could hear them platter as they struck ahead of me and around me. I could distinguish the bullets of the automatics from the slower fire of the rifles. I could hear the explosions that I thought were the flares

going up but this affected me no more. I had hit our wire, and I threw caution to the winds. Flares and lights bothered me no more, even if I made an excellent target for Fritz I wasn't thinking about that. I thought about it, but I thought also of our sheltering trench that stretched away behind the wire, and I wanted to be there, there where I could get behind something and rest a moment and get my breath. I was after shelter. I wanted to get away from those bullets and those flares, and I was headed along the shortest route.

I was on the pinnacle of a barb wire entanglement, probably five feet high, when something seemed to burst above my head. I'll never know what it was. I pitched forward, head foremost, on the stone and wire below, one foot caught above me in the wire. The strap on my wrist watch caught on something and tore loose. I couldn't lose my watch, for it was a Christmas present, so I looked until I found it, thanks to Fritz's flares.

How I ever got over the fifteen yards of wire in front of our lines I'll never know. But I did. In the daytime, a hundred miles back of the lines, I would never attempt it. But somehow, I got over.

INTO THE OUTPOST.

Ahead of me I saw our first outpost, a night position. There was a slit in it from four to eight inches wide in places where the night sentries looked out into No Man's Land. Someone was there ahead of me. And he wouldn't move. I pushed him to one side and discovered what was the matter. One of the boys had gotten all the way through, with the exception of one leg. His legging had become unraveled and was caught in the wire outside, and there he hung, one leg in No Man's Land and the rest of his body dangling inside the post. It took only a moment for me to tear the legging loose and his leg disappeared.

I have to laugh, now, after it is over, at what happened next. Whoever it was that I pushed to one side popped up again.

"Go ahead," he told me, "and I'll follow."

"No, you go," I told him, and stepped aside.

He wriggled through the hole, and I went after him. I don't remember how I did it, and I don't ever remember touching anything. I remember looking up and seeing a figure standing in the corner out of the way, smiling, and I recalled that "Sonny," an Indian from Pottawatomie County, Kansas, was on duty. But I didn't stop to speak to him. I was in a hurry. And "Sonny," I knew, was anxious to "open up" himself.

I found myself in a trench, the same one through which we passed so quietly and stealthily when we were outward bound. I didn't stop to pick my steps. I knew that at the end of the trench and around the corner was a barricade of stones and 15-inch logs and sandbags, and I wanted to get behind these so I could rest and catch my breath, and get away from those everlasting flares and bullets.

ALL THE PARTY GETS IN.

At last I got there and planted myself on a rock, and gave way to the fit of coughing while the boys came rushing in. I heard Sergeant Robinson speak to the sergeant in charge and direct his fire. My coughing ceased and I rolled the cigarette that I had been waiting to smoke. The sergeant was checking over his men. "Chick" was gone. The sergeant disappeared. He returned in a moment with "Chick," who had remained behind to shoot all the ammunition he could borrow.

"They're all in, boys. Cut 'er loose," the sergeant ordered.

And they did. Every man who could get to the parapet opened up with his rifle. The rifle grenades were snapping like cap pistols. Some of the boys were heaving grenades over the line, for someone started the report that Fritz was coming over after us. The

bullets were whining and dropping and singing all about us, but no one except me thought of them. The rest were too busy sending over some of our own.

"Gimme some more ammunition," I can remember hearing some farmer boy from Southern Missouri say, in his slow, drawling speech. "I kain't shoot without no shells."

I walked around behind the parapet to see what they were doing. When the position was built, holes had been left through which the men were to shoot. But the holes were too small. Every man who could squeeze up on the parapet was there working his rifle or automatic for all it was worth, and not coming down until his ammunition was exhausted when someone else squeezed into his place.

A TRIBUTE TO CITY BOYS.

It flashed through my mind that the pioneers of America who lived inside their stockades and fought off the Indians for their right to the land didn't have anything on these city-bred youngsters, who were raised on telephones, and electric lights, and street cars, and motor cars, and ice cream sodas, and silk socks. Every one of them could fight just like his forefathers did, and every one of them was willing to die, that the peoples of the earth might live free and untrammeled by Prussian Kultur and Kaiserism.[31]

Just how long it all lasted, I cannot say. It died down quietly, as the ammunition belts were exhausted.

"Hold up for a few minutes until we see what's going on," I heard the sergeant order.

Fritz, it seemed, had enough, for he immediately quieted down, and we all gathered around the sergeant to see what became of the prisoners.

"The wire was heavier than we thought," the sergeant told us. "Jerry (he's either Jerry or Fritz to our boys) evidently heard us

as we were crawling through, for he threw two grenades at us. The first one stuck a tree, snapped a twig and then exploded, pretty close to us. We didn't move an inch. A little later we heard them moving about and whispering. One of them whistled, and over came another grenade. This was so close that it seemed to raise us off the ground. I figured Jerry knew we were there, so pretty soon we all let fly with a grenade, and then jumped down the hill for our get-away. You all know the rest. I'm sorry we didn't get any prisoners, but we will the next time."

He passed his hand across the back of his neck and brought it away covered with blood

"It's nothing, just a scratch," he remarked.

It wasn't much more, although it bled profusely. A piece of a grenade or a piece of an explosive bullet had cut a small gash in his scalp. That was the worst wound any of us suffered, except scratches and cuts from the barbed wire, stones, and raspberry bushes, and torn clothing. The raid was over. It had failed in its object, that of taking prisoners. But every raid isn't always a success.

The following patrol order was issued for tonight:

The following five patrols are authorized for the night of August___in sector___.

All men in the frontline trenches will be notified of these patrols, the time and place of leaving, the place and probable line of return, including route to be taken.

Patrol No 1: Strength____. Leader:_____.

Mission: To go through enemy wire in the vicinity of _____ and capture prisoners.

The others read about the same. I'm wondering, as I finish this article by candlelight, whether they will all return, or whether they will be as fortunate as we were, even if we didn't bring back any prisoners. And what are they thinking about, as they are

crawling across No Man's Land towards the enemy wire, for there's where they are now at 11 o'clock, with the moon shining down on their prostrate forms.

O. P. H.[32]

Chapter 7: At St. Mihiel and in the Argonne
—September 1918

Up to this point in the war, many American units were technically still in training. State-side in the cantonments, the Americans had benefited from the instruction of French officers who had been detailed from the Zone of the Armies in France to the training camps in America to assist with first-hand knowledge of conditions at the front. Once in France, American units continued their training, taking up positions along with the French in "quiet" sectors of the trench line, where the action was not so intense. As the Americans gained experience and confidence, they gradually replaced the French units and took over their sectors. All along, General Pershing had been adamant about keeping American units intact rather than allowing them to be broken up to replace troops in British and French units depleted by combat, as the other Allies had hoped the Americans would be used. Instead, the Americans would operate as intact units, replacing positions formerly held by their Allies and in that way freeing up those Allied units to supply the necessary replacements in their own ranks.

By September 1918, General Pershing was ready to test American capability and to demonstrate to the other Allies that Americans could perform effectively in combat as an independent force. September witnessed the start of two major battles fought by U.S. troops during the Great War: The Battle of St. Mihiel in the middle of the month (September 12-16, 1918) demonstrated that Americans could operate as an intact army, and the Battle of the Meuse-Argonne beginning at the end of the month (September 26, 1918 to November 11, 1918) proved the point definitively. In the Meuse-Argonne, the American Army became a critical factor, if not *the* critical factor, in the offensive that brought about the Armistice and a cessation of fighting for another twenty years.[1]

Higgins witnessed and wrote about both battles,[2] but he began the month of September by describing in a letter to his wife, Elizabeth, a visit he had made to the Cathedral in Rheims. "It is all shot to pieces," he wrote. "I can easily understand how it was known as the most wonderful & beautiful cathedral of the world. It certainly was a [marvel]. It, however, is probably beyond repairs now." Higgins went on to describe the city itself,

comparing it in size to Kansas City, Kansas, where he and Elizabeth had grown up. "Rheims was a wonderful city, larger than K.C.K., and there isn't a house or building in the entire city that hasn't been hit. Their battle lines are just outside of Rheims, and they were being shelled. The town also was being shelled. I don't know what for, because there is nothing left but a few soldiers, and they live in cellars."

That same day, Sunday, September 1st, Higgins sent to the *Star* a picture he had taken of some Kansas City boys, not identified by unit but most likely from the 129th Field Artillery, eating dinner along the side of a road in a French village in the Vosges Mountains. Two days later, on Tuesday, September 3, Higgins wrote about Patrick F. Fleming, a private in the 138th Infantry, who, on July 12, near Oderon in the Alsace, stepped on a live grenade in an attempt to save the lives of the four soldiers who were with him in the trench. His leg had to be amputated, but Private Fleming lived another month until gangrene set in and he died. A doctor in the

field hospital where Private Fleming was taken had been a former reporter on the *Star,* and Higgins got the rest of the story from him.[3]

By Thursday, September 5th, Higgins was back with Kansas City's 140th Infantry and writing about a boche pack mule captured by the French and then sold to the Americans for a franc because the French couldn't do anything with him. Three of the boys in the 140th, however, knew how to handle Missouri mules and were able to tame their German cousin and put him to work.

In the next week, the men of the 89th Division, who had trained at Camp Funston, Kansas, set out to tame the mule's original owners, the boche, in whose honor the boys of the 140th had given the mule the nickname of "Pretzel." To begin taming the hard-headed boche, the 89th was moving into position for the Battle of St. Mihiel. On September 10, 1918, 89th Division headquarters moved from Lucey, Meurthe et Moselle, to a dugout railroad in Noviant, and then on to Flirey on the 12th and to Euvezin on the 14th.[4] During the four days of the battle, the 89th captured—by official count—18 officers and 2,209 men.[5]

Higgins followed the 89th's moves, and on Sunday, September 15, in an article delayed by the censor, OPH wrote about the advance, reporting the prisoner count at 2,248. In articles written on September 19, 20, and 21, Higgins continued to detail the advance and the capture of prisoners, provisions, equipment and weapons. Embedded now with the 89th Division's "All Kansas" 353rd Infantry, OPH reported how Sergeant Clyde G. Latchem from Ottawa, Kansas, proposed chaining a thirty-seven pound Vickers machine gun to the backs of volunteers to speed up the advance and keep pace with the infantry. OPH told how Harry J. Adams, first sergeant of Company K, 353th Infantry, captured over three hundred German prisoners with one empty pistol,[6] and how George L. Berkstresser of Company H[7], charged a machine gun nest head on, "killed three boches with his rifle, threw the machine gun into the

open, and then blew up the emplacement with boche hand grenades."[8] In his reports from St. Mihiel, OPH included stories of over twenty-seven other men, who performed extraordinary service during the battle.

By Tuesday, September 24, Higgins, along with other war correspondents, must have suspected that something bigger than St. Mihiel was in the works. Their press headquarters was to be moved the next day from the Hotel Angleterre in Nancy to a small store along a cobbled street in the town of Bar-le-Duc. Meanwhile, in anticipation, Higgins, Clare Kenamore of the *St. Louis Post-Dispatch*, and a representative of *Colliers*, likely Higgins's chum, William Slavens McNutt, visited with the commander of the 35th Division, General William M. Wright, about some feature work they wanted to do in the Division. "I was glad to see them," General Wright said.[9] But the General had other matters on his mind. Early in the morning of Thursday, September 26, the big offensive known as the Battle of the Meuse-Argonne began, and the Missouri and Kansas units of the 35th Division, which had been the subjects of so much of OPH's work, were in the thick of it.

Emmet Crozier describes what happened in Bar-le-Duc the night before the battle. The list of correspondents, who had gathered in the room of the vacated store, represented a cross-section of American newspapers and were the best in the business. "Blackout blankets hung at doors and windows," said Crozier. "The only illumination came from oil lamps and candles. There may have been as many as fifty newsmen crowded in the small room. Many were new. Major James had been succeeded as Chief Field Press Officer by a genial, slow-spoken sports writer form the *New York Evening World*, Major Bozeman Bulger. Out of his military experience with the New York National Guard, Bulger had conducted an officer's training school for newspapermen early in 1917 in the old 69th Regiment Armory. Now, after service with the

79th Division, he had been transferred to G-2-D and was to carry on, with Gerald Morgan's help, the work begun by Frederick Palmer fifteen months before. Damon Runyon, one of Hearst's sports writers, was there for Universal Service. Newly accredited reporters included Bernard J. O'Donnell of the *Cincinnati Enquirer*; Guy C. Hickok of the *Brooklyn Eagle*; two men from Pittsburgh, George S. Applegarth of *The Post* and Charles J. Doyle of the *Gazette Times*. Among the dozen 'visiting' correspondents (white brassards and red C's) who crowded around the walls were two old-timers, Frank Sibley of the Boston Globe and Otto Higgins of the *Kansas City Star*. Walter S. Ball was there for the *Providence Journal*. The 1917 veterans formed a little group apart—Lincoln Eyre, Tom Johnson, Junius Wood, Herb Corey, Ray Carroll, and Wilbur Forrest."[10]

Facing the group, Major General Fox Connor delivered a briefing about the impending battle of the Meuse-Argonne, pointing out the objective—the railhead at Sedan—on a map that covered the whole front wall, reviewing the obstacles the men would face and expressing the concern of General Pershing and the War Department about public opinion over the stalemate in the war up to that point, after so many men and so much materiel had been expended in the effort. General Connor worried about the public reaction to the cost in lives that the impending battle would bring the next day.

"'Well, General,' Junius Wood said after an interval of silence, 'I think the people back home are just beginning to find out there is a war.'"[11]

If the home front was not so fully informed that it couldn't appreciate the cost, the lack of information up to that point couldn't be laid at the feet of the war correspondents, who had made every attempt to report on the war and were ready to continue doing so. "At daybreak most of the correspondents climbed in their cars and made their way northward from Bar-le-Duc to see the surge of

American forces into the battle that might decide the war. It was a long, exhausting day. By noon, they knew that the German front line had broken and the attack was gaining momentum.

They also were aware that the operation was too big for personal experience. There was not much they could see that made sense. About all they could do was to record scenes of the confused rear areas: prisoners straggling back, ambulances and Army trucks crawling along the roads, artillery moving up. Nearly all the newspapermen encountered some significant portents of the battle raging up ahead, but no one had it in perspective. They were glad to get back to Bar-le-Duc late in the afternoon to find out what had happened."[12]

What had happened constituted a significant break in the fighting lines. Northwest of Verdun, the 1st Army attacked the enemy on a front of 20 miles and penetrated lines to an average of 7 miles. Pennsylvania, Kansas, and Missouri troops serving in Major General Hunter Liggett's corps stormed Varennes, Montblainville, Vauquois and Cheppy after stubborn resistance.[13] OPH observed the action and wrote about the misery and suffering of the 35th Division, but, perhaps in reference to Junius Wood's earlier comment to General Connor, couldn't get details published until a month later.

As the *Star* acknowledged to its readers as late as November 1st, "Only the barest of facts of that great struggle have seeped through the fingers of the military censors, and so the casualties suffered there have not appeared in the official lists. Incomplete cable dispatches received shortly after the stirring days of the last week of September, when the 35th was going up the Aire River on the east side of the Argonne Forest told of terrific fighting and heavy losses and the capture of Cheppy, Exermont, Very, Charpentry and Vauquois Hill, but names and units were rigidly cut out by the censor."[14]

On Monday, September 30, OPH wrote a story describing action in the Meuse-Argonne, but the story was not published until a month later. Even so, prohibited as he was from identifying the 140th Infantry and the 129th Field Artillery by name, OPH was still able to let his readers know who his subjects were. Everyone in Kansas City knew that "the Kansas City infantry" referred to the 140th and "the Kansas City artillery" referred to the 129th. "The Kansas City regiment of infantry has more than lived up to the highest expectations," OPH wrote. "The first day it didn't do much fighting but trailed along after another regiment. But when the going became heavy, the men swung right into line. It was this regiment that had to bear the brunt of the heavy boche counter attack, and it was the Kansas City regiment that held its ground and forced the boche back.

"And it was a regiment of artillery from Kansas City that helped them do it. Yesterday afternoon, when the going became so rough the men had to dig in until our own artillery cleaned the way for them a little, I visited the Kansas City outfit," Higgins wrote. "I found the men and the guns all out in the open, not a bit of shelter. Every one of the batteries was working full blast, and the noise was so terrific it was impossible to make one's voice audible. The ammunition dumps were full, and the men were throwing in shells and shooting them just as fast as the guns would work. There was no thought of danger any place."[15]

OPH closed the article with the stories of two men who also "had no thought of danger." Higgins came across Henry J. Allen, the 35th Division's YMCA Director, who had just been nominated for governor of Kansas but was now slogging through the mud of the Argonne. Because Allen was a non-combatant, OPH could mention him by name, but he could not name the 68-year-old major whose son had just been killed in the fight. Even so, everyone in

Kansas City would know the reference; OPH saw to that by the detailed description he provided.

"At the headquarters of the troops, yesterday morning, I found a major. He was a lawyer in St. Joseph, Mo, before war was declared, and for thirty-seven years he had been a member of the Missouri Guard. He is now 68 years old and, because of his age, he was relieved of his command and placed in charge of the postal work for the troops. His son, a lieutenant of infantry, had been killed the day before in the advance. With tears running down his wrinkled cheeks, the father had pleaded with the commanding general to be assigned to command a battalion, that he might lead them against the boche to avenge the death of his son. "The boche can't kill my boy and get away with it," the major told Higgins. "They will have to pay for it in blood, and while I am at it, I will collect for some of the other boys."[16] Major Clay C. MacDonald got his wish, and Kansas City got the story.[17]

"O.P.H." WITH THE 89TH

FIRST DIRECT WORD FROM THE MEN
WHO TRAINED AT FUNSTON.

The Fighting in the Vosges Mountains
Easy Beside the Strenuous Days
In the St. Mihiel Sector—
National Army Men Like It.

The Star received a letter today from "O. P. H." (O. P. Higgins), The Star's correspondent with the home boys in France, in which he says he has been with the 89th Division, which trained at Camp Funston. Evidently, the 164th Field Artillery Brigade, when this letter was written, had joined the 89th after its period of artillery training on the western coast of France. The American drive which wiped out the St. Mihiel sector began September 12 and lasted two days. This letter is dated September 23. As this is the first word that has come directly from the 89th, The Star herewith prints Mr. Higgins's letter.

They don't do anything except fight in this sector. It is the busiest place I ever saw. There is more artillery banging loose around here every day than there was in the Vosges in a week. I'm up here in the St. Mihiel sector living with the old Camp Funston men, and they surely are hitting her up. The first pop out of the box they knocked 'em cold. Took an interesting part in the fracas and came through with flying colors.

It is a regular war up here. Down in the Vosges, if we pulled off a raid once in six weeks we thought we were doing wonders. Up here there is something doing every night, or we don't feel at home. I haven't had a full night's sleep since I have been in the line. It's artillery every night and numerous gas alarms. It's the gas that puts

147

the fear of God in your heart. The artillery shells singing past your window or overhead or dropping in front of you only make the cold chills run up and down your back. When I get back to Paris I am going to lie in bed for two days, have all my meals brought to me and sleep and just rest and sleep and rest. If you can get four hours sleep in succession here you are doing well. I haven't had anything off except my shoes for about a week.

I am living with Colonel Brown[18] and Major Wilder[19], in quarters formerly occupied by a German major. We have two wonderful rooms, even though they are faced towards the boche artillery. We have plenty of boche cigarettes, plenty of boche matches and a lot of boche liquor. I don't know what it is. Some tastes like hair tonic and some like Tabasco sauce, but the rest is fair.

Had lunch with Ray Palmer, artillery lieutenant, the other day at his headquarters.[20] Ray is having a pretty tough time, even if he is on the staff. Being the junior officer of the bunch means that he has to do everything the rest of them don't care to do and it keeps him busy early and late. He is looking fine and feeling fine, although he was in the hospital about two weeks.

Had dinner with Doctor Cavaness the other night.[21] He organized the ambulance company in Kansas City that Montgomery Wright of *The Star's* staff joined. Wright was ill that night, the first time he has been ill since joining the army.[22] Arthur Duncan, another one of our boys, is in the same town.[23] I was Duncan's guest of honor the other night and slept with him. Being the guest of honor, it was my privilege to sleep in a little bunk while the rest of the boys slept on the floor. All the boys are having a great time, and wouldn't quit for the world. The boches are shelling us tonight, but I don't think any of our boys have been hurt. The shelling is so fierce that our shanty is constantly rocking, and the windows rattling. Jerry is sending over a lot of big fellows, and I know we

won't get much sleep. It is about our turn, anyhow. They have shelled every other place in the area but ours, and our time is coming.

I went down into one of the towns we captured the other afternoon to take some pictures, when Jerry opened up with big fellows. I fell into a basement, and then when it slacked up I high stepped it for a valley. I am getting so I can run. I take setting up exercises every day just to keep in condition. I certainly can cover ground when I am put to it.

FUNSTON MUD WAS NOTHING.

We have been having wonderful weather the last two weeks. It rains every day or every night and the only time my feet have been dry is when I wipe them off with a towel. Mud! I used to think we had mud out at Funston, but here it is nothing but mud. You don't mind it, however, as long as you can find a dry place in which to sleep. You can't find many safe spots here.

I certainly am a lucky dog. When I get fed up on the mud and the rain and the bully beef and the shells—two big ones just exploded up the hill—I go back to Paris and crawl in between the sheets and eat regular food. But the rest of the poor boys, they have to stick it out, day in and day out. There isn't anything in the world too good for the worst of them. Every one of them deserves a medal for being here, because this is War, War with a capital "W." The Missouri and Kansas boys (the 35th Division) are getting into it also. They went up around Verdun about the same time I came into this sector and they, too, will get a touch of high life.[24]

Chapter 8: With the 35th—October 1918

"'We were advancing along a road,' a wounded lieutenant told Higgins, "'when someone called the major. We crawled over to the roadside, and, lying there in a shell hole, muddied from water and blood, was one of the boys. Both legs had been mangled by a shell, and one arm was gone. A faint smile was on his face as he held out his one hand to shake with the major.

"'Just tell them that you saw me and that I 'died game.'"

"'That was all he said. He knew he was dying. The major gave him a drink and a cigarette, and we went on. Two days later the major himself was killed.'"[1]

This is just one of nearly fifty stories OPH reported in the seven articles he wrote during the month following the start of the Battle of the Meuse-Argonne. Like this story, many of the other stories end with an ironic twist, and many, like this one, involve a soldier's dying request to tell his story. The marvel is that the story lives on, often the only thing that does remain, but so enduring that it lives through three iterations until it reaches the ear of the war correspondent who can then relay it home. The dying man tells the major, whose lieutenant tells OPH after the major himself dies.

Sometimes the subject of the story does survive, as in the case of Private Thomas B. Kelly, Company L, 140th Infantry, but the subject refuses to tell his story. Instead, he tells everyone else's stories, while the others tell his. "The stories about the things that happened to Kelly do not come from him," OPH wrote on October 4, northwest of Verdun. "Kelly wants to forget them, if forgetting is possible. But the other boys never tire of telling about the things Kelly did and the things that happened to Kelly." OPH narrates what he has heard from the boys about Kelly and then finally meets up with Kelly himself. "When I found Kelly, to ask him about all the things I heard he had gone through, I found him sitting on a hillside in the wet grass, toasting his naked feet on a small bonfire

he had built. He wouldn't talk about what he had done, but insisted upon telling me about friends of mine in whom he knew I was interested. 'The Kaiser hasn't got around to make the shell that carries my number as yet,' was all he would say about himself."[2]

Sometimes the story is re-told so often from so many different sources, that it gains in verisimilitude as it goes, until, after a facetious turn of phrase, the reader questions whether OPH isn't telling a story on himself. This may well be the case with OPH's

October 22nd story of Sid Houston, whom Higgins had known from *The Star*, and who had transferred from the medical corps to a machine gun company "in order to see more action," as OPH put it.

"'Did you hear about Sid?'" Major W. L. Gist, director of the ambulance companies,[3] asked OPH. "'Sid is gone,'" the Major continued. "'One of the boys told me he saw a figure lying in a shell hole that looked like Sid, and when he rolled him over and looked at his identification tag, it read 'Sid Houston.' He was hit by a piece of shrapnel."

Sid Houston, "next" in his first chance for a shave in seven days.[4]

The story gains in credibility. "A few minutes later I met one of the boys coming in wounded," Higgins continued. "He, too, told me about Sid. It seemed every other fellow I met told me about Sid and his quick finish. Several said they had seen the body, and others had first-hand information. I couldn't help but think of the

places in Kansas City where Sid and I used to drop in occasionally for a cup of tea and a cookie or two, and wondered how it would feel to visit them without Sid"—and then OPH adds a phrase that prompts the reader to question the complete probity of the correspondent's narrative—"*if the prohibitory law didn't close them before I get back.*" [5]

But Higgins continues unabated. "We sat at the roadside with the shells whistling overhead, and talked about Sid, his vices and his virtues."

A little later, OPH, the Major, "along with some two hundred other soldiers," shared some chicken wire in a boche dugout, while artillery fire continued throughout the night. It was only after breakfast the next day, while the Major was shaving, standing in mud along the roadside, that he and OPH heard a familiar voice.

"'Have you got anything to eat? I haven't had a bite for a week, and I'm starved. Who the hell said I was dead? I'm the hungriest dead man you ever saw. Gimme something to eat, quick. I'm starved.'"

"It was Sid," says OPH. "He had heard he was dead and came back to deny indignantly the assertion, to get something to eat, and to shave. It was his first opportunity to shave. Yes, he borrowed the Major's razor, and Sid is a buck private. But then Sid is no respecter of rank when it comes to borrowing."[6]

Of course, Private Sid Houston and Major W. L. Gist are perfectly real, and OPH is not at all facetious when he relates what happened.[7] Whether it was OPH himself who was strung along, however, is the whole other story.

Higgins' sense of humor comes into play throughout his writing, but was especially at work on October 24, 1918, when he visited Battery A. of the 129th Field Artillery. "The boys sometimes do other kinds of shooting besides shooting artillery," OPH confides. "I bumped into a 'crap' game, going full swing right

under the cannon's mouth. It was a bright, clear afternoon and the artillerymen were making the best of it while waiting for orders.

"I stood there watching the boys a while, when things began to happen. It all started when some little cannoneer kneeling in the background leaped out of obscurity and ran a five franc note up to forty francs, and then shot the entire roll.

"I remember correctly eight was his 'point,' when Jerry took a hand," OPH says. From there on, OPH reaches into his own considerable experience with the dice and makes a German pilot flying overhead a part of the game.[8]

"There was a whiz and a bang. A shell that passed overhead dropped about one hundred feet behind us and exploded. I know just enough about gambling never to play with strangers, and when anyone takes a hand that I don't know I leave," OPH confesses.

"I followed my natural inclination, and left by the road. I didn't like to run too fast, because I was afraid the boys might think I was scared, but I made the fastest slow time down that road that had been made in many a day. I looked back once, and the game was still going on. But I had the correct hunch."

At this point, 'Jerry' shows up, playing a real game: "An airplane bearing the red, white and blue circle flew overhead and dropped a note, and the game ended, and the men began firing. Jerry evidently liked the game, because he took a few shots himself, and I never was good at being able to discern whether shells were coming or going. But I was going."[9] Before OPH left, however, he snapped a picture of "Independence boys 'shooting' under the gun, and it, too, became part of the story."[10]

Throughout the month of October, the stories OPH heard, told and re-told ranged from the excruciatingly serious and tragic October 4 story of the boy who had died 'game' to the semi-humorous October 24th story of the game the artillerymen were playing their game under the gun. OPH had visited the Field

153

Ambulance Section, the 110th Engineers, the 140th Infantry, and the 129th Field Artillery—all Kansas City units in the 35th Division; all men he knew, shared in their hardships, endured their pain, lived their lives. On October 3, OPH described the worst of their Argonne fight in the seven days from September 26 to October 2, 1918, but the censor had made seven cuts in his article, eight per cent of the total content, and the article was not published by the *Star* until November 1.

It had taken almost a month for the details of Kansas City's part in the Argonne battle to reach home, and even then much remained to be told—most especially, the casualty reports and the stories about how the men had died. These stories took longer to reach home, and many awaited the notification of next-of-kin. One story, in particular, was especially compelling. Two men had been killed trying to rescue thirty-three-year-old 2nd Lieutenant Cloyd B. Champion, who lay in a shell hole out in No Man's Land, pinned down for hours by a machine gun, well concealed. Lt. Champion seemed to have had a premonition of his own death, and his insistence on saving lives was underscored in the loss of his own. His name and his story lead the list of 31 names whose stories OPH had gathered during the first ten days of the battle in the Argonne and that finally appeared in the paper two weeks after the Armistice ended the war.[11]

Now that the worst of the fighting was over and OPH had a chance to tell the stories of the boys in the fight, perhaps he himself could sense that the end was in sight, that the killing could stop and the stories would not be so grim. The newspaper, too, seemed to sense that the end was near. On the last day of the month of October, the *Star* announced an extension of its news service to include the *Chicago Daily News* foreign cable service, and the paper summarized for its readers the extensive coverage it was offering on the war. "There are two great foreign cable services established by

American newspapers, the *Star* noted. "One is that of the *New York Times*, the other that of the *Chicago Daily News*. Readers of the *Star* are familiar with the merits of the service of the *New York Times*. They will now be able to supplement this with the reports from the second great service.

"In addition they will have, of course, the regular service of the Associated Press and the United Press, as well as the reports on the doings of the Missouri and Kansas troops from the *Star's* own correspondent, "O.P.H.," and the brilliant occasional correspondence of such travelers as Henry Allen and Dr. Burris A. Jenkins.

"There are also the contributions of Theodore Roosevelt, whose discussions of peace terms are assuming international importance.

"The *Star* believes," the paper concluded, that "it has thus provided its readers with the essentials of current history that will prove invaluable to them in understanding events in the stirring era on which the world now enters."[12]

OPH's work is a critical element of those "essentials of current history" because he relates to his readers on a personal level; he remains "game." He enjoys telling a good story, and even his subjects, like Sid Houston and his friends, are not above doing the same—especially when Higgins himself is involved.

"O.P.H." IN A FRENCH VILLAGE.

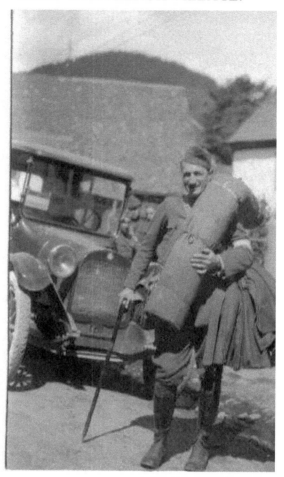

No, this is not Harry Lauder.[13] It is "O.P.H."—otherwise, O. P. Higgins—The *Star's* correspondent with the Missouri and Kansas boys, who are fighting for us in France.

Harry Lauder[14]

Otto P. Higgins[15]

"'O.P.H.' has been living with the soldiers for more than a year. He was with them when they were fitting themselves at Camp Funston and Camp Doniphan, where the 89th and 35th divisions got their training. When the 35th left Camp Doniphan he quickly followed them overseas and has been with that division, most of the time with it because its training was further advanced, and the 89th in France. He was with the 35th when it had its baptism of fire in the Vosges and with it in the more severe fighting it has been going through within the last week. This picture is from a snapshot taken in a French village. The only weapon he is allowed to carry is the mountain walking stick shown in the picture. 'O.P.H.' grew up in Kansas City, Kas., where he first became a reporter for the *Star*, later coming to work on the Missouri side. He was the *Star's* reporter at police headquarters before he was assigned to duty at the training camp and later given the assignment of going with the home boys in all their training and fighting in France."[16]

SEVEN DAYS OF HELL

The Misery and Suffering of the
Thirty-fifth Division Described
By "O. P. H."

BEAT HUNS AT EVERY TURN

Under Withering Fire and Mustard Gas
Kansas City Men Wrestled
Seven Miles from Germans.

In an Official Report, Fighters Who
Took Cheppy, a Hun Strong-
hold, Were Praised.

ENGINEERS SAVED THE DAY

Preparing the Way for Tanks, Mis-
souri Men worked Under Con-
tinuous Shell Fire.

Reports have been coming into Kansas City from many sources about the hard fighting, the heroic gallantry and the great suffering and losses of the 35th Division in the Argonne Forest battle the last days in September. Only the barest facts of that great struggle have seeped through the fingers of the military censors, and so far the casualties suffered there have not appeared in the official lists.

Incomplete cable dispatches received shortly after the stirring days of the last week of September, when the 35th was going up the Aire River on the east side of the Argonne Forest told of terrific fighting and heavy losses and the capture of Cheppy, Exermont, Very, Charpentry and Vauquois Hill, but names and units were rigidly cut out by the censor. The censor has been slightly more lenient with the present article.

The 140th Regiment of the division is made up of the old 3rd Regiment of Kansas City and the 6th Regiment, recruited in Missouri towns, and both members of the old National Guard. The 129th Field Artillery is also a part of the 35th Division. In includes old Battery B of Kansas City and other batteries from Independence and from Kansas.[17]

WITH THE FIGHTING AMERICAN ARMIES Oct. 3—A small bunch of men lay upon the crest of Vauquois Hill in the early morning of September 26, waiting for orders to proceed forward. They had just captured the hill, one of the most strongly fortified positions along the Hindenburg line.[18]

Shells from the boche artillery were breaking all about them. Their own artillery was whistling past overhead. Now and then a soldier would stumble on a wire and explode a concealed boche mine. Enemy machine gun bullets were whizzing by just clipping the tops of the weeds and grass. A boche airplane had braved the artillery fire to drop hand grenades on the men and sweep them with machine gun fire. The men were lumbering their way along on either side of the hill, bent upon crushing enemy machine gun nests.

COULDN'T KILL ONE MAN.

A high explosive shell landed among several of the khaki-clad men from Missouri and Kansas, killing some, wounding some, and blowing one boy straight up in the air. He landed upon the ground, uninjured, jumped up, regardless of the danger, waved his automatic revolver in the air and shouted:

"So this is war, is it? Sherman didn't know what he was talking about. Come on, men, follow me."[19]

The foregoing incident was related to me by one of the men, who was there and who was wounded. It is typical of what the men from home went through (five words deleted) and the spirit with which they did it. Death was stalking about on every hand, but it had lost its meaning. No one was afraid to die. No one thought about it. There wasn't any such thing as fear.

"We were advancing along a road," a wounded lieutenant told me, "when someone called the major. We crawled over to the roadside, and, lying there in a shell hole, muddied from water and

blood, was one of the boys. Both legs had been mangled by a shell and one arm was gone. A faint smile was on his face as he held out his one hand to shake with the major.

'Just tell them that you saw me and that I died game!'

"That was all he said. He knew he was dying. The major gave him a drink and a cigarette, and we went on. Two days later the major himself was killed."

A SPIRIT THAT CAN'T BE BEATEN.

This is only one of hundreds of instances that occurred during the advance of the Missouri and Kansas troops. It only serves to show what the men are made of and the spirit with which they fight, a spirit that cannot be beaten.

"Just say they are all nerve, every one of them, and that they can't be whipped. The men haven't been made yet who can equal them," officer after officer told me, both during the fight and after it was over. And in the army no higher compliment can be paid to a man than to say he is all nerve, which means that he isn't afraid of anything made by God or man.

The boche made one of the most determined stands of the war against the Missouri and Kansas troops, and if it hadn't been for the rain and the mud, the men might have been going yet. They wrested slightly more than seven miles of the famous Hindenburg line away from the enemy, fighting against everything the Germans had to offer.

An idea of what the men went through in the advance may be gained from an excerpt taken from an official report made by one of the regimental commanders who was wounded in describing the capture of Cheppy,[20] one of the German strongholds. It follows:

 I had just ordered the German prisoners to the rear when a
 German battery, probably a few kilometers to the northwest,
 in the direction of Very, opened seemingly direct fire upon

us, throwing a deluge of high explosive shells upon the ground and terrain within a radius of one hundred yards. Some of the men had not as yet gotten into the position ordered, but they immediately scattered and dropped on the ground for protection (twenty-six words deleted). Simultaneously enemy machine guns opened terrific fire from both flanks and in front (thirty-four words deleted). The slightest movement brought a combination of machine gun fire upon that point. I had only one automatic rifleman who had been able to get up to that point. However, attempts to fire served only to draw annihilating fire upon us. The enemy machine gun nests could not be located in the fog.

It is felt that every officer and man who participated in the three hours stand at Cheppy is worthy of the highest commendation. It was an epic that will live in the annals of the division and the army.

Many performed acts of the greatest heroism, worthy of all that is finest and noblest in the annals of our army and the history of our country. It means more than I can say for the spirit of the division and the regiment, and that those worthy of the highest awards be discovered and cited as early as possible.

And this was only one of the stands made by the home troops, one out of five. They were all practically alike, only some were worse than others.

CAPTURED HOT CANNON.

The second day of the battle a Kansas City regiment of Infantry[21] captured eight boche cannon, big guns that had been shooting pointblank at them, sometimes at a range as close as four hundred yards, and twenty machine guns, all in one wood. The

cannon had been fired until they were worn out. They were so hot when the infantry captured them that the barrels would burn your fingers. The machine guns never stopped until their operators were finished. This was only part of the booty taken by one regiment in an advance of slightly more than one mile.

To every man who went into the attack credit is due. It doesn't make any difference whether they were doughboys, artillery, engineers, hospital corps men or litter bearers. None of them could have gotten along without the others, and now, after it is over, each branch admires the others, something they didn't do before they went into battle.

The Kansas City regiment of engineers[22] saved the day time after time. They always worked under fire and sometimes their work was done under a terrific artillery and machine gun fire. Whenever the doughboys were held up by machine gun nests in large numbers the tanks were called for.

The tanks couldn't go very far without the engineers, who had to precede them most of the time to construct small bridges or fill up wide trenches left by the boche just to hinder the progress of the tanks. And tanks always draw heavy artillery fire, because that is the only way they can be put out of commission forever. It was the Kansas City engineers who worked with the tanks and who enabled them to proceed.

BOCHE WIRE WAS THICK.

At times the boche wire entanglements were so thick the infantry couldn't pick their way through. Here again the engineers came into prominence, two platoons of wire cutters accompanied the infantry, always ready to cut their way through the wire to allow the infantry to proceed. As fast as the territory was wrested from the hands of the boche the engineers were put to work repairing roads,

building bridges, removing obstacles left in the roads so supply and ammunition trains, ambulances and artillery could follow along.

Another one of the duties of the engineers was "mine sweeping." Scattered all up and down the line of advance were engineers, who had made a study of boche mines and traps, for this is one of the favorite tricks of the boche. It was the engineers' duty to examine all roads, all dugouts, trenches and fields for hidden mines and traps, and they found them by the hundreds. The infantry soon learned to leave everything boche alone, for it might explode upon the slightest touch.

Then, when a regiment of Kansas City infantry,[23] or what was left of it, had taken Exermont[24] and driven the boche out and then pushed on ahead, it was the engineers who dug a line of trenches in the rear of the infantry, which later saved the day.[25]

The Missouri and Kansas troops had advanced farther than the units on either side, which left them upon to fire from the front and both flanks. The boche were flooding the sector with mustard gas and high explosive shells. An order came for the men to retire to the line prepared by the engineers. It passed like wildfire among the little groups of fighting units entrenched here and there (eleven words deleted).

STARTED TO RETREAT.

The order hadn't gone far until it had become twisted into an order to retreat. Not knowing what was going on, either in front of them or behind them, the men started back as fast as they could run. The engineers, signal corps men, pioneers,[26] and everyone else who could handle a rifle had been ordered into the newly created reserve line, to hold it against the boche counter attack, which had helped to frighten the men. So many of them started on past, not waiting for anything.

163

Captain Ralph E. Truman (after his promotion to major)[27]

Here is where discipline and training told. Capt. Ralph Truman, a former Kansas City detective and now intelligence officer of a Kansas City regiment of infantry,[28] saw what was going on as well as other men who were there. Captain Truman (three words deleted) ran up and down the line, halting the men and directing them into the trenches.[29]

Chaplain Oliver Buswell, recently attached to one of the Kansas City battalions, rallied the men and held them until he was wounded by a piece of shrapnel in the leg.[30]

(Seventy-five words deleted.)

Lieut. Eustace Smith of Hutchinson, Kas., and Lieut. Duke Sheahan of St. Louis were busy doing the same thing as were the remainder of the officers who were left.[31]

THE LINE HELD.

And the line held. Three times the boches came out from their shelter in waves, only to be scattered by the rifle and machine gun fire, for Capt. Warren Osgood had succeeded in placing what few machine guns he had left in the trenches.[32] It took the engineers, the doughboys (three words deleted), the clerks, the signal men and the pioneers to do the job, but they did it, and when the troops were relieved, the incoming troops had the trenches to work from and a front line that was even with the troops on either side.

"On the morning of the third day we attacked from 5:30 o'clock until 8 o'clock," Lieut. Col. C. E. Delaplane, in command of the Kansas City infantry told me. "We advanced along the

Charpentry Road, taking Charpentry and Baulny, sending our scouts into the outskirts of Apremont on our left, and to Chaudron Farm, ahead of us. We dug in then, and lay there waiting, all the time under terrific fire, for the tanks to come up to open the way for us. They came during the afternoon, and at 5 o'clock we attacked again until dark, gaining almost four miles in the two attacks. It was one of the pictures that will always live in my memory. Two battalions went over first, with the third in support. They went over in waves, keeping their formation perfectly, and driving the boche before them. All the time they were being gassed, shelled from three sides by artillery and machine guns. (Eleven words deleted.) None who could walk faltered. They kept right on going until their objective was reached, where they dug in for the night."[33]

It was the next morning that Lieutenant Colonel Delaplane, with two hundred men, took one side of Exermont, while Capt. Jack Armour[34] of Kansas City, with ten men, took the other side. More men came in continually, and the boche were driven out and considerably beyond the town. It was from this point that the troops had to fall back that afternoon.

KANSAS CITIANS IN FRONT.

The work of the medical officers, litter bearers and sanitary men will never be forgotten by those who took part in the battle.

Capt. John F. Howell, formerly a Kansas City physician, established an advance dressing station at Chaudron Farm and kept it in operation until the troops had to fall back.[35] This was directly behind the advancing lines. The boche seemed to take particular delight in shelling and gassing dressing stations, as did their aviators in shooting machine gun bullets at them and dropping grenades on them. Many of the wounded were killed as a result of this work on the part of the boche.

165

Major E. W. Slusher with D.S.C.[36]

Maj. E. W. Slusher, the regimental surgeon, who brought with him the sanitary detachment from Kansas City, worked up in front until the last day, until he was forced to be carried back because of gas and exhaustion.[37] Capt Frank Hurwitt, who has command of the ambulance company organized by Maj. W. L. Gist; Lieut.. Richard Speck, who has the Kansas side company; Captain Broyles, who came over with Major Slusher, and all the others in the front line dressing stations worked day and night, always under fire.[38]

Major Gist, who had charge of the clearing station in the front lines for the wounded, not only looked after those who were injured, but operated a restaurant in connection.

FOUGHT WITHOUT FOOD.

It was impossible for the men to do any cooking, and it was impossible to get cooked food to them. They were scattered through woods and fields and were too busy fighting to think much about eating, and it would have been impossible to find them, even though hot food could have been carried to them. The supply wagons left most of their food near Major Gist's place, so he had some of the slightly wounded men put to work carrying wood, cooking and serving. During the four days that the station was in the one place, more than three thousand men were given hot food.

"You have got to give it to the litter bearers," every doughboy will tell you. "Those are the boys who have the nerve and do the work."

You hear that expression on every side. For all the men are proud of the litter bearers, who worked continuously, day and night, always under fire and in gas, carrying in the wounded.

"I saw four litter bearers carrying a wounded man on a stretcher when a shell exploded in their midst," Captain Howell told me. "It killed three of the men and the one who was injured, and left the fourth standing there holding a piece of the handle of the litter. He wasn't wounded, didn't have a scratch on him, but he was so shaken up and so frightened that we had to send him in."

That just shows the conditions under which the litter bearers worked.

SHELLED THE DRESSING STATION.

Captain Hurwitt's dressing station was shelled continuously for seven hours one night with high explosive shells and gas. One shell exploded in the dressing station, killing two men. Another took the head off the gas guard, who was standing in the doorway.

Another took off a corner of the roof, and any number exploded all around the frame building.

One of the men who had a leg blown almost entirely off, made no effort to put on his gas mask. One of the other boys reached over to help him.

THEY KNOW HOW TO DIE.

"Never mind my gas mask," he replied. "Just throw that leg of mine back on the litter. I don't like to see it lying there on the floor, and then give me a cigarette so I can die happy."

Which goes to show that the men know how to die, as well as how to fight.

"Do you remember that picture of Remington's, where a lone Indian, riding a horse, is silhouetted against the sunset, as he trails along the crest of a hill," Heinie Schult, regimental sergeant major asked me.[39] "I saw that same picture, only slightly changed,

the fourth night of the battle. I was sitting upon the crest of a hill, for want of any other place to sit, when I saw a lone figure on the next hill. It was a soldier. One leg had been shattered. He had fixed a crutch out of a limb off a tree, and was trying to hobble some place, evidently to shelter. The sun was just going down, and he was silhouetted perfectly against the horizon, slowly and feebly making his way along.

"A boche observation post evidently saw him, because a boche cannon opened fire upon him. Every two minutes for half an hour that gun dropped a shell along the crest of that hill, trying to hit that wounded soldier. But nothing seemed to touch him, although several of the shells exploded very close to him. He just kept on hobbling along until he disappeared into a wood, when the cannon ceased firing. Who he was or where he was going, I don't know. But I'll never forget that as long as I live, and some day—and I hope it will be in the near future—some boche artilleryman is going to pay for the little bit of sport they had that evening shooting at that wounded soldier."

O. P. H.[40]

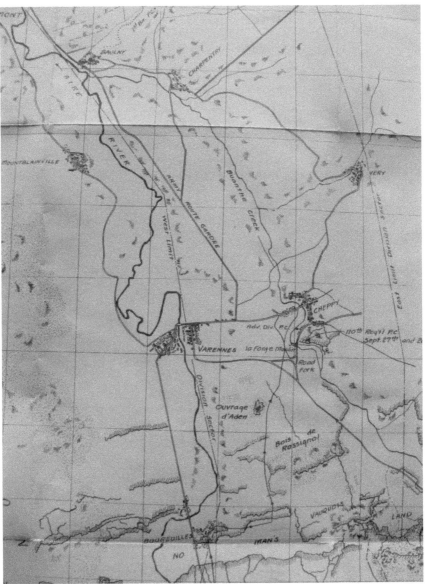

110th Engineers map along Aire River, showing from bottom right to top left, Vauquois Hill, Varennes, Cheppy, Very, Charpentry, and Baulny.[41]

Figure 2

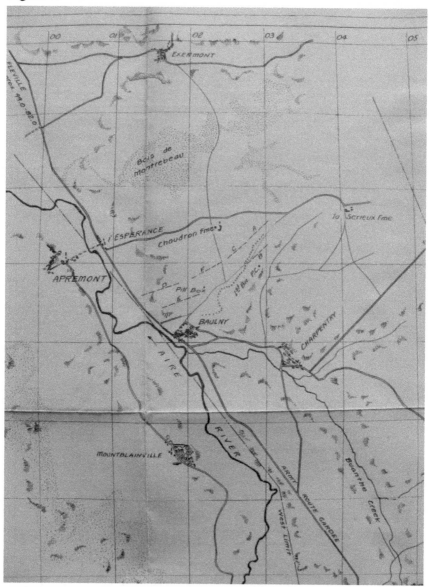

110th Engineers map along the Aire River, showing bottom left Mount Blainville, over to Charpentry, up to Baulny, Apremont, l'Esperance, Chaudron Farm, Bois de Montrebeau, and Exermont.[42]

Chapter 9: On the Way to the End—November 1918

At the 11th hour of the 11th day of the 11th month, 1918, the guns fell finally silent. "That was a wonderful day, that last day of the war," OPH wrote two weeks later, on Tuesday, November 26. "I'll never forget that last lonesome gun that barked out over our heads when we thought everything had ceased. It sounded as if someone had forgotten to stop fighting."[1]

That "someone" was certainly not OPH. He had his own story to tell about the end of the war, and most of that story was with the 89th Division. Throughout the fall, during the Battle of St. Mihiel and up to the first part of November, Higgins had been with the 35th Division.

"I was in the Vosges with the 35th, resting easy," OPH wrote the last week of November, "because I knew the 89th was in a training area, and I supposed it would be there at least another month. But the first thing I knew, the Division was a fighting unit in the Lucy sector, and the boche had put over a big gas attack two nights after it had taken over the sector."[2]

The 89th divisional history remembered that "on the night of the 7th-8th of August, the front line battalions in Bois de Jury, Bois de la Hazelle, and to the south and west of Flirey were subject to a most severe bombardment of gas shells."[3] During the bombardment, the Germans fired between 9,000 and 10,000 shells, mostly mustard gas and phosgene, interspersed with rounds of high explosives. The 89th took 556 casualties, mostly light, but forty-two officers and enlisted men were killed.

It wasn't until November 29 from Nancy, France, that OPH reported on that attack, the brunt of which was borne by the 354th and 355th infantry regiments. In his report, Higgins set the casualty figure at seven hundred, "and only a small percentage of the patients died."[4] But the effect of the attack on the men and their fighting spirit was even greater. As a result of the Division's first gas

experience and its first experience under fire, OPH concluded that "the men were wild to get after the boche when they later participated in the St. Mihiel-Verdun drives. They fought viciously and established a great reputation for the Division."[5]

That fury against the enemy's first attack on the 89th in August reached its culmination in November at the very end of the war, when the 89th was singularly intent on crossing the Meuse and taking Stenay. Most of the sixteen articles Higgins wrote in November 1918 described what led up to the attack on Stenay, when hostilities finally came to an end on November 11th. But just three days earlier, on Friday, November 8, word reached OPH that the 42nd Rainbow Division was on its way to take Sedan, a little town in the northeast of France on the Meuse River, not far from the Belgian border on the edge of the French Ardennes. With its large fort—the largest castle in Europe—and strategic position, Sedan had been occupied for four years by the Germans, the Crown Prince especially conspicuous. Its capture, announced on the 7th, was a serious blow for the Germans, and meant that the war was quickly drawing to an end.

All of the correspondents wanted to be on the front when the end finally came, and Sedan would be an excellent place to be because none of the correspondents had been able to get there yet, and an early story would find an eager audience. Higgins had an edge because he knew that Lt. Col. Ruby D. Garrett, the chief signal officer of the 42nd Division, would be in the forefront of the action. So OPH, William Slavens McNutt of *Collier's*, Burr Price of the New York and Paris editions of *The Herald*, and later, Bernie O'Donnell of the *Cincinnati Enquirer* set out for Sedan early on the morning of Saturday, November 9, for the ninety mile trek to Sedan. The correspondents finally found Lt. Col. Garrett and reached Bucanzy, but the story, OPH discovered, was not to be Sedan, but the misadventures that occurred in getting there, for once they had

arrived, they set out almost immediately for Tailly, headquarters of the 89th, where they were to cross the Meuse and with the advance patrols enter Stenay to witness the end of the war there. OPH wrote the story of the race to Sedan sometime later, and it was apparently not published in the *Star,* but it remained among Higgins's war memorabilia and is included here for the great detail it contains of the last few days of the war. Also included here is a redaction of Lt. Col. Ruby D. Garret's version of the same story, with wry commentary OPH had neglected to include about himself and war correspondents in general.

By the night of November 10, OPH was finally with the 89th Division on the west bank of the Meuse River, between Letanne and a point west of Tailly. While sitting in the intelligence office of the 89th Division in the company of operations officer Captain Inghram Hook and assistant chief of staff Major Frank Wilbur Smith, OPH looked up from the conversation as an orderly walked in. In the orderly's hand was a German radiogram that had just been intercepted. It read, simply, "'Accepted all Armistice terms.'"

"Everybody yelled," Higgins said. "Joy was supreme, although it was hard to believe what we saw. We told the artillery headquarters of the intercepted radiogram saying the Armistice was signed. The commanding officer said: 'Continue firing until the targets supplied are finished.'"[6]

General William Wright was also part of the conversation that evening, but he was skeptical of the news. Wright, commander of the 89th Division, recorded in his diary that OPH and other reporters had visited him and relayed news of the impending collapse of Germany. "During the evening Higgins of the *Kansas City Star*, a man named McNutt [William Slavens McNutt of *Collier's*], and correspondents of the *Philadelphia* and *New York Herald* came in. They said that it was a fact that the Kaiser had abdicated, that Bavaria was a republic, that Bavaria had invaded

Austria, and that the Kiel mutiny was also true. About an hour after that we got a radio flash to the effect that Germany had accepted the terms of an armistice as laid down by General Foch. About this time I heard the guns of my attack commencing to fire. This news may be a Boche trick. I have received no statement from higher authority to that effect as yet."[7]

That was at 9:10 p.m., and "those who knew were sworn to absolute secrecy until the official announcement," Higgins noted. By 9 a.m. the next morning, "the targets supplied had been finished, and new aims were sent to the artillery. The firing continued." It was as if, as Higgins had noted earlier, "someone had forgotten to stop fighting."

Then a message came in from HQ: "'Stop firing at 11 o'clock,'" it said. "'Keep eyes open and watch enemy. Do not fraternize with him.'"

As soon as the news became official, OPH bolted from his chair and headed for the front line. "With three other correspondents I jumped into a motor car to race to the front to witness the cessation of the Great War.[8]

"We stopped a truck train filled with shells and told the men. They did not believe us and looked at us with suspicion, as though fearing we might be traitors or tricksters. One could scarcely blame them, however, for guns were pounding away everywhere, and as far as could be seen, there was no evidence of the approaching end of the war.

"We passed a company of doughboys, with full packs, hiking through the mud. They were going to relieve fighting troops.

"'The war is over,' I shouted to them.

"Their only reply was astonished queries as to what I was talking about.

"'An armistice has been signed, and all fighting will stop,' I continued.

"'What time does that peace begin?' one asked me. It then was 10 o'clock.

"'Eleven o'clock,' I answered, and there was a hasty glancing at watches.

"They cheered, and then they were sober.

"'There's an hour yet,' a sergeant yelled. 'Come on, let's hurry.' Away they went on their hike, evidently trying to get to the front before it was too late.

"We met an ambulance filled with wounded men. Leaning near, I yelled the good news.

"'Cut the comedy,' was the response.

"More doughboys, and again we told the story.

"'Take my gun,' one answered and shoved it at me. 'I don't want the thing anymore.'

"Another bunch threw helmets away and danced and sang.

"We passed a number of Nebraska men, and when we told them, they pointed rifles into the air and made the ears ache with the roar of their celebration fire.

"The roads were covered with dead horses and a few dead men. Much enemy materiale was lying near.

"As we passed through Beauclair and LaNeuville, the enemy stopped shelling those places. Coming to the [Meuse] river, we found it at flood stage and the approaches destroyed. Crawling on logs and rocks and hanging onto trees and vines, we were able to reach the bridge and cross into Stenay."[9]

One of the other three newspapermen with OPH that morning was William Slavens McNutt, correspondent for *Collier's Weekly*. While Higgins and McNutt were making their way over the logs and rocks of the Meuse River, McNutt slipped, lost his balance, and fell into the river. Higgins had to fish him out of the water—a story he never let the *Collier's* correspondent forget.[10]

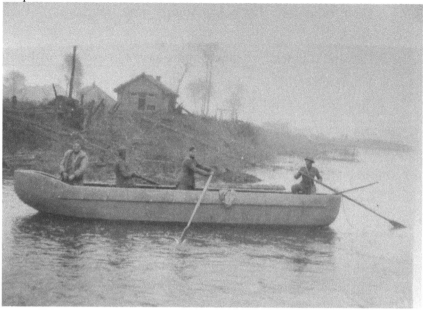

"Stenay, Meuse River, Nov 11-1918"[11]

The crossing of the Meuse River was a story OPH himself would never forget. As he summarized it for the *Star* on November 11, the tension of the crossing is still palpable in the staccato of his sentences. "A crossing of the Meuse River was effected under great difficulties," OPH wrote. "Two battalions of the 355th Infantry crossed at LaNeuville, paddling open pontoons.

"Two battalions of the 356th crossed at Pouilly, going over single file across a shell-torn bridge. The 353rd Infantry crossed just below Stenay, going over on a pontoon bridge. The 354th was covering the crossing of the other units, meeting the fire of the boche from the west bank. Crossing was made in the face of machine gun fire, hampered to some extent by the counter fire of the 354th. In the taking of Pouilly, some men swam the Meuse, while others waded. The boche had blown out pontoon bridges as well as foot bridges."[12]

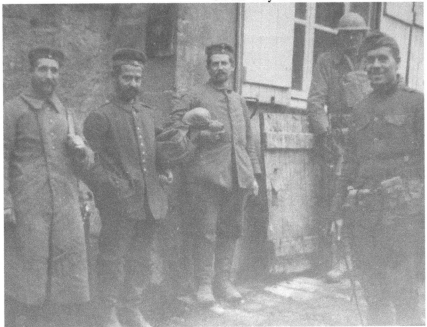

L to R: Three German prisoners captured by OPH in Stenay. William Slavens McNutt is to the right. Picture by OPH.[13]

The two correspondents made their way into Stenay, where Otto Higgins captured three Germans in a cellar, and Bill McNutt captured an eighty year-old French woman who had been living in the basement since the beginning of the war. Then Higgins and McNutt made their way into the chateau, where Crown Prince Frederick had made his headquarters, and from where he commanded German troops up until two months earlier; now it had been vacated and was ripe for the pickings. "The chateau was filled with hiding civilians," Higgins remembered. "Elaborate equipage is everywhere in this former home of the Crown Prince. I have talked with a French woman who attended him.

"In Stenay. Nov. 11." (Higgins)[14]

She says the Crown Prince was very pleasant and of good temper. Kaiser William visited the Crown Prince frequently, she says, and their visits were attended always by quarrels."[15]

After picking up some of the "elaborate equipage" as souvenirs, Higgins departed Stenay, and like many of the other reporters, took some time off.[16] "The show was over. Tension built up over months of danger and continuous excitement suddenly eased off. The newspapermen began to relax and unwind.

"Frank Sibley bought a canary bird on the Ile de la Cité; thereafter in its small cage it accompanied him in hotels, restaurants, bars and trains." Webb Miller, with whom OPH had sailed to Liverpool on board the S.S. *Lapland* in April, "climbed a utility pole in the Place de la Concorde and proved it was practical to light his cigarette from a gas street lamp. The correspondent from Pittsburgh established his headquarters at Harry's New York Bar," a place frequented by OPH as well, and "offered to buy a drink for any soldier from Pittsburgh. Otto Higgins started for Nice to see

178

something of life on the Riviera, but stopped off at an officers' club at Commercy, lost $1,500 in a dice game, and had to return to Paris, where he sold his typewriter."[17]

No record exists of how much money OPH got for his typewriter or of what he did to substitute for it after it was gone, but he did continue to write and to submit copy to the *Star*. On November 25, he visited the 117th Field Signal Battalion in Mersch, the Duchy of Luxembourg, and told a story of staying with a German family "who speak only German, and as I know the language, they treat me cordially." Aware of his financial straits, he then proceeded to catalogue how much he paid for a chunk of coal, noted that coffee cost $10 a pound, when you could find it, chocolate cost $12 a pound, and a pair of shoes that cost $2 at home cost $35 there.[18]

The next day he summarized the story of the 89th Division in France and passed along Thanksgiving messages from the 89th, the 35th, and the 42nd Division's 117th Field Signal Battalion and 117th Ammunition Train. On November 28, he sent a picture and a description of how the Germans were able to forgo the use of rubber on their bicycle tires by using double rims with springs in between, and on November 29 he produced a feature piece about how Sergeant Harry Adams of the 353rd Infantry Regiment captured three hundred German prisoners with an empty revolver.

During the month, he interviewed 35th Division YMCA Director Henry Allen after Allen was notified that he had been elected Governor of Kansas, and Higgins shared with his readers the sad details of the death of Kansas City lawyer Major Murray Davis of the 140th Infantry. Still in possession of his camera, he sent pictures of the 35th Division on the move and of the YMCA secretaries serving them, and he documented the citations received by the 89th for its work in the Argonne.

It had been a month filled with excitement, adventure, agony and loss. It was no wonder that he wanted to take some time off in Nice.

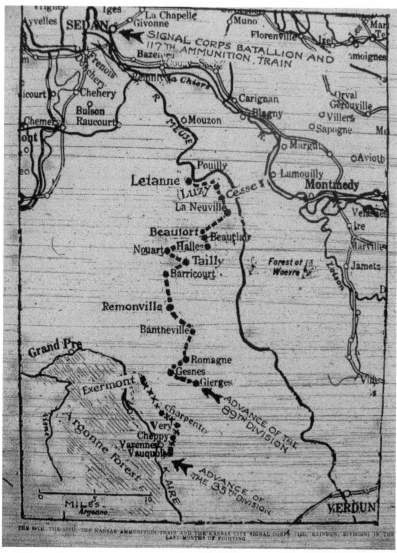

Map showing the advance of the 35th Division (arrow, lower left, from Vauquois to Exermont) and the advance of the 89th Division (arrow, middle, from Gierges to Letanne). The River Meuse cuts diagonally from Verdun (lower right) towards Sedan (upper left),

where the arrow shows the advance of the 117ᵗʰ Signal Corps and 117ᵗʰ Ammunition Train.[19]

KANSAS CITY MEN AT SEDAN.

KANSAS AMMUNITION TRAIN HELPED TO TAKE DEFENDED CITY.

(By Cable from The Star's Own Correspondent.)

WITH THE AMERICAN ARMY IN FRANCE., Nov 8 (delayed).—The Kansas City Signal Corps Battalion strung American telegraph wires today in that part of Sedan lying on the west bank of the Meuse River, also the heights southeast of Sedan.[20]

The Kansas Ammunition Train, one-half of which was recruited in Rosedale, by working continuously two nights furnishing supplies, played an important part in making it possible to take Sedan, one of the most strongly defended cities held by the boche.[21]

Kansas City and Kansas men were present today and assisted in taking this historic city from the boche.[22]

[Our Race for Sedan][23]

by Otto Higgins

There was more than one race for Sedan, that famous old French town that figures so prominently in French history. The Rainbow[24] and the First divisions made one race, now being chronicled in the daily press by Junius Wood, war correspondent,[25] and then there was our race for Sedan, which never has been told.

For thrills, adventure, fatigue, hunger, mud, rain and cold, neither of the two famous divisions had anything on us four war correspondents the closing days of the war. While the divisions went fast, we went faster. None of us ever reached Sedan, but we made a mighty effort.

The official American communiqué the night of November 7 announced that Sedan was taken. At the time I was with the 89th Division, [which was] on the Meuse River at the time. The night of November 8, I reached press headquarters at Bar le Duc about 10 o'clock, filing a cable story about the 89th's fighting. Then I heard about the Rainbow Division, of which the Kansas City signal corps battalion and the Kansas ammunition train were a part, taking Sedan. The official communiqué was on the wall, and all the men had filed stories about it. The line at Sedan was approximately ninety miles distant by road and no one had had an opportunity to reach the city as yet.

It looked like the war was over. The German sailors were in a mutiny, the boche had asked for an armistice, the war was going so fast we couldn't catch up with it. We all wanted to be on the front line the last day of the war. Sedan seemed to be the most ideal place.

Burr Price of the New York and Paris edition of *The Herald*, William Slavens McNutt of *Colliers'*, and myself arranged a Sedan party. It was then 11 o'clock at night. We all had writing to do,

which would require an hour or two, and we wanted to start at 2 o'clock in the morning hoping to arrive by that night. We knew traveling was difficult for we had all just returned from the front, and traffic conditions were worse than they had ever been before.

After two hours sleep on a wooden floor—none of us dared go to bed for fear we wouldn't be able to get up—we started out in a big motor car, Price with his typewriter and a bottle of St. James Rum, McNutt and I with canes. We took Richie for a chauffeur, because he was long-suffering, an excellent mechanic, and good thief, and kind at heart, and he was driving a new machine that had arrived but the day before. Outside of Bar le Duc the roads were in fair condition, and we made excellent time, considering the fact we had to drive without lights. At Rarecourt we picked up some hot coffee and bread for breakfast at a kitchen set up in a bar, and on we went. It only took Ritchie a few minutes to change a tire at Neuvilly. Just as we passed Varennes we got caught in a road jam. It was raining. In fact it had been raining for what seemed to us to be days, and was extremely muddy on the torn-up road. Ritchie looked over the machine and found two tires down. That meant delay. But I didn't mind it.

A small boche narrow-gauge locomotive was caught in the same jam near us, and I borrowed some hot water from the engineer. Standing in the mud to my ankles, bundled up in a sweater and overcoat, I shaved, despite the jibes and cutting words that came from McNutt and Price, for it was my first opportunity to shave in three days. Next we found a kitchen and "persuaded" the cook to slip us a bit of bread and bacon. It was hard to get, for supplies were short, and hungry casuals many. By that time Ritchie was ready to go again. The road along the Aire River was rough and rocky. It was full of holes, and the traffic was heavy.

About ten kilometers south of Grandpre two of our tires went down, and we had no more inner tubes. It was up to Ritchie to patch

183

the old ones. For a time we stood around trying to keep warm by dancing, boxing and using the rum bottle. We managed to keep warm, but we were losing valuable time, and Ritchie had no idea how long he would be. So we decided to "bum" our way to the line by hopping trucks.

"We'll meet you at the headquarters of the Forty-second Division," we told Ritchie. Neither he nor we knew where it was or when we would be there. But those were the kind of appointments we had to make in those days.

Down the road we started, headed for Sedan, about sixty miles distant, plodding through the mud and rain, looking for the war. A truck train came by. We stopped it but the Lieutenant in charge would have none of us. All his trucks were loaded to capacity, and besides, there was plenty of room on the side of the road for "stragglers" he told us. I stopped the next truck and the driver said to climb in.

We did. The truck was a steel-sided affair, high and sharp-cornered. Inside we found it to be loaded with 155 caliber shells, those great big six inch things that do so much damage. That driver seemed to be in a hurry, for he opened up and hit every bump on the road. Now we weren't afraid the shells would explode, but you load a truck helter-skelter with shells and then get bounced around on them, and it's hard on the anatomy. That was without doubt the roughest ride I ever had in my life, and I've had some rough ones. We were all glad when he turned off the road and gave us an opportunity to get out, while we were all in one piece.

After that it was more walking. It seemed like all the traffic was going backwards instead of forwards. Finally, another truck train came along, and we hailed it. We picked out the most likely looking truck and went over the back end on the fly. The top was covered with a hooded tarpaulin. The inside was loaded with cases of tomatoes. Now I don't mind riding on a hard surface if the

surface is stationery. But those cases of tomatoes were several inches higher than the sides of the truck. They didn't fit very tight, and as a result, they were always moving backward and forward a few inches every time the truck hit a bump—and the road was full of holes. There was no way we could hold on, so we had to lie flat on the tomatoes. This worked for a while until we sort of began to settle down, and get comfortable when a large hole caused everything to shift and we were all pinched between the cases. It was tough but it was better than walking. The next big hole we struck Price went over the side. Fortunately for him, we were on the edge of the road, and he fell in a mud hole and was not injured.

But all good things come to an end, and so did that one. At Buzancy. the truck went one way and we went the other. All this country had been fought over from one to four days previous, and as a result, it was in almost a ruined condition. There were shell holes in the roads; some of the bridges had been blown up by the boche to cover their retreat; in places, the roads had been mined, and the mines exploded. Very few civilians were in the villages, and food was so scarce we could hardly buy even bread and coffee for any amount of money. Money did little good in that country. What everyone wanted was food, and not money.

After leaving Buzancy, we found ourselves on a one-way road. Then we learned for the first time that Sedan had not been captured, that the French wanted the privilege of being the first to enter the town, and that they were relieving the American divisions who held the heights south of the town, while the relieved divisions were coming out and going to the Woevre to be ready for the November 14 attack that was to capture Metz. But we went on, nevertheless, on foot, for all traffic was coming out. We were going in. Somewhere in the neighborhood of Autruche we found one of the worst pieces of destroyed road that we had found during the war. For more than a kilometer the road had been mined and blown up in

eight different places. The engineers were then throwing a one-way corduroy road across a swamp to replace it. At Autruche, we found we were on the wrong road.

But we did find a medical officer from the Rainbow, who informed us the headquarters of the Division was at Maisoncelle. We also found a marmite can with some stew in the bottom,[26] which we ate by taking it out by hands full and drinking it like coffee. Anything was better than starving. Here also we found an ambulance that carried us a few kilometers, and then again it was the everlasting plodding through the mud.

In a pasture near Brieulles-sur-Bar we found some Rainbow troops. They were a supply unit coming out. Here also we found Bernie O'Donnell of the *Cincinnati Enquirer*, whom we left several days before when I went with the Eighty-ninth. Bernie wanted to throw in with us, for he didn't know how he was going to get back. Through a little "salve"[27] and Bernie's acquaintance with the cooks, we were able here to salvage some corned willy, even though the officers had told us there wasn't enough for the men.[28]

Once more we started out, walking two and two. An orderly came down the road riding a bony, broken-down horse and leading two others. We were not missing any bets. McNutt and I each borrowed a bony animal, loaded our arms with typewriters and bags, and we were off. It was almost as rough riding as the ammunition truck. But we stuck until the orderly reached his destination. There we waited for the others, who came up on a load of hay. The driver's boss, a second lieutenant, refused to let us ride, but he couldn't watch the back end of the truck and the front end too. So we made that for a few kilometers. After that, it was more walking and we were tired, dead tired. Very little sleep and no square meals had any of us for four and five days, and we were gone. But we struck the main highway to Sedan, at a point near Tannay, and we felt better. Here the road was good and it was being cleaned by

boche prisoners. On we plugged until 8 o'clock, when we found what had once been a little French café but now was full of holes, at Mon Idée. It was anything but my idea of a place to stay, but here we stopped, for at the side of the building was a kitchen, which we found belonged to a supply company of a Chicago regiment of artillery, "Reilly's Bucks."[29]

When the men learned we were correspondents, they couldn't be too nice to us, and it wasn't long before we had an excellent meal. That night they said they would put on a band concert if we would stay over. Of course we would.

About that time a motor car came down the road headed toward the front. We stopped it.

"I have room for two men," the officer in charge said.

So McNutt and Price got in and said they would send a car for us as quickly as they found Lieut. Col. Ruby D. Garrett of Kansas City, Division signal officer of the Rainbow, whose headquarters was in Maisoncelle. Bernie and I stayed for the show, which was a good one, put on there by the boys in this old café. A few candles were burning and the place was closed tight not to allow any light outside. Nothing else could get out as well, and no fresh air could get in. But we didn't mind that part, as long as it was dry.

When neither McNutt nor Price appeared by 11 o'clock, Bernie and I started walking again. It was some twenty-odd kilometers to Maisoncelle, but we were going to get there. There wasn't any moon. The rain came up again. A battalion of artillery was coming out. We were going in, alone. Every motor car that came along we stopped to see who was in it.

Boche airplanes came over. Bernie and I dove for the woods. The artillerymen could only draw their horses to one side of the road and wait, praying no bombs landed in their vicinity. But we were fooled. The planes evidently were only observers. A little later, however, more came over. This time we didn't leave the road

but continued walking. This time we were fooled, too. For not only did they drop some eggs, but they flew low and opened fire with machine guns on the transport just in the rear of us. It didn't last long, and we went on faster than ever. We had a real incentive to move now.

Luck was with us. As we were in sight of Chemery, where we were to turn off the road, I stopped the right car. It was Colonel Garrett's car, and in it was Major Ransopher of Kansas City[30], and McNutt, coming for us. Price had "died" the moment he struck a warm room and was then asleep in Colonel Garrett's quarters. We were to return to Mon Idée for the night, and Colonel Garrett was to pick us up there the following morning, for division headquarters was moving.

At Mon Idée we awoke our friends in the abandoned café, and they squeezed over a bit. I managed to get a blanket and a shelter half, a piece of canvas,[31] and with this below and above me, I slept on a cold concrete floor. Bill and Bernie each managed to get a blanket, and they slept the same way, but we could have slept that night on a buzz saw, we were so tired.

Early in the morning we were out for breakfast, for the company was on the move. No morning wash, no shave, no nothing, but some hot breakfast, and we were more than thankful for that. A few hours later, Colonel Garrett appeared, and by noon we were at Buzancy, the camp for the night. Here we had our first regular meal with the Kansas City signal corps, and while we were eating, up came Ritchie, our chauffeur, with the car. And we were off again, this time for Tailly, headquarters of the 89th, where we were to enter Stenay with the advance patrols.

So ended our race for Sedan, the city we never captured, although credited with it in the communiqué. And such was life those closing days of the war.

O.P.H.

WITH O.P.H. AT THE FRONT

LIEUT. COL. GARRETT TELLS OF WAR CORRESPONDENTS' HARDSHIPS.

Following the Advance Lines Through Freezing Mud and Living on "Handouts" Some of Their Troubles.

[by Lt. Col. Ruby D. Garrett][32]

If you have imagined the war correspondent lounging in an easy chair and smoking a real Havana cigar before a glowing fire in the palatial old chateau occupied by army headquarters in France, as Lieut. Col. Ruby D. Garrett admits he pictured the setting, you have another guess coming. In a letter to Albert H. King of *The Star* staff, Lieutenant Colonel Garrett, commanding the signal corps of the 42d Division, writes of his enlightenment as follows:

In our recent advance Higgins of the *Star* (O.P.H.) was with us quite a bit, and I saw a good deal of McNutt of *Colliers*, O'Donnell of the *Cincinnati Enquirer* and Price of the *New York Herald*. I ran into them near the front. They were without food, bedding or a place to sleep They carried a few toilet articles, their note books, typewriters, kodaks and an extra pair of socks –(every newspaper man I have met has carried an extra pair of socks—like the rabbit's foot, they seem to insure good luck). I have seldom found one carrying food or bedding. They keep from starving by

eating wherever and whenever they can. If they have just had a meal and pass a kitchen, they go in and eat again because sometimes it is a long time between kitchens over here.

When we were advancing over the rolling fields and wooded hills south of Sedan, Higgins, McNutt, O'Donnell and Price determined to join the Rainbow Division and go with it into Sedan, as it had been noised about that we would enter Sedan. This great honor, however, was allotted to the French, and we stopped and turned back after capturing the heights dominating the city. The correspondents started from press headquarters more than a hundred miles away riding in a big new car. During the first hour, they had four punctures. After that they ran into a continuous traffic jam. For days it had been raining and the roads were slick and muddy and covered with running water. Higgins had just returned from another part of the front and had not had time to bathe, change clothing or shave. While the third puncture was being fixed, he drew hot water from a captured narrow gauge boche engine, stood in the rain and shaved. It was so cold that he did not remove his hat, overcoat or gloves.

BLOCKED BY TRAFFIC JAM.

Congested traffic soon stopped their advance. After fighting the jams for twelve hours, the correspondents temporarily abandoned their car and slopped forward on foot. Several times they got short rides on vehicles bound in their direction. One time they hopped on an ammunition "quad," loaded with 155s. These are large, long, sharp-pointed shells. The quad bounced rapidly along the rough road and scrambled the wet correspondents among the big shells. It was a rough and noisy journey. And it appeared dangerous, and there was an extravagant use of prayers and profanity. Soon the writers jumped and Higgins landed clear of the road in a side ditch full of water and sank above his knees in the

mud. McNutt rushed to his rescue and mired also. The others were helpless. At last a big truck loaded with crates of canned tomatoes came by, and it was commandeered to "tow" Higgins and McNutt out of the mire. At once they hopped the rescue truck and soon were bouncing along the road sliding about among the crates. In hopping trucks, Higgins declared he utilized his early experience when he was "seeing America first" from the rods of some of the best trains in the country.

By midnight, they had reached such congestion of traffic that they had to leave the truck and wade through the soft, muddy fields. It was still raining, and the night was so dark that they had to walk close together to prevent getting lost. No lights were permitted. They got a short, unhappy ride in a ration wagon, which turned over five minutes after they got in.

The infantrymen were all wet and tired, but they had nothing on Higgins and the others. The men had a definite place to go and knew they would get food soon, but Higgins and his bunch did not know where to go, they had lost their car and were more than a hundred miles from their base. The roads were jammed tight for miles and miles, the rain was still falling and the weather was growing colder every minute.

APPOINTED A RENDEZVOUS.

They separated and agreed to meet the next morning at a certain old vacated roadhouse. McNutt and Price followed one road and Higgins and O'Donnell another. All of them were on the lookout for three things: first of all, grub; second, news; and third, their lost car.

At 8 o'clock that night, McNutt and Price reached the little village where I was staying and obtained hot coffee and corn beef hash. They certainly showed they had been fighting a wet, hard war, and as they shivered around my little fire everything looked dark for

them, and McNutt freely predicted that the war could not end for five years. Price was exhausted and piled in a bed at my place, while McNutt was driven in my car to the roadhouse to see if Higgins and O'Donnell had found the car. The next morning, Price and I drove by and picked up the others. They had spent the night on the concrete floor of the roadhouse, with only three blankets for cover. The night had been the coldest of the fall; they had all been wet and were hungry and tired. How they kept warm, or rather, why they did not take cold, I cannot understand. That cold morning, life looked blue to them, and when they talked the air became bluer. I hurried them to the officers' mess of the signal battalion and saw to it that they all got steak, fried potatoes and coffee.

After filling their stomachs, they became more cheerful, McNutt whistled and Higgins threatened to sing; the world looked brighter and they all predicted a speedy ending of the war, bumper crops, golden prosperity, and pensions for the press. I sometimes am convinced that optimism has its seat in a man's stomach, and not in his head. Shortly after mess, their lame car rolled in, and the correspondents breezed off to another part of the front.

<div align="center">* * *</div>

One more story about Higgins: Two days ago we reached a little village which had been the line before the Armistice. Higgins and McNutt were assigned to my billet. This billet consisted of one large airy bedroom and a big sitting room with a great wide fireplace stretching almost across its end. Higgins became enthusiastic and began cleaning out the rubbish and sweeping up the trash and litter from the floor. Soon he had the place clean, had "salvaged" some chairs and made it look very comfortable and really homelike. Then he built a cheerful fire in the great fireplace. The back of the house had been ruined by shells. Great masses of tangled, broken timbers filled the back rooms and the upstairs, and a shell had made a large hole in the chimney, and trash, straw and rubbish had accumulated

about this hole. In a few minutes after Higgins started the fire, the place was ablaze and all of us were plunging here and there and carrying buckets of water, trying to win congressional medals fighting the flames. But it was no use. Our beautiful home was destroyed.

Now, if a writer writes facts he works hard, risks much and suffers every privation. McNutt has lost seventy-five pounds since coming over, and Higgins has lost thirty pounds. No organization carries more bedding or rations than absolutely necessary, and nobody provides for the correspondent. He must rustle for his food as well as his facts, and the best part about it all is that the ones I have known have been able to land both with reasonable regularity.

Chapter 10: To Luxembourg with the 89th —December 1918

After the Armistice, the 89th became one of eight American divisions that made up the Third Army, also known as the Army of Occupation[1]. Departing from its headquarters in Stenay, on the Meuse River, the 89th began a two days' march to the vicinity of Virton in Belgium, and then on into Luxembourg, where the 89th established itself in the area around Echternach, on the Sauer river, the border between Luxembourg and Germany.[2]

Not far away at Bouillonville on December 1, OPH wrote the first of five articles sent to the *Star* in December 1918. Three of the articles are made up of what might be considered "bulletins," a series of short vignettes or "scraps from a notebook," as Higgins called them, focusing on specific men and their stories. Seven stories of stretcher bearers and ambulance drivers with the 314th Sanitary Train and the medical units of the 353rd and 355th Infantry Regiments comprise the first article.

The second article, written on the same day, is not a bulletin piece at all, but a delightful story about a double entertainment the boys of the 353rd and 355th Ambulance companies had devised. The first entertainment, consisting of films about five feet long spliced together in a continuous belt wound around two wheels, required an admission price of two cigarettes, which OPH paid but which was refunded out of special consideration. That entertainment ended abruptly when the films caught fire, so OPH moved to the second entertainment, which the motor mechanic usher announced as the "Cavalry Rushedthecan," and Otto later discovered was actually a recording of the "Cavaleria Rusticana." The entry fee of one cigarette was again waived for Higgins, and he considered that recording and the recordings to follow, well "worth the price."

A week later, on December 7, from Birresorn, Germany, a little village just inside the German border, OPH explained in a

letter home that "the boche are all glad that the Americans came through this section and not the French or the Belgians. They are glad the war is over and that the Kaiser is gone, as they won't have any more war, and they say if America hadn't come into it, they would have won last summer. Which we admit, of course. The ordinary German in the villages through which we have passed has no conception of the war. They don't know why they were in it, who started it, or anything else about it. All they know is that it is over, and they are glad of it."[3]

Shortly after OPH sent that letter, he moved from the Kansas City Ambulance units of the 89th Division to the Kansas City Field Signal Battalion of the 42nd Division, which had also been assigned to occupation duty in Germany. On December 13, 1918, the 117th Field Signal Battalion moved to Ahrweiler, Germany, where Division Headquarters was established and the unit set up its communications network, putting existing German wire to work in the process. "Enough German lines were taken over to provide communication for all units in the division and to the Corps and Army headquarters," battalion commander Lieutenant Colonel Ruby D. Garrett recorded.[4] Three days later, on December 16, OPH sent a postcard from Ahrweiler to his parents, James and Delia Higgins, in Kansas City, Kansas. "We drove through this town and along this road through the valley of the Ahr River," Higgins wrote. "It is one of the beauty spots of the world and a great health resort. Merry Xmas & a Happy N Y, OPH."[5]

Throughout his time with the 117th Field Signal Battalion, OPH continued jotting in his notebook, and by Christmas Eve, he had gathered enough material to put together an article about the 117th Field Signal Battalion similar to the article he had written about the ambulance companies of the 89th Division with whom he had been billeted at the beginning of the month. That earlier article on December 1 had contained seven vignettes; the Christmas Eve

195

article written at the end of the month contained eleven vignettes and covered everything from Sergeant Eugene Lott, who captured and then employed seven Germans to string telephone wire, to Sergeant Harold Simpson, who cobbled together German, French, and American electrical parts to construct a wireless set able to pick up news bulletins from as far away as the United States. Lieutenant Warren C. Bailey studied a German grammar so he could talk with the German girls; Private First Class Gerald Ford picked up the time broadcast from the Eiffel tower, and then hurried over to every headquarters in the Division to set the correct time; and former prize fighter Private Bobbie Dibbons dealt with a bully who had just joined the unit. OPH concluded the article with a story about the signal men assisting General Douglas MacArthur as he moved about the Division.

Christmas Day 1918 found OPH with the 117th Field Signal Battalion near Mersch in Luxembourg.[6] The next day, he wired home Christmas greetings from the Kansas City units of the 89th, 42nd and 35th Divisions. That same day, he described in considerable detail the work of the 117th Field Signal Battalion as it strung miles of telephone wire, set up telephone exchanges, serviced storage batteries and then took the apparatus down to set it up all over again when the Division moved to its next duty station. That particular piece, "The Signal Men Fed Best," is the most succinct and personable expression Kansas City was to see of the work of the signal men in the two years that unit spent in France and Germany.

NERVE AMAZED THE BOCHE.

Ambulance Men "Got the Jump" and
Rescued Wounded Men.

WITH THE 89TH DIVISION, Dec. 1.—The road may be under fire, the area may be filled with gas, the ambulance drivers may have had only a snatch of sleep in days, but—

Here are a few scraps from a notebook that tells of the work of the ambulance companies with the 89th Division[7]:

A boy had been lying out in No Man's Land two days with a broken leg, a little water in his canteen and a few hard biscuits. He had managed to bind up his leg with his first aid packet, but he had been unable to crawl to the lines. Several times the boys had attempted to reach him, but a boche machine gunner had the place covered and each time drove them back. Victor Allen of Kansas City, driver of an ambulance,[8] and Charles Grout, his orderly[9], volunteered. Allen drove his ambulance out into No Man's Land, stopped, descended and helped Grout bind up the man's leg so he could ride in the ambulance. The two placed the wounded soldier inside, then calmly turned around and drove back to the lines.

The boche were so amazed they didn't shoot for about two minutes, but when they did open up, they sprayed the entire place. Several bullets struck the ambulance, but no one was scratched.

In the early part of the St. Mihiel drive four of the boys with the Kansas City outfit did such fine work in carrying in the wounded that they were mentioned especially in orders. They were stretcher bearers. Among those mentioned were Dwight Swanson, Oliver W. Holmes, G. D. Ferris and Lloyd E. Manning, all of Kansas City.

Capt. H. E. McCarthy, a Kansas City physician, had a narrow escape once. He was stationed near Xammes at a first aid

station when a boche shell landed in the center of it. The captain and eight others were there, and all were wounded except the captain, who wasn't scratched.

Colonel Reeves[10] slipped this one to me and swore it was true:

"The boche was pouring shells into us," he said. "Everyone who could find shelter was under it. There was a captain in the shell hole next to me. A few shells dropped right close to us, and I heard a thud in the captain's place. A buck private had made a dive for the hole and landed on top of the captain.

'I beg your pardon, sir, but I didn't know you were an officer,' the private apologized.

'Just stay where you are,' the captain answered. 'The more there is on top of me the safer I will be.'"

Once the troops stopped long enough to dig in and consolidate their positions. The engineers were in front of the frontline positions stringing barb wire to make the defense more secure. Jerry saw them at work and dropped a shell in the midst of a working party, seriously injuring four.

Col. James H. Reeves[11]

John Rutledge, who was driving an ambulance, and Dan D. Porter, his orderly, both from Kansas City, drove their ambulance up in front of the place, which was in front of our advanced positions, placed the wounded engineers in the ambulance, then loaded up the barbed wire, and drove back to the dressing station.

When the St. Mihiel attack began, the 355th, the company Capt. E. W. Cavaness organized in Kansas City, was attached to the All-Kansas Infantry. The All-Kansas was the first to enter Bouillonville, and Captain Cavaness's ambulance company was the first to open a dressing station there in the hospital abandoned by the boche. The soldiers had been so busy fighting that they had no time to eat. The boche had left a lot of rations behind, so Sergt. Franklin Moore of Kansas City gathered up a lot of boche food and made soup out of it. Sergeant Franklin had himself a soup-line in "Souptown" that fed some three thousand men in one day and one night, before the ration wagons and rolling kitchens could get up.[12]

Capt. F. C. Albright, a doctor from Bronaugh, MO., who was attached to the 356th Infantry, had some exciting times. Captain Albright had been assigned to the 3d Battalion, and it was up to him to remain with the battalion during the advance. This was a pretty hard thing to do, as the battalion was going forward all the time.

So Captain Albright had his men just load up on dressings and bandages and foot it after the battalion. Whenever any of the men would be wounded, he would be dressed right where he fell, then carried to a place of comparative safety by the stretcher bearers, while the doctor and his assistants moved on to the next man. Only once did they have time or a place to establish a dressing station, and that was in a boche dugout. But they couldn't remain there long, as the line was continually moving forward, and there was work to do.

O. P. H.[13]

CAVE OPERA 89TH'S TREAT.

"O. P. H." GOES TO TWO SHOWS IN
ONE NIGHT AT THE FRONT.

At the First One, a Movie, a Spectator
Falls Off a Stove—In the Jostle
The Film Takes Fire,
Ending Show.

(From The Star's Own Correspondent.)

WITH THE 89TH DIVISION, Dec. 1—If you don't "kid" the war, the war will "kid" you.[14] One of the best incidents of "kidding" the war I found in Bouillonville, fondly called "Souptown,"[15] headquarters of the All-Kansas regiment [the 353rd Infantry], as well as the 353rd and 355th Ambulance companies.

I found the boys having the time of their lives. The boche had once had an officer's club there, a recreation room for the soldiers, and a large hospital. Therefore, there was plenty to eat and drink. I had dinner with Capt. E. W. Cavaness, who organized the 355th Ambulance Company in Kansas City, and Capt. Christian H. Koontz of Onaga, Kas.

"A LITTLE PARTY TONIGHT."

Then I hunted up Sergt. Arthur Duncan, a former reporter on *The Star*, in the 353rd Ambulance Company, which was raised at Fredonia, Hutchinson, and Winfield. "Dunc" said the boys were "going to put on a little party tonight." So I stayed.[16]

We had noticed a sign tacked on a door that read:

Moving Pictures Tonight. 8 O'clock.
Admission 2 Cigarettes.

A few doors further down was another sign:

Patronize Your Allies.
To Hell With
the Boche.
French Grand Opera Tonight.
Admission 1 Cigarette.

We decided to take in both shows. At 8 o'clock, we went to where the movie was to be held, and stood in line at the front door with our cigarettes in hand. Something evidently had hit the door, because there wasn't any door left. A gas blanket took its place. Inside was a sort of antechamber, as dark as a stack of black cats. The "guest" had to pass through a second gas blanket, where he paid his fare and looked about for a seat on the floor of the smoke-filled little room.

IN THE SEAT OF HONOR.

The head usher gave me the seat of honor—the smooth side of an empty soup can. Then he surreptitiously slipped me my two cigarettes, and whispered that while the house never made it a custom to issue any "comps," they would make an exception in my case and herewith returned the purchase price of my ticket, which I accepted, and returned half of it to him in exchange for a match. After which the candles were blown out and the show was ready to begin.

The picture machine was one of these small affairs that costs about $3 apiece at home. The pictures were thrown on a sheet stretched across the wall. The films were only about five feet long, fastened together in the shape of a belt which worked on two wheels. Sergt. William Cunningham, better known as "Candy" Cunningham, was the operator. He formerly operated a movie of his own at Fredonia. Sergt. Leonard Sohn of Severy, Kas, was the

201

official announcer. He stood beside the machine and explained the pictures.

The two evidently had [not] rehearsed because Sohn went right along with his speeches regardless of whether the machine was going. Sometimes he was ahead of the pictures, sometimes behind.

One film showed the Kaiser and the Kaiserin out for an airing. Sohn would run along like this:

"Now ladies and gentlemen, you will see a life-size picture of the man whose dream it was to rule the world. He and his old lady will pass before you riding in a hack. There are three or four boobs scattered around on different parts of the hack, but they haven't anything to do with the picture. Somebody just threw them in for good measure. Here they come now. The guy with the high hat sitting in the rear of the vehicle is Bill. The woman on his left is Mrs. Bill."

THE ANNOUNCER WAS FIRM.

The picture would be over and the lecturer would just be well started. But he had plenty of time, because it took some time to adjust the machine for the next picture, and the lecture usually would be finished by that time. If it wasn't, the sergeant would put his hand over the projector and announce:

"These ladies and gentlemen have paid their good money to see this show, and they are going to see it all if I have anything to do with it."

Then he would continue until the lecture was ended.

"Dunc" had taken up a point of vantage on top of a little iron stove. Everybody was jammed in around him. Cunningham had thrown a picture on the screen showing the boche infantry in an attack. They were going forward at a great rate, mowing the Allied soldiers down before them. Then the stove was overturned, Duncan

with it. Someone jarred the machine, causing the film to catch fire, and the show was over for the evening.

"Now we must go and listen to the grand opera," Duncan said.

"Do you think you can deadhead me in, because my cigarettes are running low," I asked him. He thought he could.

We wandered around until we came to what appeared like a black hole in the hillside. After more winding around we came to a curtain and there we were, right smack in the opera house.

"FIXED" THE MANAGEMENT.

I waited while Duncan "parleyed" with the "manager," Ernest Yount, of Winfield, Kas. Duncan whispered in my ear that "everything had been squared with the management."

The hall was about as large as an ordinary living room. The place had been blasted out. Here and there candles were stuck into wine bottles. Sitting on a large box was the "grand opera," in the shape of a disc phonograph, being operated by Yount and Harry Evans of Kansas City[17], both motor mechanics. At first I couldn't quite understand why it needed motor mechanics to operate a phonograph, but I soon found out. In one place the boys had used the trachea tube of a gas mask to replace a part of the machine. The trachea tube is the rubber hose that connects the mouthpiece and the canister on the gas mask, but just what it connected on the machine will always remain a mystery to me. In another place was a piece taken from a bicycle. In another place I found the handle from a razor blade sharpener.

"The next piece is "The Cavalry Rushedthecan," the motor mechanic called. "It is French, and if you don't understand it act like you do, because if you raise a rumpus the bouncer will throw you out. Just remember that I've got two hand grenades in my pocket, and I'll splatter you over the wall. Proceed."

There it was, sure enough, "Cavalleria Rusticana," in the dulcet tone of a singer known to two continents.[18] Someone had stepped on the record and cracked it a bit in the center, but we didn't notice that. Then followed the "Miserere," the Barcarole from "The Tales of Hoffman," the Soldiers' Chorus from "Faust," the jewel song from "Faust," the sextet from "Lucia" and others. It was worth the price.

A few hours later, we went to bed in the office of the 353rd Ambulance Company. "Dunc" rolled up alongside of me, while at my feet lay Herbert Roemer, a wholesale jeweler from Kansas City[19]. Ray Holderman, who, before he joined the army, was piano instructor at the Winfield College of Music, had to sleep over by the window, because he was the telephone "girl" for that night and had to keep his head close to the telephone.

O. P. H.[20]

THE SIGNAL MEN FED BEST

THE HOME FOLKS' FUND IS A BIG HELP.

How Garrett's Command Maintains Communication Is Told by O. P. H.—Stories Of the Kansas City Battalion

WITH THE KANSAS CITY SIGNAL BATTALION, Dec. 26.—This battalion has the reputation of being the best fed organization in France. That's correct.[21]

Some units will dispute that assertion, but no fighting unit will deny it. Besides the edibles the War Department gives the troops, the battalion has a fund that rises and falls, a fund kept up by the folks at home. No matter where the battalion is, the men always have plenty to eat—with extras.

BOUGHT THE DINNER IN BELGIUM.

Before one big dinner, Lucien LeGrand, the French interpreter attached to the battalion and Chester Miles of Liberty, Mo., started out in a small truck, their pockets full of francs. We were at a Luxembourg village and food was scarce. They had to go all the way to Belgium and wander around for a day, but when they returned, they had the truck full of supplies, such as chickens and geese, and eggs, vegetables, and butter.

The battalion's cooks are famous. Now there's Jiloco. I don't know whether that is his first name or his last. Jiloco is a Filipino, and for several years was a chef of a popular cafe at Twelfth Street and Grand Avenue.[22]

Then there is "Dippy" Diers—William Diers mess sergeant for headquarters. He is always the last to leave when we move, and he travels alone, but somehow he usually is the first to arrive at the next stopping place. Then he wanders around, finds a kitchen and a

dining room, and a little later, the meal is ready. In civilian life he was a typewriter salesman for a concern on Grand Avenue.[23]

Dier's assistant is William Dole, known as the second cook. He is a wizard on pancakes, too. By profession Dole is a model for sculptors and artists.[24]

The Kansas City signal battalion now maintains two lines of communication between division headquarters and each of the three brigades. Each brigade must maintain two lines of communication with each regiment, and each regiment must be connected with its battalion. Division headquarters must maintain two distinct means of communication with corps headquarters and with army headquarters.

Capt. V. A. Diggs, formerly construction engineer for a Kansas City telephone company, commands the telephone company, and is in charge of the advance detail and the "clean up gang." Captain Diggs and Sergt. Robert Rooney, formerly with the Home Company, go forward with the crew and locate the telephone office, or, if there is none, they set up a switchboard. Sergt. Phil Niclas, formerly a cable splicer for the Bell, installs the switchboard. Sergt. "Pop" Gallagher,[25] formerly construction foreman for the Bell, locates the circuits to corps and the brigades and connects up.

Clyde Van Biber and Thomas Hickey, both former Kansas City linemen, string the telephones. Wallace Weiss, who formerly drove an ice wagon, now is a lineman. He and Edward Glayzer must put up the wires. After the board is up it is turned over to Sergt. Dorsey Cott, formerly a student at William Jewell College, and his crew of operators. Cott is chief operator and his assistants are Corporals Harry Halderman, Pertle Canady and Charles Spickard.

HUNS HEAR "HIS NUMBER."

When the division was in the Argonne fighting near Exermont, Hickey, a member of Company B, was No 58. Therefore he is called "B58." A big shell exploded near Hickey, knocking him down and covering him with mud. A piece of the shell was stamped "B28," which was some kind of a boche identification mark.

"Jerry almost had my number," he said, as he looked at the mark.[26]

———————————

Sergt. "Pony" Daniels, a former Kansas City lineman, oversees all exchanges. By the time the work is completed, the troops on the move are arriving, and their telephone communication is waiting for them.

One crew always is left to "clean up" when the division moves ahead. That crew usually consists of Daniels, Sergt. George Graba, formerly night wire chief in Kansas City, and Canady, Spickard, and Glayzer. When they finish "cleaning up," they must catch up with the division, and either relieve the men at work there or pick up the construction crew and move to the next place to get it ready for the coming of the division.

PICK UP PRESS COMMUNICATIONS.

The other means of communications always kept up is the radio. Division headquarters has three different kinds of wireless outfits, and each brigade and regimental headquarters has a set. Division headquarters communicates only with army headquarters, corps headquarters and adjoining division headquarters. Another is tuned to communicate only with brigade headquarters and with adjoining brigades. The third is a press outfit, built entirely by Sergt. Harold L. Simpson, a Kansas City electrician, and it picks up all the foreign press communications. It doesn't send anything. Sergeant Simpson has assisting him E. R. Warren, Arthur G. Hahn, and Joseph Ciro, commercial operators from Kansas City.

The big headquarters set is in the charge of Sergt. Harry King, Jr., formerly with a Kansas City wholesale shoe company. Assisting him is Ernest R. McReynolds of Fairfield, Nebraska; Benjamin F. Burkhaulter, a Missouri University student; and Charles E. Thompson, formerly operator and ticket clerk at the Argentine railroad station. Dale V. Stample and Jule H. Thompson, telegraphers in Kansas City, have the smaller set.

Whenever the division moves, Sergt. Wilbur Witcraft, in charge of the radio station, takes three men, a truck and a wireless outfit and jumps to the next town. By the time the division arrives, the wireless is working. Other Kansas City men with the headquarters radio outfit are: Sergt. George Henderson, electrician; William Bowman, chauffeur; and Gerald J. Ford, formerly a salesman.

The storage batteries for the wireless outfits must be charged almost daily, so the charging plant works at night. All the men at the plant are from Kansas City. Roy P. Bearrow drives the big truck. Alfred Frontana repairs storage batteries. Charles L. Nichols was a switchboard man for a telephone company;[27] Ernest E. Engler is the machinist, as he was at home.

Cyrus B. Summers was a shipping clerk. He must see that the newly charged batteries are delivered. John A. Leas was a traction engineer, while Thaddeus Prentice of Lawrence, Kas, was a traveling electrician for a Chicago concern.

All the men belonging to the radio company are under the command of Lieut. Warren C. Bailey, formerly in the signal corps of the regular army.

CAN TALK UNDERGROUND, TOO

When units are in line, the "T.P.S" generally is employed between regimental and battalion headquarters. That is an

instrument that talks through the ground, just like the wireless talks through the air, but it cannot be picked up by the enemy.[28]

Men in the Kansas City outfit are so fond of their battalion that twelve who were sent to the hospital, and from there to other outfits, have been A. W. O. L., absent without leave, to return to their old organization. So far none has been sent to jail for it.

A captain is always addressed "Captain" and a sergeant is "Sergeant So and So." Privates are addressed by the last name, never by the first or a nickname. But I know one army man to whom the rule never applies. He is Leslie Robinson, sergeant first class, with the 117th Field Signal Battalion, formerly in the Kansas City Associated Press office.[29]

When Robinson first joined someone called him "Skinnay." He doesn't look it, but "Skinnay" has stuck and "Skinnay" he is, from buck private to the colonel himself. "Skinnay" is father confessor to officers and men. Then he is a banker, carrying many a man's money. He settles disputes without quarreling himself. When anyone wants anything from a needle to a truck he calls on "Skinnay." Just where he secures things is not known or asked, but he never fails to produce.

Horses are short-lived in battle. The losses are frequent, so it is difficult to get them. Once the battalion needed a team immediately. "We need a team of good horses right away, "Skinnay." Colonel Garrett told him over the telephone.

HE GOT THE HORSES.

Fifteen minutes later the bell rang. "Skinnay" said, "I have a good team of grays here, sir. Where shall I send them?"

The other morning I wanted to see "Skinnay." I supposed his billet would be a real nice barn. When I investigated, I found the number given me belonged to a big stone house. I walked around

the barn, but "Skinnay" wasn't there. I knocked at the door of the house. The woman took me into the house, where I found "Skinnay." The big living room, fireplace, electric lights and all had been turned over to him for a bedroom. His bed was a fancy one. The furniture was hand-carved and the walls covered with tapestries. "Skinnay" was in the library adjoining, which had been converted into his office.

The woman explained that "Skinnay" was such a nice boy. She said he always whistled, sang—and once in a while he gave her a little white flour. She said he couldn't talk to her a great deal, so I knew it was the smile and the flour that did the work.

"Skinnay" invited me to luncheon next door. The German family spoke no French at all. "Skinnay's" German is simply rotten. The meal set before us was as fine as the city afforded. I marveled, because each person is allowed one-half pound of meat each week and other restrictions are almost as strict. Here was "Skinnay" getting the cream of the pantry.

"He always smiles and sings, and the first time I saw him he gave me a bar of laundry soap," the frau said in German.

"I don't know how he does it," the colonel said. "But 'Skinnay' is just "Skinnay," and if he didn't do all these things I suppose he wouldn't be 'Skinnay" at all, but would be known as Sergeant Robinson.'"[30]

Chapter 11: Into Germany with the 42nd and the 89th —January 1919

OPH spent the beginning of January 1919 with Lieutenant Colonel Ruby D. Garrett's 117th Field Signal Battalion as it departed from Mersch and arrived in Consdorf, both towns in Luxembourg.

Echternach

"A very good view of Echternach, Echternachenbrucke and the Sauer River. The arrow [to the left of the twin spires of the church] points to the house where Howard Haverty and I live."[1] – Sergeant J. W. Diefendorf

Because the signalmen were required to lay telephone cable in advance of the rest of the 42nd Division, the 117th was the first of the Division's troops to cross the Sauer River at Echternach and enter Germany. In an article written on Thursday, January 2, OPH reported that because he had been suffering from influenza for several days, Lt. Colonel Garrett had insisted that OPH occupy the colonel's billet "in the biggest house in town." However, after Higgins had slogged through the mud and rain and attempted to gain entrance, he was denied, despite a persistent campaign, which he kept up for over an hour and then, when he was compelled to depart,

211

delegated to the M.P. directing traffic outside the house. Meanwhile, Higgins repaired to the colonel's office, where the two men finally just rolled up in their overcoats and slept on the floor.[2] After that ordeal, Higgins spent time with the 89th Division, reported on a commendation which 35th Division Major General Peter E. Traub sent to Y.M.C.A. Divisional Secretary and newly elected Kansas governor, Henry J. Allen, and in another five articles described in a relaxed tone some of the more humorous aspects of the occupation of Germany.

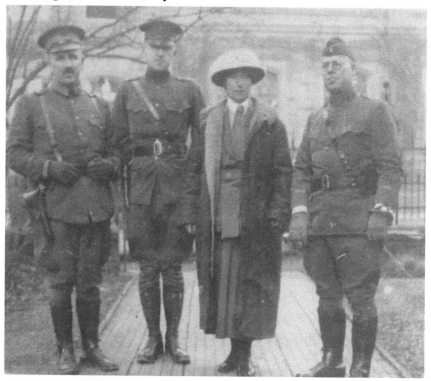

Maude Radford Warren in YMCA uniform and distinctive service hat. Lt. Col. Ruby D. Garret is on the right[3]

The first of these articles introduced Gretchen, a goat the boys of the 89th had found wandering around loose in the St. Mihiel Sector. After various failed attempts to coax Gretchen into yielding milk, G. H. Craig of Rawlings, Wyoming, discovered Gretchen's

secret, which OPH revealed in an undated article appearing in the *Star* on January 4.[4] The article is short, only 181 words, accompanied by a picture, and likely a vignette which Higgins had written earlier in September 1918, when the 89th was actually at St. Mihiel.

Meanwhile, evidence suggests that in the middle of January 1919, OPH had recovered sufficiently from his earlier bout of influenza to spend some time in Cologne and Coblenz, Germany.[5] On December 8, 1918, the A.E.F. G-2-D Press Division Headquarters had moved from Trier to Coblenz, where the American Army of Occupation had its permanent headquarters.[6] Higgins had joined fellow correspondents there in a hotel overlooking the Rhine. "The Coblenz collection of newspaper talent has formed what is known as "The Raspberry Club," a publishing industry periodical reported at the time.[7] "Within is a large picture of the Kaiser, under which is the inscription 'Head Raspberry,'" while on the flank is a photograph of Von Hindenburg, beneath which is the caption, 'First Assistant Raspberry.'"[8]

With tongue in cheek, Maude Radford Warren,[9] a war correspondent herself, described the scene for the *Saturday Evening Post*, and because she mentioned OPH by name, her observations were reprinted in the *Star*.[10] "They may reproach me for saying so," Warren began in reference to her colleagues, "but to my mind the persons who were really 'living the life of Reilly' were the newspaper correspondents in the city of Coblenz. They called themselves the Raspberry Club, and they lived by the Rhine in a comfortable hotel named, as I recollect, the Riesen-Fursterhof, in which, it was said, the Kaiser used to have rooms in those days when he was the Kaiser. They had their own dining room, where they had army mess and were served by as fine a detail of soldiers as I ever saw. They had a big writing room, where they composed the lucubrations that enlightened the world at home, and a big reception

room, where they repaired about 4 o'clock in the afternoon and where I have heard most scintillating talk."

Warren went on to describe the officers of the mess and then listed the correspondents themselves, providing more documentation of the professional company in which OPH worked: "Then there were the correspondents—whom I won't describe in detail," Warren said, "because they were not officers, but merely human beings— Damon Runyon and Otto Higgins and Park Brown and Edwin James and Webb Miller and Junius Wood and Messrs McPhail and Ford and one or two or three others, all excellent writers and likable human beings."[11]

Writing and scintillating conversation weren't the only activities enjoyed by the Razz Club. Poker and, for a time, crap shooting, were also included. "The craps, however, were cut out because of the necessity of setting a good example to the officers," Warren opined. But poker remained. "Visitors liked to come to that Razz room," she remembered. "We had great generals and great magnates and just real people like Will Irwin and Fred Howe. Once a magnate, unbelievably rich, sat down to our humble board and afterward played poker! He did his best to lose, but he won four hundred marks; and then Damon Runyon said sepulchrally: 'To him that hath shall be given.'

Higgins' contributions to the poker pot weren't recorded, but his contributions to the conversation were, especially regarding the hotel staff of locals, who looked after the correspondents. Radford explained: "Susie was one of the three chambermaids who took particular care of the press correspondents—Susie and Erma and a French Alsatian girl whom none of us liked, who had traveled to the Rhineland in company with a French soldier. But Susie and Erma were respectable and rather winning people, especially Susie. To me, they both said that they no longer considered the Rhineland as

Germany since the Americans occupied it, and still they liked the Americans.

"Susie was a little creature who might have been good looking if she had been properly dressed and who talked faster than anyone I have ever heard. That she could get out the guttural German language at such a rate was nothing short of a miracle. When she got really going, it took Otto Higgins and two other correspondents who spoke German really well to translate her for the others. Susie had two great beliefs—that men were tyrants and that Germany was invincible. On these two points she and Damon Runyon had long discussions. As he knew no German and she knew no English, I don't see how they understood each other, but they seemed to.

"'Susie,' he would say, '*Gott is nicht mit the Germans.*'"[12]

"'God is with us!' Susie would reply rapidly. 'Have we not prayed more than any other nation?'

"'*Sure, Gott is nicht mit sie. If he was mit sie, do you suppose he would have turned so many American correspondents loose on sie?*'

"Sometimes those correspondents acted like important writers, or officers, or statesmen, and sometimes they acted like schoolboys," Warren admitted. Her observations of one-liners provide some insight into the wry sense of humor and camaraderie of the correspondents, who, despite their keen competition for an exclusive story and their penchant for bizarre character and gratuitous conflict, nevertheless cultivated an *esprit de corps* as strong as any American doughboy had for his own unit.

"Now and then I have heard two of them make remarks to each other of such a nature that if two women had said them, they would never have spoken together again, and yet next morning the two men would be amiably passing each other the butter and the condensed milk," Warren noted.

215

"The end of a perfect day was sometimes the remark, 'I've a mind to hit that fellow a clip on the jaw.'

"But the beginning of the next day would be, 'Well, old top, what's on your program for the morning?'"

Warren couldn't resist the story potential of such contentious behavior, or the unique ways in which the correspondents had of expressing it, so she reported on the reporters. "It was my chief delight," she admitted, "to wander from group to group and hear such detached remarks as these:

"'Let me loose for an hour with a butcher knife in that Mexican church full of paintings, and I'll promise never to come back to Mexico.'

"'They're ripe for a row. I'm going to take a ring-side seat and egg 'em on.'

"'She asked him to take care of a white wooly dog with a black head, and he came back a raving nut.'

"'He makes a speech every time he sees you. All he needs is a table and a glass of water.'

"'His wife has come, and he is more querulous than ever.'

"'He makes favors and then he coppers them.'"[13]

"Stirring days those were up in Coblenz," observed Warren, as the correspondents took stock of their work. And as their time overseas drew to a close, their own appreciation for the unique opportunity they had experienced began to dawn on them. "It used often to be proved," Warren said, "by such remarks as:

"'I don't know what I'll do when I have to report at a newspaper office at the same old hour every morning.'

"'I know darn well I am going to look back on this time and say "What was the matter with me that I didn't know what a good time I was having?"

"Yes, take it by and large, and fore and aft, and from the beginning of the war to the end," Warren concluded, "newspaper

correspondents, in spite of hard and conscientious work, were more than anyone else really living the life of Reilly."[14]

For all of the easy life Warren claimed the correspondents enjoyed in Coblenz,[15] Higgins did not remain there with the Razz Club very long, and by January 20, he was back with the 355th Ambulance Company, 89th Division, which, originally, had been Red Cross Ambulance Company No. 24, raised in Kansas City by Captain Ernest W. Cavaness. According to the 89th Divisional history, "this company established the gas hospital at Bouillonville, and while in that sector operated its ambulances, not only from the regimental dressing stations, but even directly from the front line trenches on occasions."[16] Now, however, the 355th was serving with the rest of the 89th Division as part of the Army of Occupation stationed in Bitburg, Germany.

As the commanding officer of his unit, Captain Cavaness had the task of reading and censoring the correspondence of his men, but the task had become increasingly frustrating.

"'Every time I am in a hurry,'" Captain Cavaness said, "'along comes two or three of these letters that look like a Chinese laundry advertisement, and the War Department expects us to read through and censor them.'"

To address the situation, Captain Cavaness set up a school that met for thirty minutes every morning in a vacant boche school building. Student attendance was voluntary, for the most part, although some were, as OPH discretely put it, "'drafted'" to attend classes in penmanship, English, arithmetic, and even German—all conducted by two graduates of the Normal School in Warrensburg, Missouri, along with a former reporter from the *Kansas City Star,* who held a university degree in English.[17]

Academic improvement was not the only troop concern to be addressed during the occupation. All staff officers and men "whose duties required them to sit at a desk for the better part of the day"

were required to exercise at least five hours a week. Naturally, the men selected dancing as their preferred physical activity, and for partners, they selected the young women of the Y.M.C.A., the Red Cross, and the nursing corps—all of whom obliged, until the Surgeon General determined that the nurses had received enough exercise during the day that they had no particular need of engaging in any more at night.

In addition to dancing, Captain Paul Withington, Division Athletic Director, set up basketball teams, and arranged for wrestling and boxing matches. The athletic program was so successful that the 89th's team won the A.E.F. championship in football.[18]

Not everyone, however, qualified for the football team or displayed an interest in basketball, wrestling or boxing. Instead, certain members of the 355th Ambulance Company and the 314th Motor Supply Train, now themselves sufficiently accomplished at dancing, but still somewhat chagrined at the Surgeon General's previous pronouncements on the health needs of potential female dancing partners, elected to give a ball. Fraternization with the Germans was strictly forbidden, of course, and only two American women were stationed close enough to accept invitations. As a result, one of the women, Y.M.C.A worker Miss Josephine Russell, formerly of Chicago, accompanied by an interpreter, canvassed the houses in Bitburg and, with some difficulty, procured dresses, wigs, women's shoes and hats in quantities sufficient enough to address the deficiencies in the number of female partners, at least to all appearances.

Even so, Sgt. Walter G. Chestnut, who had lived at Linwood and Main in Kansas City and now served as master of ceremonies and front door guard, was put to some lengths when approached by an attendee who had made particularly convincing use of the procured attire and responded in fluent German when challenged at

the door. It was only with the removal of a wig that equanimity could be restored. OPH reported another similar stir when a figure plumed and braided like a boche general later turned out to be sporting a German mail carrier's Sunday uniform.[19]

From that point, it was only a short stretch of imagination for the boys of the 355th to begin rehearsals for a farce, which they entitled, "'Oh! La! La!,' a very common expression in France, which," OPH noted, "may mean anything, depending upon how you roll your eyes, shrug your shoulders, and manipulate your hands." Higgins then went on to describe the production in much the same language as a theatrical publicist might employ in advertising an evening's entertainment at a local venue.

The last of the seven articles OPH sent the *Star* in January 1919 was written in a more sobering tone on Tuesday, the 28th. "Modification in military censorship now permits free mention of casualties for the first time since America entered the war," Higgins wrote. For the 89th Division, "the entire casualties, including killed, wounded, and missing were 8,473, according to a report issued January 22," and covering the period from August 6 through November 11, 1918.[20]

The occupation might have its lighter moments to relieve the boredom and sustain the strength and morale of the men, but the reality of the cost in lives during the preceding months of war could not ever be forgotten.

MEN OF THE 89TH LEARN GRETCHEN'S SECRET

(From The Star's Own Correspondent.)

WITH THE 89TH DIVISION—The boys found Gretchen wandering around loose in the St. Mihiel sector. Gretchen's duty in life evidently had been to furnish boche officers with fresh goat's milk daily. Being tired of the milk that came from tin cans, the boys looked to Gretchen. However, she didn't agree, even if they would rope and throw her, scold, tease, or coax her.

The next day the boys were moving some things out of town on a boche train and decided Gretchen should go along. She liked the rolling motion of the train and the boys could not coax her away. Gretchen let the boys scratch her head, ruffle the hair on her back and tickle her ribs.

"I'm going to try again to milk this goat," G. H. Craig of Rawlings, Wyo., said. He gave Gretchen a sandwich and backed her against a flat car. Gretchen was a mild as a kitten. She munched on the sandwich until Craig's cup was full of milk.

Craig had found Gretchen's secret, and unless she was backed up against a train no one could milk her.

O. P. H.[21]

MEN OF 89TH ATTEND SCHOOL.

The Three "R's" Wooed by Soldiers
In a German Village.

(From the Star's Own Correspondent.)

WITH THE 89TH DIVISION IN GERMANY, Jan. 20.— Capt E. W. Cavaness,[22] commanding the 355th Ambulance Company, organized in Kansas City and attached to the 89th Division, when he was censoring letters during the war, said frequently,

"If this war is ever finished, I'm going to open a school and teach certain young men how to write and spell. Every time I'm in a hurry, along comes two or three of these letters that look like a Chinese laundry advertisement, and the War Department expects us to read them through and censor them."

Captain Ernest W. Cavaness' censor stamp A2156 and signature.[23]

Captain Cavaness stuck to his word. The company now is quartered at Bitburg, a pretty town in Germany, and as there isn't much for the men to do, the captain has opened a school. Attendance is voluntary, for the most part, but there are certain men who were "drafted" to attend, whose names the captain had his eyes glued on every time he had to censor one of their letters.

Half-hour sessions are held every morning in a vacant boche school building. The rules are strict and there is no 'playing hooky' or 'being tardy.'

They have experienced teachers in the school. Pvt. Charles Brady teaches penmanship and arithmetic. He is a graduate of the Warrensburg Normal School, and by profession was a teacher, so the men have a good opportunity to develop.[24] Sgt. Anthony Willibrand, also a graduate of Warrensburg Normal, teaches German.[25] He talks perfect German, as he taught the language after leaving the normal. Volunteers attend the German classes. Montgomery Wright, formerly a reporter on the *Star* and a graduate of the University, teaches English.[26] Wright is the only instructor who never has had any teaching experience, but he has specialized in literature. He also acts as truant officer. The school will continue until the men are discharged.

O. P. H.[27]

Soldiers enjoyed a "franking privilege" by simply designating "Soldiers Mail" where a postage stamp would normally appear.[28]

OVERSEAS "DESK" MEN DANCE.

Terpsichors Chosen as Form of Exercise for "Inside" Soldiers.

(By The Star's Correspondent).

WITH THE 89TH DIVISION IN GERMANY, Jan. 20.— Now that the army is not moving from one sector to another almost every day, there are certain men and officers whose duties require them to sit at a desk for the better part of the day. It was for their special benefit that a rule was passed making it obligatory upon all staff officers and men who worked inside to take five hours exercise a week.

Many officers in the division claim the honor of discovering that dancing could be classed as an "exercise," and the regulation has now been lengthened to include horseback riding, with physical exercise taken either alone or under the direction of the division athletic director.

Dancing is the most desirable form of exercise that the men have found. There usually are three dances a week in the division and one would believe all officers from the entire 89th were taking their prescribed form of exercise. Their work is sometimes broken, as there aren't enough girls to 'go around.'

The Y. M. C. A. in addition to its other duties, furnishes a lot of the young women. The Red Cross does its share, and until a few nights ago the nurses always participated in making the 'exercise' nights enjoyable. Now that is strictly '*defendu*'[29] as the surgeon general ordered that the nurses got enough exercise in the day, and do not need any at night.

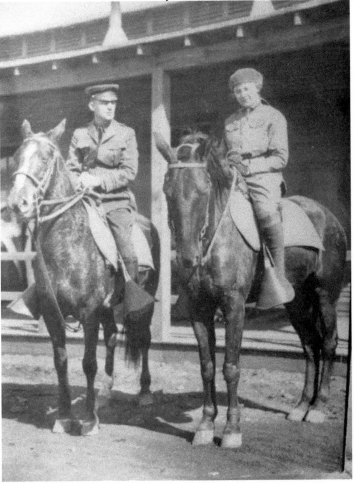

"Red cross nurse and a field secretary off for an afternoon's ride."[30]

Capt. Paul Withington, athletic director, who held the same position under Maj. Gen. Leonard Wood when the division first was organized at Camp Funston, still is directing athletics. Captain Withington is forming basketball teams throughout the division, as well as boxing and wrestling groups and in a few weeks expects to have the old Camp Funston schedules in running order again.[31]

O. P. H.[32]

NO BOCHE AT 89TH DANCE

BOYS ATTIRED AS FRAULEINS WERE FORCED TO PROVE IDENTITY.

One Chap, Who Appeared in a German Postman's Sunday Uniform, Caused A Sensation—Practicing on a Farce Now

(By The Star's Own Correspondent).

WITH THE 89TH DIVISION IN GERMANY, Jan 25—Fraternizing with the Germans is against all army regulations, but that didn't hinder the men of the 355th Ambulance Company and the men of the supply train in giving a ball the other night, although it did produce difficulties.

Because of the territory over which the 3rd Army is scattered, it was possible for only two American women to accept invitations—Miss Josephine S. Russell[33] and Miss Laura Hatch,[34] Y. M. C. A. workers from Chicago.[35] So it was decided the dance should be a masquerade affair and some of the boys would attend dressed in feminine attire.

Miss Josephine S. Russell, 1918.[36]

Miss Russell and an interpreter were two days in a house-to-house canvas of Bitburg, seeking suitable clothing. Clothes are scarce in Germany, but after great difficulty, Miss Russell produced a quantity of dresses, wigs, women's shoes and hats.

BARRED THE BOCHE "GIRLS".

The ball was held in the "gym." Sergt. Walter G. Chestnut, Linwood Boulevard and Main Street, Kansas City, was master of

ceremonies and guard of the front door.[37] He faced annihilation several times when he refused to permit soldiers who applied for entrance carrying coy looking boche girls on their arms. Of course, it wasn't up to the frauleins to do any explaining and their partners didn't wish to reveal the secret, but the sergeant was adamant and the 'girls' always were forced to prove their identity.

Miss Laura Hatch, 1918[38]

The outlook was serious for Chestnut once, however. One of the boys appeared with a good-looking girl, who spoke German fluently. She was dressed magnificently. When the sergeant questioned her, she replied in boche. Several Yanks standing by helped the affair along by trying to argue Chestnut down, and a crisis was just averted by the 'fraulein' jerking off a wig while everybody but Chestnut—laughed.

A sensation was caused later in the evening when a figure, attired like a couple of boche generals, with gold lace and silver braid, plumes on his hat and bells on his feet, paraded down the center of the hall. The comment was at its height when someone shouted:

'Throw him out!'

The furor was quieted when the figure explained he was not a member of the 'Prussian Guard,' but was an 89th boy dressed in a boche mail carrier's Sunday uniform. He got away with it.

Fred Thayer, 2904 Linwood Boulevard, and 'her' dancing partner, Edward A. Andruss, Holden, Mo., won first prize, a box of candy from 'The States.' Dressed as a cavalier and his senorita, their Spanish dance was a feature.

Dan F. Porter, Kansas City, did some lively 'stepping,' even if he was a 'grandmother.' He is an excellent dancer and rather showed the younger folks what the steps were back in 1917.[39]

PLANNING A FARCE NOW.

At present the boys are rehearsing a farce—'Oh! La! La!'—a very common expression in France, which may mean almost anything, depending upon how you roll your eyes, shrug your shoulders and manipulate your hands.

The scene is laid in a Y. M. C. A. hut somewhere in the S. O. S., which means 'Service of Supplies,'[40] and the action centers around the trouble which results when the 'Y. M. C. A. lady,' played by Miss Russell, the only woman in the cast, leaves 'Sergeant Rough' and two buck privates to entertain the 'Countess de La La,' who was educated in a London Music hall, and her two beautiful daughters.

The cast includes Miss Russell as the Y. M. C. A. secretary; Andruss as Sergeant Rough; Sergt. Elmer Howard, Salisbury, Mo., as Major Trowbridge; Sergt. John Diefendorf, Otterville, Mo.[41], as Mr. Parsons of the Y. M. C. A; and Fred Thayer of Kansas City as the Countess de La La. Rosette and Posette, her two daughters, are to be enacted by Sergt. Anthony Willibrand, Freeburg, Mo.[42], and Herbert Coulan, La Crosse, Wis. Sergt. Eugene O. Petty, Liberty, Mo., is Jack Hogan. Arthur Van Raensalar and Corp. Montgomery Wright, patrons of the hut.[43]

The quartet, which will furnish the major portion of the music, is composed of Sergt. Hallie Baker, Corp. Byron Arbuckle,

Wagner Dale Warrick and Price Cordier, all of Kansas City. Sergeant Chestnut is producer and stage manager.

O. P. H.[44]

Chapter 12: Back to the 35th—February 1919

For OPH, February of 1919 was a bittersweet month. He spent almost the entire time with the 35th Division, which, since early November, had established its headquarters at Commercy.[1] The four articles he sent to the *Star* during this time were either reports of celebrations or remembrances of the dead; even in the celebrations, the memory of those missing, wounded or buried could not be forgotten. Thoughts of home occupied the minds of the men, and throughout the articles, OPH noted how much the area over which the men marched, entrained or were billeted reminded them of the Kansas countryside and of home.

The connection with home was never far away. Included here with the February articles is a humorous piece published in June about an unusual train ride OPH had taken in February with a sailor he met in the Commercy train station. The sailor was on leave from his ship at port in Brest and had been visiting a buddy in the 140th Infantry, stationed near Commercy. Offering chocolate, OPH struck up a conversation with the sailor and discovered a mutual acquaintance—another example of how the same camaraderie which appears in the articles written during the month established an instant bond with home and provided the basis for adventure abroad.

A celebration of home was the subject of the first of the four articles composed in February. Written on Monday, February 10th, the article recalls the night of Wednesday, January 29th, "Kansas Day," the fifty-eighth anniversary of the state's admission into the Union. Higgins spent that evening with the men of the 137th Infantry "in three half-destroyed French villages," where the separate battalions held their own distinct celebrations.

"The Jayhawkers forgot all about cold billets, wet feet, darkened streets, shell-shattered houses, bully beef and front line trenches," OPH wrote. "They thought only of Kansas, garden spot of the world, some six thousand miles away. Gosh, you can think of

a lot of nice things in Kansas when you are six thousand miles away, living in a half-ruined French village."

The regimental officers shared their thoughts of Kansas in the *mairie*, the town hall, at Sampigny, while the men in the battalions shared their thoughts in the Y.M.C.A. huts scattered through the villages where they were billeted—villages such as Courcelles or Menil-aux-Bois, just south of St. Mihiel. "And so it came," Higgins concluded, "that three partly ruined villages in France, accustomed to the whistle of shells or the bur-r-r of boche avions, rang with the old 'Rock Chalk Jay Hawk,' yell instead."[2]

The next week, OPH attended another celebration, this time a farewell dance given by the officers of Kansas City's 140th Infantry in a vacant building at Base Hospital 91 in Commercy. Thoughts of home were again on his mind. "It was just like a homecoming," OPH observed. "Or at least just like we who have been over for many months dream that a homecoming would be like. On every hand, fellows that you know, fellows that you haven't seen for weeks, months and some for years, all of them glad to see you, all of them happy and wearing smiles, and everything lovely."

Two-thirds of the guests were officers, while a third were women serving as Army and Red Cross nurses or staffing the "Y" huts. Higgins saw familiar faces, like Colonel Carl Ristine, commander of the 139th Infantry, or 140th Infantry officers Lt. Fred W. Buell, Major Bill Smith from the Old Missouri Third, Capt. Joe Salisbury of Sedalia and Capt. Robert K. Brady from Richmond, Missouri.

But "there were quite a few who were missed," OPH remembered. "Some were lying out there under the muddy clay of the Argonne with a little white cross to mark their final resting place, while some were back in the States convalescing at

hospitals." Too many were "old pals, who would never dance again."[3]

It was the white crosses over men who would never dance again that received Higgins' attention in the last two of the February articles. Writing from Commercy on Wednesday, February 19, OPH poignantly described a visit he made to the battlefield where the 35th had fought in the Argonne. At the suggestion of W. Y. Morgan of Hutchinson, Y.M.C.A. educational director for the 35th Division, and the master of ceremonies at the Kansas Day celebration OPH had attended earlier in the month, Higgins "yielded with a sickening dread of seeing again those hills and valleys that flanked the River Aire from Neuvilly to Exermont."[4]

Again, OPH was reminded of home. "We came to where the tanks made their first big attack," Higgins recalled. "It was just south and southwest of Vauquois Hill. Glancing over this particular battle ground from the motor car was just like looking at a Kansas Farm in January. Mud, a little drifting snow, a little barbed wire, dead underbrush and shrubbery and dead grass."

"Pictures that I don't like to recall rise up," Higgins wrote. He gazed at the spot where Vic Stark had lain wounded on a litter in the rain and mud, and at the dugout that had served as a dressing station. He fixated on the mental image of Captain James C. Kenady "lying wounded unto death."

"'I got mine,' Captain Kenady had told Higgins, 'but I was right out in front leading the men, and we sure made the boche like it. Do you think you can get a cablegram through to my wife telling her that I am O.K.?'"[5]

Whether OPH was able to send the cablegram to Lydia W. Kenady in Dexter, Missouri, is not part of the written record, but it is recorded that the War Department notified her that her husband had died of wounds on October 17, 1918.[6] Higgins knew that too and could not forget.

Nor could he forget the picture in his mind of "a row of seven doughboys lying beside an unused road, each lying on his side with his head toward the boche lines, tightly grasping his bayoneted rifle." "They seemed to have become tired carrying their packs," Higgins recalled, "and just sort of sunk down in the mud for a rest, tired and peaceful. The same boche machine gun got them all while they were advancing."

Along with the word pictures so vivid in his article, OPH sent to the *Star* a photograph of W.Y. Morgan standing in front of one of the dugouts that had served as 35th Division field headquarters at Cheppy. OPH also sent a picture of the dressing station nestled into the side of a hill, where the casualties had been taken, and, finally, he included a picture of the white crosses, row on row over the winter mounds of graves still bare of grass on the slope of a hill in the Argonne.

Three days later, on Saturday, February 22, OPH cabled from Paris the official figures on the casualties the 35th Division had taken in France. Of the 8,000 killed, wounded, missing, or dead from wounds, 6,967 had occurred in the Argonne.[7]

Longing for home, the men of the 35th Division were haunted by the images of the comrades they were about to leave behind, already at rest in their final home. Writing from France, OPH was preparing the folks at home for the images the boys would carry with them inside when they finally did return to Kansas City.

KANSAS DAY IN FRANCE

MEN IN THE 137TH INFANTRY CELE-BRATED STATE'S BIRTHDAY.

A Program Was Given for Each Bat-talion and the Regiment's Offi-cers the Night of January 29, O. P. H. Writes.

(From The Star's Own Correspondent.)

WITH THE 35TH DIVISION, Feb. 10.—It might have been the auditorium of Hutchinson. It might have been the Odd Fellows Hall at Fredonia. It might have been the court house at Holton. It might have been in any number of town halls scattered through Kansas the night of January 29, the anniversary of the admission of the state into the Union.[8]

Wherever they may be on that date, Kansans get together and celebrate. But of all such celebrations none probably was more unique or more generally attended than the three held by members of the 137th Infantry, an all-Kansas unit,[9] in the three half-destroyed French villages where the men were billeted.[10]

So many Kansans were stationed near the villages that four distinct celebrations were held.

The Jayhawkers forgot all about cold billets, wet feet, darkened streets, shell-shattered houses, bully beef and front line trenches. They thought only of Kansas, garden spot of the world, some six thousand miles away. Gosh, you can think of a lot of nice things in Kansas when you are six thousand miles away, living in a half-ruined French village.

Each battalion had its own celebration in the 'Y' huts,[11] while the officers of the regiment had a celebration all their own in the 'Marie' at Sampigny. 'Marie' isn't a girl's name, but the French

for 'city hall.' The French, I think, spell it 'Mairie.' But we all call it 'Marie.' The dictionary, as usual, doesn't give it.[12] W. Y. Morgan, former lieutenant governor of Kansas and now a 'Y' worker attaché to the regiment, presided over the program. The hall was decorated with evergreen, paper sunflowers and Kansas posters.

It wasn't a 'cut and dried' celebration. Everybody had a good time smoking, eating and telling of Kansas. Now and then some Kansas man would arise, call the meeting to order, and speak briefly. Col. Ira L. Reeves, regimental commander, talked first. He was followed by Maj. Fred L. Lemmon of Hutchinson, who is with the 140ᵗʰ Infantry;[13] Maj. John H. O'Connor of the 137ᵗʰ;[14] Maj. Carl White of Topeka, division paymaster;[15] Captain Hughes and Lieutenant McFarland of the 130ᵗʰ Field Artillery;[16] and Lieutenant Woodard of the 139ᵗʰ Infantry.[17]

The Kansans of the 1ˢᵗ Battalion, including the headquarters, machine and supply companies, held their celebration in the supply company's new mess hall. Secretary Bader of the 'Y,' who is from Atchison, Kas., presided.[18]

The mess hall was all dressed up like the Piney Ridge School House on Christmas Eve.[19] Lieut. Eustace Smith of the 140ᵗʰ Infantry, who in private life is a lawyer at Hutchinson, did most of the talking.[20] The roll of Kansas counties was called and nearly everyone was represented in that portion of the regiment. The boys put on a mock trial and then listened to talks by F. E. Barr of Wichita, regimental supply officer; Lieut. Paul J. Simpson of McPherson, regimental transport officer; Capt. D. J. Wilson of Hutchinson, commanding Company E; Capt. Harvey Rankin of Hutchinson of Company H and Lieut. Fred B. Ewing of the supply company.

The 2d Battalion, stationed at Courcelles, held its celebration in the big 'Y' tent. Major Lemmon, who for years was a member of the old 2ⁿᵈ Kansas, and Mr. Morgan addressed the boys, who put on

a short program of their own, assisted by Ray Richardson of Fredonia, a 'Y' worker.[21] Cocoa and cakes were served and the celebration closed in a stag dance.

At Menil-aux-Bois, the Kansans of the 3rd Battalion celebrated in the 'Y' hall. Mr. Morgan and Major Lemmon visited them and spoke briefly.

And so it came that three partly ruined villages in France, accustomed to the whistle of shells or the bur-r-r of boche avions, rang with the old 'Rock Chalk Jay Hawk' yell instead.

O. P. H.[22]

THE 140TH GAVE A DANCE

FAREWELL PARTY BROUGHT TOGETHER MANY HOME FOLK.

What Mattered It If Roads Were Bumpy and Muddy and the Floor Was Uneven. There Were Real Music and Girls.

(From The Star's Own Correspondent.)

WITH THE 35TH DIVISION AT COMMERCY, Feb. 16.— It was just like a homecoming. Or at least just like we who have been over for many months dream that a homecoming would be like. On every hand, fellows that you know, fellows that you haven't seen for weeks, months, and some for years, all of them glad to see you, all of them happy and wearing smiles, and everything lovely.

It all happened last night in a vacant building at Base Hospital 91 at Commercy, where the 140th Infantry officers gave their farewell dance. These farewell parties over here are just like they used to be in the States. Some units have been having 'farewell' parties for three months and are still working at it.

INVITED NURSES AND Y.M.C.A. GIRLS.

The officers of the 140th decided to wind up their army career in France in a round of gayety. There wasn't anything else to give, so they gave a dance and invited all the nurses and 'Y' girls from all round the neighborhood to attend, as well as all the officers of the regiment, those who formerly belonged to the outfit, the general officers of the division, and most anyone else.

The orchestra was there in full force, an orchestra organized from the men of the band and it is one of the best in the A. E. F. The hall was decorated with the insignia of the regiment and

evergreens that the boys gathered in the hills. Behind the refreshment stand, where lunch, sandwiches, cigarettes, chocolates, and chewing gum were served, stood Capt. John Pleasants, formerly a Kansas City policeman, whose sole duty it was to see that everyone was supplied with everything he desired.

INVITATIONS WERE VERY FANCY.

The invitations were drawn and colored by hand, and delivered in person by couriers riding motorcycles. My invitation had for the frontispiece, a spread eagle standing on the regimental insignia, which was set into the regimental colors. To the right was a pen and ink sketch of the sky line of New York with our old friend, the Goddess of Liberty, standing in the foreground.

The detachable leaf on the inside was printed in ink, and informed me that 'the officers of the 140th Infantry requested my presence at their farewell dance to be given at Base Hospital Ninety-one.' Down in one corner was painted a book with a pen and a bottle of ink resting on it, while a shell was exploding just above it.

The artists who were responsible for the decorations and invitations are members of the intelligence department, and ordinarily work on making maps. They are J. M. Yadon of Kansas City, a draughtsman, Felix Kubicki, a Kansas City artist, and C. E. Tenney, a draughtsman from Shelbina, Mo.

MUD DIDN'T MATTER.

The big park in front of the hospital was crowded with ambulances and trucks. In arriving there the girls were assisting each other out of the cumbersome high army trucks into the mud and half frozen slush below.

The floor of the improvised ballroom was of marble blocks and had been freshly scrubbed. It wouldn't rank very high as a dance floor, but the water on it coupled with the mud on the dancers' feet, helped matters somewhat. A regulation check stand

was in one corner, where you could check your wraps and side-arms. In the opposite corner Captain Pleasants held forth with his refreshments, and the band occupied the stage at the end.

The dancers occupied only half the floor. Two-thirds of the guests were officers, while the other third consisted of women connected with various branches of the service.

OLD FRIENDS AT THE DANCE.

The first familiar face that I bumped into was Fred Buell. Fred was promoted to a first lieutenancy immediately after the Argonne fight.[23] Col. Carl Ristine was flying around.[24] Maj 'Bill' Smith, one of the old timers from the Third, and promoted to a majority after the Argonne, was acting as a floor manager.[25]

It was there that I found Capt. Byron Dudley, of Kansas City, Kas. Capt. J. H. Salisbury of Sedalia, who had gone up a notch and added another bar to the one on his shoulder the last time I saw him, when he was trying to get a transport of supplies over the shell-swept roads of the Argonne, was essaying to dance. Capt. R. K. Brady of Richmond, another one of those who went up after the Argonne, was there.

PALS WHO WERE MISSED.

There were quite a few we missed, old pals, who would never dance again. Some were lying out there under the muddy clay of the Argonne with a little white cross to mark their final resting place, while some were back in the States convalescing at hospitals.

Most of the conversation centered about things at home, what we were going to do when we got back, when we were going back, and what Congress would do with Governor Allen's charges,[26] the Prohibition Law[27] and a lot of other things that had nothing whatever to do with war.

And at 11:30 o'clock, the time the nurses had to be in Saturday night, the farewell dance of the 140th Infantry, the old Third and Sixth Missouri, ended.

O. P. H.[28]

GOT TO PARIS 'TOOT SWEET'

AT THAT, A GOB AND O. P. H. WERE
ON THE WRONG TRAIN.

"You Can't Tell a Darn Thing About
These French Trains," an M. P. at
Commercy Had Told Them—
Why they Couldn't

The little shell-shattered railroad station at Commercy was packed with men waiting for the Paris-Metz express, due at 9 o'clock.[29] It was some three months after the signing of the Armistice, and the night was cold, that damp, piercing cold so peculiar to a French winter. In the waiting room were many French *poilus*, some going home on *permission*, some to the demobilization camps, some returning from their *permission*, and some going from one camp to another.

This postcard view of the train depot at Commercy was taken in 1910 and shows how the station looked before it had sustained damage in the war. (Author's collection).

All the benches were taken, and be-whiskered figures dressed in sky blue covered the floor. Some were lying on the hard floor sound asleep, their raucous snores vibrating even above the talk and laughter of some of their comrades. A few men were munching hunks of hard, dark bread and washing it down with the *pinard* from their canteens.[30] The Alpine *chausseur*, in his dark blue, close-

fitting uniform with the jaunty little cap perched on one side of his head, kept himself aloof from the *poilus*, not joining in the fun, the eating or the snoring. The stripes on his arm showed three years' service on the front, three wounds; displayed on his left breast was the cross of the *Legion d'Honour*, the *Croix de Guerre* with four palms, and over his shoulder was the pretty looped cord showing his regiment had been cited six times.[31]

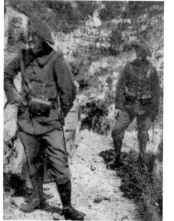

ALWAYS THE U. S. M. P.

Now and then one of the American military police would come in, his automatic strapped tightly about the waist of his overcoat, to try and thaw himself out in the warm, stuffy, ill-smelling room.

The Alpine chausseur. (Author's collection)

A figure in blue, lying on the floor, his head resting on the leg of a *poilu*, stirred himself, raised up and inquired:

'Say, Bo, has that 10 o'clock train come through yet?'

'It won't be in until 12 tonight,' the M. P. answered. "And then again, it might not come until 1. You can't tell a darn thing about these French trains."

The figure on the floor was an American sailor. He gathered up two old dirty shells and a rusty boche helmet and placed them between his legs, so they would be safe before he rubbed the sleep out of his eyes with both fists.

'Have some chocolate?' I asked him, chocolate being the *piece de resistance* of every American traveler in France.

'Sure, Mike,' he said. 'I've been hanging around this depot since 9 o'clock tonight, but I don't mind it as long as this Frog don't move his legs too much. Did you know that a "Frog's" legs make a

mighty comfortable pillow? Well, they do. You going to Paris, too?'

'Yes,' I said. 'I'm going at midnight on the 10 o'clock train. You are a long way from salt water for a gob.'

SEEKING A MISSOURI "BUDDY."

Yes, but I'm on a 2-week leave and I came up here to see a buddy of mine in the 140th Infantry,' he said. 'He and I used to go to school together down in Mexico, Mo.'

'Mexico, Mo?' I queried. 'You should know Sid Houston, christened Algernon.'[32]

'Sure, I know Sid. He used to work on the newspaper there,' was the answer.

I placed my *musette* and typewriter on the floor and squeezed over, making room for him on the hard wood bench, and we became very chummy.

He was H. J. Williams, sailor on board the destroyer *U.S.S. Conner*, headquarters at Brest.[33] His chum in the 140th was Corp. W. R. Ballew of Company A, also of Mexico.[34]

'I never saw any battles,' he remarked after washing down the chocolate with a little *vin ordinaire* from my canteen. 'So when I got my leave I thought I would run up here for a couple of days to see what a battle field really looked like. Been out all day tramping through the mud in the Mihiel sector looking at it and trying to find souvenirs. The doughboys must have had a tough time living up here in the mud. Me for the briny every time. The more I see of the front, the more I appreciate my hammock and the salty sea.'

NO TRAIN AT 12 O'CLOCK.

Conversation languished and again we both dozed off, and maybe we joined the 'Frogs' in their nasal melodies. Twelve o'clock came and went. There wasn't even a toot in the railroad yards. A little later a head was thrust through the door.

243

'She's coming through in two seconds,' one of the M. P.'s remarked casually. 'The first section should be along presently.'

The noise of a locomotive slowing down in the yards was heard. Everybody made a rush for the door, *musettes*, canteens, kit bags and all other things a French soldier carried hanging form his shoulders, jamming the doorway. The train had stopped in the yard below the station while the locomotive took on water.

'The second section is running twenty minutes behind this one,' the M. P. called out.

In a few minutes the platform was filled. The engineer gave a couple of toots with his whistle, and began moving towards the platform, where we were all waiting in the cold drizzle that came down through the broken glass of the one-time sheltering roof. As the train neared it gathered speed, and by the time it reached us it was going at a fairly good rate. It kept on gathering speed, and in about two minutes disappeared down the track.

Everyone swore. It was the second section for us. Everybody crowded back into the waiting room.

'Here she comes, men,' an M. P. who stuck his head inside the door some forty minutes later, called.

A RUSH, BUT IT WAS NO USE.

We could hear the rumble of the train as it bumped over the switches down in the yards and see a faint glow in front of the station from the little kerosene headlight as we all tried to get through the door at once. The engineer didn't even whistle. He just sailed on past, caring not whether we ever got to Paris.

Back to the waiting room again. A little later the M. P. came in again and announced that another section would be through in thirty or forty minutes. So this time we weren't taking any chances. The gob and I went outside and walked up and down to keep warm. We weren't going to get caught in any jam again if we could help it

and we weren't going to miss any trains. We had to be in Paris by morning.

A bright headlight—it looked like an electric light—appeared down the track. In a moment we could hear the rumble of the wheels and in another the grinding of the brakes. The Frenchmen began to yell as they squeezed through the door, and I began to run, the gob from Mexico after me. I was going to get that train if I had to break a leg, and the gob was going to follow my lead.

'Hey! Hey! *Ou allez-vous? Attendre! Attendre!'*

That and similar cries were coming from the rear. I looked around and saw six or eight French railroad men following the gob, running on high. I didn't stop running and neither did the gob.

We reached the engine. Passed it. Passed one sleeping car and another and another. There were five in all before we reached a first class carriage. We couldn't understand it, for the Paris-Metz express usually carried but one, but we had no time to ask questions. The train might pull out at any time, and we either were going to leave with it or die trying.

HELD THE DOOR AGAINST ODDS.

The handle on the door to the carriage turned easily, and I climbed in. The gob came after me, and the string of 'Frogs' after him. I slammed the door, ducked, and the two of us held it shut while the yelling Frenchmen tried to open it. The train started, and one of them climbed on the step, beating on the window and shouting something at us in French, which we, of course, couldn't understand. As it gathered speed the Frenchman dropped off. The station quickly slipped behind us. The crowd on the platform shook their fists and yelled. It was the third train through that night, and all trains were scheduled to stop at Commercy. But we cared not.

We were on board. Neither did we know where we were going, but anything was better than the foul-smelling station.

I started down the aisle to look for a seat. The aisle was empty, something I had never seen before. I pulled open a door to the first compartment. This, too, was empty. Again, I was surprised. Usually the train is so crowded you can't even find room to stand up in the aisles. I couldn't understand it. With a flashlight we arranged the seats on either side, drawing them out and putting the side arms in place for a pillow. French first class compartment cars are made so the seats can be turned into beds—and I told the gob he could go to sleep. I closed the door, fastening it shut with a magazine, drew the curtains and turned in. Five minutes later we were sound asleep on comfortable beds.

About 7:30 o'clock that morning I awoke and found the train at a standstill. Looking out of the window I recognized the station as being the *Gare de l'Est* in Paris. Awakening the gob, I told him we were there. I couldn't understand it, and neither could he. As far as we knew, the train had made no stops since we left Commercy, but even at that, it wasn't due until after 9 o'clock, even though it ran on schedule. I drew open the door. The aisle was empty. We both jumped down on the platform. There wasn't any hurried crowding to the doors by the passengers.

AND STILL NO PASSENGERS.

In fact, we didn't see any passengers. Several Allied officers were standing near one of the sleeping cars. Soon more came out. There were British, French, American and a few Italian, all well dressed, the Sam Browne belts highly polished and strings of service ribbons and medals on their chests. They moved off to the right and walked through a private entrance, where any number of handsome, highly polished limousines stood, their doors being held open by soldiers in various uniforms. We couldn't understand it. So I

stopped a British officer and inquired about the personnel of the train.

'This is Marshal Foch's private train,' he answered. 'The marshal and the Allied commission were at Treves yesterday to meet the German peace commission concerning an extension of the Armistice. We are just coming back to Paris.'

O.P.H.[35]

SCARS OF ARGONNE PASS

"O. P. H." GOES BACK TO THE SCENE
OF THE 35TH'S GLORY.

Even Division Headquarters Has
Changed, but the Many, Many
White-crossed Graves Tell
The Story of Heroism.

(From The Star's Own Correspondent.)

WITH THE 35TH DIVISION AT COMMERCY, Feb. 19.—
W. Y. Morgan of Hutchinson, Kas., educational director of the 'Y'
with the 35th Division, desired to visit the old battle ground of the
Argonne. I yielded to his invitation to accompany him; yielded with
a sickening dread of seeing again those hills and valleys that flanked
the River Aire from Neuvilly to Exermont.

Thinking of the Argonne recalled rain, mud, cold, traffic
jams miles long, the roar of our artillery and the explosion of boche
shells, the dead lying on the hills and the wounded all about, unable
to be moved for lack of transportation and because of the jams
behind us.

Pictures that I don't like to recall rise up. I can see the spot
where I found Vic Stark lying wounded in the rain and mud, on a
litter.[36] I can see Captain Kenady lying there in the dressing station
wounded unto death, and saying:

'I got mine, but I was right out in front leading the men and
we sure made the boche like it. Do you think you can get a
cablegram through to my wife telling her that I am O. K.?'[37]

SEVEN DIED CLASPING RIFLES.

I can see Lieutenant Gardner sitting on a board in the temporary hospital, waiting for an ambulance and remember how eagerly he took the cigarettes I gave him.[38] There is another picture. A row of seven doughboys lying beside an unused road, each lying on his side with his head toward the boche lines, tightly grasping his bayoneted rifle. They seemed to have become tired carrying their packs and just sort of sunk down in the mud for a rest, tired and peaceful. The same boche machine gun got them all while they were advancing.

We made our visit one Sunday morning—Mr. Morgan, Sergt. W. J. Struder of Herndon, Kas., Earl C. Warnock of Hutchinson, the chauffeur, and Sergt. Karl L. Burns of Chicago, wounded during the fight, and myself. To a casual visitor it would have looked like any other part of France that had been fought over, ruined villages, here and there a line of barb wire entanglements, once in a while a row of boche trenches, trees broken and scarred.

THE SILENT REMINDERS.

But, oh the graves. The little plots of raised earth with the white wooden crosses at one end with only a little tag on it. These were the silent reminders of the battle that crushed the Hun hordes. Every place you looked you saw graves located and marked and laid out neatly by the graves registration bureau, graves that no one had time to look after during the fight. Some soldiers were buried where they fell, some were gathered up and buried in small plots, some by the roadside, some in the fields, some on the hillsides, some in the valleys where the blood-red poppies abound in the spring and summer.

We came to where the tanks made their first big attack. It was just south and southwest of Vauquois Hill. Glancing over this particular battle ground from the motor car was just like looking at a

Kansas farm in January. Mud, a little drifting snow, a little barbed wire, dead underbrush and shrubbery and dead grass.

The graves, being small and the color of the surrounding terrain, could not, of course, be seen from where we were. There was nothing there to tell you that a few months ago this place was filled with disabled tanks, tanks that had suffered direct hits and put out of business; there was nothing there to tell you that here a battery of artillery had its position out in the open; there was nothing there to remind you of the dead horses which had given their lives in the drive; the smashed camions, the abandoned wagons and caissons, the matériel, all had been cleaned up. There weren't even any gas masks, helmets, packs or rifles lying around, equipment dropped by the killed and wounded. It looked as though some giant had stepped out of the past and swept the place clean, erasing many scars of battle.

ONLY THE GRAVES REMAIN.

At Varennes, in the valley of the Aire, the railhead there had been built up and cleaned up until it resembled any other camp in the S. O. S. except for the piles of sorted salvage ready to be shipped.[39] Here had stood a battery of heavy artillery; there an ammunition dump, where the trucks would unload and the caissons load up to the tune of cannon and shells popping all about; here some supply company had managed to get through; over there should be a bunch of graves, little heaps of earth that were all that remained of some of the men who had assisted in capturing Cheppy; right over the brow of that hill several batteries of the 129th Field Artillery had been stationed. Now all was gone, all except the little mounds of earth.

Cheppy didn't seem the same. The streets and buildings had been cleared. No ambulances and trucks in sight. The dugout that had once been division headquarters had been swept clean. The

doors and windows were closed. The triage, where all the wounded passed through, was just as clean. Not a sign of a stretcher, not even a bit of gauze or cotton. Even the signs, 'Gas Patients Here' and 'Slightly Wounded Here,' and so on, were gone.

It was a quiet, peaceful, placid Cheppy now, more like the old Quindaro ruins than the center of a roaring furnace of hell fire.[40]

The roads were all in good shape, though muddy, and it didn't take us long to get to Very, Charpentry, Baulny and Baulny Hill. Here the ground took on a little more the aspect of a battle field. It was around Baulny and Charpentry and a little north of Chaudron Farm, where the boys finally dug in and held until relieved. Would it have been possible to lay the hillsides out flat, they would have resembled a section of Kansas prairie covered with prairie dogholes, only over here, we call them fox holes. Each man had to dig for himself a hole into which he could crawl as a protection against shrapnel and high explosives. On every hand the hillsides were scarred with little holes where the men had lain, waiting, holding the line. But all other evidences of the struggle had been removed, except the graves, the everlasting graves.

The debris in the towns had been cleaned up. Here and there a room had been patched up and was being occupied by salvage units or graves registration men. No civilians had returned, for there was nothing for them to return to. Exermont, the town where our troops lost most heavily, looked just like the other villages.

As I stood at the head of the main street and looked into the town, I could picture Lieut. Sam Adams, 'Paducah Sam,' as we always called him, rushing down the center of the street, an automatic in each hand, as the boys described it, leading his platoon into the town, unmindful of machine gun bullets spattering all about him. I could almost pick out the place where they got him, the machine gun that had been firing from that window there in the corner.[41] I could picture 'Red' Smith and Duke Sheahan running

251

around the town with what few men they had left, trying to clean out the boche machine gunners.[42]

It was growing dusk, and we had to be going. No, it wasn't the same Argonne. It was a quiet, peaceful, placid Argonne, with many, many graves.

O. P. H.[43]

Chapter 13: While Packing Up—March 1919

Although OPH began and ended the month of March 1919 with articles about the 89th Division, the bulk of his reporting that month centered on the 35th Division and its preparations for going home. "Home" was in OPH's thoughts, as well. The first of March found Higgins in Cologne, Germany.[1] By Wednesday, March 5, he had traveled to Trier, taking a few days off to see American soldiers on German soil amidst Roman ruins.

"*Dear Mother & Dad*," he wrote on a postcard home, "*Roman ruins and American soldiers. Quite a contrast. Here for a few days.*"[2]

The next day he continued the theme of the Roman ruins in a postcard to his daughter, Carol, whom he had nicknamed "Bill," adding as a kind of postscript a parental concern for her music lessons. "*Dear Bill, This is a picture of a gate to the ancient city of Tervious, built by the Romans hundreds of years ago—and how is the music getting along—Daddy.*"[3]

In addition to the postcards OPH sent home to family, he sent to the *Star* Sergeant Richard F. Begulin's line drawing of the 89th Division's area of occupation, the outline of which, when imaginatively filled in, resembled the head of a German woman and prompted divisional intelligence officer Major Frank Wilbur Smith to affix the label, "*From Area Line to Fraü-lein,*" and to include the drawing among the Division's official documents.[4]

Five days following the transmission of that drawing, OPH sent, almost as if in tribute, a brief biography of Col. John D. Lee, 89th Chief of Staff, age 31, whom Higgins had known as the 89th Division information officer from the training days at Camp Funston, Fort Riley, Kansas. Col. Lee was the youngest C.of S. serving with a combat division in France and was "credited with being highly instrumental in the success of his division," Higgins observed.[5]

By March 9, Higgins had stopped by 35th Division headquarters in Commercy and was back in Paris, writing the longest piece of the month, a 1,475 word article about a variety show he had seen produced in Commercy by a troupe of 64 performers from the 35th Division. "The army has made feminine impersonators out of blacksmiths, buck and wing dancers out of salesmen, comedians out of farmers, singers out of chauffeurs and mechanics, and even made assistants to chaplains out of railroad men, a most difficult performance to accomplish,"[6] OPH wrote.

Higgins attended the show along with Lee Shippey, a journalist OPH had known at the *Star* and now a publicist with the Y.M.C.A. "The old theater at Commercy was rehabilitated and re-arranged so it would seat considerably more than a thousand soldiers," Higgins continued. "Generals from nearby divisions were invited for the opening night, and the show was a scream. After playing in the vicinity, the army took up the matter and booked the troupe for a seventeen-week tour, which was cut short only by the best news in the world—orders home."[7]

Two days later, on Thursday, March 11, OPH cabled the *Star* with the front-page news that the 35th was moving towards Le Mans, homeward bound, with an anticipated sailing date in April.[8] The following day, however, Higgins reported that 137 men from the Division would not be sailing with the rest because the men had opted to take advantage of an offer to attend various colleges in France and England for four months at the expense the American government. "General courses are offered in the British universities, while the French are teaching law, letters, science and medicine," OPH reported.[9] Kansas and Missouri boys attended the Sorbonne in Paris as well as universities in Nancy, Dijon, Montpelier, Grenoble, Bordeaux, and Lyon.

On the same day that Higgins reported on the men attending British and French universities, he reflected once again on other men

who would also be left behind, but these men permanently so—in the 35th Division burial ground in the Argonne, which OPH had visited with Y.M.C.A. educational director W. Y. Morgan early in February.[10] Higgins had reported on that visit in an article written on February 19.[11] Three weeks later, in a poignant piece written on March 12, Higgins remembered three men in particular—Lieutenant William E. Scott, Captain Jacob L. Milligan, and Major Murray Davis, all of the 140th Infantry.

That same day, the *Star* published an article OPH wrote from Paris, recalling the last patrol carried out by the 35th Division before the Armistice took effect. The patrol was conducted by Captain Ralph E. Truman, 140th Infantry Regiment intelligence officer and cousin to Captain Harry S. Truman, commander of Battery D, 129th Field Artillery.[12] On November 5, 1918, Captain Ralph Truman had volunteered to raise a patrol after two previous patrols had failed in their attempts to procure information on enemy strength and positions for an anticipated move against the German railroad facilities in Metz, the Division's next target. Captain Truman and his men penetrated German lines near the city of Etain, located strong points fortified with machine gun and artillery emplacements, and drove off a German patrol attempting to gain information on American positions. Truman's patrol remained in the field until recalled on November 8, when the 35th was relieved and ordered back from the sector. "The last patrol executed by the 35th Division will live in the history of the Division," Higgins wrote. "Three days later, the Armistice was signed."[13]

Remembering that last patrol and the men who would be left behind as the 35th boarded ships bound for home were ways OPH could bring closure to the contribution the 35th had made in the war. The Division had extended every effort, made every sacrifice, and was committed to continuing to do so, when it was called back, relieved, and now about to be returned home.

Reporting from Le Mans, France, on Sunday, March 28, OPH noted that the 35th Division's 128th, 129th, and 130th Regiments of the 60th Artillery Brigade would leave for Brest that very day, "having been assigned an early convoy." The 35th Division's infantry regiments would leave the next day for St. Nazaire, with the promise of early embarkation. Continuing an emphasis on the Division's accomplishments, OPH added that "the brilliant work of the Kansas and Missouri soldiers is not being overlooked, for General Wright has recommended a large number for bravery medals for distinguished service and heroism in the Argonne drive. The men are in high spirits and the slogan has changed from 'We wanta go home' to 'We're going home.'"[14]

OPH was about to join them on their voyage across the Atlantic, but before reporting on the 35th's embarkation and the trip aboard the *U.S.S. DeKalb*, Higgins sent the last report on the 89th that he would make from France. Like the success throughout the A.E.F that the 35th had enjoyed with their variety show, the 89th Division had also made its mark on the A. E. F., as well. On Saturday, March 29, OPH reported from Paris that "the 89th Division won the football championship of the American Expeditionary Forces here by defeating the 36th Oklahoma -Texas Division, 14 to 6. The 36th team was outplayed in every quarter except the second," OPH conceded, "when a touchdown was made on a fumble."[15]

Finally, things were beginning to get back to normal, and victories could now be reported in peace as well as in war.

AS AN 89TH DIVISION ARTIST SEES IT.

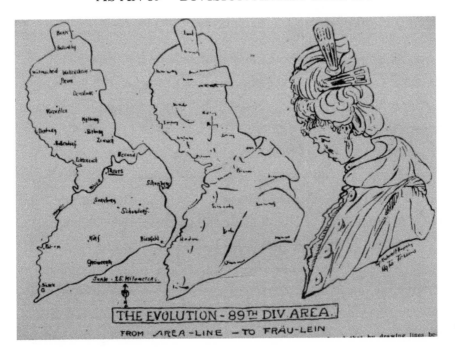

THE EVOLUTION - 89TH DIV. AREA.

FROM AREA - LINE — TO FRÄU-LEIN

THE EVOLUTION – 89TH DIV. AREA.

FROM AREA-LINE - TO FRÄU-LEIN

When the Armistice ended the Argonne drive, the 89th Division was holding a line extending east of Stenay and Inor to east of Autreville, on the eastern side of the Meuse River. From there the division marched through Belgium and Luxembourg into Germany and, as part of the army of occupation, was assigned to the Prum-Bitburg-Treves-Saarburg area. This area is in the southwest portion of Prussia and Luxembourg, and Prussia and Belgium. The area is northwest of the city of Metz and southwest of Coblenz.

Sergt. Richard F. Begulin, a designer and engraver of St. Louis, who is Col. W. W. Whiteside's[16] personal interpreter, in studying the maps of the divisional area, found that by drawing lines between the towns, a rough sketch of a woman's head was made. He gave it to Maj. Frank Wilbur Smith, division intelligence officer, who immediately labeled the drawing, "From Area Line to Fräu-lein," and had it issued as one of the records of the division. The sketch was sent by "O. P. H.," the *Star's* own correspondent in France.[17]

FIND GRAVES OF FRIENDS.

Officers of 35th Division Visit the
Battle Field at Argonne.

(By The Star's Correspondent.)

PARIS, March 12.—On a recent trip into the Argonne, officers of the 35th Division located many graves of friends or others who were known to have been killed or were reported missing in action. One of the graves found was that of Lieut. William E. Scott, 140th Infantry, of Kansas City. 'Scotty,' as he was known, died as typically 'Scotty' as he had lived, carefree and happy.[18]

The fourth day of the Argonne drive 'Scotty' and Capt. J. L. Milligan,[19] a Missouri attorney, had sought shelter in a shell hole, while the boche shells churned the ground around them and machine gun bullets zipped past. As they crawled out to go forward again Lieutenant Scott started off toward the left flank, but turned to Captain Milligan and laughingly shouted:

'So long, Jake. Ten minutes from now, you'll be eight minutes dead.'

"Never mind, old boy,' returned Milligan. 'I'll walk around over your grave.'

That was the last time anyone saw Scott alive.

An effort has been made to locate the grave of Maj. Murray Davis of Kansas City,[20] but without success. That is not strange, however, in view of the fact that the ground over which the Missouri and Kansas men advanced the last two days of their fight is covered with graves. That was when the Division had pushed a narrow salient nearly three miles deep into the Hun line and were being fired upon from three sides. Many a grave is unmarked, except for the crude wooden cross or in some cases, the steel helmet. That was because the identification tags were not with the body when it was buried.

O. P. H.[21]

TWO DAYS IN HUN LINES

CAPT. RALPH TRUMAN AND PATROL
CARRIED OUT DARING FEAT.

Ordered to Get Information, the Kansas
City Officer and Last Patrol
Fought Way Through and
Obtained Data.

(From The Star's Own Correspondent.)

Paris.—The last patrol executed by the 35th Division will live in the history of the division. Three days later the Armistice was signed.

In daring and nerve, the exploit of the thirty men, led by Capt. Ralph Truman, intelligence officer of the 140th Infantry and a former Kansas City detective, seldom has been equaled.[22] The men left the front lines one night, penetrated the enemy's lines six kilometers, and remained two days and nights, gathering information that later would have led to an attack at that point had not the war ended immediately.

PLENTY OF GAS AND SHELLS.

The division took over the sector October 12. It was a live place as far as artillery and gas were concerned. Both sides were well dug in. During the last drive on the Meuse, accurate information was desired as to the enemy's strength and positions all along the line, as another drive towards Metz was contemplated.

Several patrols were sent out with this end in view, but their reports were unsatisfactory. One patrol finally was ordered to go out and not return until it had obtained the information or was defeated in action. It did not return with the information. This was a patrol of five hundred men.

Being regimental intelligence officer, Captain Truman was responsible for the gathering of information in the salient held by the 140th.

'If you will let me pick my own men, I'll get the information the general desires,' Captain Truman told Col. Alonzo Gray, then regimental commander.[23]

So Captain Truman picked thirty men and two officers, men who had worked in the intelligence section of the 140th. The night of November 5 the little party started out through the wire, carrying a large supply of ammunition and reserve rations for two days.

RAN INTO ENEMY PATROL.

A boche patrol was out in the same sector that night, bent on obtaining information. Just before daylight, the two patrols came upon each other and battled in the darkness, each man firing at the flashes made by the shots of his enemy. The fight continued half an hour.

Then Captain Truman gave orders to rush the boche with hand grenades and bayonets. The scheme worked. The boche made a clean getaway. Truman's party advanced and found shelter, as dawn was breaking, just inside the boche lines in the basement of what had once been a house. Here they ate their bread and corned 'willy' and huddled together in the cold and dampness to get what sleep they could.

COUNTED MEN AT THE GUNS.

Captain Truman made out reports on what he had found and sent them in by separate runners, as well as sending in one man who was ill and another who had been wounded slightly. That night under cover of darkness the party started out again. The men wandered around all night, mostly on their hands and knees. They found strong points. Machine gun emplacements, boche artillery, some that was being fired at the time and some that was just waiting,

261

but ready to fire. In several instances, they were even able to get close enough to count the number of men to a gun. All these things were noted carefully.

They went within one thousand yards of the city of Etain, and found no boche garrison, only strong points, machine guns and artillery. The boche infantry had withdrawn, but a reserve was at Etain, some eight kilometers behind.

WROTE REPORT IN BOCHE DUGOUT.

Early that morning, in a boche dugout at Supleville Farm, Captain Truman wrote his complete report, giving the exact locations of the boche machine gun nests and artillery positions, and sent it in by separate runners, with a request for more ammunition, food and reinforcements. The men had run completely out of food, and several others had to be sent back because of illness developed from exposure.

"I expect to go into Etain tonight and spend tomorrow in town," Captain Truman wrote.

But that night the runners returned with a message that the division was to be relieved immediately and for the patrol to return. The next day Colonel Gray issued the following memorandum to the regiment.

> The night of November 5 a patrol was sent out under Capt. R. E. Truman, accompanied by Capt. Ralph L. Ware and First Lieut. Jacob W. Grondyke. The patrol penetrated way beyond Abaucourt to not far from Etain, well within the enemy's lines and obtained valuable information. It also had a fight with and defeated an enemy patrol of superior strength.

> The regimental commander is pleased to note that this regiment, through this patrol, obtained more important information than probably any other regiment on our

neighboring front. He wishes particularly to commend the officers. He hopes the conduct of this patrol will be a model for all others in that when given a mission to perform they should never turn back until the mission is accomplished.

Special credit is given to Sergt. Walter W. Ilam for fearlessness and attention to duty. Other members of the regiment, whose conduct and ability deserve special mention are: Corp. Thomas Summers, Corp. Loyd D. Knox, Corp. Joseph E. Franklin, Corp. Alfred Cosine, Privates Dewey Wells, Emil Kroncke, Harry Bussing, Alfred Anderson, Stephen Miller, Edward Tomplin, Edward P. Stone, all members of the 140th Infantry.

All the men except Captain Ware and Lieutenant Grondyke are from Kansas City. The following day from General Traub, the division commander, came this order to Captain Truman:

PRAISE FROM GENERAL TRAUB.

Information obtained by this patrol was of great value to me and to the higher command, and it gives me pleasure to inform you that your action was a subject of enthusiastic comment by the corps commander. To me it is a source of great satisfaction that this patrol, the last to be executed by this division against the enemy before the signing of the Armistice, should have been thus executed.

I am glad to make this commendation official record.

Thus the last patrol of the 35th became history.[24]

O. P. H.[25]

FOOTBALL TITLE TO 89^TH

THE 36^TH DIVISION WAS DEFEATED IN A. E. F. GAME, 6 TO 14

Potsy Clark, Former Illinois Star,
Scored Two Touchdowns, the Last
Coming After a 65-Yard Run—General
Pershing at the Game.

(By The Star's Own Correspondent.)

PARIS, Saturday, March 29.—The 89^th Division won the football championship of the American Expeditionary Forces here by defeating the 36^th Oklahoma-Texas Division, 14 to 6. The 36^th team was outplayed in every quarter except the second, when a touchdown was made on a fumble.

Potsy Clark, assistant coach of the University of the Kansas eleven, two years ago, and former Illinois star, was the hero of the game.[26] He made both touchdowns for the 89^th, the last score coming after a 65-yard run around left end. Both goals were kicked by Clark. A crowd of 10,000 persons saw the game, which was played in the Paris Veladrome.

After the game, General Pershing, who saw the entire game, went out on the field to congratulate the players.

'You have carried out the letter and spirit of the plans adopted to promote clean sports in the army,' he said. 'You have gone at the game with the same [spirit that you brought to the fight against the enemy] and it is a spirit that makes the American and the Americans' great game.'[27]

Chapter 14: On the Way Home—April 1919

"Everybody knew we were coming, of course, but no one knew just when," OPH noted on Monday, April 21. "We had been hanging around the camps at St. Nazaire for several days and were not expecting to leave for several days. The orders to embark came at 1:39 o'clock Monday afternoon [April 7, 1919] and by 4 o'clock the boat was loaded. The next afternoon, we dropped down the river with the tide and started on our journey."[1] With elements of the 35th Division headquarters, OPH had secured passage on the *U.S.S. DeKalb,* formerly the *Prinz Eitel Friedrich,* a commandeered German passenger vessel originally dedicated to trips between Germany and the Orient, then assigned duties as a merchant raider but now refitted for the purpose of transporting American troops.[2] From the time the troops boarded, the voyage took thirteen days, with arrival at Newport News, Virginia, on Sunday, April 20, almost at the same hour as their departure from St. Nazaire, France. The boys and OPH were on their way home to Missouri and Kansas.

While awaiting departure, Higgins had begun work on one of his longest pieces, 7,452 words recounting the history of the 35th Division's time in France, but told from the perspective of the individual soldier. Throughout the narrative, Higgins keeps bumping into "Skinny" Johnson, an enlisted man from Nemaha County, Kansas, who has served honorably as a scout but whose thoughts are focused on the girl back home, whom OPH calls "Hazel Eyes."[3] "Skinny's" story is complicated by the introduction of a rival for Hazel's affections, a college student back home who finally does enlist, is posted to Camp Sheridan, and emerges as an officer. On a personal level, Skinny Johnson's campaign to win Hazel's affections serves as counterpoint to the larger story of the 35th Division's own contest to resolve the threat posed by the boche.[4] More importantly, Sgt. "Skinny" Johnson is a character type. A common man, he represents the hero in every man coming

home, and his story prepares OPH's readers for the homecomings of their own particular heroes.

The return home is also the subject of the remainder of the thirty-some stories Higgins filed during the month of April 1919. After his own arrival on Sunday, April 20, Higgins spent the rest of the month shuttling between Newport News and New York City and ended the month at Camp Stuart, Virginia, where units of the 35th were collected prior to their entrainment west. To broaden its coverage of the arriving servicemen, the *Star* sent four reporters to New York and an additional reporter to assist OPH in Newport News, Virginia.[5]

As reports of the anticipated unit arrivals were received, OPH and his colleague headed for the designated dock at Newport News. The reporters dutifully recorded date and time of arrival, name of unit and ship, and then got as close as possible to interview individual men streaming off the transports. For the readers back home, the reporters included the names and home addresses of as many men as possible, and often articles appeared in the form of

Mrs. Elizabeth Higgins.
(Photo courtesy of
Sheila Scott.)

bulletins—a series of "notes," where one name after another was listed, as if filing past, down the gangway and onto the dock. Often, Higgins' work was clearly identified: the paper carried the OPH moniker at the end of an article or introduced a piece with the by-line, "From The *Star's* Own Correspondent." But on other occasions, Higgins' work was mixed with the work of the other correspondent(s) and identified only as, "By a Staff Correspondent." In such instances, the typical elements of Higgins' own breezy style, as well as his use of the

first person and his allusions to experiences in France, help distinguish OPH's contributions.

On one occasion, Tuesday, April 28, the reporters themselves actually became part of the story, along with Otto's wife, Elizabeth. She had arrived in Newport News a few days earlier to greet her husband when he arrived, and she remained with him as he, in turn, greeted the boys when they arrived. "Alderman Griffin was the sole official Kansas City representative," the staff correspondent—most likely OPH himself—reported from Newport News on April 28, then added that Griffin was "aided by the *Star's* two correspondents and Mrs. O. P. Higgins."[6]

OPH had begun the arrival reports the day before he actually landed. On Saturday, April 19, while still onboard his own transport, the *DeKalb*, he cabled to the *Star* that 12,428 men and 345 officers of the 35th would be demobilized at Camp Funston on the Fort Riley reservation, and the remainder would be mustered out from whichever one of the twenty-five other camps was closest to home. Once the *DeKalb* had docked, Higgins, in his eagerness to see Elizabeth after a year apart, managed somehow to elude the requirement of passing through the de-lousing station.[7] He then set to work reporting on the voyage across, focusing especially on the emotions of the men as their homeland came into sight. Throughout the report, Higgins developed a theme of "difference": the departure from France was different from the reception in the States, the voyage home was different from the voyage across, the food and sleeping arrangements, as well as the entertainment and the boys' routines, were different from their experiences of their mess and billets in France.

"Different? Well, I should say 'Yes'!" OPH exclaimed. The boys were not at all used to having plenty of ice cream and sweets or the most current magazines; their life vests and overalls covered brand new uniforms and gave them a different look from

their appearance in France. Striking his usual personal, conversational tone, OPH expressed what a difference this homecoming made for these boys. He drew his readers into the moment and into the minds of the men as they calmly anticipated within themselves the scene and the reception each of them would experience when he finally reached his own hometown and was greeted by his own mother and father, wife or sweetheart, brothers and sisters, relatives and friends.

The result was that OPH had prepared the readers at home for the differences they would see when their boys returned, men tempered by war. Later on, Lt. Col. Fred L. Lemmon, second in command of Kansas City's 140th Infantry, took up a similar theme. In an interview with OPH, Col. Lemmon stressed the change that had come over the men. The war had transformed them: they thought more deeply, were more self-reliant and had returned leaders, not followers. Kansas City should expect to see a difference in them. They were no longer "boys," but men.

Lieut. Charles A. Grimes

But first the various units of the 35th would have to check in. On April 21, while OPH was awaiting the arrivals, he reached into his cache of stories and reported on one rather remarkable distinction achieved by a group of support elements of the 35th Division while they were still in Germany. OPH reported by name and unit the twenty-four mess sergeants, cooks and orderlies whom Lieut. Charles A. Grimes, secretary of the general staff of the 35th Division, was assigned to deliver as support for the American detachment in Berlin. By the terms of the Armistice, American soldiers were not to bear arms outside of the

occupied areas, but nobody had communicated those orders to Lieut. Grimes, and so he "paraded a group of armed men through the streets of Berlin, which included Unter den Linden . . . much to the horror of the boche." Of course, protests and an investigation ensued, but to little avail. "We never heard what resulted from the investigation," Higgins reported, "but these men, whose homes are in Missouri and Kansas for the most part, have the honor of being the only Allied troops to march armed through the streets of Berlin."[8]

That parade was unplanned. More important to the men, however, were the plans being made for parades down the streets of their own hometowns. To that end, unit commanders who had trained the men at Camp Doniphan and had taken them to France but who, upon arrival there, had been re-assigned to other tasks, now were ordered back to their original units for the trip home. This meant that Colonel Albert Linxwiler, who had trained the hometown 140th Infantry at Camp Doniphan but had been reassigned to serve as a corps inspector and later as liaison with the British occupation, would now take charge of his men on their way home. Col. Bennett Clark, who had also served with the 140th and wanted to return with that unit, was instead assigned to return on the *DeKalb* as part of the 35th Division headquarters, reflecting his re-assignment as assistant chief of staff for administration and supplies. However, Col. Clark had gone to Paris as part of the American Legion executive committee and missed the *DeKalb* sailing, so he ended up having his original wish restored. He returned with the 70th Brigade, which included the 140th.[9]

General Pershing, on the other hand, who had been appointed over General Leonard Wood to command the A.E.F., remained in France and did not return stateside until September 8, 1919, when he arrived at Hoboken, New Jersey, on board the *U.S.A.T. Leviathan*.[10] The election year of 1920 was rapidly

approaching, and the men under Pershing's command were speculating about what his next command would be—specifically whether he would run for the presidency and thereby assume the role of the nation's commander-in-chief. "The chief talk in the A.E.F. now centers upon two subjects," Higgins reported in an article written from New York on Tuesday, April 22. "The first is: 'When are we going to get home?' The second: 'Who is going to be the next President?'"[11] The consensus of the men was that Wood and not Pershing should be President. Using a card-playing analogy, OPH explains why. "Wood, having made good in all that was given him to do, should be able to keep on going and make good further up. But Pershing, no. They have had enough of Pershing and army methods as they existed in France, and even before the war. They want a new shuffle and a new deal, and the majority of them will tell you that Wood is the logical man to run the deck."[12]

From the time of that article on April 23 to the end of the month, Higgins spent his time with the individual units as they began to arrive. On Wednesday, April 23, OPH was among the first from shore to board the *Mobile*, another of the ex-German liners which the Inter-allied Maritime Transport Council had assigned to the U.S. for the return of troops after the signing of the Armistice.[13] Here OPH interviewed a number of officers and men with whom he had served in France. Major John F. Howell, 130th Field Artillery regimental surgeon, reported to Higgins that "we had a great trip. There were 473 nurses on board and only 200 officers. But don't put that in the paper. My wife might think I had some flirting on board."[14] Equally mindful of the hometown ladies was Captain Frank T. Priest with Battery F from Wichita,[15] who told Otto that "Kansas girls are good enough for us. They don't grow them any better in the world than in Kansas. Just put that in the paper." Always the fair journalist, Otto submitted both commentaries.

Nor would he be taken in by a story two artillerymen from Pittsburg, Kansas, told him about a couple of shinny brass-trimmed black leather boche helmets that the boys claimed they had taken from German prisoners at Varennes.

"'You better save that for Pittsburg,'" Higgins shot back, himself a veteran of the fight at Varennes and something of an authority on souvenir collecting. "'The only boche officers you ever saw in Varennes came through under escort and they had lost every souvenir of value long before then.'" "The boys only grinned as they marched on," OPH reported, "but the others behind them only hurrahed. Because, you see, I spent some time in Varennes myself during the Argonne and I'm some souvenir collector."

In reporting the exchange, Higgins again was preparing the folks at home, this time for the stories they were about to hear as the boys unpacked. "'Well, you see, the home folks expect us to have a little romance connected with our souvenirs,' A. B. Brown, a sergeant from Topeka explained to me, 'and we have to tell them something. We wouldn't dare go home and say we won a helmet in a crap game or paid someone seventy-five francs for it. That wouldn't sound a bit good and wouldn't even be interesting.'" [16]

Besides the souvenirs, OPH also reported on the arrival of a mascot, a little black and tan terrier named, "Boob, a land dog who didn't like the sea," and remained perched atop the pack of J. A. Cameron of Smith Center, Kansas. Boob "was dressed up in a blanket, on the left side of which was one gold service stripe and a *Croix de Guerre* earned for bravery under fire." But he "appeared to be a trifle frightened for he wouldn't respond to my advances," Higgins acknowledged, as he went on to describe medals and commendations the men had received, including thirty from the regiment, who had been recommended for the Distinguished Service Cross. [17]

The boys would be able soon to show off some of that hardware. By Wednesday, April 24, OPH reported that an order had been received "from the War Department stating that certain units will spend a few hours in their home towns on the way back to camp—anywhere from three hours to all day." This will give them an opportunity to strut about town and exhibit their tail feathers and be entertained from soup to fish," Higgins observed.[18] Even though, in their eagerness to get home, the barracks talk of some of the boys dismissed the intrusion of a parade, OPH knew from remembering their talk around the campfires in France, that the parade through the streets of the hometown was the stuff of their dreams.[19]

The day before, on April 23, OPH met the mostly Kansas 137th Infantry as it docked on the same pier but on the opposite side as its sister unit, the 137th Artillery. In a 1,210-word article written from New York the next day, Higgins narrated the regiment's history at Varennes and Montrebeau Woods, culminating in the attack of September 29 when Major J. C. Kalloch, second in command, led 125 men against German artillery and machine guns with only 35 minutes notice.[20]

On Friday, April 25, Higgins reported that on the next day, Lt. Col. Ruby D. Garrett's 117th Field Signal Battalion, 42nd Division, was slated to arrive at Newport News on the *South Carolina,* and that four days later, on Wednesday, April 30, Kansas City's 110th Engineers would leave Camp Mills for the three-day train trip home. Unfortunately, Lt. Col. Garrett was not able to accompany his battalion on the voyage home from Brest. As 42nd Division Field Signal officer, he had already arrived on April 25 with the headquarters company of the 42nd Division. "'The greatest disappointment I had in France was in not being able to return home with the battalion,' the Colonel told Higgins. "'I may be able, however, to get to Newport News and meet them Sunday, and I may

be able to go home with them.'" "His heart's desire always has been and still is wrapped up in the battalion," Higgins observed.[21]

On the next day, the 470 Kansas City men of the 117th Field Signal Battalion did arrive with nine campaign service ribbons streaming from their battalion standard. They had been the first of the Kansas City units to go overseas, and they were now back in the states after two years abroad. They had faced adversity from the very start. Having first set sail for France on the commandeered *U.S.A.T. President Grant* on October 3, 1917, after nine days at sea, they were forced to return when earlier German sabotage eventually had its effect in crippling that ship's engines.[22] The men then transferred to the *S. S. Lapland*, the same White Star Liner that OPH boarded for Liverpool six months later on Saturday, April 6, 1918.[23]

Now a year later, Kansas City's Field Signal Battalion was finally back stateside. In a 3,929 word article from Newport News dated April 26, OPH provided a detailed and fluid history of the 117th's war experience. The following day he added a happy postscript: Major Richard T. Smith, who was in command of the battalion at that point, "jumped across the open space between the ships and the dock and landed right side up just at the spot where he wanted to land." The Major wanted OPH to include the following announcement in the paper:

> *Mr. and Mrs. C. E. Plank, 1601 Linwood Boulevard, wish to announce the marriage of their daughter, Bethine, to Maj. Richard T. Smith, commanding the 117th Field Signal Battalion, in the parlors of the Hotel Chamberlain & Old Point Comfort, Sunday evening at 6 o'clock.*

"Now do you think that's fair?" Higgins asked his readers. He then went on to explain why Major Smith deserved more than just a wedding announcement, and concluded by observing that "Major Smith was the first Kansas or Missouri man to be married at the port of debarkation, and a great many of them have landed in the past eight days. Now I'll leave it to you if this isn't worth more than just a mere formal announcement. I think so myself."[24]

With slightly less fanfare, during the day on Monday, April 28, OPH reported the arrival of the 138th Infantry, constituted from the old 1st and 5th Missouri National Guard units from St. Louis and other parts of Missouri. They were led by Lieutenant Colonel James E. Rieger, who had distinguished himself in the Argonne as commander of the 139th Infantry, made up of the old Missouri 4th National Guard and the old 3rd Kansas National Guard. Lt. Col. Rieger arrived in Newport News with a Distinguished Service Cross as well as a French *Croix de Guerre*.

The arrivals of the old Missouri 1st, 4th and 5th infantry regiments were but a prelude to the excitement felt when Kansas City's own 3rd Regiment—now the 140th Infantry—arrived at Newport News on Monday, April 28. OPH was there to interview the officers and to greet the men as they began to jump off the gangplanks onto the dock. The boys' parents were also there to greet them as they were made to re-group, march onto the street and head off to Camp Stuart, people lining the way, waving and cheering.

"'Son, you're great! You're looking great!'" F.F. Cowherd yelled out as his son, Private Edgar F. Cowherd of the old Missouri 3rd, headed down the gangplank of the *Nansemond* and onto the street.[25]

There were some fathers, however, who would never be able to shout greetings to their sons because the sons would never return alive. OPH narrated one such poignant story he recalled on the

evening of Monday, April 28, when he attended a dinner party at the Chamberlain Hotel, near Camp Stuart, Virginia, given to the officers of the 139th Infantry by Col. Carl. L. Ristine.

In the course of a conversation with the Colonel, OPH remembered an incident in the Argonne when he interviewed Major Clay C. MacDonald, who had been able to secure a position as postmaster so he could accompany his 4th Missouri National Guard unit to France. The major's son, Lieut. Malcolm Donald MacDonald, was also in the same National Guard unit, now the 139th Infantry, serving at headquarters as battalion adjunct. Anxious about being removed from the fighting, the lieutenant requested command of a company, got it, and led his men straight up Vauquois Hill in the face of raging machine gun fire. Lt. MacDonald was killed instantly.

When Major MacDonald received the news of his son's death, the major begged for command of a battalion so he could exact revenge. At first the major was refused, until finally, so many officers had been lost in the offensive, that General Traub relented. OPH narrated the outcome in a compelling story written from Camp Stuart on Tuesday, April 29.[26] Drawing a parallel between the character of Major MacDonald and that of his son, the story allowed Colonel Ristine to add a finishing touch.

In another compelling narrative posted the same day, Higgins told about another older man, who regarded his men with the same feeling as Major MacDonald regarded his own son but who was not allowed to remain with them in the fight. Brigadier General Charles I. Martin commanded the 70th Brigade, 35th Division. He had trained those Kansas National Guard boys at Camp Doniphan and accompanied them to France, but was relieved of command on the very eve of the battle in the Argonne and sent to a re-classification camp in the rear. Just after the first phase of the battle in the Argonne was over, OPH ran into the general in Paris and

interviewed him at the Hotel Lotti, where OPH had a room. Higgins recalled General Martin's consternation.

"'My God, if they had only left me there to fight and die with the boys,'" the General told OPH. "'I didn't want their job. All I wanted was to be with the men, to lead them in battle and to die with them. A man can't do any more than give his life, and I wanted to give mine and help save the boys. Just think of it—my boys up there fighting, dying, and me back here in Paris. Oh, why wouldn't they let me stay and die? I know I could have saved some of them. They were all young with everything in life before them, and I am getting old. It would have been much easier for me than for them—and they wouldn't let me do it.' "The tears were trickling from between the fingers on both the general's hands," OPH wrote. Now back stateside at Newport News and Hoboken, OPH watched the general as he greeted his boys, with a quiver in his voice. [27]

General Martin wasn't the only National Guard commander whom the Regular Army replaced with one of their own on the eve of the Battle of the Meuse-Argonne. At such a critical moment, the replacement of National Guard officers, who knew their men, with Regular Army officers, who did not, generated a great deal of ill-will and, some said, accounted for a series of blunders that resulted in unnecessary loss of life. The resentment against the Regular Army, which had little respect for the military expertise of the Guard, persisted, and shortly after the men arrived on shore, found expression in a meeting of high-ranking Guard commanders at the Hotel Warwick. OPH was there for the story, whose seriousness grew in the months ahead.

There were lighter moments, as well, for Higgins, as he recognized familiar faces among the new arrivals. While at Camp Stuart, Virginia, OPH continued to interview men from the 140th and 138th regiments. "I've always had a soft spot in my heart for Fred," OPH confided in an article from April 30. "Fred" was 1st Lt. Fred

Buell, Company G, 140th Infantry. "He is one of those kind of fellows who realize somehow that a newspaper correspondent occasionally eats as well as sleeps, which is something that a world of army officers never think about. We don't have restaurants and hotels in the front line, and sometimes it is hard for a stranger to pick up things to eat, especially when the rations are short. But with Fred, after the first greeting was over, it was always: 'Had anything to eat yet?' and next would always come: 'Where you going to sleep tonight? I've got a couple of extra blankets down in my dugout.'

Equally aware of a reporter's needs was Sergeant Jack Helmick, at one time a corporal in battalion headquarters, who "used to arrange it so I could 'salvage' some government paper occasionally when my supply ran low," OPH noted. Higgins enjoyed meeting Jack again, along with four former *Star* employees, in the barracks at Camp Stuart. The five of them "used to be together in the front line in the Vosges," Higgins remembered, "out in front of battalion headquarters on top of the dugout I occupied, because it stuck up above the path just enough to make a good seat." There in the barracks at Camp Stuart the group laughed about Sgt. Chet Youngberg's experience of being falsely reported killed in the Argonne. 'Just tell them that I'm coming back home alive and in one piece, and that any reports to the contrary are false, official reports and government records notwithstanding,' Chet instructed.[28]

But for all the renewed friendships and the joy of homecoming, the month's reporting ended on a somber note as Higgins recalled the gathering for the boys who did not come back. "Scattered over the hills and valleys between Neuvilly and Montrebeau Woods, in the Argonne," Higgins wrote, "are approximately one hundred little mounds of earth, with a white wooden cross at the end of each, each mound precisely like its neighbor. Here lie buried the Kansas boys who fell when the 137th

277

swept relentlessly up the Aire Valley, from September 26 to October 1. Early in February, while the regiment was billeted in and around Sampigny, word came that it was going home shortly. A Requiem High Mass for those who will remain behind to sleep under French soil was arranged. A large flat trailer was obtained and an altar constructed of canvas and blankets. It was built facing to the north, for in that general direction lie the fallen heroes."[29]

As OPH welcomed home the boys with whom he had served, he remembered both the men who would remain in France never to return and the men like Lt. Col. Clay C. MacDonald, Col. Carl L. Ristine and General Charles I. Martin, who greeted their comrades who did come back, but whose thoughts could never leave the ones that they, too, had left behind in France.

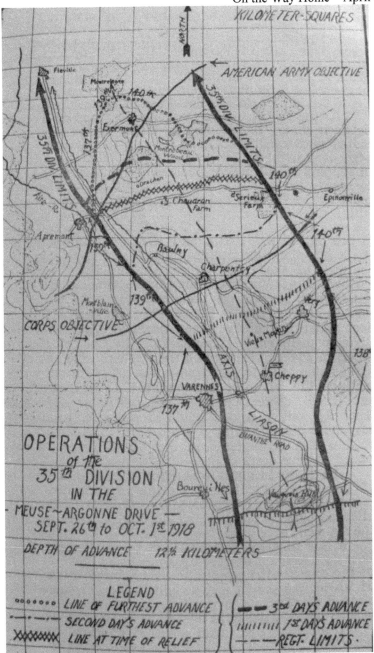

"Operations of the 35th Division in the Meuse-Argonne Drive—Sept. 26th to Oct. 1st, 1918," showing the limits of the 35th Division's sector. Note that Varennes is technically just outside the 35th Division sector, on the east side.[30]

Chapter 14

AVENENGED HIS BOY'S DEATH

MAJOR MacDONALD OF ST. JOSEPH
PROVED OLD AGE WAS NO BARRIER.

After His Son Had Been Felled by
Boche Fire, Father Demanded a
Chance on Firing Line—Was
Cited for Great Bravery.

(From The Star's Correspondent.)

CAMP STUART, Va., April 29—Two officers in the 35th Division were father and son. The boy, Lieut. Malcolm Donald MacDonald, was adjutant of the Third Battalion of the 139th Infantry, composed of the old Fourth Missouri and the Third Kansas. The father, Maj. Clay C. MacDonald, was division postmaster. Major MacDonald was 64 years old, too old, the medical officers said, to be an efficient line officer.

'He can't stand the gaff,' they reported. 'He is sound physically, but he wouldn't be able to withstand a strenuous job in France.'

NO HOME GUARD FOR HIM.

Therefore, Major MacDonald was to be left behind, maybe to remain in the army, maybe to be discharged and sent back to his home at St. Joseph. This plan didn't suit the major. He had been in the guard for a number of years, and now that something was going on he wasn't going to be left out. So he went to work on it and in the end was able to go to France as postmaster of the division, attached to division headquarters.

Lieutenant MacDonald, the son, had a reasonably good job, too. In the ordinary run of things a battalion adjutant is fairly safe. He runs a lot of chances, of course. They all do. But he doesn't have to go out on night patrols, or lead his men over the top, or

280

capture machine gun nests, or take any unnecessary chances like the other lieutenants in a battalion. It is his duty to remain at headquarters and handle the paper work and look after things in general. But this didn't suit Lieutenant MacDonald.

Shortly before the Argonne he went to Col. Carl. L. Ristine, regimental commander and had a talk with him.

SON ALSO WANTED ACTION.

'I want to get a platoon,' he told Colonel Ristine. 'I've been battalion adjutant a long time: I'm perfectly familiar with the work. But it's too quiet. Here are all the rest of the fellows going out on patrols and over the top, and I have to remain behind and read their reports and forward them. I want something to do myself. I want to lead the men.'

Colonel Ristine told him it would be all right with regimental headquarters if the battalion commander acquiesced. The battalion commander did, and just before the troops went into the Argonne he was placed in command of a platoon.

The division jumped off the morning of September 26. They were right in front of Vauquois Hill, that famous hill that the boche had mined and tunneled until it was practically a shell, and a shell that was so full of machine gun nests and other death-dealing implements of war that the French said it could never be taken. So when the attack was made, the troops passed on either side of it, closing in on the far side. But it was alive with boches, and it was left to a battalion of the 139th Infantry to go right straight up the hill from the front and take it, which meant silencing the machine guns and killing the gunners.[31]

LED MEN THROUGH FIRE.

Lieut. Malcolm Donald MacDonald was leading a platoon right up the face of the hill, paying no attention to the machine guns that were spattering on very side, mowing down his men. He was

right out in front, and his men were following. He was doing just what he had wanted to do, lead his men in battle, and he was doing it gloriously. Machine guns, barbed wire, artillery, mines, nothing could stop them.

A boche machine gunner got the range of the platoon. Lieutenant MacDonald was the first to fall. A sergeant jumped in his place. The attacking wave went on; another followed it, and still another. The hill was taken. The machine gun nest quieted forever; the tunnels cleaned out; the artillery silenced.

When they returned, Lieutenant MacDonald, the first of his regiment to fall in the battle, was dead. The surgeon said death was instantaneous. The battalion carried on. Men have no time for sentiment during a fight, and when one falls, another takes his place and continues the onslaught. The stretcher bearers are supposed to look after the wounded and dying. The fighting men are supposed to keep on fighting.[32]

The troops advanced so far that first day that it was necessary to move divisional headquarters forward to the town of Cheppy. Major MacDonald went with it as divisional postmaster. Word was received in the natural course of events that Lieutenant MacDonald was killed.

'He was killed by a German machine gunner while leading his men up Vauquois Hill,' the report stated.

It was passed to Major MacDonald, sitting there at an improvised desk, in the long, low stone building formerly used by the boche as sleeping quarters for the 35th Division.

BROKE NEWS TO FATHER.

'My boy killed leading his men,' the major repeated half aloud while the tears that he tried to hold back made two tiny streams down his cheek.

'My boy killed leading his men,' he repeated once more, his eyes still on the message which he could not see. His mind was some place else. It might have been back in St. Joe, back home: or it might have been picturing the scene of the charge up Vauquois Hill. I don't know: I cannot read minds.

A little later Colonel Hawkins, chief of staff,[33] was startled by a man demanding over his shoulder:

'I want a battalion, and I want it right away,' the voice said.

The colonel looked around. Officers weren't in the habit of addressing the chief of staff in a voice like that. He recognized Major MacDonald. He knew about the boy's death.

'Haven't got a thing,' he told the Major.

But the Major wasn't to be put off. He knew they all thought he was too old, that he wasn't physically able to stand the strain of the days and nights of exposure and living under fire without food, sleep or heat. But he knew he was good for all those things. He could get no satisfaction out of the chief of staff, so he went to Maj. Gen. Peter Traub, commanding the division. Traub told him the same thing. Again and again he went to both men, first one and then the other, all through the second day of the fight. But he couldn't get an assignment.

The going was tough. A large number of officers had been killed, wounded or were missing. Officers were needed and needed sorely. The men were lost in many instances and regiments had dwindled down to battalions. It was impossible to keep a unit together for long. The division suffered more casualties the first two days of the fight than they had suffered during their entire period in France. For us it was something unheard of. We had been through nothing like it.

'Why are you so insistent upon getting a battalion?' I asked the Major that morning. We are all apt to ask a lot of foolish questions in times of stress.

283

WANTED VENGEANCE ON THE BOCHE.

'Command a battalion?' he repeated. 'Why, they killed my boy. Those boche machine gunners killed him, and he was only a boy. But they can't kill my boy and get away with it. Not while I am alive. They will have to kill me, too.'

He cried as he told me his initials and address and answered the other questions a newspaper correspondent is compelled to ask. It was not the ordinary crying, but more like the overflowing of a broken heart, the giving up of all that life held dear to him showing itself in the two steady little streams that trickled from the inside corners of his eyes. His voice was just as firm and steady as it ever was as he answered my questions. It was difficult to associate the tears and voice with the same man at the same time. And so I left him standing there in the mud and drizzling rain, a lonely figure in his helmet and gas mask at the alert position, waiting, waiting, waiting for an opportunity to avenge the death of his boy.

The shortage of officers became acute as the morning's reports came, and something had to be done.

'Where's that old man that wanted a battalion?' General Traub asked. 'Send him up and [we'll] see what he can do.'

The general dismissed the matter from his mind. He had too many other things to think about. The major had his chance. A few minutes later I saw him, a 45-caliber automatic strapped around his waist outside his raincoat. He was swinging on the back end of an ambulance on his way towards Charpentry to report to the headquarters of the 139th Infantry, where he had orders to be assigned to his former battalion, the one with which his boy was fighting when he died.

That was the last time I saw Major MacDonald. I wrote the story, but because of the censorship was unable to use names, dates, places or localities.[34] The thing slipped my mind after that.

I attended a dinner dance at the Hotel Chamberlain last night, given by Colonel Ristine to the officers of the 139th Infantry. In talking over old times the colonel mentioned Major MacDonald's name.

'How did he make out in the Argonne,' I asked, 'when he went up to take one of your battalions?'

AVENGED HIS BOY'S DEATH.

'He did some of the finest work any of the officers performed,' the colonel answered. 'He took charge with courage and determination. He reorganized the battalion, held the left end of the divisional sector, and it was a tough one: took part in all the attacks and helped to repel all the enemy counter-attacks. He led his battalion there for three days and three nights. I don't know how he could stand the strain, but he did it. Nothing was too dangerous for him. Nothing could stop him. He worked like he was inspired. He did so well that he was cited in both divisional and regimental orders for his good work.'

'He didn't come back with the outfit?' I asked.

'No,' the colonel said. 'He made such a great record there in those three days that he was promoted a grade higher and became a lieutenant colonel and was assigned to duty with the 81st Division. I understand he is now home.'[35]

'He avenged his boy's death, too, time after time.'

O. P. H.[36]

Chapter 15: Into Kansas City—May 1919

For OPH, May 1919 proved to be the most productive of the last twelve months of reporting. Throughout most of that last year, the fight was still raging, and most of the articles Higgins had written were published only after considerable delay—slowed down by censorship, the priorities and costs associated with cables, or the time constraints of transmitting physical copy through the volume of transatlantic mail. Once hostilities had ceased and the troops were arriving home at the ports in New York, New Jersey and Virginia, overseas restrictions on the transmission of newspaper copy no longer applied, and OPH, now stateside, could deliver his work the same day or overnight. As a result, readers of the *Star* in May saw at least twenty-three pieces that appeared under the familiar by-line, "by the Star's Correspondent," or that concluded with the distinctive monogram, "OPH."

However, such high production couldn't meet the even higher demand for news of the troop arrivals. As prolific as he was, even OPH couldn't be in multiple places at once. The troops were landing in New York and Newport News in multiple ships at multiple times. For each of the units, readers wanted daily reports of their boys' deployments to camp, their prospective routes home, the names of the trains the boys would take, departure schedules, the plans for stops along the way and for parades in full dress—any and all the details they could get. As a result, two-thirds of the way into the month, the Star made the rare decision of reporting on its reporting, explaining to its readers the "elaborate arrangements" the newspaper had made regarding the 35th Division and would continue to make now that the 89th Division was on its way home, too.

"When the 35th came home, the *Star* had a corps of staff correspondents on hand to meet the Division at both New York and Newport News," the newspaper observed. "It took every pain that

careful organization could suggest to rush to the home folks the first news of their boys."[1]

Proud of its achievement, the newspaper editorialized even further: "For days its men were welcoming the soldiers and wiring columns of incidents. It ventures the opinion that since the Armistice, no newspaper has had more fascinating reading than the news of the 35th."[2]

The *Star* did not hesitate to point out that its coverage was more than just a matter of quantity. The quality of writing—humor, pathos, excitement, and the "personal touch"—made the reporting even more noteworthy. Those same qualities had been the attributes of Higgins' writing throughout the war. From his own personal experience of a year of war, he had set a high standard for war reporting, and the staff correspondents who joined him in New York, New Jersey and Virginia could only strive to reach that standard.

The *Star* was mindful of Higgins' appeal and was careful to distinguish his work. For the most part, when his work appeared in print, the newspaper carried the by-line most associated with Higgins—"The Star's Correspondent." If the byline "Staff Correspondent" was used with one of his stories, then the "OPH" monogram would usually appear at the end. On the rare occasions when neither designation indicated OPH authorship, first person allusions within the article or simply the distinctive style itself would be enough to make it clear to readers that OPH was writing from the credibility of his own personal experience. It was also likely that at least on some occasions, either the reporters themselves or the *Star's* editors in Kansas City combined under one heading the snippets reporters had collected from the men as they streamed off the ships and onto the docks

Perhaps nothing so much represents the transition the men were making as the picture of L. J. Carpenter of Kansas City on

board the *DeKalb* just before it sailed from France on April 7. "Coin of a Real Realm," the title read. Homebound, Carpenter is squatting down on the deck of the ship, legs crossed, "life preserver around his neck, gazing at a $1 federal reserve note. He understands its value," OPH wrote, not just the cash itself but the realization that this was U.S. currency—not francs—and that very shortly he would be spending money and his time at home. Even though picture and text were composed in April, both appeared in the newspaper on the first day of May, 1919.[3]

That same day, the *Star* published an OPH article made up of seven separate reports in bulletin-like format, each featuring different men and their stories. Sergeant Frank Cole of the 140th Ambulance Company "is in a hurry to get home to see if his drug store in Kansas City, Kansas is still doing business at the same old stand."[4] Captain T. J. Wilson "was wounded by high explosives one morning and gassed that afternoon while at a dressing station."[5] Lieutenant M. S. Stevenson, who had also been wounded and was now walking with the aid of two crutches, would be hospitalized for yet another year because his left foot was paralyzed from seven wounds received on October 9 near Exermont.[6]

Even the arrival itself posed a danger to the returning soldier. "Mrs. Carl Ristine of Lexington, Missouri, was the cause of sending her husband, Col. Carl Ristine of the 139th Infantry, to the hospital here the same day the colonel landed. When he stepped off the boat Mrs. Ristine was here to meet him," OPH reported. "She threw her arms about her husband's neck and proceeded to hug and kiss him for all he was worth. She bruised a large carbuncle that had developed on the left side of the colonel's neck. The hugging and kissing was so hard he was obliged to go to the hospital for treatment."[7]

Col. Ristine wasn't in the hospital for long, however. On May 1, the *Star's* Correspondent reported a last-minute change in

the routing of the 139th Infantry to include a stop in Hannibal, Missouri, so Company F could parade in full kit before they turned in their equipment. The same article reported the home-bound routes for the 117th Field Signal Battalion, the 110th Sanitary Train and the 110th Supply Train. Departure schedules for the 138th and 140th Infantry Regiments were also included.

As more attention became focused on the arrivals in Kansas City, the reception the men wished to receive at home assumed paramount importance. On May 2 from Newport News, Virginia, the *Star* reported in a front page article that Kansas City alderman Frank Griffin, who had been sent in the name of the city to welcome the boys officially, sent a telegram to the welcoming committee back home with the request that Major General Peter E. Traub not be permitted to address the troops upon their arrival in Kansas City. "'Both men and officers told me they had seen some of the speeches General Traub made in the States after he left the Division, and they didn't like some of them. They all seem to feel very unkindly toward him, and privately they will tell you why,'" Griffin said. "'At present they are in the army and cannot talk for publication, so they asked me to send the telegram.'"[8]

But the discontent of officers and enlisted men could not be contained for long. In a signed article from Newport News, Virginia, written on April 30 and appearing in the newspaper on May 7, OPH reported on a meeting held the week before at the Warwick Hotel and chaired by Harvey C. Clark, Adjutant General of Missouri. At that meeting, Colonel Ristine expressed the resentment which the Missouri National Guard units felt towards the Regular Army for replacing the National Guard commanders of Missouri units on the very eve of the battle of the Meuse-Argonne. Colonel Ristine had even more to say about current attempts of the Regular Army to dictate the role the National Guard would have in the post-war military. "'We are through following in the steps of the

Regular Army and taking what they give us,'" Ristine said. "'From now on the Guard will dictate to the Army and tell them what we want. The Guard has always played the game open and above board. The Regular Army has played 'dirty politics' with us.'"[9]

The War Department and the Regular Army did not take long to react to Colonel Ristine's assertions. The same day as the OPH report of Colonel's remarks, a *Kansas City Star* staff correspondent reported from Camp Funston, Kansas, that Colonel Ristine was being held "under secret orders from the War Department."[10] "The holding of Colonel Ristine is the result of statements he made at the port of debarkation, derogatory to the Regular Army element in that he declared the National Guard deliberately handicapped in the attempt to discredit and embarrass it," the staff correspondent continued.

By refusing to release Colonel Ristine from active service, the War Department could exercise more control over any further inclinations he might otherwise have had to speak out against the Regular Army, but the War Department could not control the speech of other officers and enlisted men once they had been returned to civilian life. "Telegrams from other National Guard officers are known to have been received by officers here in the camp [Camp Funston], announcing the intention of an open fight between the Guard and Regulars if Colonel Ristine is held for court martial," the *Star's* staff correspondent reported. "So many of these messages have been received that the Regular Army element here at Funston is openly expressing the hope that Ristine may be honorably discharged and the entire matter dropped."

The controversy between the National Guard and the Regular Army continued, and on May 19, the *Star* published statements from a source whom OPH had interviewed. "I will quote from a statement of a Regular Army officer who served with the Division, who is well-known throughout the Regular Army," OPH

wrote. "He asked that his name not be used in connection with the statement, because army officers must not talk, and whenever they do, their future in the army is jeopardized," Higgins explained.[11]

The Regular Army officer noted that over the years, the army had allowed a certain number of incompetent officers— "driftwood," the source called them—to remain in service. As a result, "a large amount of this driftwood" rose up in rank because of seniority, and "the 35th Division was given a large per cent of this driftwood," the source concluded. The source granted that "there were a number of very high class officers assigned to the Division. But I do firmly believe," the source said, "that the 35th had more of the driftwood from the Regulars than any other division in France." The reason was a matter of speculation; however, the source alleged, "the National Guard officers who were in a position to watch the proceedings will tell you that the old fight between the Regulars and the Guard was behind it and that the Regulars saw a chance to discredit the Guard by sending the Guard some inefficient officers."[12]

On the same day, May 19, in a separate article, Higgins explored in detail the changes the Regular Army had made in the command structure of the 35th Division the night before the Battle of the Argonne. A number of commanders were replaced by Regular Army officers who had no combat experience, orders were sent and received in the field after the time the units were directed to attack, and General Traub, the Division commander, had left his headquarters and "spent some of his time at the front in various places during the fight."[13]

Higgins went on to elaborate on the impact of General Traub's absence from his headquarters at such a critical time. "'If a National Guard officer had exposed himself and left his headquarters like General Traub did, he would have been court-martialed,' many an officer told me. 'While being brave and

wandering around under shell fire is a mighty fine thing, yet it is one of the cardinal principles of the army that a unit commander should not expose himself unnecessarily, because the safety of his unit depends upon the proper functioning of the unit commander.'"[14] Higgins then added that "after the Armistice he [General Traub] was sent back home and made speeches in various cities.'"[15] Critical of the 35th Division's performance during the Battle of the Argonne, Traub's comments in those speeches provoked the ire of the 35th Division rank and file, and they did not want him addressing them upon their return home.[16]

As it turned out, General Traub was present when units of the 35th returned, but he remained in the background, greeting some of the officers with whom he was on good terms, but avoiding any formal presentations to the men. After a while, Colonel Ristine received his discharge, Kansas governor and former 35th Division YMCA Director Henry Allen demanded a formal investigation of the allegations made against the Regular Army, hearings were held—and nothing happened. Once back home, the men of the 35th turned their attention to civilian life; they wanted to forget the war.

In the meantime, Higgins was with the boys of the 35th Division, greeting them as they passed through St. Louis on May 9, where the first American Legion convention was being held. "You would imagine there would be a lot of cheering and yelling and waving of hands," Higgins observed. "But there wasn't on leaving St. Louis, or even upon entering it. The boys have been 'arriving' and 'leaving' so many places within the last two years that it has become sort of a habit with them."

Then he added, almost if he could see the boys from the inside out: "But it wasn't hard to detect how they felt. It was written plainly all over their faces, in their manner, in the way they walked up and down the platform. When one of the boys spoke to you he did it with a smile. Now there wasn't any reason for that—

nothing funny had happened—but down deep inside he was so happy that every time he opened his lips to speak his face naturally broke into a wide grin. It couldn't be helped."[17] They would be in Kansas City the next day.

"Union Station, Grand Avenue, mother, sweetheart—In just a few hours all these desires and many others will be realized by the home boys who are doing all they can in their way to assist the engineer to shorten the schedule between here and Kansas City. If there is anybody in Kansas City near and dear to the boys in the 140th, they had better make a point of seeing them at the station or at some one of the places the reception committee has arranged for the troops to be in the course of their stay. If they neglect to meet the fellows, there is going to be a lot of disappointment."[18]

"Kansas City has no idea how the veterans look forward to the homecoming. It will be the principal event for the boys since the war ended and they received notice they were to embark for demobilization points. They have been accorded a royal welcome all along the line, especially since they entered Missouri. But Kansas City is the ultimate point, and it is Kansas City they are bent on reaching," Higgins continued.

"Kansas City is going to notice a more serious countenance on its sons tomorrow than when they marched away. Those 'boys' have since become men, not only by the two years that have been added, but because of experiences in that period of time. That does not mean that they are entirely changed, for they are not. But they are wiser men; they have seen the things that they can only tell you of, and then you will fail to appreciate just what they have been through."[19]

Before arriving in Kansas City, Higgins submitted his last signed article from St. Louis on May 9. Other Higgins articles appeared in the *Star* on Friday, May 16, and Monday, May 19, but these articles did not include a dateline and were likely composed

sometime earlier.[20] It is not until Wednesday, May 21, that readers saw another OPH dateline, this time from New York, where Higgins was awaiting the arrival of the 89th Division. By all appearances, then, from Saturday, May 10, to sometime during the weekend of May 17-18, OPH took some much needed leave to be with his family.

His wife Elizabeth had been there at the dock in Newport News, Virginia, to greet him when he arrived on board the *DeKalb* on April 20, but during the three weeks since Higgins had been back stateside, he had not yet been able come all the way home. One can only imagine that as he talked with the boys in St. Louis, he too, could not help smiling, and when he reached Kansas City, he, like them, returned home "with a more serious countenance," a wiser man, sobered somewhat by all that he had witnessed, felt, thought, and written in the year away at war.

Once back in New York again, Higgins was ready to greet the men of the 89th Division, draftees whom he had first met as he reported on their training at Camp Funston, outside of Junction City, Kansas, while he shuttled back and forth from there to the 35th Division National Guard Units training at Camp Doniphan in Lawton, Oklahoma. Now on May 21, 1919, OPH reported on the race between the *Imperator* and the *Leviathan*, the two sister ships bringing the 89th across the Atlantic to the piers at Hoboken, New Jersey, both ships having departed from Brest on May 15 within a few hours of each other.[21]

As OPH listed the units on board the sister ships, he retold highlights of the history he himself had witnessed. He recounted how the "All-Kansas" 353rd Infantry Regiment had made "'Jerry' hunt his hole at St. Mihiel and again in the Meuse-Argonne offensive, where they shoved him out of the Bois de Bantheville and clear over across the Meuse River."[22]

OPH then mentioned that the 355th Infantry complete, from Nebraska and Colorado, was on the same ship, the *Leviathan*, while most of the 354th was coming across on the *Imperator*. The 340th Machine Gun Battalion was on its way to Camp Grant, while most of the 341st Machine Gun Battalion was headed for Camp Funston. The 177th Infantry Brigade with its veterinary unit was also arriving on the *Leviathan*. Finally came the welcoming delegation that had arrived from St. Louis—Kansas Governor Henry J. Allen with his delegation late that night, and the Kansas City committee of four the next day. All was anticipation.

Then, like a cloud bank, the *Leviathan* appeared, and OPH painted the picture in words so his readers could visualize the huge ship as it emerged from the mist and made its way into port. "A few minutes later we could discern the three giant smokestacks on the boat and it began to take form," Higgins wrote. "And then we could see the tugs darting around it, little fellows who were standing off to lend a hand when it came to docking. Then out from some place came three tugs. They seemed to drift right out of the clouds. One, the 'Mayor's welcome boat' out of New York City, which contained the delegations from Colorado and Nebraska; another, the *Montauck* carrying Governor Allen, the Kansas delegation, and Maj. Gen. Leonard Wood, and the third carrying Brig. Gen. Harvey C. Clark and the Missouri delegation. They had all gone down the bay to meet the first men of the 89th Division to come home."[23]

A few minutes later another dark cloud bank down the river appeared with a rim of white, growing until the sister ship, the *Imperator*, took form. Again, OPH painted a moving picture of words. On the *Leviathan*, "faces, faces, faces, everywhere faces. Rows upon rows of them, one and two in every porthole all the way up the great sides of the ship, and along the decks; every place there was an inch of room there was a face, or, if there wasn't enough room for a face, a nose would be sticking out, in the hopes of

finding an opening. The ship carried 11,958 soldiers, and from the way it looked all of them were at least part way outside."[24]

And when the boys on the ship got close enough to hear a yell from the dock, the boys themselves took up the cue. "I have seen many transports leaving France and many of them land in this country," OPH declared, "but never before did I hear so much noise among them. Maybe it was because they came from the Rhine, and therefore doubly glad to get home, or maybe it was the spirit that goes with the monster boat. I don't know, but there was something different in it. The men on the *Imperator* that passed a few minutes later, didn't yell like those on the *Leviathan;* I doubt if the men on any more of the transports do. But the 11,958 on the big liner sure opened their lungs."[25]

Once in dock, the officers of the "All Kansas" 353rd Infantry were greeted by Governor Allen. "'Kansas is certainly glad to welcome home her heroes,' Governor Allen told them. 'We are all proud of you. You made a wonderful record in your fight for democracy, one that will go down into history and live forevermore. You will find that there isn't anything that you will not get when you get home. They have been fattening up the calves and the chickens for some time now, in preparation for your return, and when you get there all will be in readiness for you.'" After Governor Allen's speech, General Leonard Wood circulated among the officers, renewing old acquaintances, happy to see his men once again.

In subsequent articles, OPH described the work of the Kansas 353rd as well as the 355th Nebraska men under the command of Lt. Col. Levi G. Brown.[26] Then on May 23, a pall descended over the homecoming. "There is a rumor the 89th Division may be held in the East until the present crisis with Germany over signing the Peace Treaty is settled and all danger of another clash between the Allies and the boche is past," OPH reported.[27] Both the

Leviathan and the *Imperator* remained at anchor in the harbor; together the two ships could deliver a division to France in a matter of ten days. Another division was at sea and could be turned around, so that two divisions could be brought to bear should the crisis continue. "None of the men is particularly anxious to return to France at this time," OPH added in understatement. "They have been looking forward to going home for almost a year now, and today finds them on the last lap."[28] Fortunately, as it turned out, the immediate crisis eased, and on May 26 the schedules for entrainment began to appear once more.[29]

On May 27 more elements of the 89th Division arrived on the *Prinz Friederich Wilhelm*, and OPH enjoyed some repartee with them about meeting General Vin Rouge and General Vin Blanc.

"'I spent some thirteen months with the two generals myself, but I never could get along with them,'" OPH maintained. The irony was all the more poignant because the band was playing "How Dry I Am." The boys were coming home to Prohibition.

But OPH was thinking more of what the boys were bringing back with them than what they would face once they arrived home. From May 24th until May 30th, OPH related stories of the exploits of the men of the 89th—from the reluctant Sergeant Arthur R. Forrest, Company B, 354th Infantry, who took sixty German prisoners a little southeast of Ramonville and in the process won the Medal of Honor,[30] to Waggoner Victor Allen and Charles Grout of the 355th Ambulance Company, who under enemy fire drove an ambulance into No Man's Land to rescue a private suffering from thirst and the pain of a broken leg.[31]

Those stories were true and witnessed by the men themselves, but other depictions of the war were blatantly false. Higgins exposed a number of such false depictions in an exhibition of war paintings on display in New York show windows. "They were so far away from conditions as I saw them," he wrote on May

24, "that time after time I would stop and gaze in amazement at the marvels wrought with a mere brush."[32]

Higgins, on the other hand, had his own stories to tell—equally marvelous, but true. On May 28, OPH acknowledged the popularity of Sergeant Alvin C. York but added "there are a lot of unsung and unheralded heroes of the war whose deeds have never been mentioned. Maybe because no newspaper correspondent or magazine writers ever heard about them, or maybe because the regulations of the censor wouldn't permit it."[33]

"The latter was the case with this incident," OPH continued. "The censor wouldn't pass the story in full for reasons best known to himself." Higgins then set out to relate the story of six soldiers in three teams of two, who attempted to cross the River Meuse and procure information on the strength of the German defenses at Pouilly and Stenay on the night of November 9, 1918, two days before the end of the war. After two attempts to cross, one team was forced to return. Two other men drowned, and only two others of the original six returned alive.

"The two were Sergt. Harold Johnstone of Denver, Col, and Sergt. M. Waldo Hatter of Neosho, Mo." Higgins reported, "and they had completed the trip across the river, into the woods on the other side, up and down the bank and up to the edge of the town. The information they obtained that night resulted in the plans being made for the crossing of the river, the eventual crossing of the river the night of November 10 and the morning of November 11 by the 89th Division, and the capture of the towns of Pouilly and Stenay. The capture of the heights on the east bank of the Meuse, was the principal thing in the great Meuse-Argonne offensive." Both Sergeant Johnstone and Sergeant M. Waldo Hatter received the Medal of Honor for their bravery.

Higgins himself was on the scene that night and crossed the river after it had been secured, but he was prevented at the time from

telling that story, too—even though the Armistice was declared the next day. "The censorship refused at that time to allow the mention of units, only under certain conditions. It also refused to pass casualties only until they had been verified by the central records bureau—which required months. So the story in full was never printed."[34] Now, six months later, OPH was finally able to reveal the extraordinary bravery of six men of the 356th Infantry and to see the story in print.

In articles written on May 28 and May 29, OPH followed up with the stories of other men who had returned on the big ships during the month of May, and on Memorial Day, May 30, from Camp Upton, New York, while he stood with head bared in the cemetery, he remembered the men who did not return, the men who were buried three thousand miles away.

"But these silent, lonesome little spots on the hills from Vauquois Hill on through Varennes, Cheppy, Charpentry, Very, Baulny--those hills and valleys that the men fought their way through—here and there, every few yards, can be found a bit of freshly turned earth. The last time I saw many of them, only a helmet or a rifle lay there to make known the fact that it was a grave. That was before the graves registration people worked the territory. But tonight I can't help but wonder if any of the curious visitors left their motor cars and wandered out over the hills of the old battle field, and gathering up a handful of wild flowers, placed them beside the lone little wooden crosses."[35]

For Otto P. Higgins, May 1919 began with welcoming home the men of the 35th and the 89th Divisions who had returned, and it ended the same way previous months had ended—with remembrance of the men of those Divisions who had not returned.

"O. P. H." SEES 'EM AGAIN.

The Star's Correspondent Overseas
Met 140th in St. Louis.

(By The Star's Correspondent.)

ST. LOUIS, May 9.—If there was anything the matter with the four trainloads of soldiers who passed through here this afternoon, a casual visitor couldn't notice it. They were homeward bound—you didn't have to be a mind reader to know that. You would have had to be blind and deaf not to know that. For they were on their way to Kansas City, four train loads of them—count 'em—and they didn't care who knew it.

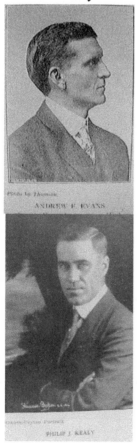

Photo by Thurston.
ANDREW F. EVANS

PHILIP J. KEALY

The first section arrived shortly after 5 o'clock at Union Station. They were met by Col. Philip J. Kealy, Chairman of the Kansas City delegation on welcoming.[36] Judge Andrew E. Evans,[37] John A. Eames,[38] secretary to Mayor Cowgill,[39] and Alderman W. F. Fleming.[40] The committee remained in the yards until the last section pulled out shortly after 7 o'clock.

But Colonel Kealy wasn't the only welcoming committee present. There were a great many others, mostly wives, mothers, sisters, and quite a sprinkling of sweethearts. Just how they got there I don't know. I went down with Col. Bennett Clark, former lieutenant colonel of the regiment,[41] and it took us more than an hour to reach the place. No one was allowed in the yards except Red Cross workers, who always are on hand to

give the boys a welcome and a feed. But the relatives and friends crept in somehow. You can't keep them out.

The boys were given an opportunity to stretch their legs, and the Red Cross was given an opportunity to load them up with dainties, newspapers and anything else they wanted, and then they were off.

You would imagine there would be a lot of cheering and yelling and waving of hands. But there wasn't Maybe there will be tomorrow when Kansas City comes into view. But there wasn't on leaving St. Louis, or even upon entering it. The boys have been 'arriving' and 'leaving' so many places within the last two years that it has become sort of a habit with them.

But it wasn't hard to detect how they felt. It was written plainly all over their faces, in their manner, in the way they walked up and down the platform. When one of the boys spoke to you he did it with a smile. Now there wasn't any reason for that—nothing funny had happened—but down deep inside he was so happy that every time he opened his lips to speak, his face naturally broke into a wide grin. It couldn't be helped.

And so the coaches rolled out of the yards with from one to six heads protruding from every window, and short of a quiet, happy smile on every face.

Colonel Kealy and the delegation will leave here tonight on a later train for Kansas City, accompanied by Governor Gardner, Brig. Gen. Harvey C. Clark, Col. Ruby D. Garrett, and possibly some others who have been here attending the American Legion convention.

O. P. H.[42]

LAURELS TO LITTER BEARERS.

The 353d Men Displayed Heroism
In Caring for Wounded.

(By a Staff Correspondent.)

NEW YORK, May 24.—In New York I have seen paintings on exhibition in show windows, depicting alleged scenes of the war, that were foreign to anything I ever saw in France. They were so far away from conditions as I saw them, that time after time I would stop and gaze in amazement at the marvels wrought with a mere brush.

One painting depicted a nurse in uniform kneeling on a muddy battlefield. A soldier's blood-stained head lay in her lap. With one hand she caressed his forehead, while with the other she held his hand. Shells were bursting all about, and soldiers were running here and there with the blood dripping from their bayonets.

NURSE HELD CAMPAIGN HAT.

Another painting showed a nurse standing on a battlefield holding a soldier's campaign hat in her hand. Practically the same background was used, shells and all. A lost hat meant to her that the soldier to whom it belonged evidently had been shot from under it; so, calling a dog, she sent him in search of the wounded soldier, who could be seen partly concealed by some brush.

Now I never saw a nurse on a battlefield. Soldiers don't wear campaign hats in the field, but steel helmets. Men in battle don't fight without wearing gas masks at the alert, and the pictures seldom show gas masks. And last, but not least, when shells are bursting about one's head one doesn't stand and look at them, but drops into the first hole found. I saw but a small part of the war women, and I believed maybe some of the men who were with the ambulance units and who saw much more than I did, would know

more about it. So I asked some of the farmer boys from out around Fredonia and Winfield, boys who joined the Ambulance Company 353.

SAW ONLY TWO WOMEN.

'Women? No. We never had any women,' one fellow said. 'The only ones we saw were Mrs. Fitzgerald,[43] who made doughnuts for us, and Mrs. Maude Radford Warren,[44] who made us chocolate. Both of them were Y.M.C.A. women.'

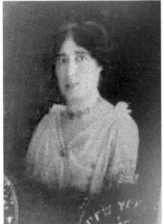

'But didn't you even have nurses in the dressing stations, to hold the hands of the boys?' I insisted.

'Nurses in the dressing stations? another said. 'What's the matter with you? They all stay back with the hospitals. They chased all the Y. M. C. A. women out of the Division when we went into the line. Women have no place in a fight, but some of them got back anyway.' Then the informant started off on another line.

Maude Radford Warren from her Passport Application, 2 April 1919

CALM WHEN WOUNDED.

'You never saw anything like our men when they were wounded,' he said. 'I never saw but one fellow get mad about it the whole time we were in the line, and he had a right to. He was an artist of some kind, and had his right arm shot off about twenty minutes before the Armistice went into effect. That fellow surely went on a tear. Usually they never said much, and about all they wanted was cigarettes and water.'

That recalled Clyde L. ('Cowboy') Thompson, a Fredonia, Kas., farmer. 'The cowboy is some guy,' the informant remarked. 'He had charge of a squad. They were killing and wounding the

boys rather fast in the Meuse-Argonne fight. So fast, in fact, that we didn't have time to bury the dead.

'Somebody started back with one hundred German prisoners one afternoon when the cowboy saw them. "Here's where I get myself some good litter bearers," he told us.

PUT PRISONERS TO WORK.

'Tearing off his Red Cross brassard, he picked up a forty-five and strapped it around his waist and went after the boche, who were headed for the rear. He brought all those prisoners to the dressing station and put them to work carrying litters and digging graves. Pretty good for a Kansas farmer, don't you think?

'And there was Paul Phelps and Howard Rounds of Ottawa, Kas., They were attached to the medical supply depot at Bouillonville, in the St. Mihiel sector. The boche put down a barrage one afternoon when some doughboys were passing. A number of them were wounded. Phelps and Rounds went to help them, dressed their wounded under shell fire and saved one boy's life by stopping the flow of blood when his leg was shot off. Oh, these Kansas farmers make pretty good nurses.'

TWO OFFICERS PROMOTED.

Maj. Edgar C. Duncan of Fredonia, who organized the unit, was promoted soon after reaching France and placed in command of the ambulance battalion. He brought the battalion home.

Col. F. W. O'Donnell of Junction City, who commanded the sanitary train, was promoted to Division surgeon, just before the troops sailed from Brest.

O.P.H.[45]

Chapter 16: "From the Notebook of O.P.H."—June 1919

Now that the boys were safely home, Higgins' job of writing about them was drawing to a close. Like them, he was returning home to point his life in a different direction, and like them, too, he

still had stories to tell, many humorous and mostly of the curious sort that continue to lurk in the back of your head long after the event is over. During the month of June, 1919, the *Star* published seventeen such pieces under the O.P.H. monogram, thirteen of which took on the characteristics of a regular column with the heading, "From the Notebook of O.P.H."

The notebook stories were introduced on June 8, 1919, with a specially illustrated article entitled, "That Job of 'Writing Up' the War: O.P.H. Tells How Correspondents Worked in France."[1] Towards the end of the month, on June 23, 1919, OPH again wrote about his experience as a correspondent, this time dealing with the censorship.[2]

The remaining notebook stories span the total time Higgins was overseas, from a humorous incident during a submarine scare on board the *Lapland* on the way over to Liverpool in April, 1918,[3] to the spontaneous reception OPH and his colleagues received at Bastogne in Belgium on their way to the occupation of Germany.[4] Many of the stories include fellow correspondents: William Slavens McNutt, who was with Higgins in that spontaneous reception in Bastogne and in a rather dubious visit to the schloss of a self-serving count and countess near Mersch in the Grand Duchy of

Luxembourg;[5] Maude Radford Warren of the *Saturday Evening Post*, with whom OPH interviewed German citizens during the American occupation after the Armistice;[6] Adam Breede of the *Hastings Daily Tribune*, Hastings, Nebraska, and George Seldes of the Marshall Syndicate, both of whom, together with OPH, encountered 200 army nurses on their way to the front but temporaily billeted for the night at the Regina Hotel during an air raid on Paris.[7] The inclusion of other correspondents as part of the story allows the reader some insight into the personality of writers in the context of how the news is gathered and how the story is told.

Also figuring largely in the stories is Lieutenant Colonel Ruby D. Garrett, field signal officer of the 42nd Division and commander of the 117th Field Signal Battalion from Kansas City. Lt. Col. Garrett had a staff car at his disposal, and Higgins, Breede and McNutt were able sometimes to accompany him as he moved in advance of the Division to set up communications. OPH's affiliation with Lt. Col. Garrett also afforded Higgins and Breede the opportunity to participate in an unnerving night reconnaissance into No Man's Land during the summer of 1918.[8]

Throughout the stories, OPH makes connections with people from home. "The world is such a small place. And the war made it even smaller," he says as he sets up to tell the story of arriving late at night at the Y.M.C.A. canteen in the citadel of Verdun. Higgins was in the company of W. Y. Morgan, a Y.M.C.A. educational director with the 35th Division, editor-owner of the *Hutchinson News* and *Hutchinson Harold* and current Lieutenant Governor of Kansas. The two were traveling in Morgan's car on their way through the Argonne forest back to 35th Division Headquarters at Commercy when they stopped late in the evening at the "Y" canteen and headquarters in Verdun, hoping to get something to eat.

The "Y" secretary unlocked the door and admitted Higgins and Morgan into the dining room while the French civilians working

for the "Y" warmed up the leftovers. Meanwhile, Higgins and Morgan warmed themselves up at the fireplace, and during the conversation, the secretary mentioned that a "Y" female secretary assigned there was also from Kansas.

"'Trot her out,' Mr. Morgan remarked. 'We always want to talk with anyone from home.'

"'She would be down in a few minutes,' the secretary said when he returned. She was reading herself to sleep, and as quickly as she could dress would come down, for she was eager to see the folks from home."

"When we introduced ourselves, she told us her name was Alpha Miller, that her home was in Lawrence, Kas., where she graduated from the University in the class of '13, and that for the last three years she had been teaching botany in the Kansas Side High School," the same high school from which OPH had graduated in 1909.

Alfa Miller's passport picture, November, 1918.

Although OPH does not say so in the article, Alpha Miller, who spelled her name "Alfa," was born in White Church, an historic neighborhood in Kansas City, Kansas, with which Higgins would have been quite familiar, having grown up just east of there himself. Both OPH and Alfa were the same age, 29 years old, and the two would certainly have had in common a familiarity with a number of teachers at the high school and perhaps at the University of Kansas, where both had attended at the same time.

"'Now I am serving chocolate and cakes to soldiers in the citadel at Verdun,' Alfa said, 'besides meeting the trains at the station and serving the boys as they come through. I always loved

teaching, and I love Kansas City, Kansas, and Lawrence, but I like this best of all.'"[9]

OPH tells other stories, equally memorable, but where he managed somehow to violate French sensibilities and customs that seem to have the force of law. There was, for instance, the time he and Adam Breede, elated at having found two bunches of spring onions nestled in the window of a little French shop, insisted on having the onions prepared and served to them at a Paris café where they had previously made dinner reservations. Servers and cooks refused to touch the onions but were willing enough to allow Higgins and Breede to prepare them on their own, after which Breede himself proceeded to serve the onions to the clientele in the café. "Everyone took an onion, but no one ate," OPH recalled. "Each person was waiting for us to see what we did with them when we sat down." Soon the two journalists discovered the reason behind the French reluctance to have anything to do with raw onions.[10]

OPH learned another French custom when he met the three 'rubbers' who worked at a French "Turkish" bath, "strong, powerful men running around with a towel around their groins," men who, OPH discovered from a sign on the wall, "receive no pay for their work."

"'That's too bad,' I told John, who seemed to know some six or seven words of English. 'Why do you work here if they don't pay you?'

'You no *donnez moi*?' he said, which translated, asks if I am not going to give him something.

'I can't give you anything,' I explained. 'I can't carry money around in my hand when I'm taking a Turkish bath.'

Then Higgins meets Maxine, and matters became much clearer.[11]

On another occasion, at the Eduard VII Theatre in Paris, Higgins saw a sign similar to the one he had seen posted at the Turkish bath. The sign at the theatre seemed to indicate that usherettes were not permitted to accept gratuities.

To Our Patrons
————

The attachés of this theater are
not permitted to accept fees for
gratuities. Admission covers all the
advantages and conveniences afforded
for your entire comfort and pleasure.

Thus informed, Higgins and his companions entered the theater. After the four in Higgins' party were taken to their seats near the front, Higgins offered the usherette a 50-centime tip and was met with a "torrent of French."

"'I don't know what you're saying,' I told her. 'Speak English.'" She grabbed Higgins' arm and became even louder.

By that point, the actors on stage had stopped acting and the "eyes, lorgnettes and opera glasses" of the audience were trained on OPH. An American soldier nearby explained to Higgins that the usherette was complaining that she should have received 4 francs instead of the 50 centimes. Hearing the explanation, the members of Higgins' party immediately ponied up an additional 2 francs. The situation was resolved, for the moment, and Higgins learned that unwritten prescriptions took precedence over anything stated in print. "In France, you tip the maid for bringing in your breakfast; you tip another one for cleaning your room; you tip the elevator boy for taking you downstairs; you tip the concierge porter for letting you out, and then you tip him again for letting you in." And if you tip lower than ten percent, you will hear about it."[12]

Chagrined by such French notions of customer relations, OPH expanded on why American boys became equally disgusted with the poor accommodations and inhospitable weather conditions the French had to offer their American guests. "Week after week, month after month, they lived in the mud and slime and desolation of the front," OPH explained. "Shell-torn villages, rat infested camps, dark dugouts, no lights, no stores, no people, no nothing, except mud, rain, hiking and fighting. Is it any wonder they don't like France?"[13]

Then there was the matter of bargaining, another French custom which Americans found particularly irksome. "To the French, an article is worth whatever they can get for it. The Americans didn't know the custom of bargaining, or couldn't speak the language," Higgins noted. "As a result, Americans often spent more than what an article was worth, and prices went up as soon as Americans appeared. All these things caused ill feeling on the part of the French toward Americans, because the French couldn't pay the prices the Americans could, therefore they couldn't buy. In some places a double scale of prices was maintained, one for the French, another for the Americans."[14]

Similar economic discrimination was directed at German shopkeepers in the Alsace-Lorraine, and American soldiers were the unwitting pawns. Once the French had regained Alsace and Lorraine from the Germans, the French began to squeeze the Germans economically until they left, just as the Germans had done to the French after the Franco-Prussian War. The strategy was simple: men in uniform were restricted from German shops. "The fact that men in uniform were forbidden to buy from them caused civilians to shun the places, because they feared they would be classed a German sympathizer and punished in some way," OPH said. "That was the same attitude taken toward all businesses in Alsace and Lorraine which were suspected of being German, and it

means that before many months had gone by they would all be insolvent and forced to leave, to be replaced by French firms."[15]

Perhaps one of the best examples of ethnic and cultural difference came during the occupation of Germany, when OPH visited Metz, Cologne and Wiesbaden. "Up and down the Moselle and in the interior of the Rhineland, public opinion about the Kaiser was the same. 'The Kaiser is a good man,' the people would say."[16] To the German people, OPH explained, the Kaiser "embodies all that is holy, good and kind, generous to a fault, always looking after the best interests of his subjects and always acting with their welfare in mind."[17] The German people whom Higgins interviewed believed that the Kaiser was not the one responsible for the war. Instead, the war was caused by "those who worked their way into his good graces and gained control of the government, chiefly by misrepresenting things."[18] In Cologne, OPH and another journalist, *Saturday Evening Post* writer Maud Radford Warren, interviewed a wealthy social activist who tearfully acknowledged that when the Kaiser "left Germany to her fate and escaped to Holland he did it because he believed it was in the best interests of his subjects."[19]

Directly contrasting with the notebook story where Germany is personified in the figure of the Kaiser was a notebook narrative where America is personified in the emblem of the flag. In both stories, the patriotic principle is similar, but the circumstances of its application differ. Like most of Europe, Germany was a monarchy, where governance was inherited in the person of the Kaiser; however, in America, a democratic republic where governance was elected, it is the flag itself that represents the character of the people. Unlike the Kaiser, who later left Germany for asylum in Holland, the stars and stripes accompanied Americans wherever they went. It was the flag that lead the way and stood the ground.

The difference between Americans and Germans was played out in a particular way during July 1918, when the 1st Battalion of

Kansas City's 140th Infantry took over the Balmain Sector of the Vosges Mountains. A year later, as part of his notebook series, OPH published a story about the posting of an American flag over a stone house that had served as an observation post in No Man's Land. With the posting of the American flag, "No Man's Land" had been re-claimed as "Yankee Land."

Previously, the area had been known as a "rest sector": the French and the Germans had an implicit agreement. "Here the French and Germans had been sending their troops to rest up. It was said that the soldiers would wash their clothing in the same creek with the enemy and that the wet wash would be hung on the barb wire in front of the respective trenches. Occasionally a few shots were fired by the artillery, but always at the same time on the same targets, so no one was ever hit." But all that changed when the 35th Division arrived. "The boys from Missouri and Kansas felt that they went to France to fight, and the quicker they began fighting, the better." "It was something like high school days," Higgins remembered. "Spring after spring the juniors and seniors place their colors in a highly dangerous place and then defend them. But over there, lives were at stake."[20]

After clearing out German patrols from No Man's Land, the Americans set out to take over the stone house that had served as a German observation point. The Americans picked off German snipers and harassed the enemy "by all sorts of fire, ruses, patrolling at night and day" so that German morale had been broken down. Now the 140th Infantry 1st Battalion was requesting from Division headquarters permission to post a small American flag over the stone house in No Man's Land. When the Divisional endorsement came back, two Kansas City boys raised the flag during the night.

OPH quoted from the report made the next day. "The flag flies. 'Twas a narrow escape. The boys just reached the top of the house when Jerry evidently hearing them, opened up, and bullets

rained all about. The flag went up just the same." [21] It remained in place, guarded day and night until the 35th Division was relieved by the French and prepared for its role in the Battle of St. Mihiel.

In many ways, the story of the 140th Infantry's raising and defending the American flag as it flew over the stone house in "No Man's Land" stands as an icon for Kansas City's patriotism and courage during the war. The little stone house in the Balmain Sector of the Vosges Mountains was the 140th Infantry's Fort McHenry, and although the OPH story that records the incident lacks the dramatic caché of *The Star Spangled Banner*, the spirit it evokes is certainly the same.

From the Note Book of O. P. H.[22]

'Just take the car around to the garage, and when you put it up you can go to the basement and ask the chef for some coffee. He won't understand you, but make a motion like you are thirsty and then look for the coffee pot, and you'll get it.'

The count turned to Col. Ruby D. Garrett and myself after giving those directions to the man on the front seat.[23] The count was explaining that his home, which we were about to enter, was built in the thirteenth century by some of his ancestors, and the original towers of the schloss were still standing, while his aunt had constructed a modern chateau on one end of the building.

'I passed on to the chauffeur the directions you gave me, and I'd rather have tea than coffee, anyway. That's a great dog you have there. Looks like he might have come from Alaska.'

DESIRED TO SEE THE COUNTESS.

The count looked around, raised his eyebrows a trifle, took the cue and seized the conversation about the dog. He had mistaken William Slavens McNutt, war correspondent for *Collier's*, for the chauffeur, but Bill wouldn't stand for it.[24] We had been invited to take tea with the count and countess at their schloss, near Mersch, in the Grand Duchy of Luxembourg, and Bill proposed to have his tea with the countess.[25]

But you could hardly blame the count. We had gone through the last phase of the Argonne and were on the way to Germany with the Kansas City signal battalion. Our only baggage was what we could carry on our backs. Bill had misplaced his safety razor three days previous and it had been just that long since Bill had shaved. His shoes had belonged at one time to a British Tommy and showed it. Part of the steel toe plate on one was loose, several steel nails in the sole of one boot had pushed through, causing Bill to limp. Having no orderly and no polish, both shoes were muddy. His

uniform had been through several months of sleeping and eating on the front, with no chance of a change, as its appearance indicated. On the outside of the blouse he wore a black leather vest, on the inside several layers of sweaters, over all of which was wrapped an army blanket.

GARRETT WAS "IN RUBBER."

My outfit was more or less like Bill's, only I wore a necktie and had shaved that morning. The colonel was the Beau Brummel.[26] While in Paris several months before, he had purchased a rubber collar and a pair of detachable rubber cuffs. When occasion required, he could pour some water on the collar, rub it off on the leg of his trousers, turn in his shirt collar and wrap the rubber collar around his neck; his cuffs, which he tied on his wrists with string, were cleaned in the same manner.

'That dog looks like one I used to have in Alaska,' Bill continued, still patting the dog, who would make friends with no one else.

'Yes, he came from Alaska,' the count answered, glancing again at the colonel. 'My brother brought him from there. Won't you come inside?'

Bill hobbled along with the aid of his heavy, steel-pointed stick. I accompanied him, while the colonel came along with the count, talking about dogs. A man in full dress opened the door.

MEEET THE DRESS SUIT!

'I'm Bill McNutt,' Bill said as he stuck out his right hand. The Dress Suit merely raised its eyebrows a trifle, but Bill took its hand and shook hard. 'This is Higgie and the colonel is coming with that other fellow there,' Bill continued.

The Dress Suit merely held the door open and pointed down the hall. The colonel tried to speak, but couldn't. We never learned just what the count was thinking. Bill afterwards said that he was

just trying to get even with the count for the chauffeur stuff, and that even though he hadn't seen a dress suit for years, he could recognize a butler when he saw one.

The count preceded us through several halls and finally opened a door into a wonderfully furnished living room. Bill walked across the highly polished floor, his hobnails biting into the finish like a buzz saw into a piece of pine, his spiked stick swinging to and fro. The colonel was wearing his lightweight barracks shoes, forgetting about the slippery floors. The minute he struck the floor, however, it was instantly called to his mind, and only the count's assistance saved him. Then he sat down in the nearest chair.

Dress Suit came in just then, and the count told him in German to pass the cigarettes. Understanding German, I passed mine first.

The countess came, and we were presented. She was beautiful. She took her seat behind the silver tea service, switched on the electricity, while Bill, sitting on a settee of beautiful tapestry, his bewhiskered chin resting on his crossed hands and his hands on the head of his spiked cane, carried the conversation across the tea table to the countess and ran away with it. I kept her supplied with cigarettes—she preferred my American brand to her own gold-tipped, monogrammed kind.

About the time tea was ready to be served the daughter, a beautiful little golden-haired girl of 14 came in, accompanied by a dachshund. Dress Suit was hovering in the offing. It wasn't difficult for me to follow the conversation, but when the dachshund entered into it I quit. The count and countess addressed Dress Suit in German, spoke to each other in French, talked with us in exceptionally good English, and spoke to the dog in Flemish. That was too much.

It was like a dream to us, coming out of the mud, rain, cold, the shelling, suffering and dying of the front, and walking right into

the middle of a modernized thirteenth century castle, taking tea with a count and countess. The manner of our dress didn't strike us, of course, until we were leaving. For we were accustomed to going dressed as we were, from the long weeks on the front. From the minute we bumped into Dress Suit, however, we felt it, although it didn't find expression until after we left.

But in spite of Bill's whiskers, in spite of his hobnailed shoes and spiked cane, in spite of our soiled clothing and the colonel's rubber collars and cuffs, we accepted an urgent invitation for a day's shooting and dinner on the count's preserve.

The news soon spread in Mersch, of course, about our 'teaing' with the count and countess, and it resulted in the following being told us by the civilian population:

The countess was a sister of the assistant secretary of state of the German government;[27] during the war they always entertained German officers and the Kaiser himself occasionally came to visit; the count had handled American Red Cross food in Belgium and Northern France, having charge of one sector which resulted in his having his cellars stocked with excellent foodstuffs while no one else in the neighborhood had much of anything; that he was in league with the German government in the substitution of poor boche food for the good American food, and that he probably would ask us for gasoline or some other commodity before we left.[28]

We knew not about all the foregoing, except the gasoline, and he had asked for that. So we bid farewell to the count and countess without returning for the day's shooting and the dinner.

Chapter 16

From the Note Book of O. P. H.[29]

Don't ever try to give an onion to a Frenchman. One Sunday afternoon last summer Adam Breede, correspondent for the *Hastings Tribune*, and I were promenading through the Luxembourg Gardens in Paris[30]. Accidentally, we were watching for a little restaurant called, "La Furet," a famous little café in the Latin Quarter.

We didn't know the location, but we found the café through the noise that came through the door. Just why it is called "Le Furet" I do not know.[31] The three corpulent mademoiselles—each called 'madame,' but out of respect for age and weight—have been there for years and know the inside history of almost everyone who has lived in that section the last score of years. After introducing ourselves in English to these women, who understood only French, we reserved places for dinner and continued our promenade.

THE FIRST ONION.

Now, we had not been able to find green onions in our journeys throughout France. Time after time we had made an effort, but always failed. Nestling in the window of a little French shop we spied two bunches of spring onions. We bought them for our dinner. The madame wrapped a small piece of newspaper around the business end of each bunch, leaving the green stalks to trail outside. Again we started on our promenade, each carrying a small bunch of onions under one arm.

We were in a much frequented part of the city, and everyone turned to stare. Soon our laughs at the curiosity of the people became slightly forced. So when we spied one of the mademoiselles who worked in the café we ran to her with outstretched onions.

'Won't you please be so kind to take our onions to the café and serve them to us with our dinner?' we pleaded in our best French.

MADEMOISELLE RETREATS.

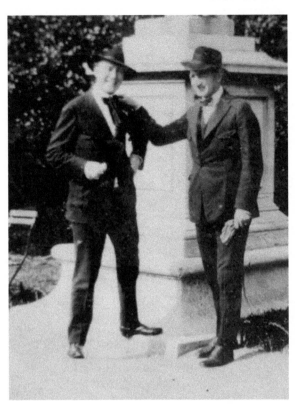

Adam Breede (left) and OPH (right) pausing on promenade before the statue of Diana in Le Jardin des Tuileries, Paris. (Photo courtesy of Sheila Scott).

She didn't smile or speak. Instead, she raised both hands, with a horrified expression, a thumb and forefinger of one hand grasping her nostrils as she backed away, waving us away with her free hand. We both followed smiling our best made-to-order smile, pleading and expostulating, and holding out the onions. By this time we were the center of a curious crowd. Finally the mademoiselle turned and ran as fast as she could. There wasn't anything to do except tuck the green vegetables under our arms and, as nonchalantly as we could, continue our promenade, which had lost much of its zest.

Dinner time found us back at the café, now well filled with the regular clientele awaiting the regulation family service, beginning with the passing of the great bowl of soup. We hesitated at the door because of the onions. Mme. Louise waddled up to us. We thrust the onions towards her, trying to make her understand that we wanted them cleaned and served with our dinner.

Mme. Louise began talking as fast as a machine gun. We could not understand her, but all eyes in the place soon were focused upon us. Mme. Eloise, from her high stool behind the counter that acted as a cash drawer, drew her silver rimmed spectacles a little farther down on her nose and came over. Mme. Marie stopped her chatter with a group of Frenchmen in the other end of the room and joined us. Even the waitresses and cooks came out.

WANTED TO KEEP PATRONAGE.

Madame would not touch the onions. We must take them out. The customers put on pained expressions. If we wanted onions we must bring them back some morning or noon, when none of the other patrons was present, madame said. Besides, she couldn't understand why anyone would want to eat the dreadful, foul-smelling things.

Carefully I explained to her that it wasn't necessary to cook the onions, that if the chefs were too busy to clean them I would do it myself. Pushing my way past the 'Three Furies,' I went out the back door in search of the kitchen. The cooks refused to touch the onions. I found one who was an Alsatian, and she spoke German with her French. With the aid of three languages I finally made her understand that I would do the work myself, provided I could have a knife, a pan, and some water. Those she gladly gave me. Adam came in, and we cleaned the onions and placed them on two platters.

Adam believed that the French should learn the truth about onions, and so he passed his plate around to the other tables, nodding, smiling and keeping up a running fire of English conversation, which no one understood. But the French weren't to be roped in so easily. Everyone took an onion, but no one ate. Each person was waiting to see what we did with them when we sat down.

THE AWAKENING.

Sprinkling a little salt on my first onion, I took a large bite. Adam took a bite too. I know an amazed expression must have come over my face. I looked at Adam and found him looking wildly at me. Both of us had stopped eating. Glancing about, I saw everyone was watching us. Adam's eyes followed mine. Again I looked at him as much as to say: 'Shall we?' and his eyes in turn said: 'Yes.' So we began chewing, determined to eat at least two onions each if we died trying.

These were the strongest onions I ever tasted in my life. Each bite was as hot as a mouthful of red pepper. If those were fair samples of the French onions it isn't any wonder the French never eat them.

Not one onion was touched when Mme. Louise cleared the tables for the next course.

The Frenchmen had used rare judgment.

From the Note Book of O. P. H.[32]

Lost in No Man's Land at night. That's the position in which five men found themselves last summer in the Baccarat sector. They were Lieut. Col. Ruby D. Garrett, signal officer of the Rainbow Division;[33] Adam Breede, correspondent;[34] two officers who were supposed to know the lines; and myself.

'Go as far as you like. Get your heads shot off if you want to, but don't draw fire on any of the other boys,' was what Brig. Gen. Douglas MacArthur, chief of staff, said when we reported to him.[35]

'Two patrols are going out tonight,' Colonel Garrett said. 'I must go to the front line to inspect some wire, and you can go with me.'

On the way to the front we picked up two officers, one signal officer attached to the regiment, the other a lieutenant from battalion headquarters. They said they were acquainted with the terrain at night, and would see us through.

'SHOOT FIRST AND TALK LATER.'

In this sector the men were withdrawn from duty in the trenches at night, leaving only what is called 'strong points,' a protected place with two men on guard. At sunrise and sunset 'stand to' was held, when all men on duty took places in the line, for anything might happen then. At night all gates are closed, the barbwire entanglements filled in, and the guards ask no questions.

'Shoot first and talk later,' were the orders.

The first two guards we met asked for the password. Colonel Garrett answered.

'That isn't it,' they said.

But the colonel explained he was Division signal officer and had been given the password not more than two hours before at headquarters.

'In fact, I suggested the words,' he said.

The sentries passed us, but they were shaking their heads.

Our party came to a quick standstill. No one said a word. I looked ahead and saw a soldier standing in front of the colonel with a .45 caliber automatic pistol pressed against the colonel's stomach. In the soldier's left hand were two grenades. Standing behind him and slightly to one side was another soldier with a liberal supply of grenades in his hands. We stood there for what seemed to be an hour.

'Handle those grenades gently, brother,' Breede spoke up.

That broke the tension and the colonel recovered his breath enough to give the password.

That isn't correct,' the soldier answered, and the colonel felt the automatic pressed a little harder against him. Followed very quickly explanations. But they were not sufficient. No one had identification papers. All these had been left behind.

COULDN'T CONVINCE SENTRY.

Maybe you are telling the truth, and maybe you are not,' the guard told us. 'We are the last outposts, and you couldn't have passed us going out without us knowing it. Come on to headquarters.'

The next two were the same. We had to argue our way past them. And the next two—the men always stand guard in pairs— were going to turn us back. Finally the Colonel managed to learn the words they believed were the correct ones.

'The last outpost is about four rods down the trench,' this pair told us. 'You better report there so they will know you are around.'

On we walked, silently, moving with as little noise as possible along the duckboards in the trench. It seemed to me we had gone more than four rods.[36] The colonel was leading, and with him

were two armed officers, who said they knew the ground. On and on we went, the trench becoming shallower and shallower, until we finally were out on open ground. Several times we had ducked under barb wire which we thought had carelessly been left across the top of the trench, and when we came out into the open, we saw behind us, by the light of the moon, the wire entanglements.

On went the leaders. They seemed bent on going to the German lines or so it seemed to me. Later I learned they believed it was another line of defense.

Pfist,' I heard someone hiss.

HEARD THE BOCHE.

Everyone stopped, hardly daring to breathe. We heard low, deep guttural voices talking German. Perspiration popped out all over me. All I carried was a cane. Slowly, quietly, our little party began retracing steps, with the colonel still in the lead and me bringing up the rear. Instinct must have caused him to lead us right back to where we came out, a spot we later learned was used by patrols going to and coming back from No Man's Land, the only break in our wire in that sector. At last we struck the shallow trench and just as quietly as an Indian slipping over the ground we went along the duckboards.

'Halt and give the password,' I heard a tense voice whisper hoarsely.

We were glad to accompany him. He led the way still carrying his automatic and hand grenades, and his partner brought up in the rear, carrying nothing except hand grenades, any one of which would have been sufficient to have blown us to pieces.

At battalion headquarters we were safe. The major knew the colonel.

'You had the division password,' the major explained, 'while up here we use a battalion password. You missed the last outpost

because the entrance was wired and the men were out in a sap,[37] a precaution we always take at night to prevent a surprise attack.'

Chapter 17: At the End—July 1919

The last article "From the Notebook of O.P.H." to appear in the *Star* was published in Kansas City on Wednesday, July 2, 1919. It is the story of Madame Girot, a 94-year old widow who refused to leave her home in a small village of the Lorraine sector, even though all that remained was a cellar, some twelve by eighteen feet. In many ways, her story is similar to another piece by OPH, untitled and not published in the *Star*, but which survived for over 90 years in the old steamer trunk where he kept his war memorabilia. The

manuscript shares a narrative style similar to the narrative style of the other stories appearing in the OPH Notebook column, and the unpublished manuscript treats the same themes and has a setting similar to those in Madame Girot's story. For those reasons, the steamer trunk story is included here, preceding and complementing Madam Girot's story. For easy reference, the new addition is entitled *"Mon Enfant,"* to reflect its central focus.

"Alsacienne et Lorraine."[1]

"Mon Enfant" takes place in Essey, a village near St. Mihiel, the scene of the first large-scale test of American troops against German entrenchment. Throughout the French countryside, in the center of so many villages and towns similar to Essey and totally rebuilt after the war, stands a monument dedicated to *Les Enfants*, referring to the town's natives, victims who never returned. Ironically, in the OPH story, the artillery lieutenant, Pierre, who stands for all French *poilu*,[2] does return, but his wife and their five-

year-old daughter, who believed Pierre when he told them that the war would not last long, do not return.

When Pierre comes back, he finds his home sliced off as if by a knife, his family missing. The severed home and family are a symbol for the terrible loss France has suffered in the war. The supreme irony is that the military police are dispatched to capture Pierre on suspicion that he may be the enemy. His glassy-eyed look makes the M.P.s wary. Unrecognized, he is a suspicious alien now in the home for which he has risked his life and lost the lives of his family. In a real sense, like his family, he is also lost, and to extend the symbolism in the story, like France itself, military "intelligence," must question who Pierre has become through the alienation of war and why he is there at all.[3] The reader, however, has the intelligence to recognize why he is there.

Intellectual recognition and legitimate presence are also central themes in Madam Girot's story, but recognition is more credible and accepted than it is in "*Mon Enfant.*" It is Madam Girot who reconciles the differences between the French and the Germans who visit her, and, although, like Pierre's house in "*Mon Enfant,*" the physical dimensions of her home are in ruins, the legitimacy of madam's insistence on her place there is recognized by both sides. For years, the Alsace-Lorraine had personified the struggle between France and Germany. Comprised of both German and French inhabitants, the border region had been occupied first by one country, then by the other. As control shifted, harsh measures were imposed on the opposing population, with the result that a great bitterness arose, and the Alsace-Lorraine became a righteous symbol for both nations, but most especially for France. Madam Girot's story embodies this history, but unlike the alienated conditions in "*Mon Enfant,*" madam's story goes beyond the past devastation and becomes an emblem for recognizing what is possible for the future.

Placed together, the two stories also seem to complement one another: *"Mon Enfant"* raises the question of alienation and despair among the ruins of war; Madam Girot's story demonstrates a resolution, where even among the ruins, differences are buried in recognition that both French and German, side by side, can continue to say the same thing.

By all appearances, Madam Girot's story is the last of the war articles OPH published in the *Star*, and—whether planned or not, we'll perhaps never know—the theme of the piece is a fitting close to this chapter in Otto P. Higgins's life as a war correspondent. He had begun his overseas pieces on May 1, 1918, in the cemetery of Clon Mell, in the hills in back of Queenstown, where the victims of the *Lusitania* had been buried in May 1915,[4] and he ended his war writing on July 2, 1919, with a piece describing another burial, also in the spring of 1915, in the very place where the bitterness between France and Germany had reached a symbolic crescendo.

In the person of a 94-year old widow, the age-old war had been resolved, at least for a while, and its resolution is proclaimed in writing by the same words in both French and German. And so it is in English; for OPH, his last word is "written."

[*"Mon Enfant"*][5]

By Otto P. Higgins

Back in the summer of 1914, just as Germany started its invasion of Belgium, the French began mobilizing troops. In the little village of Essey, near the town of St. Mihiel and only a few hours from Nancy by motor car, lived a happy little French family— a father, a mother, and their dark-haired, brown-eyed, five-year-old daughter. The father was a lieutenant in a French regiment of artillery, but he lived at home, something not unusual in the French army.

The day he received his orders he called the wife and daughter to him, telling them what had happened.

"It won't last very long," he told them. "It will all be over in a few months. We will drive the boche beyond the Rhine."

Hoped for Peace, [but Lived in] War

French women have lived in the shadow of war all their lives. And when Pierre—that isn't his name, but it will do—told his wife and daughter, they believed and were happy because for once and for all the boche menace that had threatened continuously would be ended. Wasn't it worth a few months war to put an end to it all?

"Air View of Essey while still occupied by Germans."[6]

Nothing seemed to be able to stop the boche advance. On, on, they came, sweeping everything, destroying and pillaging, sending the civilians back to Germany to work the factories and

329

mines, dismantling and shipping to Germany what was needed of the industrial machinery. They went on through Belgium and Northern France, and finally were stopped.

The line on the East became more or less permanent. Both the French and the Germans dug in. The Germans made themselves at home, and from the permanency of the buildings it looked like they expected to remain forever.

"St. Mihiel – Rue Général Pershing."[7]

At St. Mihiel the line stuck out like a sore thumb on a hand, St. Mihiel being near the apex. The little town of Essey was included in the territory occupied by the boche. Here the boche officers were billeted, and the soldiers occupied the barns. It wasn't directly in the front line, but behind it, so that it seldom was under any shell fire. Now and then it was bombed, for the boche kept many supplies in the neighborhood, and two main roads intersected in the center of the village. Here the French civilians and the boche lived together. The newspapers were filled with stories of atrocities, of rapine, murder, deportation and slavery.

Then the Americans Came

Finally the Americans, saviors of the country, came. June 6, that memorable day when the 5th and 6th Marines stopped the boche in Belleau Woods, and the regulars threw back the Hun hordes at Chateau Thierry, France once more began to have a little hope. Paris was deserted practically. Everyone had been warned to leave. The hotels were as vacant as a haunted house. Everyone who could had gone South, for France had almost given up. But June 6 and the days following revived their falling spirits, and once more they breathed. Those who remained in the most wonderful city in the world, and felt as though they had a chance.

Tried to Get News to Wife

Time after time Pierre tried to get word through to his wife. He sent harmless letters to Switzerland to friends, hoping they might get in communication with her. But these were never answered. Once when he was convalescing in a Paris hospital from a shrapnel

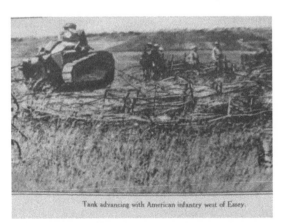

Tank advancing with American infantry west of Essey.

wound, he took the matter up with the French intelligence section to get word of her. Another time, he spent his entire *permission*[8] with the various relief societies, hoping he could get word through by them.

"Tank advancing with American infantry west of Essey."[9]

One fight followed another. The boche were thrown back in their monster Champagne drive by General Gouraud's army, and the Rainbow Division. September 12, the Americans in their first major offensive and their first real fight without French assistance, in one

swoop wiped out the entire St. Mihiel salient, freeing territory that for four years had been occupied by the boche. The boche knew the attack was coming, but they didn't know just when. But they warned the civilian population to leave, and most of them did. A few preferred to remain behind, hidden in their cellars, and take a chance on it. But most of them withdrew, not knowing what to expect.

The Americans swept through, cleaning up everything as they went, and when the kink in the line was straightened out they stopped and dug in, consolidating the lines. Many of the towns suffered from American artillery, and about two days after the boche withdrew the boche began systematically shelling the roads and villages, destroying whatever was left. They knew every inch of the territory, and they seldom wasted a shell. Nearly every shot told. Essey, devoid of civilians, was bombarded day and night.

Word was flashed over the world of the great American success. Everywhere people went wild. In France, England, America, Italy, it penetrated the French lines by way of the official communiqué, which, every night, was distributed by wireless, telephone and telegraph.

Sought the Ruined Village

About four days after the morning the advance started, a disheveled, unshaven, glassy-eyed man dressed in the uniform of a French lieutenant of artillery was seen to enter the village of Essey. He looked neither to the right nor left, neither did he ask any questions. Hurriedly he picked his way between the traffic, stopping now and then to look at a half-ruined house, sometimes entering, sometimes passing on. No one recognized him. No one knew him.

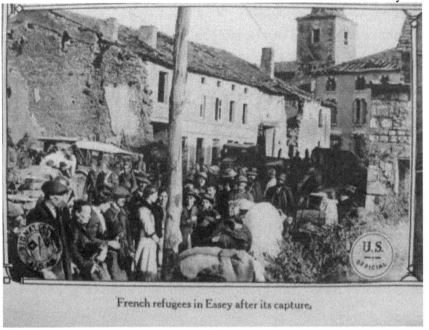

French refugees in Essey after its capture.

"French refugees in Essey after its capture."[10]

General orders had been issued from time to time during the summer to be always on the watch for spies, and never to allow a suspicious looking character to pass. Word reached headquarters about the mysterious officer who had appeared in the little half ruined village. The intelligence department, always alive, sent out its scouts.

The unkempt man with the wild look in his eyes had been seen by an M.P. to enter the garden surrounding what once had been a pretty little stone cottage. A section of the front had been shot away, and a part of one room had been left, the furniture in perfect order, just as though the missing section had been sliced off with a knife. Here the intelligence men entered.

A Little Dress Clasped in His Hand

In the next room, a combination dining room and kitchen, they saw a figure in French gray, the gold braid on his arm

indicating he was a lieutenant, sitting on a chair, his head buried on his arms, which rested on the table. On the table was a little worn-out shoe, such as a child would have, and a rag doll with the stuffing gone from one leg. Tightly clasped in his hand was a blue and white cheap gingham dress, a dress just large enough for a little child. Not a sound came from the figure, not a sob or a quiver. Not until one of the soldiers dropped a heavy hand on his shoulder and gave him a jerk, did the man look around.

'*Mon enfant,*' he said, holding out the dress in both hands. '*Mon enfant.*'

And again his head dropped to the table, the two soldiers took him to headquarters between them, each holding an arm, for the glassy stare in his sunken eyes made them watchful. He sat down in a chair in the intelligence office while his credentials were examined. Not a word did he say, not a tear did he shed. The next day he told his story to an officer from the French mission.

It was Pierre.

—Higgins

From the Note Book of O. P. H.[11]

When fighting in the Lorraine sector settled down to a steady grind after the first few months of the war, it was found that in No Man's Land, living in a cellar, was a French woman 94 years old. Her name was Madame Girot. The place once had been a thriving French Village, but the war had swept over it and now all that remained were a few cellars, half filled with debris of falling walls. All the civilians had left with the first on-sweep of the boche, all but Madame Girot.

The aged woman had made her cellar habitable. It was nothing more than a hole in the ground, about twelve by eighteen feet, but it was protected by heavy stone walls and had withstood years of wear.

A French patrol first discovered her and insisted that she go behind the lines.

'I cannot,' she told them. 'This is the only home I have. My father, my father's father, and even his father lived here. Never have I been outside the village. Here I remain until I die.'

The Frenchmen the next night sent her food and wine. After that a patrol would visit her every few nights and try to persuade her to move. About two weeks later a poilu found a German soldier in the dugout, and started to bayonet him.

'Don't,' Madame said. 'This man and his friends also have brought me food. They, too, have been good to me.'

BOTH SIDES ARRANGED VISITS.

So the two men sat there and talked, sometimes in German, sometimes in French. They arranged that every other night a patrol should visit the house, one night French, the next night German, and that the place never should be used for snipers or observers and that no shooting, not even artillery, should take place in the neighborhood

Madame became known as 'Mother of the Trenches.' Sometimes she would patch the clothing of the soldiers, sometimes fix them herb teas for colds or other ailments. Always she was kind to them; always they were good to her and never once was the agreement broken on either side. All through the winter of 1914-15 that continued. Towards spring, Madame's health seemed to be failing. But still she was happy.

THEN MADAME WAS MISSING.

One night in May, 1915, the French patrol failed to find Madame at home. The men were anxious and feared treachery by the boche. They waited until daylight to investigate. At dawn they found a little wooden cross at the end of some newly turned earth. One of them read in German script:

Here Lies Madame Girot.
Died May 14, 1915.
Aged 94 Years.
'The Mother of the Trenches.'

On the grave had been scattered bunches of wild flowers, the kind that grow only in France.

The next night another French patrol visited the grave, moved the German cross to one side and placed alongside another cross, with small red, white and blue headpiece, decorated with a rosette and three ribbons of the same color, the official decoration of French graves. Inscribed in French were the same words the Germans had written.

Epilogue: Remembering the War—Spring 1920-June 1965

Remembrance of the Great War took many forms—some oral, some written, and some in the form of artifacts, souvenirs the soldiers brought back in silent testimony. Higgins engaged in all three forms of remembrance. He listened to the stories of the men as they returned. He committed those stories to print. He was also a great collector of war souvenirs, and not only referred in print to his souvenirs but was also the subject of others, who wrote about his penchant for collecting. However, as the articles he wrote at the end of April and May have especially attested, it was the memory of the cemeteries with their white crosses row upon row that stuck with him the most and continued to require his testimony as he continued with the rest of his life.

After he returned from the war in 1919, Otto P. Higgins continued working for the *Kansas City Star* during the day, while at night he resumed the course of instruction which he had begun as a first-year student in the Kansas City School of Law during the 1912-1913 academic year.[1] He graduated from the law school in the spring of 1920 and joined the Thomas Hart Benton Kansas City Alumni Chapter of the Phi Alpha Delta Law Fraternity.

That same year, as Military Editor of the 1920 edition of *The Pandex*, the annual published by his law school graduating class, OPH found himself writing again about the war.[2] Beginning with his own biography, OPH edited the war biographies of 102 other members of the Kansas City School of Law, who had served during the war, 36.7% of the school enrollment. "HIGGINS, OTTO P.," the history begins in military style, "was not in the Army at all, but he spent the entire period during the war, and some time after it was over, with the Army as staff correspondent for the *Kansas City Star*. While the boys were doing their training and fighting, Higgins was telling the home folks 'just how they did it.' He began with the old Third Regiment when it was first called out, was with it at Camp

Nichols, later at Fort Riley, Camp Funston, Camp Doniphan, Fort Leavenworth, Fort Sheridan, and thence to France. There he spent all his time with the Missouri and Kansas troops at the front. He went into Germany with the Kansas City battalion of Signal Corps and the 89th Division, and returned home with the 35th Division."[3] Many of the men whose names followed in the list were part of the story OPH had told in his war reports, but there was also the story of those who had not returned, and to that Higgins bore particular witness.

In a piece entitled, "Our Soldiers," Higgins used the imagery of the cross and the metaphor of "crossing over" as testaments to the service of those who had died in the war. "And then there are those who crossed over but didn't come back. Up at Romagne, there near the placid, quiet flowing waters of the Meuse River, you will find thousands upon thousands of little white crosses, set neatly in rows, each with its tiny round identification disk upon it. Each cross represents the Great Sacrifice of some one. . . Each one gave his all for his principles, that the life of the world might be preserved untrammeled and unfettered by Teutonic Kultur."[4]

Like the first overseas piece written by OPH and published by the *Star* on May 20, 1918, "Our Soldiers" ended with a cold rain in a lonely cemetery. The earlier piece written before OPH entered France had evoked a sense of foreboding as he looked out over the graves of the *Lusitania* victims buried in Clon Mell, the Old Church Graveyard, in Queenstown, Ireland. Two years later, "Our Soldiers" seemed to recall that same sense as it looked back on the battle of Romagne, and the cemetery that sprouted there on a little knoll, along with cemeteries up and down France, from Calais in the north, south through the Alsace and on down to the shores of the Mediterranean. Both the 1918 and 1920 pieces concluded by referring to the price paid for German aggression—the loss of life

perpetrated by the Huns at sea in 1915 and the sacrifice of life on land in 1918, so that the future might be "untrammeled and unfettered by Teutonic Kultur."

By his testimony, OPH recognized the obligation of those other lawyers in his graduating class who had returned from the war to testify to the sacrifices of the men who had not.

<center>Our Soldiers</center>

Otto P. Higgins,
War Correspondent,
Kansas City Star 1917-1919

The rain was falling heavily. Shells were screaming past overhead. Some were dropping in front of us, some behind us. Here and there they exploded on both sides of us. The weather was cold, and the chill wind was driving the rain into our faces. It was on a little knoll of ground, near Romagne, France, where the American Cemetery now stands.

'Whoever comes through this fight alive, will only do so by the grace of God,' remarked Maj. Gen. William M. Wright then in command of the 89th Division, 'and there is nothing too good in this world for the boys who are going through it.'

It was the last phase of the Meuse-Argonne offensive, the largest and most extensive attack ever made by the Allies, the one that finally ended the war and brought an allied victory.

The men fought continuously from the morning of September 26th until 11:00 o'clock the morning of November 11, 1918—the time the Armistice went into effect.

And it was such fighting that the world had never before seen. The attacks of the Boche, even at Verdun, were as nothing

compared to it. The Americans did the fighting. They were the ones gnawing at the hinge of the great German line. And the world knows how well they fought.

Yet it wasn't much harder for those actually doing the fighting than it was for those who didn't get across. While the training camps had their comforts, the monotonous, dreary round of work the same thing day after day, week after week, and month after month, was nerve racking and the number of A.W.O.L.'s from training camps in America was much larger than from the units in France.

Across the sea there were a few added thrills that broke up the monotony of a soldier's life, while over here there was nothing to look forward to, except a possible chance to be sent overseas, or to wait patiently for the end of the war.

So those who didn't get across deserve just as much credit as those who did. It wasn't their fault.

And then there are those who crossed over but didn't come back. Up at Romagne, there near the placid, quiet flowing waters of the Meuse River, you will find thousands upon thousands of little white crosses, set neatly in rows, each with its tiny round identification disk upon it.

Each cross represents the Great Sacrifice of some one. Scattered all over France, from Calais in the north clear down to the Swiss border in Alsace, you will find the little white crosses. And on down through France, even to the shores of the Mediterranean, the length and breadth of France, you will find them.

Each gave his all for his principles, that the life of the world might be preserved untrammeled and unfettered by Teutonic Kultur.
--Otto P. Higgins, 1920[5]

340

Besides the terrible sadness evoked by the white crosses, remembrance of the war also had another side, some might say obsessive, cynical or even macabre. In a November 1, 1918, letter to Bess Wallace, Cpt. Harry S. Truman repeated a quote that had made the rounds during the war. "I heard a Frenchman remark that Germany was fighting for territory," Truman said, "England for the sea, France for patriotism and Americans for souvenirs. Yesterday made me think he was about right."[6] Truman was referring to an incident the day before when a German plane had crashed behind his position, and the French and Americans were immediately engaged in pillaging the wreckage as well as the pilots for souvenirs. OPH had made a similar observation about the 89th Division a few months earlier on September 15, 1918, while he was with the 89th during the Battle of St. Mihiel. "There is hardly a man in the entire unit that hasn't got souvenirs," OPH noted, "ranging from iron crosses to 12-inch guns. The booty taken included everything needed by an army

LAKE NEWS

UNIQUE LOG CABIN FOR KANSAS CITY ATTORNEY

in the field, and almost every man found something that he could send home for a souvenir."[7]

Higgins himself was no exception in the quest for souvenirs, combining his search for them with his search for news, but once "liberated," the souvenirs needed a home, and that home was

Higgins's cabin at Lake Lotawana, east of Kansas City. "Mr. Higgins during the recent World War acted in the capacity of staff correspondent for the *Kansas City Star*," Lake Lotawana's *Lake News,* noted, and added, "while on the battle fields of Europe in search of news he collected many souvenirs, which now adorn the walls of his summer lodge. Over the fireplace are crossed swords of Teutonic design which were once the pride of some Prussian officers. Revolvers and muskets hang on the side walls of Mr. Higgins' den to remind him of the conflicts which he so vividly described as an eye witness for the Kansas City mothers and fathers who had sent their sons to fight for justice."[8]

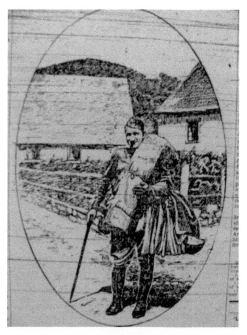

O.P.H. with "maximum load" in a French village.[9]

By November 1929 when the *News* had published its story about OPH's souvenirs, he had just finished construction of the log cabin at the head of Quantrell's Cove on the lake, but he had been thinking about a site for his souvenirs for over ten years. As early as September 1, 1918, Higgins wrote to his wife Elizabeth from the Hotel D'Angleterre, Chalons-Sur-Marne, France, shortly after visiting the ruins of the cathedral at Rheims: "I picked up some souvenirs in the cathedral for you," he coaxed. "If I am able to get home all the souvenirs I have gathered up we should be able to open a museum and charge admission. I have got most anything, everything but a live boche and a cannon. I suppose you

will put them all in the cellar because they are dirty and rusty, but if you do, I want to warn you that when I get home I'll take them out of their enforced obscurity."

OPH was anything but obscure while collecting the items he wanted to send home and display. Lieut. Col. Ruby D. Garrett noted that he had had occasion to become better acquainted with what Higgins and two other correspondents did and did not carry during a recent advance on the French town of Sedan. Garrett found, for example, that war correspondents rarely carried food or bedding. "They keep from starving," Garrett said, "by eating wherever and whenever they can. If they have just had a meal and pass a kitchen they go in and eat again because sometimes it is a long time between kitchens over here." About what they did carry, "there is one thing that has greatly impressed me," observed Garrett. "Newspaper men are great collectors. I shall tell you only about Higgins. Four days ago he had nothing but his toilet articles, typewriter, Kodak and his musette bag. Today his accumulation of junk would overload a dray.

"He has acquired another musette bag, so that he carries one on each hip. He 'salvaged' a pair of saddle bags, and an infantryman's combat pack. These he has filled with the greatest assortment of plunder I ever saw draped from one human frame. He looks like the old time Jew peddler. Wherever he goes he picks up trash. Of course, he cannot carry it all, but he keeps his maximum load all of the time. Every time he picks up on old pot or a box of machine gun ammunition or a hat full of hand grenades, he dumps out something else. He is very methodical

343

and every article has to travel through channels. He never drops the old until he has picked up the new, so that while his stock continually changes, the amount on hand remains uniform."[10]

CORONA

The Pen of the Army

Note the ease with which this portable writing machine may be used under service conditions.

Its parts never work loose or drop off. It has no attachments and does not take down.

You can carry Corona anywhere for, case and all, it weighs but 9 lbs. and measures only 10 x 11¾ x 4¼ ins.

Being built almost entirely of aluminum and steel, Corona is practically indestructible.

The Corona Folding Stand adds greatly to the convenience of using Corona in the field. This stand has three telescopic brass legs, stands 24 ins. high and collapses to 10¾ ins. It weighs 2 lbs.

Price of Corona and case, $50
Price of Folding Stand, $5

Corona Typewriter Co., Inc.
GROTON, NEW YORK

The combined circumstances of carrying so much plunder and having an uncertain schedule for meals are likely reasons for why Higgins, at least by Garrett's account, had lost thirty pounds, but the souvenir collecting reached a whole other level in the last few days of the war when Higgins entered into Stenay and proceeded to a French chateau. For four years, the Crown Prince had occupied the chateau and from that vantage point had commanded German troops in the sector.

There in the Crown Prince's private chapel, OPH discovered a crucifix of inlaid-wood, said to contain a sliver of the True Cross.[11] Intrigued by the story, he secured the crucifix as a souvenir and made his way out of the chapel. Carrying his cross, he departed Stenay and headed towards Nice, to see something of the Riviera. On the way there, however, temptation—some might say retribution—caught up with him. He stopped off at an officer's club in Commercy, lost $1,500 in a dice game and had to return to Paris to sell his typewriter. Although he lost the typewriter, he managed, somehow, to hang on to his cross and the story of the Crown Prince's chapel in Stenay.[12] The imagery of that story was not lost, least of all on him.

The Rest of the Story—Spring 1920-June1965

Now it was time to move on. After graduating law school and passing the Missouri Bar in 1920,[13] Higgins set up legal practice in the Scarritt Building, where his wartime friend, Lt. Col. Ruby D. Garrett, also kept offices.[14] But printer's ink still flowed through Higgins's veins, and in 1929 OPH became editor and part-publisher of the *Inter-City News*, a newspaper housed along Highway 24 in Fairmount, Missouri.[15] He also acquired the *Jackson County Democrat* and the *Sentinel*, both in Blue Springs, and the *Sugar Creek Herald* to the east in Sugar Creek. Pursuing both careers, legal and journalistic, Higgins continued to practice law, and in late 1931 or early 1932, he purchased the *Inter-City News* from Frank Catron, a large landowner from Lexington, Missouri.[16]

The legal career, however, took on a darker, more political and quasi-military bent on April 15, 1934, when Higgins became Kansas City, Missouri, Director of Police under the Pendergast political machine. Now OPH was director over the very place where he had once worked the beat as a newspaper reporter. His predecessor, Eugene C. Reppert, had resigned the director post as a result of mishandling the Union Station massacre on June 17, 1933, when he perjured himself by denying that he had instructed his subordinates to 'lay off' the case.[17] Tom Pendergast himself never liked Higgins, but the City Council, of which Ruby D. Garrett was a member, and on which Henry F. McElroy served as City Manager, did like the lawyer and former war reporter, so Higgins remained in the job for five years until April 15, 1939, when he resigned under pressure as the Pendergast machine fell apart. Then on October 26, 1939, Higgins was indicted in Federal Court on four counts of income tax evasion, his undeclared income having been shown to represent his "cut" from the city gambling racket.[18] "Higgins was charged with failing to pay taxes on a $1,000 lug he allegedly

received from a Kansas City gambling czar," the *Kansas City Star* reported. Federal treasury agents found that Charles Carrollo had been paying Higgins $1,000 a month for the protection of gamblers.[19] Higgins "pleaded guilty to the federal charge, was sentenced to two years in prison and served seventeen months at the federal prison at Leavenworth before being released."[20] During his time in prison he had lost a considerable amount of weight.

Disbarred now from the practice of law, OPH returned to the *Inter-City News* and his real-estate and banking interests, retiring at the age of 65 from newspaper work after 45 years in the business. By 1955, the Inter-City Press was producing two weeklies, the *Inter-City News* and the *Independence,* and two monthlies, the *Lake Lotawana News* and the *Lake Tapawingo News.* OPH retained his office in the Inter-City News building, 562 Huttig Avenue in Fairmount, but sold the newspapers to Bernard F. McCarty, advertising manager since 1952; John N. Wymore, manager of the commercial printing department; and N. Virgil Gray, a member of the composing room staff.[21]

Not long after he retired, Higgins began thinking about his war reporting years once again. Through the years that OPH had served as the *Star's* war correspondent, his wife, Elizabeth, had collected clippings of his writing, storing them in an old steamer trunk to which OPH added his field notes, photographs, military passes, and reference material pertaining to his newspaper work. Although Elizabeth, and possibly others, encouraged Otto to tell the story of his experiences during the war, he never did so until Emmet Crozier, his friend and colleague from the old days at the *Star,* produced a book about Yankee war correspondents during the Civil War.[22]

Some months after the 1956 publication of *Yankee Reporters: 1861-1865*, OPH wrote to Crozier insisting "that the newspapermen of World War I were as varied, resourceful, and worthy of historical study as the bearded journalists of the Civil war. This old friend of *Kansas City Star* days," said Crozier, "volunteered to help organize such a study."[23] "Otto P. Higgins not

only gave the work much of its early impetus but helped continuously to round up stray correspondents and gather material."[24] Over the two to three years that Crozier spent writing that book, OPH found himself reminiscing with colleagues from forty years past, telling the old stories once again.

By that time, much of the newsprint in the old steamer trunk had crumbled away, and Otto was nearly seventy years old, but he still had what

Elizabeth and Otto P. Higgins. (Photo with personal note to the author, December 1964)

Star founder William Rockhill Nelson had said a good reporter could not do without. Higgins still had "the nose for news, the instinct to recognize the real story."[25] This time the news was the newsmen themselves, and the real story was the account of how they told the story of America in the Great War.

The result is still recognized a century after America entered the war. In the last paragraph of the 2017 *American Journalists in the Great War*, military historian, newspaper journalist, editor and publisher Chris Dubbs declared in tribute that "there is no better single source of information about American correspondents on the

Western front than Emmet Crozier's 1959 book, *American Reporters on the Western Front, 1914-1918*."[26]

Higgins had the instinct to convince Crozier to get that story while the Great War journalists were still able to tell it. He did so just in the nick of time. Not long after Crozier's *American Reporters on the Western Front 1914-1918* was published, OPH left the old steamer trunk in Kansas City[27] to spend his last years in Phoenix near his daughter Eleanor and her family, continuing to collect books, read, and correspond with friends until illness forced him to curtail his activities. "I don't expect to be here next year," he wrote on the back of this picture in December 1964, "but it will be the end of a good life, with but a few knot holes here and there."

Otto P. Higgins died at John Lincoln Hospital in Phoenix on June 14, 1965, at the age of 75. He and his wife Elizabeth, who survived him by nearly eleven years, are buried together near their parents in Mount Calvary Cemetery in Kansas City, Kansas, not far from where Otto and "Higgi," as she was known, had grown up in the city's old neighborhoods. From his home at 718 Homer Avenue and later their home at 1853 Minnesota Avenue, OPH had taken his first reporting job at the *Globe*, before becoming a cub reporter at the old *Kansas City Post,* and then joining the *Kansas City Star.* Now he was back home in Kansas City, Kansas, where the stories had begun.

Acknowledgments

This study could not have been initiated or sustained without the encouragement and resourcefulness of a number of institutions and individuals. The microfilm facilities of the Kansas City Public Library first enabled me to access copies of the *Kansas City Times*, the Missouri and Kansas editions of the *Weekly Kansas City Star*, and the various evening runs of the *Kansas City Star* itself. With those resources, later supplemented by editions of the *Times* and the *Star* in the microfilm collections of the Midwest Genealogical Center in Independence, Missouri, I was able to read the daily papers from April 1917 through August 1919. There I found the dispatches Otto P. Higgins filed from Camp Funston, Kansas; Camp Doniphan, Oklahoma; and later England, France and Germany. Stitched into the fabric of daily life, threaded through weather reports, petty crimes, local and national and world events, these dispatches took on a dimension they could have never have possessed if read individually on their own. The historical materials from the *Kansas City Star* and the *Kansas City Times* are now reproduced here by permission of the *Kansas City Star,* and I thank Derek Donovan, Community Engagement Editor and Custodian of Records, for facilitating those permissions.

The collections of the Kansas City Public Library's Missouri Valley Room, the genealogical resources available at Mid-continent Library's Midwest Genealogical Center and the individual service records available from the Kansas Historical Society, the Missouri Digital Heritage and the National Archives and Records Administration in St. Louis added biographical flesh and bone. The statewide collaborative digitization project, *Over There: Missouri & the Great War*, along with the on-site physical resources available in the Edward Jones Research Center of the National World War I

Museum and Memorial provided photographs and unit histories that added vibrant detail to the project.

But it was the expertise of individuals that made these resources productive. Susan K. Nash, Archives Specialist in the Archival Research Room (ARR) of the National Archives in St. Louis helped me track down service records, which, after the 1973 fire, had been partially reconstructed and would otherwise have been completely lost to history. I am especially indebted to registrar Stacie Petersen, senior curator Doran Cart, and archivist Jonathan Casey of the National World War I Museum and Memorial for making available the Otto P. Higgins collection and the photographic and factual military histories of the men and women about whom OPH wrote. On the fictional side, by noting William Allen White's acknowledgment of using fictional characters to illustrate historical facts, Kansas Historical Museum Curator Blair D. Tarr helped me establish precedence for a vital technique in Higgins's own writing style. As for my own writing, I am indebted for the support, encouragement and professional expertise I received from Director Katie Kline and other teacher consultants with the Greater Kansas City Writing Project. On the technical side, I was especially grateful for the computer savvy of my brother Michael J. Heiman, and my grandson, Jeremy Lowery.

Other family members have been valuable resources. My brother Don is a fellow veteran of the Vietnam War, knew Otto Higgins personally, reads history, and, with the orientation of my sister-in-law Ginny, explores battlefields. Don enthusiastically supported the project and offered Kansas-side resources. My sister, Sherry A. Blaine and her husband, Michael, were vigilant and generous collectors of all manner of World War I books and memorabilia. They and my son Jamie, grandson Jeremy, and daughters Marla and Katie endured and encouraged my enthusiasm for the project; my wife Mari, not only endured and encouraged, but

blessed the work. I am indebted especially to my daughter, Marla, a professional broadcast journalist, who, with the poignancy, elegance and audience sense of a practicing reporter, determined the title of this work on the spot. Informed that my working title was *From the Star's Own Correspondent,* she immediately recognized the true arc of the book: "But, Dad," she said, "it should be *Front Lines to Headlines.*" And so it became. Otto would be very pleased that one hundred years later, a working reporter titled his book.

I owe special thanks to those individuals whose expertise and support for the project brought it home after over ten years in the making. Key to that expertise and support are the Jackson County Historical Society and the Mid-Continent Library's Woodneath Press. In his thought-filled introduction to Ruth Henning's *The First Beverly Hillbilly: The Untold Story of the Creator of Rural TV Comedy,* Brent Schondelmeyer, President of the Board of the Jackson County Historical Society, introduced me to the possibility of producing a very readable and high-quality biographical study of a writer with local roots and national prominence, whose story was yet untold, but did exist in a manuscript. Reading Brent's introduction, I was immediately struck by the similarity between the latent manuscript about scriptwriter Paul Henning and my own manuscript about the war reporting of Otto P. Higgins. Like Ruth Henning, I, too, had a manuscript about a writer with local roots whose story was yet untold. Brent met with me and suggested that I contact Woodneath Press. He also introduced me to the considerable photographic archives of the Jackson County Historical Society and offered the Society's support for the Higgins project. Another supportive president of the JCHS, J. Bradley Pace, followed through with a gracious and thoughtful foreword to my manuscript, and I hope the metaphor he sees in the work will inspire other writers to discover their stories and the publishing resources of the Woodneath Press.

Dave Burns is the Story Center Publication Manager, who shared with me the work of the Story Center and the mission of Woodneath Press. He also generously agreed to meet with me, reviewed what I had written and suggested that I submit a book proposal. His and Brent Schondelmeyer's belief in the project and advocacy for its publication are largely responsible for its appearance in print. I thank them and the support staff of Woodneath Press and Mid-Continent Library for their genuine and generous support.

In addition to that support, I had the advantage of a remarkably resourceful archivist and a remarkably talented and professional editor. Jonathan R. Casey, Director, Archives and Edward Jones Research Center at the National World War I Museum and Memorial in Kansas City, Missouri, USA, reviewed my text for historical accuracy, especially regarding my use of the Otto Paul Higgins Collection and other resources at the National World War I Museum and Memorial's Edward Jones Research Center. Throughout the years and in my many visits to the Research Center, I relied upon his encyclopedic knowledge of the war and his uncanny ability to broaden the resources of the Edward Jones Research Center through connections he made to other researchers and resources beyond the confines of the Center itself. His careful reading of the chapter introductions fixed factual errors, suggested valuable questions, and offered edits that improved the quality of the text.

Textual quality was substantially improved with the added polish of my editor, Dr. Maridella Carter, whose knowledge of history, professional publishing, and thorough reading established a uniformity of style and precision I could not have otherwise achieved. She and Jonathan Casey were the first real readers of my text and brought to life my experience of the best my audience could be.

352

Most important and critical to the success of the project was the support from the Higgins family. Granddaughters Bridget Cromer and Sheila Scott generously offered their own collections of OPH material, family photos, artifacts, letters and stories, along with a network of communication, which enriched the narrative with the personality and character of the subject of this study, whose interest and friendship I, too, had the good fortune to share.

Independence, Missouri
July 2018

OPH Timeline

January 19, 1890 – Otto Paul Higgins born in Streator, Illinois, only child of Delia ("Tillie") Schosser (born in Streator) and James J. Higgins, who was born in Bradford, England, and immigrated from Liverpool, England, on May 29, 1867. Resided in Pennsylvania before arriving in Illinois.

1891-1892 – James, Delia, and Otto move to 718 Homer Avenue, Kansas City, Kansas.

1904 – James works as a boilermaker for the Missouri Pacific Railroad. OPH earning money delivering newspapers and passing out hand bills, then at age 14 begins working as a bank janitor.

May 1909 – Otto graduates from Central High School, Kansas City, Kansas (precursor of Wyandotte High School); Captain of football team, assistant local editor of high school annual. Took the Modern Language curriculum of studies.

1909-1910 – OPH continues work as a janitor at a local bank to earn money to attend University of Kansas; lives at 1041 Vermont Street, Lawrence, KS. Family story that Otto told of driving a streetcar into the lake on campus. One summer vacation OPH takes charge of a railroad grading crew in Colorado. Another summer works railroading and then sells shoes while going to school. Otto attended KU one year, and left 'due to discouraging financial restrictions.' He was captain of the KU freshman football team.

January 17, 1910 – While attending University of Kansas, lives at 1041 Vermont, Lawrence, P.H. Owens, M.D. later says in a character reference for OPH that Owens had known OPH for 30 years. "He and I were in school at the same time at Kansas (State) University, where I ran a boarding house and he washed the dishes".

1910 – OPH takes reporting job at the *Globe*, then cub reporter at the old Kansas City *Post*, before joining the Kansas City *Star*.

December 22, 1910 – In three articles, OPH reports on court proceedings against John W. Radford, former Kansas state grain inspector, charged in Wyandotte County Court with misappropriation of founds ("A Machine Made Clerk," "Radford Denied it All," "Radford is Not Guilty").

January 24, 1911 – St. Anthony Catholic Church, Kansas City, Kansas, OPH marries 21-year old Elizabeth Frances Loschke, who was working at the time as a

stenographer. Elizabeth was a graduate of Mount St. Scholastica High School in Atchinson, KS. Her father, Louis Loschke, was born in Austria June 1863, and immigrated to US in 1885. Mother was Elizabeth Maider, born 1871 in Vienna and died when Elizabeth was a small child. Her stepmother, Mary (born February 1860 in Germany and immigrated to America in 1885), married Louis c.1894, and lived at 335 Ann in Kansas City, KS.

June 9, 1911 – OPH "scoops" main staff reporters on discovering and reporting the appointment of Ford Harvey and R. J. Dunham as receivers for the Metropolitan Street Railway Company. An announcement in the June 9, 1911 edition of *The Press*, a weekly newspaper produced in Kansas City, Kansas, states "*The Star* told the news about the Metropolitan Street Railway Company going into the hands of a receiver Saturday night in the special sport edition. This important scoop is due to the ever-alert Otto Higgins. It does seem strange that a reporter on the branch staff should beat the main guys."

November 14, 1911 – Daughter Elizabeth Carol Higgins born.

1912 – Otto and Elizabeth reside at 1853 Minnesota Avenue, Kansas City, Kansas. As early as November 26, 1912, OPH attending Kansas City School of Law at night.

February, April, 1913 – OPH still attending Kansas City School of Law at night as a 1st year, Freshman, law student.

June 11, 1913 – Daughter Eleanor Marie Higgins born.

July 3, 1914 – Son Louis James born.

June 5, 1917 – OPH registers for the first draft with A. L. Orr, Local Draft Board 14 (Precinct 6, Ward 14, Kansas City, Missouri). Age 29, born Jan 24, 1890, Streator, Illinois. Resides at 3221 East 32nd Street.

Spring 1917 – Ralph Stout, Managing Editor of KC *Star*, appoints OPH to be "*The Star's* own [war] correspondent." OPH records that he "began with the old Third Regiment, when it was first called out, was with it at Camp Nichols, later at Fort Riley, Camp Funston, Camp Doniphan, Fort Leavenworth, Fort Sheridan, and thence to France." OPH shuttles between the 89th Division training at Camp Funston, Fort Riley, Junction City, Kansas and the 35th Division training at Camp Doniphan, Fort Sill, Lawton, Oklahoma. While in Lawton, OK resides at Midland Hotel.

Camp Nichols located within the city limits of Kansas City, Missouri, and served as a site for the regiment to execute military drills. Located in Chicago, Illinois, Fort Sheridan became the site where General Wood, the Chief of Staff of the Army in 1913, instituted reserve officer training. Convinced that college men would be ideal candidates for military training, he contacted various colleges and universities and held the first Student's Training Camp for 220 men at Fort Sheridan. The attendees paid their own way, received training, and organized themselves into "The National Reserve Corps". Later on, businessmen attended camps in other parts of the country and formed an organization known as "The Military Training Camps Association". This group urged the government to more fully recognize the camps and to pay the expenses of the men who attended. The first Officers' Training Camp at Fort Sheridan was held from May 15, 1917 to August 15, 1917. The Second Officers' Training Camp at Fort Sheridan was held from August 27, 1917 to November 27, 1917. (Mryon E. Adams and Fred Girton, *The History and Achievements of the Fort Sheridan Officers' Training Camps* (Chicago: Fort Sheridan Association, 1920, pp. 174-176). Otto is not listed in the rosters of the Fort Sheridan book as attending either one of these camp sessions, but he does say in his biography for the law school annual in 1921 that he followed the old 3rd to Fort Leavenworth and to Fort Sheridan. There is some evidence that Higgins participated in training at Fort Sheridan and was commissioned as a reserve officer on April 18, 1917.

The "Old 3rd Regiment" later combined with the 6th Missouri to become the 140th Infantry, 35th Division, commanded throughout the War by Col. Albert Linxwiler. With the exception of Companies B from Boonville and H from Liberty, it was an "all-Kansas City unit,' with training grounds at the old armory, 39th and Main in Kansas City.

July 3, 1917 – Camp Funston, Ft. Riley, KS. OPH postcard to parents, Delia and James Higgins.

"Dear Ma & Dad—

There are 5,200 of these men in camp & many of them foreigners. They belong to 3 regiments of cavalry. This is a great place & I am having a good time. I get up at 5:15 a.m. & go to bed at 10 p.m. Great stuff. Working like the dickens, & it is very hot.

Otto—"

September 1, 1917 – OPH reports on inspection of 2,000 soldiers of 3rd Regiment and 2nd Missouri Field Artillery [later Kansas City's 129th Field Artillery] by Col. Karl D. Klemm at Convention Hall in Kansas City. "The artillery regiment is

expecting orders to entrain for Fort Sill anytime, and its members tried to outdo each other in preparing for what was probably their last inspection in Kansas City." ("Cleanup Day for Boys: Third Regiment and Second Artillery 'Scrubbed Up," KC *Times*, September 1, 1917, p. 9).

OPH first reports from Camp Doniphan, Fort Sill. ("Teach New Tricks at Sill: Soldiers Learn Europe's Latest Devices in the War Game, Five English and French Officers Instruct the Men in Artillery Firing—Work with Maxim and Lewis Machine Guns," KC *Star*, Saturday, September 1, 1917, p. 2)

September 5, 1917 – OPH's first article filed from Camp Funston, published in KC *Times*, September 6, 1917, p. 1. "Class of Men a Surprise: All Walks of Life Represented in First Draft Quota, Kansas City First to Have Entire Quota Report at Camp Funston for Duty—Lone New Mexico Man Represents a Regiment—All Hungry."

December 14, 1917 – 7:30 am. Midland Hotel, Lawton, OK. (Camp Doniphan). OPH postcard to parents Delia and James Higgins.

"This isn't such a bad place when you have a nice place to stay, which I now have. The tents along the hill are where all the high commanding officers of the division live, and take it from me, it is some cold up there. My address is Midland Hotel, Lawton, OK.

Otto."

Saturday, April 6, 1918 – At 5 p.m. on the one-year anniversary of the American declaration of war, OPH sailed First Class aboard the White Star Liner, *S.S. Lapland*, a twin screw liner of 18,694 tons, from Pier 66 in New York bound for Liverpool, England. Besides about 200 civilians, the *S.S.Lapland* also carried 1,500 troops, elements of the 77th Division, the first National Army troops to cross the Atlantic. Among the other first class passengers aboard was Mr. Clark Williams, who volunteered without pay to serve in the A.E.F. with the Red Cross and to identify families who needed assistance and counseling back in the states. In a privately printed book, Williams later described the voyage aboard the *Lapland* and preparations he had made for the voyage. He had to procure a birth certificate and passport, regulation American army officer's uniforms and equipment, physical examination and certificate of fitness, typhoid and paratyphoid injections and photographs for identification cards (p. 6, Clark Williams, *The Story of a Grateful Citizen: An Autobiography by Clark Williams* (New York: Privately Printed, 1934).

April 8, 1918 – At noon the *S.S. Lapland* entered Halifax harbor, "bleak and cold, with snow still on the surrounding hills" Williams recorded. "At sunset of the next day we sailed out of the harbor, taking our position at the head of a convoy of some twelve transports, all carrying troops and supplies for our army in France. Captain Bradshaw of the *S.S.Lapland* had the reputation of being the safest and the greatest zigzagger in the service and on this particular trip fully maintained the tradition. It seemed to me that we boxed the compass, by our changes of direction, every twenty-four hours. The convoy was accompanied by the United States Cruiser *St. Louis*, and it was not until April 17th that there appeared on the horizon in fan-shaped formation six torpedo-boat destroyers which converged to join us as an escort, a very welcome sight to all on board" (p. 8, Clark Williams, *The Story of a Grateful Citizen: An Autobiography by Clark Williams* (New York: Privately Printed, 1934).

Beginning on April 16th, Hutchins, Williams, and the rest of the Red Cross unit assisted with a 72–hour submarine watch under the command of Colonel I. Erwin, 307th Infantry, National Army, while the *S.S. Lapland* was "in the zone." "We would take our positions in the crow's nest above the bridge and with binoculars at hand would call down to the navigating officer if anything appeared on the surface of the water in the field assigned to each," Williams recalled (p. 9).

Correspondent Webb Miller of the United Press was also listed among those in First Class. ("List of Passengers," White Star Line, *S. S. Lapland* from New York to Liverpool, April 6, 1918). Adam Breede of the Hastings Nebraska *Daily Tribune* was also onboard but not listed in first or second class (p. 202, Emmet Crozier, *American Reporters on the Western Front 1914*-1918 (New York: Oxford University Press, 1959). In his 1936 autobiographical journal, *I Found No Peace,* Miller mentions that both Adam Breede and OPH were fellow passengers. (Webb Miller, *I Found No Peace: The Journal of a Foreign Correspondent* (New York: The Literary Guild, 1936), p. 63). Miller also provided a few details of the trip, noting that it took 17 days to reach Europe because by that time the British had instituted the "convoy system" by which destroyers escorted a dozen ships through the submarine zone, limiting the speed of the convoy to the speed of the slowest ship.

April 17, 1918 – OPH writes letter to his wife, describing voyage, 9 days out. "We have been in the danger zone and a few nuts had to sit up all night, waiting to be hit by a sub, I suppose." Describes humorous incident with boat drill and fear of passengers that a sub had been sighted.

April 19, 1918 – *S.S.Lapland* arrives in Liverpool amid snow and sleet. "The last watch was from four to six p.m.," Williams noted, "and despite the snow and sleet, I enjoyed the sight of land and, again, the enthusiastic cheers which rose from the ferry-boats on the Mersey. Here we learned that our precautions were justified, for only two days before, directly in our own course, the *Tuscania* disaster had occurred" (p. 9, Clark Williams, *The Story of a Grateful Citizen*).

Once on shore, OPH and Breed travel to London and stay at the Strand Palace Hotel, then crossed the English Channel for Paris. Higgins and Adam Breede with other newspapermen at G-2-D Press Headquarters at 10 rue Ste. Anne. OPH and Breede frequented Harry's New York Bar in the rue Danou.

Monday, April 22, 1918 – For security reasons during troop transport through the submarine-infested waters of the North Atlantic, *The Star* was very careful in its announcements of large troop movements to overseas ports. Such announcements were made only after the fact and then were usually embedded in articles about particular individuals, not large units. Articles were published after notice had been sent by the individual and received by the family. Just prior to their embarkation soldiers had been directed by military authorities to address a post card with a brief note of their arrival overseas. The postcard was held until the ship arrived then released into the mail. Even the policy itself received only passing notice in the newspaper, buried in a short general article published in the back pages of the paper. *The Star* followed its usual practice in OPH's case, as well. After receiving a cablegram on April 22 from OPH, *The Star* announced in a front page article that evening that OPH had arrived safely in France [Note: Should be "England." British identity papers were issued April 24, 1918]. "'Pleasant voyage,'" OPH noted. Reporting that OPH had "left three weeks ago," *The Star* announced the role he was about to play for the paper. He "goes as a staff correspondent for *The Star*," the paper said, and was from that point forward identified with the by-line "*The Star's* own correspondent." Along with OPH's arrival, the article also announced that "last week" an advanced guard of 35th Division arrived in France to make arrangements for the rest of the division "practically all of which has left Doniphan." *The Star* then explained the reason for its untimely reporting. "Many of these men of the Kansas and Missouri National Guard have passed through Kansas City in the last few weeks, but the voluntary censorship has prevented publication at the time." ("Goes with 35th Division: O. P. Higgins, Staff Correspondent of *The Star*, Arrives in France," KC *Star*, Main Edition and 6:30 Edition, April 22, 1918, p. 1). Two days later on April 24, as part of another article announcing the arrival in France of Major Marvin Gates, commander of the 2nd Battalion of the 129th Field Artillery, *The*

Star reported that Maj. Gates was part of the "advance detachment of 100 officers and 600 enlisted men sent from Camp Doniphan, Fort Sill, Ok., to prepare the way for the coming of the 35th Division." Notice of his arrival in France had already been received by his wife, who had been notified by an "official postcard" to that effect. ("Major Gates Safe in France," KC *Star*, April 24, 1918p. 3).

April 24, 1918 – Identity papers list OPH residence as Regent Palace Hotel, London. Issued at Vine Street Station, Liverpool.

May 1, 1918 – OPH writes first overseas article. "From The Star's Own Correspondent." Queenstown, (Cobh) Ireland, Clon Mell, or the Old Church Graveyard overlooking the River Lee, site of the graves of the victims of the sinking of the *Lusitania*, May 7, 1915. ("Sun on Lusitania Graves, KC Star, Monday, May 20, 1918, 6:30 Edition, p. 5).

May 2, 1918 – From London, first of the overseas articles to be signed "O.P.H." The article compares Irish and British rationing of meat, sugar, and matches. "Erin the Land of Plenty," Published in *Star* May 24, 1918, p. 12.

May 3, 1918 – From London. "'No. 4' An American Girl: Brother of Boston Woman Killed in France, Elsie Chapin Gives Car She Repairs and Drives Without Pay at U.S. Naval Headquarters in London." Published in *Star*, Main Edition, May 21, 1918, p. 6.

May 5-17, 1918 – Queenstown, (Cobh), Ireland. "From a British Port, with the American Destroyers, May 5 (by mail)," 7 articles.

May 1918 – With other reporters recently arrived in France, Breed and OPH "were given special passes and sent on a tour of airfields and bases—Blois, Tours, Saumur St. Nazaire, Coetquidan, Gièvres, Issoudun, Nevers, Dijon, Is-sur-Tille. They were part of a growing procession of miscellaneous visitors. Beginning about the time the German March offensive was halted, a steady stream of men and women on various pretexts and errands got the necessary approvals in Washington and crossed the Atlantic to view the great military pageant in France. The more important were shepherded about the training camps and bases by Major [Frederick] Palmer. Nearly all of them checked in at 10 rue Ste. Anne for their passes and did their sight-seeing under the auspices of G-2-D [press section of the AEF]. The General Staff, which less than a year before refused to accredit more than fifteen correspondents, now opened the floodgates, or permitted George Creel's Committee on Public Information to open them, and organized conducted tours, all for the ostensible purpose of keeping the American public informed."

(Emmet Crozier, *American Reporters on the Western Front 1914*-1918 (New York: Oxford University Press, 1959, p. 204).

1918 – OPH Identity Card states residence at Hotel Regina on the Rue Rivole, Paris.

May 22, 1918 – Tours and Is-sur-Tille, clothing salvage depot. OPH writes from Paris about the savings these depots create for the AEF.

May 25, 1918 – Visited the 3rd Aviation Instruction Center at Issoudun. OPH writes from Paris about the Red Cross canteen operating there. Mentions Miss Lois Cornforth, a former welfare worker, and Mrs. Alice Appo, a magazine writer—both from Kansas City.

May 28, 1918 – Battle of Cantigny

June 3-4, 1918 – Battle of Chauteau-Thierry

June 6-10, 1918 – OPH pass to "Chaumont, Langres, Neufchateau, Toul, Baccarat via train and return to Paris from June 6, 1918 to June 10, 1918; special dispensation for a "dispense Exceptionellement de la possession d'un Carnet d' Etranger, 6 June 1918 Gare De L'est Paris; Allen Potts June 8, 1918, Baccarat to Neufchateau; Pass extended until leaves Baccarat sector and arrives at Neufchateau, approximately until June 16, signature of MacArthur C of S. (National World War I Museum Archives, Archival Box Accession No. 2010.145).

June 8, 1918 – Because of great delays in reports of actions of divisions reaching headquarters, General Pershing sends cable to Chief of Staff in Washington changing policy that limited the number of war correspondents. Higgins included by name in Pershing's request that 25 accredited correspondents be accredited to divisions and provided with automobiles and cable facilities. (Emmet Crozier, *American Reporters on the Western Front 1914*-1918 (New York: Oxford University Press, 1959, pp. 224-225).

June 1-19, 1918 – Battle of Belleau Wood. OPH and Adam Breede were "the first to witness and report decisive American action at Belleau Wood, where US marines delivered the first great blow toward the offensive which culminated in the Armistice". "Their position here was a perilous one and the correspondents were under shell fire most of the time." (from "Sets Course From War to Law," article and portrait of OPH in uniform, *Hastings Tribune*, undated). OPH took at

least 8 pictures of before and after the action. One picture is labeled on the back with the date June 18—18 in his handwriting.

June 16, 1918 – From American Headquarters in France, (Delayed). Front page. Major Frank Carmack of St. Louis, wounded in both legs May 20, first man with the home troops in France to be wounded. Awarded *Croix de Guerre* and a ribbon for bravery and gallantry under fire. Refused to let comrades carry him to safety until a French sergeant wounded in the abdomen had been carried back. "Major Carmack was in command of a battalion of the 137th (Kansas) Infantry at Camp Doniphan last summer."

Late June 1918 – "Under the new policy, the visiting correspondents received their division credentials . . . and joined the outfits with whom they had trained. Clare Kenamore of the St. Louis Post Dispatch went with the 35th Division, already in the line. Otto Higgins of the Kansas City Star joined the 89th (he would go with the 35th later); . . . Slowly, the news coverage of the American Expeditionary Forces developed and grew. The journalistic Old Guard at Meaux handled the big battle stories, the daily cables, and urgent flashes. From the training camps and the quiet sectors came the mail stories, simple homely feature stuff, certainly harmless so far as military information was concerned, but immensely comforting to the people in the United States." (Emmet Crozier, *American Reporters on the Western Front 1914*-1918 (New York: Oxford University Press, 1959, p. 226).

June 20-June 29, 1918 – Units of the 89th Division arrived mostly at Le Havre, a few at Cherbourg, and marched to the rest camps attached to those ports. After two days on freight cars the Division stopped between Chaumont and Neufchateau in an area in the Haute-Marne known as the "Fourth Training Area," or more commonly as the "Reynel Training Area" (p. 44, English, *History of the 89th Division*). Troops were billeted at Rimaucourt, Manois, St. Blin, Trampot, Busson, Leurville, Chambroncourt, Morionvilliers, Grand, Breschainville and Aillianville and trained with live grenades and small arms.

June 22 - Aug 5, 1918 – 89th Division HQ at Reynal, Haute-Marne, France (p. 504 *History of the 89th Division*).

June 28-July 9 – OPH pass to Meaux, la Ferte, Montmirail by train our auto and return to Paris from June 28, 1918 to July 9, 1918 by Robert C. Davis Adjutant General American Armies in France. (National World War I Museum Archives, Archival Box Accession No. 2010.145).

July 1918 – OPH with the 35th Division in the Vosges Mountains.

July 15, 1918 – Germans launch their "fourth offensive" east and southwest of Rheims to broaden the Marne salient preparatory to their final drive on Paris. OPH with 3rd Battalion, 140th Infantry, 35th Division, in the Vosges Mountains. "'Fall in,'" commanded the major, a former Kansas City lawyer." [Major Murray Davis]. From "When Our Boys 'Went In,'" KC *Star*, September 9, 1918, p. 4.

July 18, 1918 – Marshal Foch inaugurates his counter-attack that cut the German communication on the tip of the salient and eliminated the Marne pocket entirely.

July 30, 1918 – Wesserling, Alsace, Vosges Mountains. OPH with the 140th Infantry, 35th Division, waiting for a night patrol to return. Reported in *The Star* on September 8, 1918. Commendations for gallant action reported on August 14, appearing in *The Star* on September 8, 1918, p. 2B.

July 30, 1918 – OPH reports from Paris that within the past three days he had met Ruby D. Garrett, Joe Ware and Harry Howland at a Red Cross hospital in Paris. Garrett had been stricken with appendicitis during the battle of Chateau Thierry, but oversaw the work of his men from his bed for two days during the battle and was then rushed to the hospital, where he was operated on the same night. Joe Ware was suffering from a broken ear drum and shell shock from a shell burst during action at Fere-en-Tardenois. Harry Howland was the one mainly responsible for Camp Funston's having a "zone" for troop rest and relaxation, the only one of its kind of all the cantonments in the states. Story in KC *Star* September 11, 1918, p. 4.

August 5 - Aug 10, 1918 – 89th Division HQ to Lagney, Meurthe et Moselle.

August 6 - August 26, 1918 – OPH pass to Neufchateau, Chaumont, Wasserling by train or auto and return to Paris from Aug 6, 1918 to Aug 26, 1918; stamped Assistant Provost Marshall AEF 5 Aug 1918; stamped Assistant Provost Marshall, 29 Aug 1918. (National World War I Museum Archives, Archival Box Accession No. 2010.145).

August 6 – November 11, 1918 – 89th Division enters into St. Mihiel salient. American attack September 12 clears entire salient in 27 hours (from Victor Duruy, *A History of the World* [*War* ?], Vol V, (Cleveland: World Syndicate Publishing Co, 1937), p. 814).

August 10, 1918 – OPH in Vosges Mountains; cables *The Star* to report citations for 7 men of 137th Infantry, 35th Div, for raid through German lines at

Landersbach and Sondernach on July 20, 1918. (OPH, "Cite 11 Kansans for Valor," KC *Star* Aug 19, 1918, p 1. OPH, "Great Record for the 137th," KC *Star* April 24, 1919, p. 6: "I wasn't supposed to bother with the 137th, but I couldn't keep away. I knew a lot of the boys pretty well and had seen them work. One morning I lay on the side of a mountain in the Vosges overlooking a little village held by the boche when the 137th made its first raid. It was one of the prettiest sights I ever witnessed An entire company went into the boche lines, killed a lot of them and brought back a bunch of live ones for souvenirs. I was taking pictures of them and Tommy Carey of Kansas City, Kas., who had taken it on himself to show them the way back, when I met Maj. Fred E. Ellis of McPherson. He was then a captain and operations officer for the regiment. He had been watching the scrap from another reserved seat. The next time I met the major was in a woods we called the 'Rat Woods' because there were so many rats in it. We had just come out of the Argonne, and all were cursing our luck to be lost in the woods and hungry, cold and wet. Yesterday I saw him again, this time a major and in command of a battalion. We talked again of our experiences, but they seemed slightly humorous this time. We had forgotten about the discomfort and remembered only the odd and lighter incidents."

August 10 – Sept 10, 1918 – 89th Division HQ at Lucey, Meurthe et Moselle (p. 501 *History of the 89th Division*).

August 19, 1918 – OPH cables *The Star* from Paris. OPH interviewed 35th Division YMCA Director Henry Allen after news reached him Aug 11 that he had been nominated by Republican party for governor of Kansas on August 6. Allen recuperating in hospital after an attack of diphtheria. Allen had worked for Red Cross, but took up work with Y.M.C.A. on July 1, 1918.

August 21, 1918 – Vosges Mountains. OPH writes about accompanying men of 140th Infantry in a raid for prisoners.

August 31, 1918 – OPH visits Rheims Cathedral.

September 1, 1918 – Paris. Letter from OPH to his wife. Envelope and stationery letterhead "G Hotel Central, Et D'Angleterre, Chalons-Sur-Marne. Otto wrote "O.P. Higgins, Paris" on the envelope. "We are looking over several sections of the French front." Describes visit to Rheims.
Concerned about articles being published in *The Star*. Writes to his wife, "Am I getting any more stuff in the paper? Haven't heard from you for oh—a hell of a long time, & I want some letters from my Honey. Compre? . . . Must stop now

and send me some clippings." [Letter transcribed by Sheila Scott, personal communication, August 28, 20ll]

OPH says he had dinner one night in Chalon-sur-Marne with General Gouraud, commander of 4th French Army ("Garrett's Men In," *The Kansas City Times,* April 28, 1918).

September 10-12, 1918 – 89th Division HQ, dugout R.R. of Noviant, Meurthe et Moselle (p. 504, *History of the 89th Division*).

September 12 – 14, 1918 – 89th Division HQ, Flirey, Meurthe et Moselle

September 15, 1918 – OPH at Bouillionville, Meurthe-et-Moselle, northeastern France. "The last time I saw J. L. Peatross, a stockman of Rolla, Mo., he was sitting in a dilapidated room in a shell-torn house in Bouillonville, on September 15. He was then a captain commanding a battalion in the front line of the St Mihiel drive. He had just come back to regimental headquarters for a breathing spell and orders." 353rd Infantry, 89th Division, ("Perched as Victors," The Kansas City *Times*, Friday, May 23, 1919, pp 1, 11).

September 12-16, 1918 – 89th and 42nd Divisions in the St. Mihiel Offensive. OPH says he was there with the 117th Field Signal Battalion for both the wiping out of the salient and its consolidation ("Garrett's Men In," *The Kansas City Times*, April 28, 1919, pp. 1-3). OPH also notes that he "lived in the dugout" of Lt. Col Levi G. Brown, the 89th operations officer, in the St. Mihiel Sector. (Otto P. Higgins, "Nebraskans Made Fur Fly," *The Kansas City Times*, Saturday, May 24, 1919, p. 3).

September 14-Oct 7, 1918 – 89th Division HQ, Euvezin, Meurthe et Moselle (p. 504 *History of the 89th Division*).

September 23, 1918 – OPH is staying with Lieutenant Colonel Levi G. Brown and Major Major Throop M. Wilder, "in quarters formerly occupied by a German major. We have two wonderful rooms, even though they are faced towards the boche artillery. We have plenty of boche cigarettes, plenty of boche matches and a lot of boche liquor. I don't know what it is. Some tastes like hair tonic and some like Tabasco sauce, but the rest is fair." He is with the 164th Artillery Brigade, 89th Division. LTC Brown was later captured by the Germans, the only American field officer to be taken prisoner during the war. See. OPH, "Nebraskans Made Fur Fly," KC *Times*, May 24, 1919, p. 3.

September 24, 1918 – OPH of KC *Star*, Clair Kenamore of the St. Louis *Post-Dispatch*, and a representative of Colliers [likely William Slavens McNutt] saw

General William M. Wright about doing some feature work in the 35th Division. "I was glad to see them," says General Wright (p. 41, *Meuse-Argonne Diary: A Division Commander in World War I*, William M. Wright, (Columbia, MO: University of Missouri Press, 2004, p. 41).

September 25, 1918 – "In the afternoon, the newspapermen left the Hotel Angleterre in Nancy and rode westward, retracing about a third of the distance back to Meaux. Their destination known only to a few, was Bar-le-Duc. That night they assembled in their new press headquarters, a small store up a cobbled side street." Higgins was among them. (Emmet Crozier, *American Reporters on the Western Front 1914*-1918 (New York: Oxford University Press, 1959, p. 251).

September 26, 1918 – Battle of Meuse-Argonne. Northwest of Verdun: 1st Army attacked enemy on a front of 20 miles and penetrated lines to an average of 7 miles. Pennsylvania, Kansas, and Missouri troops serving in Major General Hunter Liggett's corps stormed Varennes, Montblainville, Vauquois Hill and Cheppy after stubborn resistance. Higgins witnesses attack along with other correspondents. (Emmet Crozier, *American Reporters on the Western Front 1914-1918* (New York: Oxford University Press, 1959, p. 253), OPH at Vauquois Hill article October 3, 1918).

October 7-8, 8-9, 1918 – The 89th moved through the towns of Gironville, Boncourt, Erize, and St. Dizier enroute to a rear area on the Argonne as part of the reserve of the First American Army. Leaving the road at Erize la Petite, troops followed the Valley of the River Aire through Fleury, Rarecourt and Auzeville to Recicourt. The Division was immediately east of the central part of the Argonne and south of the road from Verdun to Ste. Menhould.

October 7-9, 1918 – 89th Division HQ, Commercy, Meurthe et Moselle (p. 501 *History of the 89th Division*).

October 11, 1918 – OPH pass to Headquarters of 35th Division and 89th Division via train and return to Paris by train from October 11, 1918 to November 1918, "by auto if accompanied by the proper French Automobile pass" stamped by Office of Provost Marshall Paris 10 Oct 1918, Stamped by Headquarters AEF, stamped by office Provost Marshall, Paris, 10 Oct 1918. (National World War I Museum Archives, Archival Box Accession No. 2010.145).
Sometime during the first two weeks of October, OPH, who kept a room at the Hotel Lotti in Paris, met and talked with Brigadier General Charles I. Martin,

former commander of the 70th Brigade, 35th Division, who had been removed from command on the eve of the Argonne and sent to the reclassification camp at Blois.

October 12, 1918 – On October the 12th the 89th was transferred from Third Corps to Fifth Corps and ordered to move to the vicinity of Eclisfontaine and Epinonville to support the 32nd and 42nd Divisions in the Battle of the Meuse-Argonne

October 13-14, 1918 – 89th Division HQ, Bois de Montfaucon, Meuse (point 105-752, Map ERDUN A. 1/20,000) (p. 501 *History of the 89th Division*).

October 14 – Oct 24, 1918 – 89th Division HQ, Epinoville, Meuse (p. 501 *History of the 89th Division*).

Late Sep-Oct, 1918 – OPH with the 129th Field Artillery, 35th Division, in the Meuse Valley, Argonne Forest northwest of Verdun.

October 15, 1918 – Letter to OPH from father-in-law Louis Loschke in Kansas City. Alludes to having received 3 letters from OPH, that business is fine, and that he is delivering "a bottle or 2 of the best over to Elizabeth so if the country goes dry you will find something anyway."
Louis Loschke adds "Those letters we see in *The Star* from you are very great. [Many ?] of the Peoples in Kansas City are talking about it."
Otto forwarded the letter to his wife and wrote on the outside of the envelope, "See how much your Dad thinks of your husband! Hurray for your Dad."

October 24 – Nov 1, 1918 – 89th Division HQ, Gesnes, Meuse (p. 501, *History of the 89th Division*).

November 1-3, 1918 – 89th Division HQ, LaDhuy Ferme, Meuse (p. 501, *History of the 89th Division*).

November 3, 1918 – 89th Division HQ, Remonville, Meuse (p. 501, *History of the 89th Division*). 09:00-13:30 hrs

November 3-4, 1918 – 89th Division HQ, Barricourt, Meuse (p. 501, *History of the 89th Division*).

November 4-21, 1918 – 89th Division HQ, Tailly, Meuse (p. 501, *History of the 89th Division*).

November 9, 1918 – OPH, William Slavens McNutt of *Collier's,* Burr Price of the New York and Paris editions of *The Herald,* and later, Bernie O'Donnell of the Cincinnati, *Enquirer,* set out for 90 mile trek to Sedan on the mistaken

supposition that the war will end there. Realizing the mistake, they set out immediately for Taily, 89th Division HQ.

November 10, 1918 – OPH with William Slavens McNutt of *Collier's* and correspondents of the *Philadelphia* and *New York Herald* arrive at 89th Division HQ and inform Division commander General William Wright that the end of the war is imminent. OPH and correspondents race to the front to witness the end of the war.

Nov 10 – Nov 11, a.m. – OPH enters Stenay, France, with William Slavens McNutt of *Collier's* and elements of the 353rd Infantry Regiment, 89th Division.

November 11, 1918 – "Otto Higgins started for Nice to see something of life on the Riviera, but stopped off at an officers' club at Commercy, lost $1500 in a dice game and had to return to Paris, where he sold his typewriter." (Emmet Crozier, *American Reporters on the Western Front 1914*-1918 (New York: Oxford University Press, 1959, p. 271).

November 20, 1918 – By November 20, OPH most likely with LTC Garrett and the 117th Field Signal Battalion as it began its march from the Buzancy region (Montmedy) through Belgium and towards the Rhine, where it took up its position for the occupation of Germany.

OPH writes to his wife: "Haven't been doing a thing the past two days except writing, eating and sleeping. Am way behind with my writing, and am now trying to catch up a little while we are not on the move. Hope to be able to remain here about three days more, and by that time I will be in pretty good shape unless something happens."

"I suppose you will be getting ready for Christmas by the time this letter reaches you. I haven't any idea where I will be then, as our troops are scattered throughout three countries. I may be in France, Germany, or Luxembourg. Can't tell just now, but wherever I am, I will be thinking of you and the kids and wishing that I was at home with you to enjoy the holliday (sic). It will be my first Christmas away from home. I hope the few little things that I have sent home from time to time arrive safely, and that you all will enjoy them."

"Thanksgiving will be here in a few days, and I suppose I will eat dinner at the mess, or, if we are on the move, go without dinner But I have reached the point where little things like that don't bother me any more, because as long as I am busy and moving and don't have time to think, I don't get lonesome or homesick; Gee, but I would like to be home and have some good old turkey and cranberry sauce. We won't have any over here this year."

November 21-25, 1918 – 89th Division HQ, Stenay, Meuse (p. 501, *History of the 89th Division*).

Nov 23, 1918-Jan 23, 1919 – OPH pass to headquarters of 35th and 89th Divisions via train and return to Paris via train. "When proceeding by automobile, the holder of this pass must have French papers, authorizing such travel, in his possession." From Nov 23, 1918 to Jan 23, 1919 by Robert C. Davis, Adjutant General American Armies in France. Stamp: 26 Nov 1919 Assistant Provost Marshall 315. (National World War I Museum Archives, Archival Box Accession No. 2010.145).

November 24, 1918 – OPH with the 117th Field Signal Battalion in Mersch, Duchy of Luxembourg. He stays with a German family and says he gets along well because he speaks German fluently.

November 25 – 30, 1918 – 89th Division HQ, Dampicourt, Belgium (p. 501 *History of the 89th Division*).

November 26, 1918 – OPH pass to Hdq 35th Div Coblenz via Metz-Treves (Hos); Hdq 89th Div- Commercy (___Chalons) via train or auto (with French papers authorizing travel by auto); Stamps: Assistant Provost Marshall 315. (National World War I Museum Archives, Archival Box Accession No. 2010.145).

November 28, 1918 – OPH spends Thanksgiving with 117th Field Signal Battalion at Bachem in the Ahr Valley. ("Garrett's Men In," T*he Kansas City Times*, April 28, 1919, p. 2)

November 29, 1918 – OPH with Company K, "All Kansas" 356th Infantry, 89th Division, Bouillonville, France; reports Sgt. Harry J. Adams captures 300 Germans with an empty revolver, and is awarded DSC. ("One Yank Took 300 Huns," KC Star, Dec 20, 1918, p. 6).

November 30-Dec 3, 1918 – 89th Division HQ, St. Leger, Belgium (p. 501, *History of the 89th Division*).

December 3-4, 1918 – 89th Division HQ, Mersch, Luxembourg

December 4-7, 1918 – 89th Division HQ, Echternach, Luxembourg (p. 501, *History of the 89th Division*).

December 7, 1918 – From Birresorn, Germany, a little village just inside the German border. OPH writes in a letter (probably to his mother, Delia, or to wife Elizabeth) about attitudes of German population about the war.

December 7-May 13, 1919 – 89th Division HQ, Kyllburg, Germany (p. 501 *History of the 89th Division*).

December 13, 1918 – "On December 13, 1918, the 117th moved to Ahrweiler, where Division Headquarters were established.

December 16, 1918 – OPH postcard to parents, James and Delia Higgins.
Ahrweiler, Germany
"We drove through this town and along this road through the valley of the Ahr river. It is one of the beauty spots of the world and a great health resort.
Merry Xmas & a Happy N y.
OPH"

December 20, 1918 – OPH post card of Wattfahrtsort Bornhoeven am Rhein, written from "on the Rhine," to OPH's parents, James and Delia Higgins.
"Isn't this a beautiful scene. So it is all up & down the Rhine valley. The villages are tucked in among the hills facing the river and it certainly makes wonderful scenery—Otto"

December 25, 1918 – OPH spends Christmas with the 117th Field Signal Battalion near Mersch in Luxembourg ("Garrett's Men In," The Kansas City *Times*, April 28, 1919, p. 2)

January 15, 1919 – "O.P. Higgins Coblence – Cologne, Jan. 15, 1919". Inscription written in *Dr. Friedrich Köblers Englisch-Deutsches und Deutch-Englisches Taschen-Wörterbuch* (Leipzig: Druct und Berlag von Phillip Reclam, jun., undated). 1 Mark, 50 pfennig

January 20, 1919 – OPH with 89th in Bitburg, Germany. "Men of 89th Attend School," KC *Star*, Feb 23, 1919, p, 16 A.

January 25, 1919 – OPH with 355th Ambulance Company, 89th Division, Bitburg, Germany KC *Star*, February 23, 1919, p. 17 A.

February 16, 1919 – OPH Pass to Hdq 35th Div Coblenz via Metz-Treves (Hos); Hdq 89th Div – Commercy (___Chalons) via train or auto (with French papers authorizing travel by Auto). Stamp: Assistant Provost Marshall Feb 16, 1919 No. 120; Assistant Provost Marshall No.102 undated. (National World War I Museum Archives, Archival Box Accession No. 2010.145).

February 18-23, 1919 – OPH pass to Tours and Chaumont via train and return to Paris from Feb 18, 1919 to Feb 23, 1919; STAMPS: Feb 18, 1919, Assistant

Provost Marshall, AEF 102; 19 Feb 1919 Assistant Provost Marshall No. 482; 21 Feb 1919 Assistant provost Marshall No. 464; 21___ Assistant Provost Marshall, No. 320; 20 Feb 1919, Assistant Provost Marshall No. 351; ___Feb 1919 Assistant Provost Marshall , No. 4. Total of 7 stamps. (National World War I Museum Archives, Archival Box Accession No. 2010.145).

February 26-27, 1919 – OPH Pass 26 Feb 1919 Assistant Provost Marshall, No 315; 27 Feb 1919, Coblenz, billet Haupt BHF, Assistant Provost Marshall. (National World War I Museum Archives, Archival Box Accession No. 2010.145). While in Coblenz, OPH stayed at the Riesen-Fursterhof Hotel with other correspondents including, in the words of Maude Radford Warren, ("At the Correspondents' Razz Club in Coblenz," KC *Star*, June 26, 1919. Also Otto P. Higgins, "That Job of 'Writing Up' the War: O.P.H. Tells How Correspondents Worked in France," The Kansas City *Star,* Sunday, June 8, 1919, p. 15C).

March 1, 1919 – OPH in Cologne, Germany. OPH inscription "O.P. Higgins, Cologne, Mar 1, 1919, the K.C. Star. Germany." in *The Rhine Including the Black Forest & the Vosges* (Leipzig: Karl Baedeker Publisher, 1911). Also OPH inscription "O. P. Higgins, Cologne, Mar 1, 1919, The K. C. Star. Herbert Baily *Daily Mail*, Capt. Steuart Richardson, N Y. Herely (?) – G 2 E, *Stories and Legends of the Rhine and Neckar* ,Hermann Kieser (Heidelberg: Karl Groos Nachfolger, 1910).

March 3, 1919 – General Pershing writes OPH a personal letter recognizing his service rendered "to the Army and to the public at home". "You have had the great responsibility," Pershing said, "of keeping the people of Kansas and Missouri adequately and accurately informed of the Army and its activities, and I am glad to feel that you have performed these duties in a highly satisfactory manner."

March 3, 4, 6, 7, 1919 – OPH pass to Hdq 35th Div Coblenz via Metz-Treves (Hos); Hdq 89th Div- Commercy (___Chalons) via train or auto (with French papers authorizing travel by auto); Stamps: 6 Mar 1919 Asst Provost Marshall AEF No. 366, 4 Mar 1919, Assistant Provost Marshall AEF No. 366; 3 Mar 1919 Assistant Provost Marshall 373; 7 Mar 1919 Assistant Provost Marshall AEF No. 420; Signed by Robert C. Davis, Adjutant General American Armies in France, Stamp of Headquarters American Expeditionary Forces (10 stamps total). (National World War I Museum Archives, Archival Box Accession No. 2010.145).

March 5, 1919 – Trier, Germany. OPH postcard to James and Delia Higgins.

"Roman ruins and American soldiers. Quite a contrast. Here for a few days—Otto"

March 6, 1919 – Trier, Germany. OPH postcard to daughter, Carol Higgins ("Bill").
Miss Carol Higgins 3221 East 32nd Street
Kansas City, Missouri USA
"Dear Bill,
This is a picture of a gate to the ancient city of Tervious, built by the Romans hundreds of years ago—and how is the music getting along—Daddy"

March 9, 1919 – Paris. OPH attending "The Mo-Kan Minstrels" with Lee Shippey of the 35th Division YMCA publicity department.

March 11 & 12, 1919 – Paris. OPH continues writing.

April 8, 1919 – *S. S. DeKalb* leaves St. Nazaire, France. OPH on board with headquarters elements of 35th Division. "The orders to embark came at 1:39 o'clock Monday afternoon [April 7, 1919] and by 4 o'clock the boat was loaded, the next afternoon [April 8, 1919] we dropped down the river with the tide and started on our journey.," ("But This Is Home," Kansas City *Times*, April 21, 1919, p. 1).

April 20, 1919 – Easter Sunday, 1 pm, 13 days to the hour after departing from St. Nazaire, ,France, OPH arrives Newport News, VA, Dock No. 1, on board *S.S. DeKalb* with headquarters of the 35th Division, headquarters detachment and military police company; headquarters 110th train medical detachment and sanitary detachment. Men to be sent in casual detachments from Newport News to the camp nearest their homes. The *S.S. DeKalb* was the first boat carrying units of the 35th to leave France. When Otto got back to New York he was so eager to see his wife that he maneuvered somehow to dodge the 'delousing station'. "The *DeKalb* in Tomorrow," KC *Star*, main edition, Saturday, April 19, 1919, p. 1, by wireless. Also "But This Is Home," Kansas City *Times*, April 21, 1919, p. 1, Dateline April 20, Newport News, VA). Also, 129th Field Artillery arrives in New York harbor. (See Giangreco, *The Soldier from Independence,* p. 255).

April 23, 1919 – OPH reference to Lt. Jim Pendergast, 130th Field Artillery, 35th Division, "looks a lot different than he did when we used to go to law school together and shoot craps down at the court house." ("When the Mobile Docked," KC *Times*, April 24, 1919, pp. 1-2. [indicates that OPH attended law school before he left for Europe in April 1918].

April 23, 1919 – OPH reference to joining Knights of Columbus: "Then there was Eddie McDonnel of Kansas City, who was initiated into the Knights of Columbus the same afternoon I was, and who heard me make the only speech I ever made in my life, and the last one. It made such an impression upon him that he never forgot me." ("When the *Mobile* Docked," KC *Times*, April 24, 1919, pp. 1-2).

April 28, 1919 – OPH attends a dinner party at Hotel Chamberlain, near Camp Stuart, Va., given to the officers of the 139th Infantry, 35th Division, by Col. Carl. L. Ristine, who mentions Major Clay C. MacDonald's avenging of his son's death at Vauquois Hill ("Avenged His Boy's Death," The Kansas City *Times*, Wednesday, April 30, 1919, p. 5).

April 28, 1919 – 140th Infantry Regiment, 35th Division, arrives in Newport News aboard the *Nansemond* (*From Doniphan to Verdun*, Evans, p. 143).

April 29, 1919 – At Camp Stuart, Va., OPH interviews men of 140th and 138th regiments, 35th Division. OPH recognizes 1st Lt. Fred Buell, Company G, 140th Infantry.

April 29, 1919 – At Camp Stuart, Newport News, Va, OPH has a reunion with 4 former KC *Star* employees, who were also members of the 140th Infantry: Sgt. Chet Youngberg, Bugler 1st Class Wolfe Rothband, Sgt. Chick Hoover and Sgt. Maj. John W. Keys. ("A Reunion at Camp Stuart," The Kansas City *Star*, April 29, 1919, p. 2). OPH also mentions Jack Helmick, one of the men in the raid conducted by the old 3rd, in which OPH participated, August 21, 1918. ("The Old Third in a Raid," The Kansas City *Star*, September 29, 1918, p. 2B, Editorial Section).

May 10, 1919 – 140th Infantry Regiment arrives in Kansas City to parade before departing to Camp Funston, Kansas, for demobilization. OPH likely accompanies 140th by train from St. Louis into KC and then returns again to New York on the weekend of May 17-18 to greet the 89th Division when it lands in New York on May 22.

May 19, 1919 – 89th Division HQ, Brest, France, sets sail (p. 501 *History of the 89th Division*).

May 22, 1919 – Thursday, OPH meets 89th Division landing of *S.S. Leviathan* (11,958 soldiers) at Hoboken, NJ and sister ship *S.S. Imperator* (2,010)." After war reports, OPH returns to Kansas City and resumes position with *The Star*,

covering Prosecutor's office. Returns to night school at Kansas City School of Law ("May We Present Otto P. Higgins, *Future*, Vol 1, No. 9, March 8, 1935, Kansas City Publishing Company.

June 29, 1919 – Kansas City. Throughout June, OPH reminiscing about the war in a regular column, "From the Notebook of O.P.H." OPH writes about having accompanied LTC Ruby D. Garrett on a patrol; reported to Brig. Gen. Douglas MacArthur; with Adam Breede. ("From the Notebook of OPH," The Kansas City *Star*, June 29,1919, p. 8A).

November 21, 1919 – Member Phi Alpha Delta Law Fraternity (KC Star Obituary, Monday, June 14, 1965).

January 12, 1920 – Otto and Elizabeth residing at 3221 East 32nd Street, Kansas City, MO (US Census January 12, 1920).

Spring 1920 – OPH graduates with L.L.B law degree from Kansas City School of Law, passes bar exam, leaves *The Star*, and enters into private practice of law (*The Kansas City Investigation: Pendergast's Downfall 1938-1939*, Rudolph H. Hartmann, (Columbia, MO: University of Missouri Press, 1999), p. 133).

1920 – "After the war, Higgins returned to Kansas City, worked on the paper and studied law for a year for a year. He passed the bar examination and went into private practice." (OPH obit.,"Otto Higgins Had Variety of "Roles," *KC Star*, June 15, 1965, p. 3). OPH admitted to Missouri Bar (Chapter 16, p. 133. *The Kansas City Investigation: Pendergast's Downfall 1938-1939*, Rudolph H. Hartmann, (Columbia, MO: University of Missouri Press, 1999)).

1921 – Otto P. Higgins, Lawyer, 613 Scarritt Bldg, Telephone: Harrison 6671, Bell Main, 6671; residence 3221 E. 32nd Street, Telephone Elmridge 2072, Bell Elmridge 2972. *City Directories of the US., Segment IV, 1902-1939*, p. 1361, Microfilm.
"Mr Higgins entered the employ of the Kansas City *Star* as a reporter. He severed his connection in 1921 to enter the practice of law." *"Otto P. Higgins is Appointed Police Head," East Side* _____*,* Vol 1, No 42, February [Bridget Cromer archival material].
Also "Higgins is Named," The Kansas City *Star*, Saturday, April 14, 1934, 6:00 edition, p.1. "From 1910 to 1921 Higgins was a member of *The Star*'s news staff. As such he reported the activities and participation of Missouri and Kansas troops overseas in the World War

1922 – References in Otto's file from his time in the Federal Prison at Leavenworth indicated that he "started work at The Kansas City *Star* in 1920 and worked there for 12 years." However, *KC Star* obit and 1921 City Directory evidence indicate 10 years on *The Star*).

1923 – James J. Higgins Otto's father, dies and is buried at Mount Calvary Catholic Cemetery,38th and State, Kansas City, Kansas. Age 70. (date from headstone Mount Calvary Catholic Cemetery, 38th & State, Kansas City, KS).

1929 – OPH becomes editor and part-publisher of *Inter-City News*; also owns *Jackson County Democrat* and *The Sentinel*, both in Blue Springs, and the *Sugar Creek Herald* (Chapter 16, *The Kansas City Investigation: Pendergast's Downfall 1938-1939*, Rudolph H. Hartmann, (Columbia, MO: University of Missouri Press, 1999)). (1929 Date from KC *Star* Obituary June 15, 1965, 3).

November 25, 1929 – OPH war memorabilia referenced in *Lake News*, Vol 2, No. 8, November 25, 1929, Lake Lotawana Development Company, 3247 Broadway, Kansas City, MO.

March 1931 – OPH fought bull in Monterrey, Mexico (Eleanor Carter's scrapbook, April 21, 1980).

Late 1931 or early 1932 – OPH purchases *Inter-City News* from Frank Catron, a large landowner from Lexington, MO (Jerry N. Hess, "Oral History Interview with Stanley R. Fike," Jackson County , Missouri journalist and friend of Harry S. Truman, May 10, 1972, p. 9, located in Harry S. Truman Library).

June 27, 1932 – Eleanor Marie Higgins married Alpha George ("A.G.") Carter in Kansas City, MO. (Rotogravure picture form Vick Visquesney's CD). (Year from 60th wedding anniversary picture in 1992 Christmas Gretting).

March 1, 1934 – OPH, lawyer, elected president of Standard State Bank of Fairmount (14-year-old bank with capital of $10,000 survived depression. Newspaper article on Vick Visquesney's CD.

April 15, 1934 – Appointed Director of Police, Kansas City, MO, after Eugene C. Reppert resigns the post as a result of his mishandling of the Union Station massacre on June 17, 1933, when he perjured himself by denying that he had instructed his subordinates to 'lay off' the case. Pendergast never liked OPH, but the City Council and City Manager, Henry F. McElroy did. (Rudolph H. Hartmann, *The Kansas City Investigation: Pendergast's Downfall 1938-1939*(Columbia, MO: University of Missouri Press, 1999, Ch. 16). Also

"Higgins is Named," The Kansas City *Star*, Saturday, April 14, 1934, 6:00 edition, p.1. "From 1910 to 1921 Higgins was a member of *The Star*'s news staff. As such he reported the activities and participation of Missouri and Kansas troops overseas in the World War."

July 28, 1935 – "In Rehearsal in Washington," cartoon of OPH, Police Director, and daughter Carol Higgins, detective catching father in "No Parking" zone with caption "What if it comes to this in the Higgins family?" The Kansas City *Star*, Sunday, July 28, 1935, 4D.

January 16, 1936 – "Mr. and Mrs. Harry S. Truman regret that because of absence from town, they cannot accept the very kind invitation of Mr. and Mrs. Otto P. Higgins for Friday, January the twenty-fourth." Postmarked Washington, D.C., Jan 16, 1936, 4:00 P.M. [Bridget Cromer archival material].

January 24, 1936 – Elizabeth Carol Higgins marries Edward Patrick Larkin, Annunciation Church, Kansas City, MO. See KC *Star* (or *Times*), "A Day Off for Higgins, "January 19, 1936, 12A "So the director is going to forget his work, attend his daughter's wedding and celebrate his birthday with his wife on their twenty-fifth wedding anniversary."

December 1936 – "Polar Club at it Again," KC S*tar* or *Times*, undated article from December of "1936." Makes reference to Inghram D. Hook as member of a party which swam in Union Cove, an arm of Lake Lotawanna. Sleepy Hollow Lodge. Also included Clay Roger, Elliott Nortquist, Alex F. Sachs, county highway engineer, Paul T. White and Woodward S. (Woody) James. "Mr Hook won the swimming race and won the honor of snuggling up closest to the barbecue fire in the big brick oven. The police director reported that guests all were well barbecued after the swim." [Bridget Cromer archival material].

April 15, 1939 – "Higgins resigned as Director of Police." (*The Kansas City Investigation: Pendergast's Downfall 1938-1939*, Rudolph H. Hartmann, (Columbia, MO: University of Missouri Press, 1999), p. 133). OPH's tenure as Police Director was 5 years to the day.

July 15, 1939 – St. Joseph Hospital, Kansas City, Mo; son Louis James Higgins dies of bulbar paralysis and acute pneumonia; 25 years of age, studying law at time of death (Death Certificate 24639, Missouri State Board of Health Bureau of Vital Statistics). Also See "L. James Higgins Dies," KC *Star or Times*, July 15, 1939 with pic.

October 26, 1939 – Indicted in Federal Court on 4 counts of income tax evasion. "His undeclared income was shown to have been his 'cut' from the city gambling racket." (p. 2, "1939: Kansas City Political Machine" http://www.kcfop.org/history/art/encarta- 1939kcmachine.htm July 9, 2008). "Higgins was charged with failing to pay taxes on a $1,000 lug he allegedly received from a Kansas City gambling czar." Served 17 months of sentence. (KC *Star* Obituary June 1965). The gambling czar was likely Charles Corollo. (Chapter 16, *The Kansas City Investigation: Pendergast's Downfall 1938-1939*, Rudolph H. Hartmann, (Columbia, MO: University of Missouri Press, 1999)).

November 3, 1939 – OPH pleaded guilty to counts 3 & 4. Sentenced to serve 2 years in Leavenworth Penitentiary on count 3 and 5 years probation on count 4 after the prison term. (Chapter 16, *The Kansas City Investigation: Pendergast's Downfall 1938-1939*, Rudolph H. Hartmann, (Columbia, MO: University of Missouri Press, 1999)). OPH's reg. no at Leavenworth 55996-L.

July 5, 1940 – OPH released from Leavenworth prison. Weighed 196 pounds down from 244 pounds 2 years earlier (from Eleanor Carter's scrapbook clippings, April 21, 1980). Character reference letters written by a number of men who knew OPH from the war: William Gist, MD, family doctor for 22 years and commander of 1st Missouri Ambulance Company, 110th Sanitary Train; Sid Houston, assigned to the Sanitary Train, reporter for KC *Star* and later Assoc Editor for *Stars and Stripes*; knew OPH since 1914; Herbert Corey with Associated Press from New York; W. B. Stone; W. H. Warren. (Sheila Scott email 14 Dec 2016).

June 14, 1942 – Delia ("Tillie") Schosser Higgins, Otto's mother, dies and is buried at Mount Calvary Catholic Cemetery, 38th & State, Kansas City, KS. Age 86. Delia, 86 years old, suffered a fractured hip in a fall at her home. She lived 51 years in Kansas City, Kansas, 50 years at 718 Homer Avenue. Funeral services at St. Anthony's Church. (Delia Higgins Death Notice, KC *Star*).

1954 – OPH and Higgie sell their home at 3221 East 32nd Street and move to spacious quarters at the Sombart Apartments on Armour Blvd.

1955 – At age 65, OPH retires from newspaper work after 45 years. Sells *Inter-City Press* (2 weeklies and 2 monthlies) to Bernard F. McCarty, advertising manager since 1952; John N. Wymore, manager of the commercial printing department; and N. Vergil Gray, a member of the composing room staff.

September 15, 1959 – OPH and Elizabeth move from the Sombart apartments to a duplex at 5424 Harrison Street, Kansas City, MO.

February 1959 – OPH and Elizabeth purchase a 50-foot mobile home in a senior citizens community (The Oregon Trail Trailer Court, 8245 N. 27th Avenue, Phoenix). They plan to winter in Phoenix and later move there.

June 14, 1965 – OPH died at John Lincoln Hospital, Phoenix, AZ; burial in Mount Calvary Cemetery, Kansas City, Kansas. Death announced that evening in "Ottto P. Higgins Dies," The Kansas City *Star,* June 14, 1965, 1. Obituary appeared the next morning: "Otto Higgins Had Variety of Roles," The Kansas City *Times,* June 15, 1965. Age 75 years, 5 mos.

June 16, 1965 – Kansas City *Star* editorial: "All men have to accept responsibility for their own actions, good and bad. The circumstances that sent Otto Higgins to prison stand to this day. But now, at the time of his death, it is only fair to go back of the official record, to the man of almost fanatic concern for human life. Kansas City's fantastic 1930s produced stark contradictions." ("Otto P. Higgins, Story of a Political Era," The Kansas City *Times,* Editorial Page, 24).

January 20, 1976 – Elizabeth F. Higgins died at home in Phoenix, AZ; buried in Mount Calvary Cemetery, Kansas City, Kansas (Elizabeth F. Higgins obituary, KC *Times*, Monday, January 26, 1976). Age 85 yrs, 5 mos.

Credits

Historical materials from the *Kansas City Star* and the *Kansas City Times* reproduced by permission of the *Kansas City Star,* Derek Donovan, Community Engagement Editor, *The Kansas City Star*.

Otto Paul Higgins Collection, Archival Box 2010.145 at the Edward Jones Research Center, National World War I Museum and Memorial, Kansas City, MO, U.S.A. Jonathan R. Casey Director, Archives and Edward Jones Research Center.

Otto P. Higgins family photos, letters, postcards, and memoranda courtesy of Sheila Larkin Scott, Bridget Larkin Cromer, and Vick Viquesney.

Kansas City, Kansas High School, 1909 Yearbook, Kansas Collection, Kansas City, Kansas Public Library, Georgia Murphy, Kansas Collection Librarian.

Endnotes

Prologue: The Style Sheet, The *Star* Man, and the Censor

[1] According to Strunk and White, in its broader meaning, style is "what is distinguished and distinguishing." It is never completely defined. "Who can confidently say what ignites a certain combination of words, causing them to explode in the mind? Who knows why certain notes in music are capable of stirring the listener deeply, though the same notes slightly rearranged are impotent. These are high mysteries. . . " William Strunk, Jr. and E. B. White, *The Elements of Style* (New York: The Penguin Press, 2005), 97.

[2] Marjorie E. Skillin, Robert M. Gay et. al., *Words into Type* (Englewood Cliffs, NJ: Prentice-Hall, 1974), 12.

[3] Members of the Staff of the *Kansas City Star, William Rockhill Nelson: The Story of a Man, a Newspaper, and a City* (Cambridge: The Riverside Press, 1915), 115. Pictures of the *Star* building, William Rockhill Nelson, and the front page of the *Kansas City Star* are also from this source.

[4] *William Rockhill Nelson: The Story of a Man, a Newspaper, and a City,* 127-128.

[5] *William Rockhill Nelson: The Story of a Man, a Newspaper, and a City,* 127.

[6] Jim Fisher, "Of '*The Kansas City Star* Style' and a reporter named Hemingway," at the *Kansas City Star* webpage, www.kansascity.com/entertainment/arts-culture/article294964/Of-i%60*The Kansas City Star*i-Style-and-a-reporter-named-Heimingway.html. Also see "Back to His First Field," *Kansas City Times*, November 26, 1949, 1, and Steve Paul, *Hemingway at Eighteen* (Chicago: Chicago Review Press, 2018), 18.

[7] The preface to Matthew Bruccoli's 1970 study of Hemingway's *Kansas City Star* stories references an earlier work recognizing the literary importance of Hemingway's time on the *Star*. "Charles Fenton's *The Apprenticeship of Ernest Hemingway* (New York: Farrar, Straus, 1954)," Bruccoli notes, "demonstrates the importance of Hemingway's seven-month stint on the *Kansas City Star* (1 October 1917—30 April 1918) in shaping the style and material of his fiction." *Ernest Hemingway, Cub Reporter: Kansas City Star Stories,* (Pittsburg, PA: University of Pittsburg Press, 1970), xi. Hemingway biographer, Carlos Baker, also acknowledges the impact of the *Star's* resources on Hemingway's writing: "The stylebook, the literary department, the example of his elders and the constant supervision of Pete Wellington gave Ernest his first real education in journalism." Carlos Baker, *Ernest Hemingway: A Life Story* (New York: Charles Scribner's Sons, 1969), 34. With careful research, Steve Paul dates Hemingway's appearance at the *Star* to mid-October 1917, at a time when the *Star* itself was undergoing a transition: "On Wednesday, October 17, Hemingway entered the formidable newsman's haven at a time of transition, as the newspaper's quaint ways were being displaced by the 'alarums of war.'" Steve Paul, *Hemingway at Eighteen: The Pivotal Year That Launched an American Legend* (Chicago: Chicago Review Press, 2018), 17.

[8] Jim Fisher, "Of '*The Kansas City Star* Style' and a Reporter named Hemingway."

[9] Steve Paul, *Hemingway at Eighteen,* 111.

[10] Steve Paul. After becoming bored with a lull in assignments for the ambulance crew, Hemingway volunteered to bicycle emergency canteen provisions to "the Piave front where the battle and the shelling had become fierce" (152). Near midnight on July 8, 1918, an Austrian Minenwerfer landed three feet away from where Hemingway crouched in the dugout of a forward listening post. An Italian soldier between Hemingway and the mortar was killed immediately, but the Italian soldier's absorption of the brunt of the hit likely saved Hemingway's life (154). Of 227 puncture wounds Hemingway sustained, 10 were deemed serious, and he underwent a series of operations and spent a long time recuperating (156).

[11] *The Star Copy Style*, circa 1915, at the *Kansas City Star* webpage, www.kansascity.com/entertainment/arts-culture/article294964/Of-i%60*The Kansas City Star*i-Style-and-a-reporter-named-Heimingway.html The picture of *The Star Copy Style* is also from this website.

[12] *The Star Copy Style.*

[13] *The Star Copy Style.*

[14] Otto P. Higgins, "MET Receivership," *Kansas City Star*, "EXTRA!" Special Sport Edition, Saturday, June 3, 1911, 1. Also, "Journalistic," *The Press,* editorial page, Friday, June 9, 1911.

[15] The clipping from the weekly editorial page of *The Press,* Friday, January 9, 1911, was pasted on a ledger page and preserved next to a clipping of the *EXTRA!* column written by OPH for the special sports edition of the *Kansas City Star,* late Saturday evening, June 3, 1911. Original newspaper clippings courtesy of Sheila Scott.

[16] *The Press* was a Kansas City, Kansas, weekly newspaper edited and published by J.B. Hipple and founded by him in 1889. See William E. Connelley, *History of Kansas Newspapers 1854-1916* (Topeka, KS: Kansas State Historical Society, 1916), 318.

[17] Article pasted on one side of a page drawn from a ledger book, and dated in pencil. Sheila Scott material, June 25, 2011.

[18] In mid-August, 1918, OPH accompanied a patrol from Kansas City's 140th Infantry on a raid to capture prisoners in the Vosges Mountains. On August 21, 1918, OPH wrote a feature story about the experience. See Otto P. Higgins, "The Old Third in a Raid," *Kansas City Star*, Sunday, September 29, 1918, Editorial Section, 2B. After reading the story, A. P. Killick, was so moved that he wrote to the *Star*: "I think OPH's story in the Sunday Star had more real stuff in it," Killick said, "than anything than has so far been chronicled either by volunteer or regular writers. He told the things that lots of us bullet proof, bombproof, and famine proof mutts have been 'wondering how it felt,' in a way that could not be mistaken. Several people with whom I talked today expressed similar sentiments," A. P. Killick, to the *Star,* "A Tribute to OPH," in "Speaking the Public Mind," *Kansas City Star,* October 3, 1918, 7. Also, in the summer of 1918, Higgins accompanied Lt. Col. Ruby D. Garrett and men from

his 117th Field Signal Battalion on a patrol into "No Man's Land" to inspect some wire in the Baccarat sector. See Otto P. Higgins, "From the Notebook of OPH," *Kansas City Star,* Sunday, June 29, 1919, 8A.

[19] Matthew J. Bruccoli, Ed., *Ernest Hemingway, Cub Reporter: Kansas City Star Stories* (Pittsburg, PA: University of Pittsburg Press, 1970), 15-66. See also Emmet Crozier, *American Reporters on the Western Front* (New York: Oxford University Press, 1959), 202-203.

[20] An example of such an assignment sheet for January 3, 1918, appears on the page facing the title page in Matthew J. Bruccoli, Ed., *Ernest Hemingway, Cub Reporter: Kansas City Star Stories.*

[21] "Rules of Censorship.[21]April 2, 1918" from the Otto P. Higgins Collection, Edward Jones Research Center, National World War I Museum and Memorial. Archival Box Accession No. 2010.145. "Paris, LeBourse" postcard from author's collection.

[22] Otto P. Higgins, "The 89th Hit 7 Divisions," *Kansas City Star*, Wednesday, November 13, 1918, 2.

[23] Otto P. Higgins, "Seven Days of Hell," *Kansas City Star,* Friday, November 1, 1918,1, Main Edition.

[24] Otto P. Higgins, "Getting by the Censor," *Kansas City Star*, Sunday, June 22, 1919, 20C.

[25] OPH refers to the summer of 1918.

[26] The Battle of St. Mihiel was fought September 12-16, 1918.

Chapter 1: The Starr's Own Correspondent—April 1918

[1] Otto P. Higgins, "Military History" in *The Pandex* Vol. XVI (Kansas City, MO: Kansas City School of Law Senior Class, 1920), 67.

[2] Cpt. Stephen O. Slaughter, "The 140th Infantry, AEF," *History of the Missouri National Guard* (Military Council, Missouri National Guard, November, 1934), 55.

[3] Cpt. Stephen O. Slaughter, 56-57.

[4] Camp Nichols was located at 63rd and Ward Parkway in Kansas City. See Evan A. Edwards, *From Doniphan to Verdun: The Official History of the 140th Infantry* (Lawrence, KS: The World Company, 1920), 250.

[5] Cpt. Stephen O. Slaughter, 56-57.

[6] For the Kansas City, Kansas High School *Jayhawker 1909* photos, I am indebted to Georgia Murphy, Kansas Collection Librarian, Main Branch, Adult Services, Kansas City, Kansas Public Library, August 31, 2009.

[7] Otto P. Higgins, "From the Note Book of O.P. H., *Kansas City Star*, July 2, 1919, p. 17. See Otto P. Higgins, "Honor in a Cup of Coffee," *Kansas City Star,* December 28, 1918, 3.Also, "O.P.H." by Jill Carter Demchak from Sheila Scott personal correspondence, December 23, 2010.

[8] *Wyandotte Harold*, May 27, 1909, Vol. 38, No., 21, 1.

[9] Matthew J. Bruccoli, ed., *Ernest Hemingway, Cub Reporter: Kansas City Star Stories* (Pittsburg, PA: University of Pittsburg Press, 1970), xi. Ernest Hemingway worked as a reporter for the *Star* from October 1, 1917 to April 30, 1918.

[10] Emmet Crozier (1893-1982) began his career at the *Kansas City Star* in 1912. See Mitchel P. Roth, *Historical Dictionary of War Journalism* (Westport CT: Greenwood Press, 1997), 75.

[11] Emmet Crozier, *American Reporters on the Western Front 1914-1918* (New York: Oxford University Press, 1959), 203.

[12] Otto P. Higgins,"Military History," in *The Pandex* ,Vol. XVI, 67.

[13] Otto P. Higgins, "The Old Third in a Raid," *Kansas City Star*, Sunday, September 29, 1918, Editorial Section, 2B.

[14] Burris Jenkins"The Drift of the Day, *Kansas City Journal-Post*, Sunday, July 3, 1927.

[15] Rudolph H. Hartmann, *The Kansas City Investigation: Pendergast's Downfall 1938-1939* (Columbia, MO: University of Missouri Press, 1999), 133.

[16] *Kansas City Star*, June 15, 1965, 3.

[17] Registration Location: Jackson County, Missouri, Roll 168, Draft Board 14 at http://search.ancestrylibrary.com/cgi-bin/ssh=30744749&db=WW1draft&indiv=try accessed October 6, 2011. Also see John J. Newman, *Uncle, We Are Ready! Registering America's Men 1917-1918* (North Salt Lake, UT: Heritage Quest, 2001), 179.

[18] The *Star's* Correspondent [Otto P. Higgins], "First Draft Quota Lucky," *Kansas City Times,* September 5, 1917, 1.

[19] "List of Passengers," White Star Line, *S. S. Lapland* from New York to Liverpool, April 6, 1918. Also see Otto P. Higgins, "From the Notebook of O.P.H," *Kansas City Star*, June 22, 1919, 13A.

[20] Rudolph H. Hartmann, *The Kansas City Investigation: Pendergast's Downfall 1938-1939* (Columbia, MO: University of Missouri Press, 1999), 133.

[21] Otto P. Higgins, "From the Notebook of OPH," *Kansas City Star,* June 22, 1919, 13 A. Fellow correspondent, Webb Miller of the United Press, also described the same incident.
(Webb Miller, *I Found No Peace: The Journal of a Foreign Correspondent* (New York: the Literary Guild, 1936), 63-64).

[22] Handwritten letter from Otto P. Higgins to Elizabeth F. Higgins, 3221 East 32nd Street, Kansas City, Missouri, U.S.A., "Opened by Censor." Contents courtesy of Sheila Scott to the author.

[23] Crozier, 203.

[24] Crozier.

[25] Crozier, 204.

[26] Crozier.

[27] Crozier, 224-225.

[28] Otto P. Higgins, "That Job of 'Writing Up' the War: OPH Tells How Correspondents Worked in France," *Kansas City Star,* June 15, 1919, 6C. So thorough was this article about the job of war correspondents during the war that it was picked up in a national publication, "A War-Correspondent's Job was Not a Soft Snap," *The Literary Digest*, July 19, 1919, 67-70. The *Digest* acknowledged the *Kansas City Star* as its source, but referred to the author only as "one of these correspondents." In some small way, that omission can now be

rectified, and the acknowledgement can finally be made to Otto P. Higgins nearly one hundred years later.

[29] Higgins.

[30] Crozier, 224.

[31] Jill Carter (Demchak), "O.P.H." from an interview with Elizabeth Higgins, 3.

[32] Author's personal communication with OPH.

[33] Jill Carter (Demchak), 4. Also see Otto P. Higgins, "The Old Third in a Raid," *Kansas City Star* September 29, 1918, 2B.

[34] Higgins, "That Job of 'Writing Up' the War: OPH Tells How Correspondents Worked in France."

[35] Otto P.Higgins, "That Job of 'Writing Up' the War.'"

[36] Otto P.Higgins, "That Job of 'Writing Up' the War.'"

[37] Otto P.Higgins, "That Job of 'Writing Up' the War.'"

[38] Otto P.Higgins, "That Job of 'Writing Up' the War.'"

[39] Otto P.Higgins, "That Job of 'Writing Up' the War.'"

[40] Otto P.Higgins, "That Job of 'Writing Up' the War.'"

Chapter 2: In British Ports—May 1918

[1] Otto P. Higgins, "Sun on Lusitania Graves," *Kansas City Star,* May 20, 1918, 6:30 Edition, 5.

[2] Otto P. Higgins, "'No. 4' An American Girl," *Kansas City Star,* May 21, 1918, 6.

[3] "Zeps" refer to "Zeppelins," rigid airships designed by Count Graf Zeppelin and used by the Germans in bombing raids over England. See Stephen Pope and Elizabeth-Anne Wheal, *Dictionary of the First World War* (New York: St. Martin's Press, 1995), 519-520.

[4] Otto P. Higgins, "Erin the Land of Plenty," *Kansas City Star,* May 24, 1918, 12.

[5] Otto P. Higgins, "Play as Danger Looms," *Kansas City Star* June 6, 1918, 5.

[6] Todd A. Woofenden, *Hunters of the Steel Sharks: The Submarine Chasers of WWI* (Bowdoinham, ME: Signal Light Books, 2006), 181.

[7] Otto P. Higgins, "Eyes of Destroyers Open," *Kansas City Star*, June 4, 1918, 4.

[8] Higgins.

[9] Otto P. Higgins, "Combine to Fight U-Boats," *Kansas City Star*, Friday, June 7, 1918, 10.

[10] Otto P. Higgins, "A Bit of Home for the Navy," *Kansas CityTimes* June 4, 1918, 7.

[11] Otto P. Higgins, in the Otto P. Higgins Archive, Edward Jones Research Center, National World War I Museum and Memorial. Accessed April 7, 2016.

[12] The "someone" is William Shakespeare and the "sometime" is *Troilus and Cressida*, Act III, sc iii, line 175. "Curiously enough, the line is always quoted as exemplifying the sympathy that, once awakened, makes men feel their close relationship to one another. 'Nature' is taken as meaning 'fellow-feeling,' one touch of which makes us all brothers. This unconscious misinterpretation, or rather misapplication, of the great poet's words shows us how innate the conviction is of the fact of our universal brotherhood." *The Path*, September

1889 (www.theosociety.org/pasdena/path/vo4no6p176_one-touch-of-nature.htm accessed July 12, 2016.

[25]OPH describes the process of "rolling his own" cigarettes. The "makin's" is slang for "makings," the term used to describe the ingredients it took for a smoker to roll his (or her) own cigarettes. These ingredients included a 2x3-inch package of thin cigarette paper wraps—the "little red book" to which OPH refers—and "fine grains of tobacco" stored in a small cloth sack with a draw string (the "tag") extended from the top. Typically, the smoker would open the package of cigarette paper, extract one of the papers, crease it into a "v" shape, then into the "V" pour a ¼-inch thick stream of tobacco the length of the paper, gently moisten one edge of the paper with his tongue, meet both ends, then roll up the tobacco and twist each end together.

Chapter 3: From Paris—May – June 1918
[1]Otto Higgins, "Our Men's Morals Good," *Kansas City Star*, Friday, July 5, 1918, 13, and Emmet Crozier, *American Reporters on the Western Front 1914-1918* (New York: Oxford University Press, 1959), 204.

[2] Emmet Crozier, *American Reporters on the Western Front 1914*-1918, 204.

[3] James A. Huston, *The Sinews of War: Army Logistics 1775-1953* (Washington, DC: Office of the Chief of Military History, US Army, 1966), 357.

[4] James A. Huston, map, 359.

[5] James A. Huston, 372.

[6] James A. Huston.

[7] On May 27, 1918, the Office of the Chief of the Quartermaster Corps prepared a map of France showing the activities performed at the various facilities. See James A. Huston, *The Sinews of War: Army Logistics 1775-1953*, 359.

[8] Otto Higgins, "Our Men's Morals Good," *Kansas City Star*, July 5, 1918, 13.

[9] Edward V. Rickenbacker, *Rickenbacker: An Autobiography*. (Englewood Cliffs, NJ: Prentice -Hall, 1967), 94.

[10]James J. Hudson, *Hostile Skies: A Combat History of the American Air Service in World War I* (Syracuse, NY: Syracuse University Press, 1968). 1st paperback edition, 1996, 35-36.

[11] Born in Gotham, Loos, New Hampshire, on April 21, 1880, Irene Maud Givenwilson took her nursing diploma from the German Red Cross at Bonn, Germany, pursued a course in elementary nursing in Holland and another in England before working in the wards of Presbyterian Hospital in New York City from November 1914 to March 1915. See American Red Cross Nursing Service, *History of American Red Cross Nursing* (New York: Macmillan, 1922), 480. Her knowledge of nursing as practiced in the United States and in Europe, as well as her proficiency in foreign languages, made her well-suited to become the director of Red Cross Activities at Issoudun. "As early as October 3, 1917, Miss Irene Given Wilson and a few other ladies from the Red Cross stepped off into the 'sea of mud' and took possession of a small section in one of three barracks. They opened a temporary canteen, and were soon cheering the men with hot coffee and sandwiches. From this little beginning, the Red Cross gradually grew until its rooms and buildings covered nearly an acre over

camp." (Chapter XV, Lt. Col. Hiram Bingham, *An Explorer in the Air Service* (New Haven, CT: Yale University Press, 1920). After ten days at sea, Miss Givenwilson returned to New York from Southampton aboard the *Oropesa* on August 19, 1921, on her way to Washington, D.C., where she became the Curator of the American Red Cross. On October 10, 1924, she married Major Walter G. Kilner, who commanded the A.E.F. Army-Air Force during the Great War, and she died on February 2, 1934, with burial at Arlington, Section 7, site 10037.

[12] Otto Higgins, "Our Men's Morals Are Good," A 1911 Kansas City directory lists Lois Cornforth as a social worker employed at the Kansas City Provident Association at 1115 Charlotte. She resided at 3236 East 7th Street. The Provident Association was created by nineteen prominent Kansas Citians under the leadership of Father William J. Dalton, who was very active in civic affairs and was one of the originators of the first city charter in 1889. The Provident Association justified its work with an objective "not only to relieve suffering and distress, but to ferret out and expose a clan of beggars who constantly imposed upon the 'confidence and liberality of the people,' and to learn how to discriminate between the worthless beggar and the deserving poor and sick." See. R. F. Townley, "A History of the Provident Family and Children's Service of Kansas City, Missouri. Est. 1880," in *Provident Association Collection (K1284)*, The State Historical Society of Missouri Research Center—Kansas City. Also see Bill R. Beemont, "The Clergy," in Dorothy Brandt Marra, *This Far by Faith: Volume I, The Story* (Kansas City, MO: Diocese of Kansas City-St. Joseph, 1992), 326.

[13] Alice Maxwell Appo was born was born in Boston, Massachusetts, on October 22, 1882. On her passport application issued on January 16, 1918, she listed "advertising" as her occupation and her current place of residence as Kansas City, although by the 1920 Census she was a writer living and working in New York City. In January 1918, she had applied to serve with the Red Cross Canteen Service for six months, anticipating departure on the French Line on January 23, 1918. She returned to New York on board the *Espagne* on June 16, 1919. See Ancestry.com , *U.S. Passport Applications 1795-1925* [database.on-line] Provo, UT, Ancestry.com Operations, Inc., 2007, and Ancestry.com *New York Passenger Lists, 1820-1957*, Microfilm Serial T-715, 1897-1957 Microfilm Role 2652, Line 6, 187.

[14] Otto Higgins, "A Rail Army of Yanks," *Kansas City Star*, June 30,1918, 8A.

[15] Higgins.

[16] Otto Higgins, "Our Men's Morals Are Good," .

[17] Otto Higgins, "U.S. Men Thrifty Abroad," *Kansas City Star*, June 29, 1918, 7.

[18] Peter N. Nelson, *A More Unbending Battle: The Harlem Hellfighters' Struggle for Freedom in WWI and Equality at Home*. (New York: Basic Civitas Books, 2009), 57.

[19] Otto Higgins, "U.S. Railway Work Huge," *Kansas City Star*, June 28, 1918, 6.

[20] Otto Higgins, "U.S. Men Thrifty Abroad."

[21] Otto Higgins, "Pep Upset a Sleepy Town," *Kansas City Star*, July 1, 1918, 6.

[22] Otto Higgins, "U.S Railway Work Huge."

[23]See endnote 12 above. Of interest to journalists was that Irene Givenwilson was instrumental in acquiring a press and establishing a printing office in the camp at Issoudun. The result was a newspaper with the playful title, *The Plane News*, that "grew in influence and importance, although from time to time its personnel had to be changed, owing to the exigencies of military service. By the middle of the year [1918] it had become recognized as the official organ of the American Air Service in France." (Chapter XV, Lt. Colonel Hiram Bingham, *An Explorer in the Air Service* (New Haven, CT: Yale University Press, 1920).

[24] Born in Boston, Massachusetts on October 22, 1882, Alice Maxwell Appo was 35 years old at the time OPH met her at the Red Cross canteen in Issoudun

[25] Otto Higgins, "Our Men's Morals Good."

Chapter 4: Behind the Lines and at Belleau Wood—June 1918

[1]Ian Westwell, *World War I Day by Day* (New York: Chartwell Books, 2012), 165-166.

[2] Westwell.

[3] Emmet Crozier, *American Reporters on the Western Front 1914*-1918 (New York: Oxford University Press, 1959), 224-225.

[4] Crozier, 226.

[5] *"Dispense Exceptionellement de la possession d'un Carnet d' Étranger, 6 June 1918 Gare De L'est Paris; Allen Potts June 8, 1918, Baccarat to Neufchateau*; Pass extended until leaves Baccarat sector and arrives at Neufchateau, approximately until June 16, signature of MacArthur C. of S." (National World War I Museum and Memorial Archives, Archival Box Accession No. 2010.145).

[6] Notes taken from OPH's daughter Eleanor Carter's scrapbook April 21, 1980; from "Sets Course from War to Law," article and portrait of OPH in uniform, *Hastings Tribune*, undated.

[7] Major John F. Carmack was born on March 12, 1887, and lived at 6325 Washington, St. Louis, MO. Inducted on August 5, 1917, he served with the 137th Infantry overseas from March 25, 1918 until September 1, 1919. He left the service with a 30% disability rating from severe wounds received on May 20, 1918. See Missouri Digital Heritage Soldiers' Records: War of 1812-World War I at https://s1.sos.mo.gov/records/archives/archivesdb/soldiers/Detail.aspx?id-A19716&conflict=World War 1.

[8] Lt. Col. Ruby D. Garrett, "The 117th Field Signal Battalion," *History of the Missouri National Guard,* (Military Council, Missouri National Guard, 1934), 247.

[9] OPH refers to the 117th Field Signal Battalion, commanded by Lt. Col. Ruby D. Garrett.

[10] A year later, the *Star* published a follow-up story revealing how OPH's appreciation for the mess sergeant's flapjacks appealed to another taste, as well. See "Flapjacks Unite Lovers," *Kansas City Star*, Tuesday, July 8 1919, 12. Having acquired a nickname for the popularity of his pancake batter, William

J."Dippy" Diers, the mess sergeant, is mentioned in Otto Higgins, "The Signal Men Fed Best," *Kansas City Star,* January 21, 1919, 5, and in "Otto Higgins, "Garrett's Men In," *Kansas City Star,* April 28, 1919, 3

[11] OPH refers to the 117th Ammunition Train raised in Rosedale, Kansas City, Kansas, by Lt. Col. Frank L. Travis.

[12] The 1st and 2nd Ambulance Companies of the Missouri National Guard became the 110th Sanitary Train, 35th Division. See "Assignment of Missouri Guard Units," Appendix H, Clair Kenamore, *From Vauquois Hill to Exermont: A History of the 35th Division* (St. Louis, MO: Guard Publishing Co., 1919), 266.

[13] "Lyonnais potatoes" from the Lyonnais region in France, "where there is an abundance of good quality potatoes as well as excellent onions." "This region, though small, comprising as it does only two departments, those of the Loire and the Rhône, nevertheless, deserves a place in the first rank for its excellent cuisine. Lyons can in fact be regarded as the gastronomic capital of France." Prosper Montagné, *Larousse Gastronomique: The Encyclopedia of Food, Wine & Cookery* (New York: Crown Publishers, 1961), 599

[14] 1st Lt. Chaplain James Small was a travelling evangelist for the Christian Church and pastor of the Hyde Park Christian Church on the northwest corner of Westport Road and Main in Kansas City, MO. Born in Ireland in 1860, he immigrated to the U.S. in 1887 and served as chaplain with the HQ Field Hospital Section of the 110th Sanitary Train, 35th Division, when it departed for France from New York on May 19, 1918, on board the *Louisville.* He returned a little over a year later as part of the HQ Company, 20th Engineers, 5th Battalion, Forestry, on board the *Princess Matoika* that had departed St. Nazaire, France, on June 12, 1919, and arrived in New York on June 23, 1919. From there he entrained for Camp Jackson, South Carolina. Always on the lookout for the unexpected, OPH took particular note of Chaplin Small's preference for an assistant with an ability to swear. After the war, Chaplain Small, who, by 1920, had returned to his position as pastor of Kansas City's Hyde Park Christian Church, in 1922, seemed to add to the notoriety of his opinions by choosing to address the Ku Klux Klan in support of their cause. In his view, three things posed a threat to America: Catholicism, lack of any religion at all and lawlessness. Throughout the city, however, fellow Protestant ministers took strong exception to his views. Chaplain Small died in 1936 and is buried in Columbus City Cemetery, Columbus, Indiana (Find-A-Grave ID 77083661). See "One Hundred Per Cent for the Ku Klux Clan," in *The Christian Century: A Journal of Religion,* December 21, 1922, 1598. Also see *U.S. Army Transport Passenger Lists, 1910-1939* for departures and arrivals of military units to and from French ports.

[15] Otto Higgins, "The Home Boys in Camp," *Kansas City Star,* July 17, 1918, 3.

[16] Otto Higgins, "Kansas City Men in France," Photos in the *Kansas City Star,* July 23, 1918, 2.

[17]Evan Alexander Edwards, *From Doniphan to Verdun* (Lawrence, KS: The World Company, 1929), 28.

[18] Edwards, 29.

[19] Refers to Old 3rd Regiment, Missouri National Guard, now 140th Infantry, strength 3,307, Col Albert Linxwiler, commanding. See "Kansas City Troops and Where They Are," *Kansas City Star*, Sunday, December 2, 1917, 2B.

[20] The Commerce Trust building was on the northwest corner of 10th and Walnut.

[21] See picture in the *Kansas City Star*, Tuesday, July 30, 1918, 3.

[22] Otto Higgins, "With Our Boys in France," *Kansas City Star,* Tuesday, July 30, 1918, 3.

[23] Otto Higgins, "Untitled: Reference to "Old Third," Now 140th Infantry, 35th Division, published with "Signal Corps Ranks High," *Kansas City Star*, Friday July 19, 1918, 7.

[24] Adjutant General's Report, "First Missouri Ambulance Company," Chapter XII, *History of the Missouri National Guard* (Jefferson City, MO: Military Council of Missouri National Guard, 1934), 256.

[25] Otto Higgins, "Steel Observation Box in 'No Man's Land.'" Original photograph for Picture #4, which appeared in the *Kansas City Star*, "With Our Boys in France," Sunday, July 24, 1918, 4. Photo courtesy of Sheila Scott.

[26] Otto Higgins, "With Our Own Boys in France," *Kansas City Star,* Sunday, July 24, 1918, 4.

[27] James J. Heiman, *Voices in Bronze and Stone: Kansas City's World War I Monuments and Memorials* (Kansas City, MO: Kansas City Star Books, 2013), 215.

[28] Raymond Sidney Tompkins, *The Story of the Rainbow Division* (New York: Boni Liveright, 1919), Appendix I, 238.

[29] Otto Higgins, "With Our Own Boys in France," *Kansas City Star*, Sunday, July 28, 1918, 12A

[30] Otto Higgins, "With Our Boys in France," *Kansas City Star*, Tuesday, August 6, 1918, 8.

[31] Otto Higgins, "With Our Boys in France," Four photographs taken by OPH on June 18, 1918, appearing with "Sweets Lighten the Pack," (composed August 12, 1918); photos and article published in the *Star,* September 22, 1918, 1B. Documentation for the date June 18, 1918 appears on the back of another of the photographs in the group not published in the *Star*. Original photographs courtesy of Sheila Scott.

[32] Original photos courtesy of Sheila Scott. These four unpublished photographs were taken the same time as four other photographs which were published in the *Kansas City Star*, on September 22, 1918, along with an article that OPH wrote on August 12, entitled. "Sweets Lighten the Pack." We know the photos are a group because of the sequence numbers preceding Higgins' name, because each photo is labeled by OPH on the back as "Belleau Wood," and because one of the photos is actually dated, June 18, 1918.

Chapter 5: In the Vosges—July 1918

[1] Alex Hook, *World War I Day by Day* (Kent, UK: Grange Books, 2004), 165.

[2] Hook, 166.

[3] OPH pass to Meaux, la Ferte, Montmirail by train or auto and return to Paris from June 28, 1918 to July 9, 1918 by Robert C. Davis Adjutant General

American Armies in France. On July 30, OPH had returned to Paris once again, most likely checking in at G-2-D, the headquarters for American correspondents at 10 Rue de Ste. Anne. (National World War I Museum Archives, Archival Box Accession No. 2010.145).

[4] Missouri Digital Heritage Soldiers' Records: id=A139678.

[5] Otto Higgins, "Met 'Back Home' Boys," *Kansas City Star*, September 11, 1918, 4.

[6] OPH is with the 117th Field Signal Battalion in the Lunneville Sector.

[7] *"adjudant-major,* and *capitaine adjudant-major"* are equivalents to a "field adjutant." See Albert Berrère, *A Dictionary of English and French Military Terms* (London: Librairie Hachette, 1916), 2. Also *Quillet Flammarion* (Paris, Quillet-Flammarion, 1957), 17.

[8] The original photograph, which OPH submitted to the *Star* with the cutline, "'Professor' Mary Louise, 14 years old, at attention." The photo passed the censor on 23 June 1918. Written in pencil on the back is the note "Mary Louise Blodell 3½ years in prison." [3½ years in reference to Mary Louise's father]. The contrast between the original photo and the version printed in the newspaper points up the production technique used at the newspaper. The *Star's* art department converted all photographs to line drawings. In this instance, the artist has eliminated the background shadow and increased the contrast so that the figure of Mary Louise appears more distinct than it was in the original. Photo courtesy Sheila Scott.

[9] Otto Higgins "Their 'Professor' at 14," *Kansas City Star*, Friday, August 23, 1918, 3.

[10] OPH is with Kansas City's 140th Infantry, 3rd Battalion, Major Murray Davis, a former Kansas City lawyer, commanding.

[11] By spending his nickels with Joe Donnegan, the speaker is pledging to be a teetotaler. The reference to Joe Donnegan may be to a Kansas City story that had some currency with an earlier Kansas City audience. The story appeared on November 8, 1909, in the *Kansas City Journal*, a weekly paper published by the Journal Company, 8th Street, McGee and Oak, Kansas City. According to the story, Joe Donnegan, a "theatrical manager and hotel man," who was also a teetotaler to begin with, was tricked into signing a pledge to abstain from alcohol for five years. In an attempt to get an alcoholic friend on the wagon, Joe had talked the friend into accompanying him to a notary where the friend was to sign a pledge to abstain from drink for five years. Joe believed he himself had signed as a witness, but as it turned out, his friend had done so, instead, and it was Joe who, unaware, had signed as the one taking the pledge. Some time had passed before Joe discovered his friend drunk in a saloon, barely able to hold on to the bar. "'You are a fine specimen of manhood,' declared Donnegan, as he grabbed his friend by the shoulders and shook him. 'I thought you took the pledge not to take a drink for five years, and here I find you so drunk you can hardly stand up.' 'Youre mishtaken, that's all,' replied the friend, at the same time pulling a sheet of paper from his coat pocket. 'You see *you* took the pledge. See your name? I am witness to it, and *you* dassent take a drink, so be careful now and don't violate your pledge. What'll you have?'"

"Wrong Man Signed Pledge," *The Kansas City Journal*, November 8, 1919. See www.vintagekansascitylcom/100yearsago/2009/11/wrong-man-signed-pledge-how-Joe.html

[12] "Starbeams" was a regular column that appeared in the *Star*. It was composed of a series of wry "one-liners," commenting on conditions and events about Kansas City. In the context of the march, the commentary offered by some of the men reminded OPH of similar commentary one might find in "Starbeams."

[13] "Slum" is a slang word for "slumgullion," a stew made up mainly of meat, potatoes and onions. "Cadets at West Point used to refer to hash as 'slumgudgeon.'" See Paul Dickson, *War Slang* (New York: Bistol Park Books, 1994), 97.

[14] Otto Higgins, "When Our Boys 'Went In,'" *Kansas City Star*, Monday, September 9, 1918, 4.

[15] OPH uses the term, "boche," or its plural form, "boches," 21 times in this article. During World War I, the term, "boche," was a slang word used disparagingly to refer to a German soldier. "Boche" is originally a French word, shortened from *alboche,* which refers to "Alemande" (German) "boche" (as in *cabache*, "caggage squarehead") (See (*Webster's Third New International Dictionary*, 245.) A pejorative, the word "boche" is variously translated as "cabbage head" (see Matt Campbell, "Poignant Piece of WWI History," *Kansas City Star*, Monday, August 26, 2013, A8), "chump," [(Paul Dickson, *War Slang* (New York: Bristol Park Books, 2007), 44], or "busher" (*War Slang*, 47).

[16] Otto Higgins, "Kansans Over Top," *Kansas City Star*, September 8, 1918, IB.

[17] From the personnel OPH mentions in the article, he is having a tasty dinner with the Kansas City 140th Infantry Regiment.

[18] OPH also says that "Doc" Hanson was a dentist. (See Otto Higgins, "Anxiety as They Go In," *Kansas City Times*, Tuesday, September 24, 1918, 8.).

[19] For a biography of Major Murray Davis and the story of the monument dedicated to him in Kansas City, see James J. Heiman, *Voices in Bronze and Stone: Kansas City's World War I Monuments and Memorials* (Kansas City, MO: Kansas City Star Books, 2013), 178-183.

[20] "Doc Hanson" is Cpt. Benjamin Hanson, who was born in Lund, Sweden, on September 20, 1868. He was originally inducted at Ft. Niagara on February 8, 1913, and served with the Medical Supply Depot in St. Louis until August 4, 1917. Two weeks later, on August 19, he became an officer with the Sanitary Company of the 35th Division, seeing overseas service from May 19, 1918 to April 27, 1919. His officer service record can be found at Missouri Digital Heritage, *Soldiers Records: War of 1812 – World War I* id=A52638). After he returned to the states, he continued service in the medical department at Fort Sill, Oklahoma, in enlisted status as a sergeant. OPH mentions Doc Hanson in a number of articles, one of which describes a poker game during a German bombardment. See Otto Higgins, "Barrage Made Poker Quit," *Kansas City Star*, Friday, September 20, 1918, 1B.

[21] Cassimir John Joseph Michael Welch (1873-1936). Cas Welch, also known as the "Boss of Fifteenth Street," was a justice-of-the-peace, who, since 1891, had been the protégé of Joe Shannon, the head of the "Rabbit" faction in Kansas

City politics. Welch's headquarters was called "Little Tammany" for its resemblance to the New York organization of that name. "An old garage building served as the control center for two important wards in a business and residential area bordering the downtown section. The job of serving the political needs of this region required the services of a man of many talents, for the Little Tammany district contained most of the elements that go to make the modern city a bewildering complex. The boss had to work with important commercial interests and at the same time satisfy a large population of native whites mixed with Negro and foreign-born groups who existed on the subsistence level. Welch rose to power administering justice, after he had won some political recognition through his Irish geniality and pugnacity." As for his qualifications, "Judge Welch didn't have a lawyer's degree—fortunately for him none was required by the law—but he had the judicial temperament without the legal solemnity." Among the rules in his court was Rule 4: "'People won't have to have a lawyer to get justice here,'" he said. "'I'll be their lawyer.'" William M. Reddig, *Tom's Town: Kansas City and the Pendergast Legend* (Philadelphia: J. B. Lippincott Company, 1947), 109-111.

[22] Cpt. John F. Howell. See notes in Chapter 8, where many of the same names from the 140th Infantry are mentioned in Otto P. Higgins, "Seven Days of Hell," *The Kansas City Star*, Friday, November 1, 1918, Main Edition, 1.

[23] 1st Lt. Stephen Olin Slaughter was born on August 4, 1886, in Dover, Delaware. He was inducted into the 3rd Infantry, Missouri National Guard, and served with the 140th Infantry. Overseas from April 24, 1918 to December 11, 1918, he was wounded in the Meuse Argonne on September 29, 1918, and rated with a 20% disability. Transferred to the 164th Depot Brigade, he then served with the 41st and the 64th Infantry regiments until discharged. See Missouri Digital Heritage, *Soldiers' Records: War of 1812 – World War I*, ID = A119563.

[24] This is Victor Stark, service number 2,199,155, who was born in Perry, Kansas, and was inducted at Camp Funston at the age of 31 and one month on October 11, 1917. He served in the quartermaster department and reached the rank of sergeant in September 1919. See Missouri Digital Heritage Soldiers Records: id=A12346. In another article, "Anxiety as They Go In," *Kansas Times,* Tuesday, September 24, 1918, 8, OPH remembered Vic's last name and that he worked directing traffic on the Metropolitan Street Railway Company in Kansas City.

[25] Both Ralph Truman and Bill Gordon worked in the intelligence section of Headquarters Company, 140th Infantry. Both men had served in the Kansas City Police Department before their time in service. "Fergie" is likely Joseph D. Ferguson. See "Feast for Home Boys," *Kansas City* Star, September 19, 1918, 3.

[26] Major Ernest W. Slusher was born in Dover, Missouri, on January 15, 1875, and lived at 3410 Cherry in Kansas City, Missouri. He was 42 when he was inducted on August 5, 1917, into the Sanitary Detachment of the 3rd Missouri Infantry National Guard. He served overseas with the 140th Infantry from April 25, 1918, to April 25, 1919, and was wounded in the Argonne on September 39, 1918. His service record indicates that the extent of his wounds was

"undetermined," "Taken to a hospital twice, gassed, he had each time returned to his work," remembered 1st Lt. Evan Edwards, the regiment's chaplain. "For his courage there and at the Chaudron Farm dressing station he received the Distinguished Service Cross. He had always looked for the good points in his officers and developed them. He had a splendid attitude towards the men; with a strict discipline, he combined an interest and care that made for the effectiveness of the regiment. The 140th felt that he was just about all that a medical officer should be. Certainly he was always on the lookout to preserve the health of the regiment." Evan Alexander Edwards, *From Doniphan to Verdun: The Official History of the 140th Infantry* (Lawrence, KS: The World Company, 1920), 94-95.

[27] Otto Higgins, "Feast for Home Boys," *Kansas City Star*, Wednesday, September 18, 1918, 3.

[28] The "Red Triangle" is the symbol for the YMCA. The logo pictured here is taken from an original piece of YMCA stationary distributed gratis to the troops.

[29]"Tailor-Mades" were commercially made cigarettes, as opposed to "hand rolled makin's," which an individual would "make" by depositing a thin line of tobacco in the middle of a cigarette paper, wetting the edge of the paper, folding the paper around the tobacco, rolling the folded tobacco to the moistened edge and then twisting the ends of the paper into a hand-made cigarette. See OPH's "One Sack of Makin's" in Chapter 2.

[30] Otto Higgins, "Home Boys Smoked Rope," *Kansas City Star*, Friday, September 13, 1918, 7.

Chapter 6: Through Alsatian Days—August 1918
[1]Evan Alexander Edwards, *From Doniphan to Verdun: The Official History of the 140th Infantry* (Lawrence, KS: The World Company, 1920), 39. The regiment reached Saulxures on June 28th (38).

[2] Otto Higgins, "Sweets Lighten the Pack," *Kansas City Star*, September 22, 1918, Want Ad Section, 1B.

[3] Otto Higgins, "Don't Send Sad Letters," *Kansas City Star*, October 1, 1918, 6.

[4] Otto Higgins, "Sweets Lighten the Pack."

[5] Otto Higgins, "Home Letter Stopped Gun," *Kansas City Star*, September 26, 1918, 7.

[6] Otto Higgins, "Blood is Fighting Blood," *Kansas City Star*, September 10, 1918, 3.

[7] Otto Higgins, "The Old Third in a Raid: O.P.H. Goes Along to Bring Back Prisoners," *Kansas City Star*, September 28, 1918, Editorial Section, 2B.

[8] Otto Higgins, "The Old Third in a Raid: O.P.H. Goes Along to Bring Back Prisoners."

[9] Charles B. Hoyt, *Heroes of the Argonne: An Authentic History of the Thirty-fifth Division*, 46.

[10] Sergeant Albert Earl Robinson of Company L, 140th Infantry, wrote his own description of that night's raid in a little piece entitled, "The Wild West Show," published fifty years later in Albert Earl Robinson, *An Epic Day: Personal*

Glimpses of the Great World War I (New York: Carlton Press, Inc., 1968), 130-132. Following Robinson's description in that book is Higgins' article about the raid, attributed to Higgins and published in its entirety (132-157). Robinson's brief description of the August 20th raid was part of a collection of short narratives, notes, drawings, reminisces, and letters to and from his brother and sister. The collection, Robinson said, "was compiled and written in the camps and in France during the First World War, often in dugouts in the front lines. It served to relieve the tedium and to keep me from brooding too deeply. It also helped entertain some of my comrades. To keep a record of any sort was against regulations, so I concealed it in my gas mask container." After the war, Robinson added more drawings and descriptive pieces to the collection, and as a reporter, feature writer, and artist for *The Star* from 1920 to 1964, continued to produce occasional pieces about the war. He intended to compile, edit and publish the complete collection of his war writing when he reached retirement in January 1965, but he died in September 1964 before he was able to do so. His wife, Ruth, then took up the work of arranging the manuscript, drawings and poems of her husband's war experiences for a book that appeared in 1968. It was likely Ruth who included OPH's article, which added more detail to Robinson's brief story of the raid. The back of the dust jacket to the book provided a biographical sketch of Albert Earl Robinson. Born in Bangor, Main, on May 3, 1893, Robinson arrived in Kansas City in 1911, enlisted in the Missouri National Guard, Third Regiment and served on the Mexican Border War in 1916. After he was mustered out, he enrolled in the Fenway School of Art in Boston, but he re-enlisted when the war broke out and served with the 140th Infantry as a sergeant. During the World War, he "was assigned to battalion intelligence in charge of scouts in the Argonne Campaign. Sergeant Robinson was awarded the Silver Star and Purple Heart and received a Personal Citation from General Pershing. Sergeant Albert E. Robinson also figures in an OPH article about Pretzel, the mule. See Otto Higgins, "Pretzel is a Hard-Boiled Mule," *Kansas City Star*, October 3, 1918, 4.

[11] Most likely, Major Murray Davis.

[12] As manager of the Retail Merchants' Association of Kansas City, Charles Z. Coffin helped standardize merchandising policies and practices among the city's retail merchants.

[13] Sgt. Albert Earl Robinson crossed German lines on numerous occasions to bring back information and to locate and eliminate snipers. He was wounded twice. After his service, he married Roth E. Blocher on June 15, 1921 (*See Missouri Marriage Records 1805-2002*). A year earlier, he had joined the staff of *The Kansas City Star* on March 1, 1920, and remained with the paper for forty-four years until his death on September 4, 1964. (See John B Sellers, "Find-a-Grave" Memorial #147284513).

[14] Corporal Kemp I. Oliver, serial number 1,462,110, was born in Belleville, Kansas, and inducted in Kansas City on April 4, 1917, at the age of 21. He served with Company L, 3rd Infantry, Missouri National Guard, and with Company L, 140th Infantry, after the Guard unit was federalized into the 35th Division. Overseas from April 25, 1918, to April 28, 1919, he was promoted to

sergeant with an official date of rank, October 1919. (See Missouri State Archives Soldiers Records: War of 1812 – World War I, id=A96805). See the description of Kemp and Van Brunt in "Home Boys Keen Snipers," *The Kansas City Star,* October 15, 1918, 7. OPH notes that "Both are fearless as lions, as agile as tigers, as tenacious as bulldogs, as careful as a Haviland china salesman, and experts with a rifle."

[15] Corporal Odo Van Brunt, serial number 1,461,695, was born in Amber, Michigan, and was inducted in Kansas City on April 2, 1917, at the age of 18. He served with Company I, 3rd Infantry, Missouri National Guard, and later with Co I, 140th Infantry. Promoted to Corporal in March 1918, he served overseas from April 25, 1918, to May 21, 1918, and was severely wounded on November 2, 1918. He carried with him a 50% disability rating on discharge. (See Missouri State Archives Soldiers Records: War of 1812 – World War I, id=A132900). Odo Van Brunt and Kemp Oliver "always work together, both when they are sniping and when they are in raiding parties," OPH mentioned in "Home Boys Keen Snipers," *The Kansas City Star,* October 15, 1918, 7. For a variant on the spelling of Van Brunt's name, see Evan Alexander Edwards, *From Doniphan to Verdun: The Official History of the 140th Infantry* (Lawrence, KS: The World Company, 1920), 248, where Odo Van Brunt is listed as "Ode F. Van Brunt of Company I, 140th Infantry."

[16] William J. Nevins, serial number 1,462,108, was born in Pittsburg, Pennsylvania, and resided at 1418 Troost, Kansas City, Missouri,, when he was inducted at the age of 20 on January 31, 1917. Originally with Company L, 3rd Infantry, Missouri National Guard, he served with the 140th Infantry overseas from April 24, 1918 to April 28, 1919, reaching the rank of corporal in November 1919. See Missouri Digital Heritage Soldiers' Records: id=A94518.

[17] Corporal Sidney Rice, serial number 1,462,063, was born in St. Louis but lived in Kansas City, Missouri, when he was inducted at the age of 22 into Company L, 3rd Infantry, Missouri National Guard, and served with the 140th Infantry overses from April 25, 1918, to June 19, 1919. See Missouri Digital Heritage, Soldiers' Records, id=107267 and Evan Alexander Evans, *From Doniphan to Verdun,* 232.

[18] Henry H. "Chick" Hoover, entered Infantry Officers' Candidate School and remained there until his discharge. He reached the rank of sergeant in February 1919 and served overseas from April 25, 1918, until February 28, 1919. See Missouri Digital Heritage Soldiers' Records: id=A60274. His name also appears on "The Star's Roll of Honor," published in the *Kansas City Times,* Monday, October 31, 1921, 4, and is listed on the bronze service plaque that hung on the wall of the lobby of the old *Star* building at 18th and Grand, Kansas City, Missouri. He is among those who worked in the *Star's* business office prior to their inductions. Also see "A Reunion at Camp Stuart," *Kansas City Star*, on April 29, 1919, 2. In the barracks at Camp Stuart, Newport News, Virginia, shortly after the 140th Infantry landed, OPH met up again with Sgt. Hoover and three other former *Star* employees.

[19] Ralph E. Charles' service record is not included in the Missouri Digital Heritage, Soldiers' Records: War of 1812 – World War I. However, his name

does appear in Lt Evan Alexander Edwards' unit history of the 140th as a corporal in Company K. See Evan Alexander Edwards, *From Doniphan to Verdun,* 160.

[20] Pvt. Charles Wesley Coffin, serial number 1,462,135, lived at 3308 Euclid in Kansas City and was inducted into Company L, 3rd Infantry, Missouri National Guard at the age of 21 on March 27, 1917. He served with the 140th Infantry overseas from April 25, 1918, until January 18, 1919. Severely wounded on September 30, 1918, during the Battle of the Meuse Argonne, he was rated with a 20% disability. See Missouri Digital Heritage Soldiers' Records: id=A23533.

[21] Sergeant Joseph Vincent Roche, serial number 1,462,036, was born in Arcade, New York, but lived in Kansas City, Missouri, when he was inducted into Co. L, 3rd Infantry, Missouri National Guard, at the age of 22, on February 9, 1917. Having been "wounded slightly" in his service overseas (April 25, 1918-December 30, 1918), he was rated with a 10% disability upon discharge. See Missouri Digital Heritage, Soldiers' Records, id=A109418 and Evan Alexander Edwards, *From Doniphan to Verdun,* 232.

[22] Jack Strother Pride, service number 1,462,112, was born in Clay, Kentucky, but was inducted in Cape Giradeau, Missouri, on June 30, 1917, at the age of 22½. He served in Company L, 6th Infantry, Missouri National Guard, and with the 140th Infantry until he was killed in action on the second day of the Battle of the Argonne, September 27, 1918. He was awarded the rank of corporal posthumously in March 1919. See Missouri Digital Heritage Soldiers Records: id=A103646.

[23] Sergeant Andrew Jack Helmick, serial number 1,462,087, was born in Verdon, Nebraska, and lived at 4722 Park in Kansas City, when he was inducted into Co. L, 3rd Infantry, Missouri National Guard, at the age of 18 on March 30, 1917. He served verseas with the 140th Infantry from April 25, 1918, to April 28, 1919. See Missouri Digital Heritage, Soldiers' Records, id=A56045 and Evan Alexander Edwards, *From Doniphan to Verdun,* 175.

[24] This is may have been the John F. Kelly which the Missouri Digital Heritage, Soldiers' Records id=A68954 indicates was born in Kansas City and inducted into Co. A, 3rd Infantry, Missouri National Guard, at the age of 21 on March 26, 1917. Also see the roster of enlisted men in the 140th Infantry unit history, where John F. Kelly, a private, is listed with Company I. Evan Alexander Edwards, *From Doniphan to Verdun,* 180.

[25] At one point in his life, Higgins himself had worked as a mule skinner. See Burris Jenkins"The Drift of the Day," *Kansas City Journal-Post,* Sunday, July 3, 1927.

[26] Electric Park was an amusement park in Kansas City, known for its brilliant illumination at night.

[27] Joseph R. Donegan (1876-1930), the "King of Twelfth Street," was business manager of The Century Burlesque Theater, later known as The Folly Theater, at 12th and Central in Kansas City. He also managed the adjacent Edward Hotel. Both hotel and theater were designed by the renowned architect Louis Curtiss, managed by Donegan from 1902 to 1922 and became a center for the theatrical life of the city. Many of the bookings that Donegan hired to play in

the vaudeville and burlesque routines at the theater stayed in the adjacent hotel and after their performances retired to the Edward basement, where Donegan operated a small grill, which later grew into a cabaret and became a prototype for the nightlife of the 1920s and 1930s. "The cabaret was the center of Kansas City's after-hours theatrical night life, drawing showgirls from the burlesque along with the prize fighters and wrestlers that Donegan loved to get on its bill, backstage crew members, many performers from the other theaters, and even Kansas City's mayor James A. Reed." See Felicia Londré, *The Enchanted Stars of the Stage: Kansas City at the Crossroads of American Theater, 1870-1930* (Columbia, MO: University of Missouri Press, 2007), 245. Also see William M. Reddig, *Tom's Town: Kansas City and the Pendergast Legend* (New York: J. B. Lippincott, 1947), 89-90.

[28] The French 155 is the 155mm artillery piece, a reliable mainstay for the Allies during the fight.

[29] A busy intersection in the downtown shopping district of Kansas City, Missouri.

[30] In "The Wild West Show," Sergeant Robinson described events this way: "We could hear our own covering party making merry up the road. Across the road we went and along the side to our men, 'Are you ready to go back?' I asked. They were quite ready. So we stepped onto the road and were off. I heard Helmrick request someone in front of him to clear the road for a man who knew how to run. Then his puttee came undone and he set down to fix it. Higgins sailed gracefully over his head at this point. A rifle grenade burst over Joe Roche and knocked him off the road on his back. He staggered up and on. 'I used to think I could run,' said Oliver afterward, 'but I was passed by seven men.' Charlie Coffin couldn't be impeded by his rifle and threw it away. Then we reached our wire. Chick went down on one knee and blazed away whenever he saw a flash. I stayed with him to direct the fire of our rifles and grenades. Then we went in. I was the only casualty, got a scratch on the head from a passing bullet that bled a bit. One wound chevron earned easily. Then the crew mounted the parapet and put on a regular old style wild west show. The crack of the rifles was continuous, like the crackle of fire. Chick turned to me, 'When are you going out again, Rob?' he asked. 'I sure want to be in on it.'" (Albert Earl Robinson, *An Epic Day*, 132).

[31] "Prussian Kultur and Kaiserism": the phrase refers to the German insistence that German culture and militarism were so far advanced over the culture of their neighbors that imposition of German culture was wholly justified. The attitude is expressed especially well in an ironic reference by Barbara Tuchman: "In August, sitting at a café in Aachen, a German scientist said to the American journalist Irwin Cobb: 'We Germans are the most industrious, the most ernest, the best educated race in Europe. Russia stands for reaction, England for selfishness and perfidy, France for decadence, Germany for progress. German *Kultur* will enlighten the world, and after this war there will never be another.'" See Barbara W. Tuchman, *The Guns of August* (New York: Macmillan, 1962), 311-312.

[32] Otto Higgins, "The Old Third in a Raid," *Kansas City Star*, Sunday, September 29, 1918, Editorial Section, 2B.

Chapter 7: At St. Mihiel and in the Argonne—September 1918

[1] See James A. Sawicki, *Infantry Regiments of the US Army* (Dumfries, VA: Wyvern Publications, 1981), 657.

[2] "The St. Mihiel salient had to be wiped out and consolidated," OPH wrote. "Wiping it out wasn't so bad, but consolidating it was tough. I know. I was there through both performances. But the boche knew every blade of grass in the salient and was acquainted with every speck of dust on the roads, and they renewed their acquaintance every day and night with artillery, which made life anything but pleasant." See the historical review of the 117th Field Signal Battalion in Otto Higgins, "Garrett's Men In," *Kansas City Times*, April 28, 1919, 1-3.

[3] Pvt. Patrick Francis Fleming, serial number 1,454,042, resided in St. Louis, Missouri, and was inducted into Company M, 1st Infantry, Missouri National Guard, on July 6, 1917, at the age of 27 years, 8 months. He was overseas with the 138th Infantry from May 27, 1918, until his death on August 13, 1918. As next-of-kin his father, Patrick Fleming was notified. See Missouri Digital Heritage: *Soldiers' Records: War of 1812 – World War I*, id=A40749.

[4] George H. English, *History of the 89th Division, U.S.A.* (Denver, CO: The War Society of the 89th Division), 504.

[5] George H. English.

[6] 1st Sgt. Harry J. Adams, serial number 2,177,024, Bouillonville, France, September 12-13, 1918. "Sergeant Adams followed a retreating German into a house in the town of Bouillonville and, ascertaining that the enemy had entered a dugout, fired the remaining two shots in his pistol through the door and ordered the surrender of the occupants., By his bravery, coolness, and confidence, he captured single-handed approximately 300 prisoners, including seven officers." Citation for the Distinguished Service Cross, War Department, General Orders No. 20 (1919). Also see Charles F. Dienst, Clifford Chalmer, Francis M. Morgan, Charles O. Gallenkamp, Lloyd H Benning, Harold Brown, Morton S. Bailey and William J. Lee, *History of the 353rd Infantry Regiment, 89th Division, National Army—September 1917 – June 1919* (Wichita, KS: Regimental Society, The 353rd Infantry, 1921), 84 (picture of the dugout on the side of the hill), 298.

[7] Dienst, et. al., 304. The regimental directory gives Berkstresser's unit as Company M.

[8] Otto Higgins, "Kansas Led at St. Mihiel," *Kansas City Star*, November 3, 1918, Editorial Section, 1C.

[9] William M. Wright, with Robert H. Ferrell, ed., *Meuse-Argonne Diary: A Division Commander in World War I* (Columbia, MO: University of Missouri Press, 2004), 41.

[10] Emmet Crozier, *American Reporters on the Western Front 1914-1918* (New York: Oxford University Press, 1959), 251. "G-2-D" was the military designation for the Chief Press Officer of the American Expeditionary Forces, a division of G-2, Military Intelligence. [See Crozier, 126].

[11] Crozier, 252.

[12] Crozier, 253.

[13] Crozier. Also see Otto P. Higgins, "Died to Save Rescuers," *Kansas City Star,* article written on October 7, 1918, published in the newspaper on November 1, 1919, 1.

[14] Otto P. Higgins, "Seven Days of Hell," *Kansas City Star*, November 1, 1918,1.

[15] Otto P. Higgins, "Our Men Whip the Best," *Kansas City Star* , October 27, 1918, Want Ad Section, 1B

[16] Higgins, "Our Men Whip the Best." Also see Otto P. Higgins, "Avenged His Boy's Death," *Kansas City Times*, April 30, 1919, 5. After he had returned to the states, OPH retold the story with the details the censorship would not allow him to include in the original narrative.

[17] James J. Heiman, *Voices in Bronze and Stone: Kansas City's World War I Monuments and Memorials* (Kansas City, MO: Kansas City Star Books, 2013), 160.

[18] Lieut. Col. Levi G. Brown was with the 89th Division as Division Inspector and later as Operations Officer. OPH had stayed with him in his dugout in the St. Mihiel sector. Lt. Col. Brown brought the 355th Infantry Regiment home aboard the *Leviathan* on May 22, 1919. He was the highest-ranking officer and the only staff officer in the United States Army to be captured by the Germans. See Otto P. Higgins, "Nebraskans Made Fur Fly," *Kansas City Times*, May 24, 1919, 3. Lt. Col. Brown is listed as serving with the Field Artillery, Headquarters, 89th Division. See George H. English, Jr. *History of the 89th Division 1917·1918·1919,* 482, 486.

[19] Major Throop M. Wilder served in the Adjutant General's Department of 89th Division Headquarters. See George H. English, Jr., "Officers' Roster," *History of the 89th Division 1917·1918·1919,* 495.

[20] This is likely a reference to 2nd Lt. Horace R. Palmer, Field Artillery, Headquarters, 164th Field Artillery Brigade. See George H. English, Jr., *History of the 89th Division 1917·1918·1919,* 492.

[21] Capt. Ernest W. Cavaness, 3601 Prospect Ave., Kansas City, Missouri, was born August 30, 1883, and was inducted on May 22, 1917, into the 355th Ambulance Company of the 314th Sanitary Train, 89th Division. He served overseas from June 28, 1919, to May 24, 1919. See Missouri Digital Heritage, *Soldiers Records: War of 1812 – World War I,* id=20194. Captain Cavaness had charge of 122 Kansas Citians in Red Cross Ambulance Company No. 24 before it became the 355th Ambulance Company. He brought 90 of the unit back home on May 24, 1919, aboard the *Agamemnon*. Two of his men had been killed, seven were wounded, several were transferred, and seven stayed in France to study at French universities until June 1919. See Otto Higgins, "The Ambulance Men Land," *Kansas City Star*, Sunday, May 25, 1919, 2A.

[22] Montgomery M. Wright, service number 2,196,817, lived at 6115 Main, in Kansas City, Missouri. At the age of 24 years, 8 months, he was inducted into the 355th Ambulance Company, 314th Sanitary Train, in Kansas City on August 7, 1917. He served overseas from June 28, 1918, to May 24, 1919, and had achieved the rank of corporal upon discharge. See Missouri Digital Heritage, *Soldiers Records: War of 1812 – World War I* id=A137807. He is listed as part

of *The Kansas City Star's* editorial staff in serving with the military. See *"The Star's* Roll of Honor," *Kansas City Times*, Monday, October 31, 1921, 4. Also see "The Ambulance Men Land," *Kansas City Star,* Sunday, May 25, 1919, 2A, for a story about Wright borrowing press credentials in an attempt to visit Paris.

[23] Arthur F. Duncan is listed after Montgomery M. Wright as part of the *Star's* editorial staff in military service. See *"The Star's* Roll of Honor." Arthur F. Duncan, serial number 2,196,579, lived at 609 East 9th Street in Kansas City and was inducted in Fredonia, Kansas, on August 12, 1917. He served overseas with the 353rd Ambulance Company, 314th Sanitary Train, from June 28, 1918, to May 24, 1919. Missouri Digital Heritage, *Soldiers Records: War of 1812 – World War I* id=A34365. "He came back no longer fat, but sunburned and ruddy as could be. 'And where did you get all that color?' he was asked. 'Oh, boy. The sun shone in Germany, which it didn't do in France,' he said." See "The Ambulance Men Land," *Kansas City Star*, Sunday, May 35, 1919, 2A.

[24] Otto Higgins, "'O.P.H.' with the 89th," *Kansas City Star,* Wednesday, October 16, 1918, 6.

Chapter 8: With the 35th—October 1918

[1] Otto Higgins, "Seven Days of Hell," *Kansas City Star*, November 1, 1918, 1.

[2] Otto Higgins, "Huns Couldn't Kill Kelly," *Kansas City Star*, November 2, 1918, 2.

[3] Major William L. Gist was born on August 9, 1882, and lived at 2950 Victor in Kansas City, Missouri. On August 5, 1917, just four days after his 35th birthday, he was inducted into the 35th Division, where he commanded the Field Ambulance Section of the 110th Sanitary Train. Prior to that, he was captain of Kansas City's 1st Missouri Ambulance Company, Missouri National Guard, and had served in the Mexican Punitive Expedition of 1916. He served overseas from March 30, 1918, to April 27, 1919. See Clair Kenamore, *From Vauquois Hill to Exermont: A History of the 35th Division* (St. Louis, MO: Guard Publishing Co., 1919), 260, 366. Also see Missouri Digital Heritage Soldiers' Records: id=A46225. After the war, Dr. Gist was the Higgins family physician. (Sheila Scott personal correspondence, December 14, 2016).

[4] Otto Higgins, "When Sid Houston 'Fell,'" *Kansas City Star,* Thursday, November 28, 1918, 5.

[5] The "prohibitory law" is the 18th Amendment. The boys were coming home to Prohibition. The "cup of tea" is a euphemism for an alcoholic beverage.

[6] Otto Higgins, "When Sid Houston 'Fell,'" *Kansas City Star*, November 28, 1918, 5. Also see Otto Higgins, "Met 'Back Home' Boys, *Kansas City Star*, Wednesday, September 11, 1918, 4.

[7] Private Sid Houston, service number 1,472,758, was born in Mexico, Missouri, and at the age of 23½ was inducted into the army at Fort Riley on June 18, 1917. He had served under Major Gist in the First Missouri Ambulance Company, Missouri National Guard, went overseas from May 18, 1918, to July 12, 1919, and was promoted to the rank of corporal in March 1919. See Missouri Digital Heritage Soldiers' Records: id=A609648. See Clair Kenamore, *From Vauquois Hill to Exermont: A History of the 35th Division,*

367. Also see Otto Higgins, "Got to Paris 'Toot Sweet,'" *Kansas City Times*, June 9, 1919, 5. In that article, OPH tells of meeting, H. J. Williams, a sailor from the destroyer, *USS Connor*, sitting next to Higgins at the railroad station in Commercy and waiting with him for the Paris-Metz express. Williams mentions that he is from Mexico, MO. Higgins responds, "Mexico, Mo? You should know Sid Houston, christened Algernon." "Sure, I know Sid. He used to work on the newspaper there." The exchange is another example of coincidences that OPH experienced as he traveled about and the network of people he created in his role as a newspaper correspondent. Sid's name also appeared in an article OPH wrote in July, 1918. In this article, Higgins is riding in an army wagon plodding up a "steep, winding, narrow mountain road." The wagon pulls to the side to allow a motor car to pass. By this time a sergeant, Sid is "sitting in the back of the car enjoying the scenery while smoking a cigar half as big as your arm." He yells out, "'Hey, Higgins!'" as he whizzes by. (See "Met 'Back Home' Boys," *Kansas City Star*, September 11, 1918, 4. OPH had known Sid Houston since 1914, when they both worked at *Kansas City Star*. Later on, Sid became the Associate Editor for *Stars and Stripes*, Washington, D.C. (Sheila Scott personal correspondence, December 14, 2016).

[8] For another incident where OPH casts "Jerry" as an unwelcome player in a game of chance, see Otto Higgins, "Barrage Made Poker Quit," *Kansas City Star,* September 20, 1918, 1B. OPH uses the game analogy in a number of different contexts throughout his writing.

[9] Otto Higgins, "With the 129th in Battle," *Kansas City Star,* November 28, 1918, 2.

[10] Otto Higgins, "Independence Boys 'Shooting' Under the Gun: A Peek on the 35th Division Boys Shortly Before the End," *Kansas City Star*, December 1, 1918, 2A. Photo by O.P.H., France.

[11] Otto Higgins, "Died to Save Rescuers," *Kansas City Star*, Sunday, November 24, 1918, 1B.

[12] *Kansas City Star,* Tuesday, October 31, 1918, Main Edition, 1.

[13] Harry Lauder, was a well-known Scottish entertainer of the time, who, in fact, bore an uncanny resemblance to OPH. Lauder lost a son in the war but continued his work entertaining in dialect and singing Scottish tunes for his countrymen on the battlefield. See "Harry Lauder Under Fire," *Kansas City Star,* Sunday, September 8, 1917, 7C.

[14] This picture of Harry Lauder appeared with the article, "Harry Lauder a Knight," *Kansas City Star*, Thursday, April 29, 1919, 8.

[15] This picture of OPH was taken with Adam Breede in Paris, c. 1918. Original photo courtesy of Sheila Scott.

[16] A version of this picture appeared with a brief biographical sketch in the *Kansas City Star*, Wednesday, October 2, 1918, 2. Original photo courtesy of Sheila Scott.

[17] This article contains seven instances where the censor cut content, totaling 165 words out of 2,040 Higgins wrote. The censored content represents 8% of the original word count.

[18] See Figure 1 for the location of Vauquois Hill.

[19] The famous quote attributed to Civil War General William T. Sherman, "War is hell."

[20] See Figure 1.

[21] The 140th Infantry, 35th Division.

[22] The 110th Engineers. See their unit history, Edward Rankin, Jr., *The Santa Fe Trail Leads to France: A Narrative of the Battle Service of the 110th Engineers, 35th Division, in the Meuse-Argonne Offensive* (Kansas City, MO: Dick Richardson Company, 1933).

[23] The 140th Infantry, 35th Division.

[24] See Figure 2.

[25] The 110th Engineers became instant infantrymen when they were ordered to dig in and hold a line, behind which retreating elements of the 35th Division could take refuge and re-form.

[26] Like the engineers, the pioneer units did construction, bridge-building and road work in support of the infantry, artillery and medical corps requirements.

[27] Evan Alexander Edwards, *From Doniphan yo Verdun: The Official History of the 140th Infantry* (Lawrence, KS: The World Company), 84.

[28] Ralph E. Truman was the intelligence officer for the 140th Infantry [see Robert H. Ferrell, *Collapse at the Meuse-Argonne* (Columbia, MO: University of Missouri Press, 2004), 58]. In the Missouri National Guard, Ralph Truman had served as 2nd Lieutenant, 2nd Missouri Infantry Brigade, 3rd Regiment Infantry, Machine Gun Company, Missouri National Guard, from Kansas City [see Clair Kenamore, *From Vauquois Hill to Exermont*, 322].

[29] "Truman cried, 'For God's sake men, don't regard the order [to retreat]. If we retreat back over the hill, the day is lost.' He gathered the shattered troops in the engineers' line, and stood like a rock calm and fearless in the storm of shells and bullets. Some of the men always called the line 'Truman's Line' when they spoke of it. Truman was a staff officer, and could have gone back and spent the night in safety; instead, he remained in the trench with the men. Too much praise cannot be given him." Evan Alexander Edwards, 85.

[30] 1st Lieutenant J. Oliver Buswell was a chaplain with the 140th Infantry. His colleague, Chaplain Edwards, commented that Buswell "was wounded in the leg, and thoroughly angry because he had to go back. It undoubtedly saved his life, for had he remained, he would have been in the very front line the next day looking for trouble." Evan Alexander Edwards, 75.

[31] "Lt. Eustace Smith and Lt. 'Duke' Sheahan, two red-headed fighters, were among the first in Exermont. Sheahan had crossed the little creek instead of going over the bridge, which probably saved his life, as the bridge was swept by fire." See Evan Alexander Edwards, 79.

[32] Cpt. Warren L. Osgood was born in Kansas City on September 6, 1883, and resided at 4046 Bellefontaine when he was inducted into the 3rd Infantry, Missouri National Guard, on August 5, 1917. He continued to serve with that unit when it was federalized into the 140th Infantry. From January 17, 1919, until March 26, 1919, he served with the 138th Infantry, and then with the Military Police Corps until discharge. He was overseas from June 4, 1918, until August 17, 1919. See Missouri Digital Heritage Soldiers' Records, id = 97318.

[33] Lieut. Col. Channing E. Delaplane was in command of the 140th Infantry from September 22, 1918, to October 16, 1918. See Clair Kenamore, *From Vauquois Hill to Exermont: A History of the 35th Division*, 264.

[34] Cpt. John W. Armour was born in Kansas City, Missouri, on August 22, 1891, and maintained his home of record at 3505 East 12th Street. He shipped overseas from Hoboken, New Jersey, on March 30, 1918, aboard the *U.S.S. George Washington,* served with Company A, 140th Infantry, and returned a Major aboard the *U.S.S. America,* departing from Brest, France, on September 6, 1919, and arriving in the States on September 15, 1919. His service was cited in orders, and he was awarded the Silver Star. After his return to Kansas City, he married Pauline Jones in 1924 and maintained a dental practice in town until he died of coronary thrombosis on December 31, 1932. He was buried at Mount Moriah Cemetery three days later. Cpt. Armour was 41 years old; his father, Dr. Wallace A. Armour, signed his death certificate. See Missouri Digital Heritage: Soldiers' Records, id=A2857; U.S. Army Transport Service Passenger lists of Organizations and Casuals Embarking from and Returning to the United States and Missouri Death Certificate No. 40107.

[35] Cpt. John F. Howell was born in Woodland, Missouri, on April 3, 1888, and lived at 46 E. 55th Terrace in Kansas City, Missouri. He was inducted on August 5, 1917, at the age of 29, and served overseas from April 24, 1918, to April 23, 1919. Severely wounded on September 28, 1918, he was able to remain with the 140th until October 27, 1918, when he was moved to the medical department of the 130th Infantry. See Missouri Digital Heritage Soldiers' Records: id=A61274.

[36] Major E. W. Slusher with Distinguished Service Cross. Photo from Edwards, *From Doniphan to Verdun: The Official History of the 140th Infantry*, 94.

[37] "Taken to a hospital twice, gassed, he had each time returned to his work. For his courage there and at the Chaudron Farm dressing station, he received the Distinguished Service Cross. He had always looked for the good points in his officers and developed them. He had a splendid attitude towards the men; with a strict discipline, he combined an interest and care that made for the effectiveness of the regiment. The 140th felt that he was just about all that a medical officer should be. Certainly he was always on the lookout to preserve the health of the regiment." See Evan Alexander Edwards, 95.

[38] Capt. Glen H. Broyles was born on October 1, 1888, lived in Bethany, Missouri, and was inducted August 5, 1917, into the Army Medical Corps. He was overseas from April 25, 1918, until April 28, 1919. Missouri Digital Heritage Soldiers' Records:, id = A15941. Also see Evan Alexander Edwards, "Roster of Officers," *From Doniphan to Verdun: The Official History of the 140th Infantry,* 150.

[39] Reg. Sgt. Maj. Hina C. Schult, Jr., Army serial number 1,458,806, was born in Pemiscot County, Missouri, and lived in Caruthersville, MO, where he was inducted at age 28 on June 30, 1917. He served with the 6th Infantry, Missouri National Guard; and with Headquarters Company, 140th Infantry; before being transferred for a couple of months from Jan 6 to Mar 14, 1919, to Headquarters Troop, 9th Army Corps; and then returning to the 140th Infantry. He was

overseas from April 25, 1918, to April 28, 1919 . Also see Evan Alexander Edwards, 201.

[40] Otto P. Higgins, "Seven Days of Hell," *Kansas City Star,* Friday, November 1, 1918, Main Edition, 1.

[41] Figure 1. Map enclosed with Rankin, *The Santa Fe Trail Leads to France: A Narrative of the Battle Service of the 110th Engineers, 35th Division, in the Meuse-Argonne Offensive.*

[42] Figure 2. Map enclosed with Rankin.

Chapter 9: On the Way to the End—November 1918

[1] Otto P. Higgins, "The 89th's Great Record," *Kansas City Star,* January 1, 1919, 2.

[2] Otto P. Higgins, "The 89's Great Record."

[3] George H. English, *History of the 89th Division 1917·1918·1919* (Denver, CO: The War Society of the 89th Division, 1920), 71.

[4] Otto Higgins, "Avenged a Gas Attack," *Kansas City Times*, November 30, 1918, 5.

[5] Otto P. Higgins, "Avenged a Gas Attack."

[6] Otto Higgins, "When 89th Heard News," *Kansas City Star,* November 14, 1918, 2.

[7] William M. Wright (Robert H. Ferrell, ed.) *Meuse-Argonne Diary: A Division Commander in World War I*, (Columbia, MO: University of Missouri Press, 2004), 164. Don Martin was probably the correspondent from *The New York Herald,* and Raymond G. Carroll of *The Philadelphia Public Ledger* may have been the correspondent General Wright identifies from Philadelphia. See Emmet Crozier, *American Reporters on the Western Front 1914-1918* (New York: Oxford University Press, 1959), Appendix, 279.

[8] One of the correspondents was Williams Slavens McNutt of *Collier's Weekly.* From information in General Wright's diary, the other two correspondents were likely Don Martin and Raymond G. Carroll, as noted above.

[9] Otto P. Higgins, "When 89th Heard News."

[10] The story has stayed with the Higgins family ever since.

[11] Photo by OPH with his original cut-line in ink on the back. This photo was passed by censor 121 but did not appear in the newspaper. Original, courtesy of Sheila Scott.

[12] Otto Higgins, "Home Boys on Meuse," *Kansas City Times*, November 15, 1918, 4.

[13] On the back of this original photograph, OPH has written: "Three Germans captured by OPH in Stenay. They were hiding in a basement & I was looking for wine when I found them—Nov 11—"(Higgins). Photo courtesy Sheila Scott. OPH did not indicate whether he was successful in his original intention.

[14] Photo by Otto P. Higgins, November 11, 1918, in front of a Military Police station in Stenay, France. On the back of this original photograph, OPH has written: "In Stenay, Nov 11." Photo courtesy Sheila Scott.

[15] Otto P. Higgins, "Home Boys on the Meuse."

[16]See the discussion of souvenirs in the Epilogue and the picture and description of one particular piece of "elaborate equipage" that OPH collected from the Crown Prince's chapel at Stenay.

[17] Emmet Crozier, *American Reporters on the Western Front 1914-1918*, 271.

[18] Otto Higgins, "Honor in a Cup of Coffee, *Kansas City Star*, December 28, 1918, 3.

[19] Map."The 89th, the 35th, the Kansas Ammunition Train and the Kansas City Signal Corps (42nd Rainbow Division) in the last month of fighting." *Kansas City Star,* November 13, 1918, 2.

[20] The Kansas City Field Signal Battalion is the 117th Field Signal Battalion, 42nd Division, commanded by Lt. Col. Ruby D. Garrett.

[21] The Kansas Ammunition Train is the 117th Ammunition Train, 42nd Division, commanded by Lt. Col. Frank Travis, For a description of the role which both units played in the war, see Chapter 6, "We Saw the Rainbow," in James J. Heiman, *Voices in Bronze and Stone: Kansas City's World War I Monuments and Memorials*, 210-225.

[22] Otto Higgins, "Kansas City Men at Sedan," *Kansas City Star,* November 13, 1918, 2.

[23] Untitled typed article by OPH on his attempted journey to Sedan as the war drew to a close (November 8-10, 1918), Higgins Collection, Edward Jones Research Center, National World War I Museum. I have supplied the title for easy reference. See also: Ruby D. Garrett, "With OPH at the Front," *Kansas City Star,* December 23, 1918, 12.

[24]The "Rainbow" is the 42nd Division.

[25] Junius Wood was a war correspondent for the *Chicago Daily News*.

[26] A "marmite can" is a ceramic pot used for making soup (from *marmit*, Scotch dialect).

[27] "Salve" is slang for "buttering up," or "sweet talk." The "salve" OPH mentions may have included something in the way of a small bribe.

[28] "Corned willie" is corned beef or the hash made from corned beef.

[29] "Reilly's Bucks" was the popular name for the 149th Field Artillery Regiment of the 42nd ("Rainbow") Division commanded by Col. Henry J. Reilly (1881-1963). Reilly was a journalist himself and may have had a soft spot for journalists who were on the road, tired and hungry. A 1904 graduate of West Point, Reilly served in Asia and Europe before the war and wrote a weekly military column for *Chicago Tribune*. Resigning his commission in 1914, he served in British and French ambulance units until America entered the war in 1917, when he took command of the 149th Field Artillery and was awarded the Army Distinguished Service Medal in 1919. A brigadier general in the Officer Reserve Corps after the war, he edited *The Army and Navy War Journal* from 1921-1925 and helped found the Reserve Officers Association, serving as its first president. He was the author of a number of books based on his military experience: *America's Part* (1928), *Americans All—The Rainbow at War: Official History of the 42nd Rainbow Division in the World War* (1936), *Are Our Young Men to Have a Chance? Blitzkrieg—Its Political and Economic Challenge* (1940); *The World War at a Glance: Essential Facts Concerning*

the *Great Conflict Between Democracy and Autocracy* (1918), and *Why Preparedness: The Observations of an American Army Officer in Europe—1914-1915* (1916). See "Henry J. Reilly," at https://en.wikipedia.org/wiki/Henry_J._Reilly.

[30] Major Silas N. Ransopher was born in Clyde, Kansas, on May 22, 1888, and resided at 5020 College, Kansas City, when he was inducted into the 1st Field Signal Corps, Missouri National Guard, on August 5, 1917. He served overseas with the 117th Field Signal Battalion from October 18, 1917, until April 6, 1919. See Missouri Digital Heritage, Soldiers' Records, id = A105138.

[31] A shelter half is half of a pup tent.

[32] Lt. Col. Ruby D. Garrett to Albert H. King *(Kansas City Star* Staff), "With O.P.H. at the Front," *Kansas City Star,* December 23, 1918, 12.

Chapter 10: To Luxembourg with the 89th—December 1918

[1] George H. English, *History of the 89th Division, U. S. A. 1917·1918·1919* (Denver, CO: The War Society of the 89th Division, 1921), 253.

[2] George H. English, 263.

[3] Jill Carter (Demchak) through personal communication from Sheila Scott to the author, December 23, 2010.

[4] Lieutenant Colonel Ruby D. Garrett, "The 117th Field Signal Battalion," Ch XI, *History of the Missouri National Guard* (Military Council, Missouri National Guard, 1934), 250-251.

[5] Color postcard, "Altehhar, Weisses Cruz," white cross at the base of the mountain, village on right. National World War I Museum and Memorial, Edward Jones Research Center, Archives Box 2010.145. Accessed June 1, 2011. OPH's parents, James and Delia Higgins, lived at 718 Homer, Kansas City, Kansas.

[6] Otto P. Higgins, "Garrett's Men In," *Kansas City Times,* April 28, 1919, 2.

[7] These ambulance units were part of the 314th Sanitary Train, 89th Division.

[8] Victor W. Allen from Garrison, Kansas, served with the 355th Ambulance Company. See *History of Ambulance Company 355, 314th Sanitary Train, 89th Division* (Trier, Germany: J. Lintz, Printer, undated c.1919), 11.

[9] Pvt. Charles L. Grout, Army serial number 2,196,844, was born in Bosworth, Missouri, and, at the age of 21, was inducted into Red Cross Ambulance Company 24 in Kansas City on August 18, 1917. He served with the 355th Ambulance Company, 314th Sanitary Train, overseas from June 28, 191, to May 24, 1919. See Missouri Digital Heritage, Soldiers' Records, id = A49958.

[10] Colonel James H. Reeves commanded the "All Kansas" 353rd Infantry, 89th Division. See George H. English, op. cit., 481 and 492. He graduated from West Point, served in the Spanish-American War and the Cuban occupation, and was a Military Attaché, American Legation in Peking, China. See Capt. Charles F. Dienst, et al. *History of the 353rd Infantry Regiment, 89th Division, National Army* (Wichita, KS: The 353rd Infantry Society, 1921), ix. He later reached the rank of Brigadier General.

[11] Photo by Underwood & Underwood, N.Y. in "Just Off the Leviathan with the 89th," *Kansas City Star,* Sunday, May 25, 1919, 3A.

[12] The men had translated the clear broth bouillon of "Bouillionville" into the "soup" of "Souptown."

[13] Otto P. Higgins, "Nerve Amazed the Boch," *Kansas City Star,* Sunday, December 22, 1918, Want Ad Section, 1B.

[14] "Kidding the War" was the particular way American soldiers reacted to stress. An undated newspaper clipping of the time, found among the artifacts OPH had saved from the war, commented on the "happy custom of kidding": "Little did the Hun understand American temperament. Little does any European people comprehend it. We could stay over here a hundred years and they never would 'get' the American's happy custom of 'kidding' everybody. They are not built right above the chin for it."

[15] Another example of "kidding the war" was the American G.I.'s penchant for translating French into colloquial English. In this case, "bouillon" is just simply "soup."

[16] Sergeant Arthur F. Duncan, Army serial number 2,196,579, lived at 609 East 9th Street, Kansas City, Missouri, and was inducted into the 353rd Ambulance Company, 314th Sanitary Train, in Fredonia Kansas, at the age of 26, on August 12, 1917. He served overseas from June 28, 1918, to May 24, 1919. See Missouri Digital Heritage, Soldiers' Records id = 34365. His name is listed on *The Star's Roll of Honor* published in the *Kansas City Times*, Monday, October 31, 1921, 4, and also appears on the bronze memorial tabled on display in the foyer of the old *Kansas City Star* building at 14th & Grand.

[17] Mech. Harry Evans, Army serial number 1,458,940, lived at 4143 Tracy, Kansas City, Missouri, and was inducted on June 23, 1916, at age 23, into the Headquarters Company, and later Company A, of the 3rd Infantry, Missouri National Guard. He served overseas with the 140th Infantry from April 25, 1918, to April 28, 1919. See Missouri Digital Heritage, Soldiers' Records, id = A37934.

[18] More than likely, Enrico Caruso, who sang the lead in the opera's first broadcast from the Met on December 1, 1910, and who made a number of recordings of its music for the Victor Recording Company of America during the early 1900s.

[19] Pvt. Herbert Roemer, Army serial number 2,196,284, lived at 3030 Euclid, Kansas City, Missouri, and was inducted on August 18, 1917, into Red Cross Ambulance 24. He served with the 355th Ambulance Company, 314th Sanitary Train, from June 28, 1918, until May 24, 1919. See Missouri Digital Heritage, Soldiers' Records, id = A109761.

[20] Otto P. Higgins, "Cave Opera 89th's Treat," *Kansas City Star,* Sunday, December 22, 1918, Want Ad Section, 1B.

[21] Otto P. Higgins, "The Signal Men Fed Best, *Kansas City Star*, Tuesday, January 21, 1919, 5. OPH makes the same claim four months later when the 117th lands in Newport News. See Otto P. Higgins, "Garrett's Men In," *Kansas City Times*, April 28, 1919, 1-3, in Ch 14.

[22] If the criteria for "popularity" can be defined in retrospect as the only restaurant at 12th and Grand to appear in the Kansas City Street Directory two years in a row—1917 and 1918—then the "popular café" OPH references at 12th and Grand is the Mann & Abramson Restaurant in the Rookery Building, 1202 Grand. See *1917 Kansas City Missouri City Directory* (Kansas City: Gate City Directory, Co.), 117, and *1918 Kansas City-Missouri City Directory* (Kansas City: Gate City Directory, Co.), 120.

[23] Mess Sergeant William Julius "Dippy" Diers was from Kinsley, Kansas, and when he joined the 117th served with Company B. See Lt. Harold Stanley Johnson, *Roster of the Rainbow Division* (New York: Easton & Gettinger Printers, 1917), 23. Sgt. Diers figures in other OPH articles, as well. See. Otto P. Higgins, "Flapjacks Unite Lovers," *Kansas City Star,* Tuesday, July 8, 1919, 12; Otto P. Higgins, "The Home Boys in Camp," *Kansas City Star,* July 17, 1919, 3; and "Otto P. Higgins, "Garrett's Men In," *Kansas City Star,* April 28, 1919, 3.

[24] Private William A. Dole, Army serial number 200,065, resided in Kansas City, Missouri, and was inducted there at the age of 21 into Company C, 1st Battalion Signal Corps, Missouri National Guard, on May 6, 1917. He served overseas with the 117th Field Signal Battalion from October 18, 1917, to April 27, 1919. See Missouri Digital Heritage: Soldiers' Records, id = A32748.

[25] Sergeant Henry A. Gallagher, Army serial number 199,917 was a native of St. Joseph, Missouri. He was called "Pop" because he was 34 years old, 7 months, when he was inducted in Kansas City on April 7l, 1917. He was initially part of Company A of the Missouri National Guard Signal Corps and remained with Company A, 117th Field Signal Battalion until May 14, 1918, when he was transferred to Company B of the 117th Field Signal Battalion. See Missouri Digital Heritage, Soldiers' Records id=43729. Also see Lt. Harold Stanley Johnson, *Roster of the Rainbow Division* (New York: Eaton & Gettinger Printers, 1917), 22.

[26] Pvt. Thomas G. Hickey, Army serial number 199,998, was born in Hildan, Ireland, and joined the signal corps at the age of 19 on March 27, 1917. See Missouri Digital Heritage, Soldiers' Records, id = A57474.

[27] Sergeant Charles L. Nichols was born in Howard, Kansas, and joined Company C of the Field Signal Corps, Missouri National Guard, at the age of 25 on February 9, 1917, in Kansas City. He served with the 117th Field Signal Battalion from October 18, 1917, to April 27, 1919 and was wounded on July 31, 1918.

[28] T.P.S. stands for *"Télégraphie par le sol,"* literally, "telegraphy by the ground," developed by a French officer, Ferrié, before the war. See. Chapter 9, "Transport and Communication," in Guus de Vries, *The Great War Through Picture Post Cards* (S. Yorkshire, England: Pen and Sword, 2016). A technical description with detailed diagrams and photographs of equipment may be found in Signal Corps, U.S. Army, *Two-way T.P.S. Set Type SCR-76-A, Radio Pamphlet No. 15* (Washington, D.C.: Government Printing Office, 1918), 1. "The Type SCR-76-A Set is a transmitting and receiving set for ground telegraph work (t.p.s. or earth induction) and is therefore to be used at

stations where two-way communication is necessary. . . In general, it consists of generating by induction, high potential current of audio frequency, which is caused to flow through the ground between two ground terminals separated by about 500 ft. In flowing through the ground, the lines of current spread out in all directions, so that some of them may be intercepted at considerable distances by a suitable receiving device sensitive enough to respond to the extremely small currents thus received by conduction through the earth. Then, by breaking up the pulsating emf. [electromagnetic force] impressed on the ground into dots and dashes, it is possible to read the signals at the receiving station." A less complex adaptation is reflected in the following description: "My pal was listening with an iron rod driven in the ground and two copper wires leading from it to a head piece, such as a wireless operator uses, so that we could hear the approach of the enemy's sappers, who were countermining against us." See Sherwood Eddy, *With Our Soldiers in France* (New York: Association Press, 1917), 12.

[29] Sergeant Leslie H. Robinson, Army serial number 199,879, was born in Labette, Kansas, resided in Kansas City, Missouri, and was inducted on March 24, 1917, at the age of 23 years, 9 months. He served with Company C, 117th Field Signal Battalion, overseas from November 3, 1917, to April 17, 1919. See Missouri Digital Heritage Soldiers' Records: id=A109423. In a later article, OPH notes that "Skinnay" Robinson and Bobbie Dibbons, both of the 117th Field Signal Battalion, were the first men "to enlist at the opening night of the big recruiting campaign in Kansas City held in Convention Hall." See Otto P. Higgins, "Garrett's Men In," *Kansas City Times*, April 28, 1919, 1-3 (Chapter 14, "On the Way Home—April 1919").

[30] "Skin-nay" may refer to a freckled character in Clare Brigg's "The Days of Real Sport," Boyville Cartoons. Since that character appeared in a magazine for newspapermen and since Sergeant Robinson was a former newspaperman with the Kansas City Associated Press office, he may have picked up his nickname while with the newspaper, and the soubriquet stuck with him. For some time, the cartoon character was referred to only by name and had not yet appeared in the cartoon strip itself. Skin-nay remained the subject of passive conversation until popular demand prevailed upon Briggs finally to offer his readers an illustrated introduction. "He turned out carrying a flag, as his originator believes all good Americans should. Skin-nay made his first bow to his waiting audience from the pages of *Dead Line*, a magazine for newspapermen." See *The Kansas City Times*, November 16, 1917, 4.

Chapter 11: Into Germany with the 42nd and the 89th—January 1919

[1] Sergeant J. W. Diefendorf, December 20, 1918, to Mrs. J. W. Diefendorf, Odessa, Missouri, U.S.A. Author's collection. Sergeant Diefendorf continues: "Piers in the bridge across this river are almost two thousand years old. River is the line between Luxemburg, and Germany. Main part of town in Luxemburg. White ribbons in right background are roads. Feeling fine. With Love, J. W. Diefendorf." Censored by Ernest W. Cavaness, Capt. Medical Corps, U.S. Army. Sergeant John William Diefendorf, serial number 2,196,804, was

inducted in Kansas City on August 10, 1917, at the age of 25 years, 11 months. He served with Ambulance Company 355, 314th Sanitary Train, overseas from June 28, 1919, to July 13, 1919, and was promoted to sergeant in January 1919. He was born on September 10, 1891, in Clarksburg, Missouri, registered for the draft on June 2, 1917, lived at R.F.D #1, Otterville, Missouri, and was a student at the State Normal School in Warrensburg, Missouri. He was single at the time of the registration and listed his profession as "school teaching," but not presently employed. See Missouri Digital Heritage Soldiers' Records: id=A31841. Also see "United States World War I Draft Registration Cards, 1917-1918," database with images, *Family Search* (https://familysearch.org/ark:/61903/1:1:K3RZ-FTS, John William Diefendorf, 1917-1918; citing Cooper County, Missouri, United States, NARA microfilm publication M1509 (Washington, D.C.: National Archives and Records Administration. m/d/); FHL microfilm 1,683,163. "Howard Haverty" is Pvt. William L. Haverty, Army serial number 2,196,885, who resided in Sedalia, MO, was inducted in Kansas City, MO, at the age of 19 years and 9 months on November 7, 1917 and served with Ambulance Company 355, overseas from June 28, 1918, until May 24, 1919. See Missouri Digital Heritage Soldiers' Records: id=A54628.

[2] Otto P. Higgins, "O.P.H. Found 'A Better 'Ole,'" *Kansas City Star*, February 2, 1919, 15 A. The title of the article refers to a popular cartoon by British Capt. Bruce Bairsfather. Both Bill and Bert are pictured in a shoulder-deep shell hole, shells bursting in the air overhead and hitting the ground behind. Bill turns to Bert and says, "Well, if you kows of a better 'ole, go to it." The cartoon appears on the cover of Captain Bruce Bairnsfather, *Fragments from France* (New York: G. P. Putnam's Sons), undated, c. 1918), a collection of 41 drawings, reprinted nine times and selling over a quarter of a million copies. *The Better 'Ole* is also known as *The Romance of Old Bill,* an Edwardian musical comedy with book by Bairnsfather and Arthur Elliot (1917). Bairnsfather's home from 1887-1959 overlooked the Stratford Canal near Stratford-upon-Avon in Warwikshire, England. Today it is a bed-and-breakfast known as Victoria Spa Lodge because Queen Victoria stayed there in 1837, when it was a spa and she was a princess just before she became a queen. See www.victoriaspa.co.uk

[3] Original photo by OPH. To Mrs. Warren's left is Lieutenant Colonel Ruby D. Garrett, commander of the 117th Field Signal Battalion. Photo courtesy of Sheila Scott.

[4] Otto P. Higgins, "Men of the 89th Learn Gretchen's Secret," *Kansas City Star*, January 4, 1919, 5.

[5] "O.P. Higgins Coblence – Cologne, Jan. 15, 1919". Inscription written on the front flyleaf of *Dr. Friedrich Köblers Englisch-Deutsches und Deutch-Englisches Taschen-Wörterbuch* (Leipzig: Druct und Berlag von Phillip Reclam, jun., undated). OPH had purchased this compact German dictionary for use while he was in Germany.

[6] Emmet Crozier, *American Reporters on the Western Front, 1914-1918* (New York: Oxford University Press, 1959), 277.

[7] "War Writers Want to Return Home," *Editor and Publisher for March 1, 1919*, 36. See https://books.google.com/books?id=G7xNAQAAMAAJ&pg=RA8-PA36&dq=war+correspondents+in+coblenz.

[8] "War Writers Want to Return Home."

[9] Maud Radford Warren was born in Wolf Island, Ontario, on January 2, 1875, was educated at the University of Chicago, and was a professor of English and Composition there from 1893-1907. She achieved fame as a fiction writer for young people, especially known for her *Robin Hood and his Merry Men* (1914). In Europe from September 1916 to February 1917, she returned to the U.S. to lecture and to publish *The White Flame of France* in July 1917. In May 1918, she returned to France with the YMCA and also did some nursing. Made a corporal and later an honorary 2nd lieutenant by the 89th Division, she came under fire repeatedly while delivering hot chocolate in thermos containers to the men and thus providing them with their only hot food for as long as 48 hours, until the rolling kitchens could become operational. See "Letters from Maude Radford Warren, '94," *The University of Chicago Magazine* (Chicago: The University of Chicago Association, 1918), 84 at www.imdb.com/name/nm0912963/bio?ref_=nm_dyk_trv_sm#trivia. OPH said that "Maude Redford Warren of the *Saturday Evening Post* saw more actual war than any other American woman in France, just so she could write intelligently about it." See Otto P. Higgins, "That Job of Writing Up the War," *Kansas City Star*, Sunday, June 8, 1919, 15C.

[10] Maud Radford Warren, "At the Correspondents' Razz Club in Coblenz," *Kansas City Star*, Thursday, June 26, 1919, 10. Note: the original newspaper clipping of this article was found among fragments of other newspaper clippings Higgins and his wife Elizabeth had saved from his war correspondent days. The clipping itself is now reduced to a fragment, and attempts to retrieve the missing portions by reference to newspaper microfilm proved unsuccessful. Apparently, the archival issues available for microfilm did not include the particular edition of the paper from which the article was clipped, although the reverse side of the clipping contains the same Jones Store advertisement as appeared on page 9 of the microfilmed editions.

[11] Maud Radford Warren, "At the Correspondents' Razz Club in Coblenz."

[12] Undoubtedly, Runyon is referring to the inscription on the belt buckle German soldiers were issued: *"Gott mit uns,"* "God with us."

[13] "All the slang authorities derive *copper* from an old cant verb, *to cop,* meaning 'to capture or catch.'" See H. L. Mencken, *The American Language, Supplement One* (New York: Alfred A. Knopf, 1962), 516.

[14] Maud Radford Warren, "Living the Life of Reilly," *Saturday Evening Post,* June 21, 1919, 149. The article begins on page 32 with an introduction about the expression "living the life of Reilly" and concludes with the opinion that it is the newspaper correspondents who more than anyone else in the war exemplified the cliché. Fortunately, what was missing in the fragmentary newspaper clipping has been supplied from the original *Saturday Evening Post* article, only a portion of which was redacted and re-printed in the *Star*.

[15] After the war, OPH took the opportunity to comment about how easy the war correspondents had it. "While it was the dream and ambition of every American newspaper man to be a war correspondent, those who really are to be classed as such, were always complaining about the hardships they endured from day to day—the long hours they were compelled to work, the conditions under which they were forced to live, and yet probably only two or three desired to get away from it all and get back to America where they once more could live normally. There was some dining with famous generals, of course. But a correspondent never attended dinners that he could avoid. Usually they had other things to do. Sometimes they did live off the fat of the land, but never for very long at a time—maybe four or five days, maybe a week, after a big drive was over. A part of the time was spent sleeping in the finest bedroom with the finest bath attached, that Paris could offer. The rest of the time was spent in hotels that couldn't compare favorably with the Commercial House at Podunk, with bed 'from fifty cents a day up.' Sometimes they ate, and sometimes they didn't. Sometimes they slept, and sometimes they didn't. For the American public depended upon these men to keep them informed as to the progress of the war." Otto P. Higgins, "That Job of 'Writing Up' the War, *Kansas City Star,* June 8, 1919, 15C.

[16] George H. English, *History of the 89th Division 1917·1918·1919* (Denver, CO: The War Society of the 89th Division, 1920), 304. Bouillonville was located in the St. Mihiel sector, which the 89th Division entered on September 12, 1918. See English, 301.

[17] Otto P. Higgins, "Men of the 89th Attend School," *Kansas City Star*, February 23, 1919, 16A.

[18] English, 312.

[19] Otto P. Higgins, "No Boche at 89th Dance," *Kansas City Star*, February 23, 1919, 17A.

[20] Otto P. Higgins, "The 89th Losses, 8,473," *Kansas City Star*, January 29, 1919, 1.

[21] Otto P. Higgins, "Men of the 89th Learn Gretchen's Secret," *Kansas City Times,* Saturday, January 4, 1919, 5. (Photo by O.P.H.). Original photo courtesy Sheila Scott.

[22] Captain Ernest W. Cavaness. served in the Medical Corps, 314th Sanitary Train, 89th Division. See English, 486.

[23] Captain Cavaness' censor work from a postcard sent by Sergeant J. W. Diefendorf to his wife from Echternach, Luxembourg, December 20, 1918. Sergeant Diefendorf was definitely *not included* among the those whom Captain Cavaness "drafted" to improve their penmanship, grammatical usage or rhetorical expression. Original postcard from author's collection.

[24] Private Charles Henry Brady, R.F.D. 2, Edwards, Missouri, was born December 1, 1895, in Edwards, Missouri, and at the time of his draft registration on May 31, 1917, was a student at the Warrensburg State Normal School, No 2. See "United States World War I Draft Registration Cards, 1817-1918," database with images, *Familysearch* (https://familysearch.org/ark:/61903/1:1:K3R4-T6D), Charles Henry Brady, 1917-1918; citing Benton County, Missouri,

United States, NARA microfilm publication M1509 (Washington, D.C.: National Archives and Records Administration, n.d.); FHL Microfilm 1,683,092. He was assigned Army serial number 2,196,879 upon induction in Kansas City on August 14, 1917, age 21 years and 8 months. He served with Ambulance Company 355, 314th Sanitary Train, 89th Division until March 24, 1919, when he was transferred to Company D, 341st Machine Gun Company to April 1, 1919, and then again transferred to the Division Technical School, Kehr, Germany, until April 18, 1919, when he returned to Ambulance Company 355, and remained with it until discharge. He was overseas from June 29, 1918, until May 24, 1919. See Missouri Digital Heritage Soldiers' Records: id=A13093.

[25] Sergeant Anton ("Anthony") H. Willibrand lived in Freeburg, Missouri, but was born in Westphalia, Missouri, on August 13, 1890. At the time of his draft registration on June 5, 1917, he was working as a general merchandise clerk at Ben Hilkemeyer's store. See "United States World War I Draft Registration Cards, 1817-1918," *Familysearch*(https://familysearch.org/ark:/61903/1:1:K3RL-Z6T), Anton H. Willibrand, 1917-1918; citing Osage County, Missouri, United States, NARA microfilm publication M1509 (Washington, D.C.: National Archives and Records Administration, n.d.); FHL Microfilm 1,683,495. Assigned Army serial number 2,196,916 upon induction in Kansas City at the age of 25 years, 6 months, on August 10, 1917, he joined Red Cross Ambulance Company 24 and then Ambulance Company 355, 314th Sanitary Train, until March 4, 1919, when he took advantage of the government offer for a subsidy to attend a French university. He chose the University of Montpelier, France, and studied there until July 1, 1919. Later in July, he was assigned to Casual Company 1655 and then to the Demobilization Group at Camp Taylor, Kentucky, until discharge. His date of rank as sergeant was May 1918, and he was overseas from June 28, 1918 until July 23, 1919. See Missouri Digital Heritage Soldiers' Records: id=A145063.

[26] Corporal Montgomery M. Wright, Army serial number 2,196,817, lived at 6115 Main in Kansas City, Missouri, when he was inducted on August 7, 1917, at the age of 24 years, 8 months. He served in Ambulance Company 355, 314th Sanitary Train, 89th Division, overseas from June 28, 1918 until May 24, 1919. See Missouri Digital Heritage Soldiers' Records: id=A137807. Montgomery M. Wright's name also appears on "The Star's Roll of Honor" plaque, which hung in the lobby wall of the old *Kansas City Star* building at 14th and Grand, Kansas City. See "The Star's Roll of Honor," *Kansas City Times*, Monday, October 31, 1918, 4. Also see Chapter 7, September 23, 1918, "'O.P.H.' with the 89th," *Kansas City Star,* October 16, 1918, 6, and later on in Chapter 11, January 25, 1919, "No Boch at 89th Dance," *Kansas City Star,* February 23, 1919, 17A.

[27] Otto P. Higgins, "Men of the 89th Attend School," *Kansas City Star,* Sunday, February 23, 1919, 16A.

[28] A postcard from the author's collection.

[29] *Defendu* is French for "prohibit," with the sense of protection from moral harm (*"interdit ou réprouvé par la morale"*). See Pierre Gioan, *Dictionnaire Usuel Quillet Flammarion Par le Texte et par l'Image* (Paris: Quillet-Flammarion, 1957), 383.

[30] OPH original photograph and cut line on reverse. Photo courtesy of Sheila Scott.

[31] Captain Paul C. Withington had an illustrious career as a physician, an author, a college football coach and a highly decorated medical officer in two world wars. He was born on January 25, 1888, in Escondido, California, played as a guard and center at Harvard, received his bachelor's degree from there in 1909, and for the next four years worked as a line coach at Yale while attending Harvard Medical School, from which he received his medical degree in 1914. That same year, he published *The Book of Athletics* (Norwood, Mass: Lothrop, Lee & Shephard Co, 1914), with an extended list of athletic accomplishments appearing on the title page to lend credibility to what followed in the text. He returned to Harvard in 1915 as an assistant football coach and then went on to the University of Wisconsin-Madison, where he served as head coach, compiling a 4-2-1 record. He was also head coach for part of the season at Columbia, and he holds the distinction of being the only coach in collegiate athletics to work as a head coach while practicing medicine at the same time. In 1917, he joined the U.S. Army Medical Corps and took charge of athletics at Camp Funston, while also playing on the football team. Later in France, he "distinguished himself by gallantry in action while serving with the Medical Detachment, 354th Infantry, American Expeditionary Forces, in action near Nouart, France, 3 November 1918, in going out in an open field and attending to the wounded under terrific shell fire." He was awarded the Silver Star by General Pershing (General Orders: GHQ, American Expeditionary Forces, Citation Order No. 5, 3 June 1919; source: https://valor.militarytimes.com/recipient.php?recipientid=84060. During the occupation, he coached the 89th Division football team to a 14-6 victory over the 36th Division team in an A.E.F. title game in Paris with over 15,000 in attendance, including General Pershing. Withington remained as a reserve officer after the war and was called back to active duty during World War II. Altogether, from his service in both the first and second world wars, he was decorated with the Legion of Merit (U.S. Navy), the Silver Star, French *Croix de Guerre*, British Mons Star, WWI Victory Medal, Army of Occupation ribbon, American Defense ribbon, Pacific-Asiatic ribbon with star, and was made an honorary Lieutenant in the Royal Medical Corps of the British Army. The connection with Great Britain held other significance for him: his uncle, Lothrop Withington, a noted New England genealogist, died when the *Lusitania* was sunk, May 7, 1915. (www.rmsLusitania.info/people/saloon/Lathrop-Withington). Major Paul Withington died in Honolulu on April 2, 1966. See https://en.Wickipedia.org/wiki/Paul-Withington; David DeLussus *College Football Data Warehouse,* "Dr. Paul Withington Rewards by Year" and Doran C. Cart, "Kansas Football 'Over There,'" *Kansas History: A Journal of the Central Plains* (Autumn 2006), 194-199.

[32] Otto P. Higgins, "Overseas 'Desk' Men Dance, *Kansas City Star,* Sunday, February 23, 1919, 2B.

[33] Josephine S. Russell was born on March 31, 1884, in Chicago and worked as a teacher there until May16, 1918, when she applied for a passport to France (Certificate No. 17488) as a canteen worker for the Y.M.C.A. After the war she traveled extensively in Europe and eventually moved to Pasadena, California. She died in Los Angeles on September 17, 1975, at the age of 91. See National Archives and Records Administration (NARA); Washington, D.C.; NARA Series: Passport Applications, January 2, 1906-March 31, 1925; Roll No. 517, Certificates 17250-17499, 13 May 1918 – 14 May 1918. Ancestry.com U.S. Passport Applications, 1795-1925 [database on-line], Provo, UT, U.S.A.: Ancestry.com Operations, Inc., 2007.

[34] Miss Laura Hatch was born in Chicago on September 18, 1884, and was teaching at Smith College, Northampton, Massachusetts, when she applied for a passport to France on April 5, 1918, (Certificate No. 12289), for canteen service with the Y.M.C.A. On February 15, 1923, she married Major Lawrence Martin, in Manhattan. She died August 11, 1956, at the age of 71, and is buried next to her husband at Arlington (Grave 3600-2). See National Archives and Records Administration (NARA); Washington, D.C.; NARA Series: Passport Applications, January 2, 1906-March 31, 1925; Roll No.497, Certificates 12250-12499, 06 Apr 1918 – 09 Apr1918. Ancestry.com U.S. Passport Applications, 1795-1925 [database on-line], Provo, UT, U.S.A.: Ancestry.com Operations, Inc., 2007.

[35] Both Josephine Russell and Laura Hatch were assigned to the 89th Division. See Helen Sinclair, Ed., *History of the Y.M.C.A. in the Le Mans Area: Summary of Service in the Embarkation Center from December 1918 to July 1919* (Portland, Oregon: International Committee of Y.M.C.A. Associations, 1920). Also *Summary Report of the Y.M.C.A. in the Army of Occupation for Six Months, June 30, 1919* (Coblenz on the Rhine: Gebruder Bruer, 1919). https://archive.org/detailsummaryreportymca .

[36] Miss Russell's passport photo from her application, May 16, 1918, referenced above.

[37] In the unit history, Walter G. Chestnut's address is given as 2908 Charlotte, Kansas City, Missouri. *History of Ambulance Company 355, 314th Sanitary Train, 89th Division* (Trier, Germany: J.H. Lintz, n.d. (circa 1919), 11.

[38] Miss Hatch's passport photo from her application, April 5, 1918, referenced above.

[39] Pvt. Dan D Porter, Jr., Army serial number 2,196,808, was older than most of the other men with whom he served. He was 28 years, 9 months of age when he was inducted into Red Cross Ambulance Co. 24 in Kansas City on August 11, 1917. Although he was born in Marshall, Mo, he lived at 1403 Brooklyn in Kansas City at the time of his induction. He served served with Ambulance Co. 355, 314th Sanitary Train overseas from June 28, 1918, to May 24, 1919. See Missouri Digital Heritage, Soldiers' Records, id=A102639.

[40] The "Service of Supply" was an intricate and extensive rear network of storage depots, transport facilities, and distribution stations that supplied material to the "Zone of the Armies" at the Front.

[41] For the details of Sergeant John William Diefendorf's service record, see note 1. Also see roster in *History of Ambulance Company 355, 314th Sanitary Train, 89th Division*, 12.

[42] For the details of Sergeant William Anthony Willibrand's service record, see note 24. He was the teacher of German in Ambulance Company 355 company commander Captain Ernest Cavanass's "school." See Otto P. Higgins, "Men of 89th Attend School, *Kansas City* Star, February 23, 1919, 16 A, written by OPH on January 20, 1919. In the unit history's roster he is listed as "Wiltbrand, William A., Freeburg, Mo." See *History of Ambulance Company 355, 314th Sanitary Train, 89th*, 15.

[43] The names of Arthur Van Raensalar and Herbert Coulan do not appear in the unit roster or in the Missouri Digital Heritage Soldiers' Records database, but Corporal Montgomery Wright's service record is referenced in note 25. Also see roster in *History of Ambulance Company 355, 314th Sanitary Train, 89th*, 15, where Montgomery Wright's address is listed as 6115 Main, Kansas City, Missouri.

[44] Otto P. Higgins, "No Boche at 89th Dance," *Kansas City Star,* Sunday, February 23, 1919, 17A.

Chapter 12: Back to the 35th—February 1919

[1] Claire Kenamore, *From Vauquois Hill to Exermont: A History of the 35th Division* (St. Louis, MO: Guard Publishing Co., 1919), 247.

[2] Otto P. Higgins, "Kansas Day in France," *Kansas City Star*, March 6, 1919, 8.

[3] Otto P. Higgins, "The 140th Gave a Dance," *Kansas City Star,* March 17, 1919, 5.

[4] Otto P. Higgins, "Scars of Argonne Pass," *Kansas City Star*, March 18, 1919, 3 and *Weekly Kansas City Star*, April 2, 1919, 6.

[5] Otto P. Higgins, "Scars of Argonne Pass."

[6] Cpt. James C. Kenady, Missouri Archives Soldiers' Records: id=A169197.

[7] Otto P. Higgins, "The Argonne Casualties, 6,907," *Kansas City Star*, February 23, 1919, 10A.

[8] Kansas was admitted as the thirty-fourth state on January 29, 1861.

[9] The 1st Kansas merged with the 2nd Kansas to form the 137th Infantry Regiment. See "Introduction to the Roster," in Charles B. Hoyt, *Heroes of the Argonne: An Authentic History of the 35th Division* (Kansas City, MO: Franklin Hudson Publishing Company, 1919), 143.

[10] The villages, Sampigny, Courcelles-en-Barrois, and Menil-aux-Bois, are located together about 9 kilometers north, northwest of Commercy, halfway between Commercy and St. Mihiel.

[11] The "Y" huts were Y.M.C.A. ("Young Men's Christian Association") service centers where men could gather to attend programs, write letters, read magazines and newspapers, drink hot chocolate, hold conversations and relax.

[12] The mild frustration is certainly familiar to anyone disappointed with trying to verify the spelling and pronunciation of a foreign word. The dictionary OPH was using was likely his 300-page *Hill's French-English and English-French Vest-Pocket Dictionary,* Prof. C. M. Stevans (Philadelphia: David McKay Publisher, 1898). OPH's putative spelling, pronunciation and definition for *mairie* are absolutely correct, even though, as he complains, the word does not appear where he expected it on page 104 of his French dictionary.

[13] Major Fred L. Lemmon was in command of the 140th Infantry from September 16 to September 22, 1918, and then in command as a Lieutenant Colonel from March 29 to April 14, 1919. See "Division. Brigade and Regimental Commanders," in Evan Alexander Edwards, *From Doniphan to Verdun: The Official History of the 140th Infantry* (Lawrence, Kansas: The World Company, 1920), 148. Major Lemmon was originally with Headquarters, 2nd Regiment, Kansas Infantry, raised in Newton, Kansas. See Clair Kenamore *From Vauquois Hill to Exermont: A History of the 35th Division* (St. Louis, MO: Guard Publishing Company), 387. He was awarded the Distinguished Service Cross "for extraordinary heroism in action while serving with the 140th Infantry Regiment, 35th Division, A.E.F., near Charpentry, France, September 27-28, 1918. Wounded severely in the chest, Lieutenant Colonel Lemmon remained in command of his battalion for 24 hours, until no longer able to walk. He showed great personal courage and skill in leading his battalion against heavy shell and machine-gun fire, refusing to be evacuated until helpless form loss of blood." War Department General Orders No. 59 (1919). See valor.militarytimes.com/recipient.php?recipientid=13121.

[14] Along with Major Lemmon, Major John H. O'Connor was also part of Headquarters, 2nd Kansas Regiment. See Kenamore, *From Vauquois Hill to Exermont: A History of the 35th Division*, 387. Major O'Connor was credited as "contributing to the organization and perfection of the regiment at the time of consolidation." See Carl E. Haterius, *Reminiscences of the 137th Infantry* (Topeka, KS: Crane & Co., 1919), 251. Major O'Connor was in command of the 1st Battalion, 137th Infantry (Haterius, 252). Also see Haterius, 246, for a biographical sketch of Major O'Connor.

[15] Major Carl R. White was originally a captain in the Quartermaster Corps of the Kansas National Guard. See Kenamore, 370. He lived at 1615 Western Avenue, Topeka, Kansas, was the pay Dispensing Officer for the National Guard unit, later serving as the Director of the Kansas Bonus Department. See *Lawrence Journal World* , March 31, 1923, and *Official National Guard Roster* (Washington, D.D.: U. S. Government Printing Office, 1922), 103.

[16]Two possibilities exist for "Lt. McFarland": either 1st Lt. Frank H. McFarland, who was with Headquarters, 1st Regiment, Kansas Field Artillery, or Paul T. McFarland, with Battery A, 1st Regiment, Kansas Field Artillery. Captain James C. Hughes was in command of Battery C, raised in Pittsburg, Kansas. See Kenamore, 419, 420 and 422, respectively.

[17] 2nd Lieutenant George K. Woodard served with the supply company of the 3rd Kansas Infantry. The 3rd Kansas joined with the 4th Missouri to form the 139th Infantry Regiment. See the roster for the supply company, 3rd Kansas Infantry,

in Charles B. Hoyt, *Heroes of the Argonne* (Kansas City, MO: Franklin Hudson Publishing Company, 1919), 207.

[18] Jesse Moren Bader was born on April 15, 1886, in Bader, Illinois. In 1890, his family moved to Coffey County, Kansas, and in 1905, he attended the University of Kansas. While serving as a student minister in nearby Perry, Kansas, he discerned a call to ministry, moved to Drake University in Des Moines, where he took his degree, and met and later married Golda Maud Elam in 1911. Bader then posted to the First Christian Church in Atchison. In 1917, at the age of 31, he signed with the Y.M.C.A. to serve as a secretary with the 35th Division. After the war, he served pastorates in Atchison and Kansas City, Missouri, became Secretary of Evangelism for the Disciples of Christ (1920-1932), served as Director of Evangelism for the Federal Council of Churches of Christ in America (1932-1954), and organized and served as the first President of the World Convention of Churches of Christ (1930). He was the author of a number of religious books, died in New York City on August 19, 1963 at the age of 77 and is buried in Atchison, Kansas. See www.wordcat.org/identities/lccn-n94047297.

[19] The simile for a traditional Christmas program at a local school house.

[20] "Lt. Eustace Smith and Lt. 'Duke' Shehan, two red-headed fighters, were among the first in Exermont." See Edwards, *From Doniphan to Verdun: The Official History of the 140th Infantry,* 79.

[21] Roy R. Richardson of Fredonia, Kansas, worked with W. Y. Morgan in Y.M.C.A. work with the 35th Division at Sampigny and later, with Bert Mitchener, had charge of a Double "Y" hut at St. Joire, France. See "Met Overseas Comrades," *Hutchinson, News,* Saturday, December 27, 1919, 8.

[22] Otto P. Higgins, "Kansas Day in France," *Kansas City Star,* Thursday, March 6, 1919, 8.

[23] 1st Lieutenant Fred Buell was born in Paxid, Texas, on January 20, 1892, worked as a shoe salesman in Kansas City, and at the time of his registration for the draft on May 29, 1917, was a student at the Reserve Student Officers Training Camp, having served for a year as a sergeant with the Missouri National Guard. He gave his address as 111 Scott Avenue, Lawton, Oklahoma. See "United States Draft Registration Cards, 1917-1918," database with images, *FamilySearch*(https://familysearch.org/ark:/61903/1:1:K3RN-5MN), Fred W. Buell, 1917-1918, citing Kansas City No 11, Missouri, United States, NARA Microfilm publication M1509 (Washington, D.C.: National Archives and Records Administration, n.d.); FHL Microfilm 1,683,384.

[24] OPH's use of the term "flying" is in reference to "Curly" Ristine's speed on the football field. He was captain of the Missouri University football squad in 1909 and 1910.

[25] Major William A. Smith had served with the 3rd Infantry, Missouri National Guard, before it was joined with the 6th Infantry to become the 140th Infantry Regiment. See "Roster of Officers, 140th Infantry," in Edwards *From Doniphan to Verdun: The Official History of the 140th Infantry*, 149.

[26] As Director of the Y.M.C.A. for the 35th Division, Henry J. Allen had observed first-hand the Regular Army's treatment of the National Guard officers on the

eve of the Battle of the Meuse-Argonne, when many unit commanders, who had been with their men in the Guard and throughout their training, were replaced by Regular Army officers, who, in many cases, did not know their men at all. Failures in communications resulted in costly mistakes and lost lives. Allen's complaints were instrumental in generating a Congressional investigation, but after a few preliminary testimonies, little to nothing was resolved.

[27] While the boys were away, the 18th Amendment to the Constitution, prohibiting the manufacture, transport and sale of alcohol, had been ratified by the states on January 16, 1919, to take effect a year later.

[28] Otto P. Higgins, "The 140th Gave a Dance," *Kansas City Star,* March 17, 1919, 5.

[29] OPH was traveling on a Pass to Hdq 35th Division, Coblenz, via Metz-Treves (Hos); Hdq 89th Div – Commercy (____Chalons) via train or auto (with French papers authorizing travel by Auto). Stamp: Assistant Provost Marshall Feb. 16, 1919, No. 120; Assistant Provost Marshall No.102 undated. (National World War I Museum Archives, Archival Box Accession No. 2010.145).

[30] *Pinard* is the *vin ordinaire,* often referred to as common "dinner wine."

[31] "The pretty looped cord" which the French Alpine *chasseur* wore draped over his shoulder was known as a *Fourràgere.* A soldier in a unit which had been cited twice with the *Croix de guerre* with palms was permitted to wear on his left shoulder the braded cord in the red and green colors of the *Criox de guerre,* as long as the soldier remained active in that unit. See www.6thmarines.marines.mil/Units/2nd-Battalion/History/Fourragere

[32] Corporal Sid Algernon Houston, Army serial number 1,472.758, was born in Mexico, Missouri, worked at the *Star* in Kansas City, and was inducted at the age of 23½ at Fort Riley, Kansas, on June 18, 1917. He served in the 1st Ambulance Company, Missouri National Guard, and with the 18th Medical Company until discharge. He was overseas from May 18, 1918, to July 12, 1919. See Missouri Digital Heritage Soldiers' Records: id=A132850. Sid is listed with the editorial staff, along with other of the newspaper's employees who served during the war. See *"The Star's* Roll of Honor," *Kansas City Times,* Monday, October 31, 1921, 4. This is the same Corporal Sid Huston who was rumored to be dead but shows up alive and hungry in Chapter 8.

[33] Seaman 2nd Class Hugh James Williams, Navy serial number 164-36-36, lived in Benton City, Missouri, a small town a few miles southeast of Mexico, Missouri. He enlisted at the Navy Recruiting Station in St. Louis on July 5, 1917, and awaited orders at home until August 27, 1917, when he reported to the Naval Training Station in Newport, Rhode Island. He served on the USS *Louisiana,* the USS *Solace* and the USS *Carola* before being posted to the USS *Conner,* which conducted regular mail runs from Brest to Plymouth at the end of the war. Later, the USS *Conner* put out from Plymouth to escort ships carrying President Wilson and Secretary of the Navy Josephus Daniels to the Paris Peace Conference. For Seaman Williams' service record, see Missouri Digital Heritage Soldiers' Records: id=N18542.

[34] Corporal Walter R. Ballew, Army serial number 2,179,756, was born in Audrain, Missouri, and lived at RD 2 Mexico, Missouri, where he was inducted

on September 20, 1917, at the age of 24 years, 3 months. He served with Co K, 354th Infantry, until April 1, 1918, when he joined Company A, 140th Infantry, and went overseas with that unit from April 25, 1918, to April 28, 1919. He was promoted to sergeant in April 1919. For Sgt. Ballew's service record, see Missouri Digital Heritage Soldiers' Records: id=4993.

[35] Otto P. Higgins, "Got to Paris 'Toot Sweet,'" *Kansas City Times,* Monday, June 9, 1919, 5.

[36] This may be Sergeant Victor B. Stark, Army serial no. 2,199,159, who was born in Perry, Kansas, and resided at 508 Walnut Street in Kansas City, Missouri. He was inducted at Camp Funston, Kansas, on October 11, 1917, at ag e 31 years, 6 months and served in the Quartermaster Corps. See Missouri Digital Heritage Soldiers' Records: id=A69197.

[37] Captain James C. Kenady was born in Mountain Springs, Indiana, on November 7, 1877, and lived in Dexter, Missouri. He was inducted August 5, 1917, and served with the 6th Infantry, Missouri National Guard, and the 140th Infantry, 35th Division. Overseas from April 25, 1918, he died of wounds received in action on October 10, 1918. His wife, Lydia W. Kenady of Dexter, Missouri, was notified. See Missouri Digital Heritage Soldiers' Records: id=A123466.

[38] 1st Lieutenant Albert S. Gardner was born on June 7, 1895, and lived at 377 N. Taylor Avenue, St. Louis, Missouri. He was inducted on August 5, 1917, went overseas from April 26, 1917, to December 22, 1918, and was wounded severely on September 29, 1918. See Missouri Digital Heritage Soldiers' Records: id=A44088.

[39] S.O.S. is the American "Service of Supply," the large-scale system of import, maintenance, storage and distribution of supplies in support of the Zone of the Armies in France. OPH had toured much of the system before he went to the front. See Chapter 3, "From Paris—May-June, 1918."

[40] OPH refers to the ruins of Quindaro, Kansas, at 27th & Sewell, Kansas City, Kansas. The site is just south of the river that constitutes a boundary between Missouri and Kansas. Because it was near the river, Quindaro served as a port for free-state settlers entering Kansas as well as a stop on the Underground Railroad. It was a refuge for slaves who made their escape by crossing the river and seeking assistance on their way to freedom. Founded in 1856, the town grew rapidly to about 1,200 inhabitants in 1858, but as economic conditions deteriorated and civil war approached, the population declined until, by 1862, the town was abandoned and fell into ruin. All that remained were the foundations stones for buildings that once bustled with trade and optimism for the future.

[41] "Dear old Sam Adams, Lieutenant of I [Company] but now with C, was killed in the main street [of Exermont], just behind Eustace Smith. He was loved by both officers and men, brave and big hearted as a lion, and deserved the Distinguished Service Cross awarded him." See the description of the fourth day of fighting, Sunday, September 29, 1918, Exermont, in Edwards, *From Doniphan to Verdun: The Official History of the 140th Infantry*, 79, 259. 1st Lieutenant Samuel T. Adams was born in Bowling Green, Missouri, and resided in Kenneth, Missouri. He served with Company I, 140th Infantry, overseas from

April 25, 1918, until he was killed in action on September 29, 1918, in Exermont. His Missouri service record shows that he was buried in Cemetery C, 209 Grave Registration Service No.573. Mrs. Sallie George Adams, Caldwell, was next of kin. See Missouri Digital Heritage Soldiers' Records: id=A513. The citation for his DSC reads: "for extraordinary heroism in action while serving with the 140th Infantry Regiment, 35th Division, A.E.F., near Exermont, France, 29 September 1918. After all the other officers of his company had become casualties, Lieutenant Adams reorganized his company and led it brilliantly in the assault on the town of Exermont. He was killed later during the consolidation of the new position." War Department, General Orders 70 (1919). See valor.militarytimes.com/recipient.php?recipientid=10381.

[42] "Lt. Eustace Smith and Lt. "Duke" Sheahan, two red-headed fighters, were among the first in Exermont. Sheahan had crossed the little creek instead of going over the bridge, which probably saved his life, as the bridge was swept by fire." See the description of the fourth day of fighting, Sunday, September 29, 1918, Exermont, in Edwards, *From Doniphan to Verdun,* 79. 1st Lt. John J. Sheahan was born in St. Louis, Missouri, on September 28, 1887, and lived in St. Louis. He was inducted on April 3, 1918 and served with the 140th Infantry and then was assigned to the 138th Infantry until his discharge. He was overseas from April 25, 1918, to April 27, 1919. See Missouri Digital Heritage Soldiers' Records: id=A117143. Eustace Smith was born on March 26, 1889, in Kingsley, Kansas, and resided at 116 N. Elm, Hutchinson, Kansas. At the time of his registration for the draft on June 4, 1917, he was married and worked as a lawyer in his own practice. He had enlisted in the Kansas National Guard on June 4, 1917. See "United States Draft Registration Cards, 1917-1918," database with images, *FamilySearch*(https://familysearch.org/ark:/61903/1:1:K66J-ZKK), Eustace Smith 1917-1918, citing Reno County, Kansas, United States, NARA Microfilm publication M1509 (Washington, D.C.: National Archives and Records Administration, n.d.); FHL Microfilm 1,643,815.

[43] Otto P. Higgins, "Scars of Argonne Pass," *Kansas City Star,* Tuesday, March 18, 1919, p. 3 and *Weekly Kansas City Star,* Wednesday, April 2, 1919, 6.

Chapter 13: While Packing Up—March 1919

[1] OPH inscription "O.P. Higgins, Cologne, Mar 1, 1919, the K.C. *Star*. Germany." In the flyleaf of *The Rhine, Including the Black Forest & the Vosges* (Leipzig: Karl Baedeker Publisher, 1911). Also OPH inscription "O. P. Higgins, Cologne, Mar 1, 1919, The K. C. *Star*. Herbert Baily *Daily Mail*, Capt. Steuart Richardson, N Y. Herely (?) – G 2 E, on flyleaf of *Stories and Legends of the Rhine and Neckar*, Hermann Kieser (Heidelberg: Karl Groos Nachfolger, 1910). Also see OPH pass to Hdq 35th Div Coblenz via Metz-Treves (Hos); Hdq 89th Div- Commercy (___Chalons) via train or auto (with French papers authorizing travel by auto); Stamps: 6 Mar 1919 Asst Provost Marshall AEF No. 366, 4 Mar 1919, Assistant Provost Marshall AEF No. 366; 3 Mar 1919 Assistant Provost Marshall 373; 7 Mar 1919 Assistant Provost Marshall AEF No. 420; Signed by Robert C. Davis, Adjutant General American Armies in

France, Stamp of Headquarters American Expeditionary Forces (10 stamps total). [National World War I Museum Archives, Archival Box Accession No. 2010.145].

[2] Postcard, black and white, "Die Mosel , Romischer Kaiserpalasi, Trier " [World War I Museum Archives Box 2010.145].

[3] Postcard, black and white, "Die Mosel Trier, Porta Nigra." Four-story building with two arches in middle and two abutments on either end]. [World War I Museum Archives Box 2010.145].

[4] Otto P. Higgins, "The Evolution—89th Division Area," *Kansas City Star*, March 3, 1919, 3.

[5] Otto P. Higgins, "A Chief of Staff at 31," *Kansas City Times*, March 8, 1919, 8.

[6] Otto P. Higgins, "Home Yanks in Big Show," *Kansas City Times*, April 8, 1919, 7

[7] Otto P. Higgins, "A Chief of Staff at 31,"

[8] Otto P. Higgins, "The 35th Gets Ready to Sail," *Kansas City Star,* March 11, 1919, 1.

[9] Otto P. Higgins, "Going to School in France," *Kansas City Star,* April 2, 1919, 1.

[10] Like Lee Shippey, W. Y. Morgan was also a writer. He was editor of the *Hutchinson, News* and the *Hutchinson Herald.* His books included *A Journey of a Jayhawker* (Topeka, KS: Crane & Company, 1905) and *"Yurrup" As Is* (Topeka, KS: Crane & Company, 1926). See the latter, 76-77, for an eyewitness account of the 35th Division as it came out of the Argonne.

[11] Otto P. Higgins, "Scars of Argonne Pass," *Kansas City Star*, March 18, 1919, 3 and *Weekly Kansas City Star*, April 2, 1919, 6.

[12] D. M. Giangreco, *The Soldier from Independence: A Military Biography of Harry Truman* (Minneapolis, MN: Zenith Press, 2009), 9.

[13] Otto P. Higgins, "Two Days in Hun Lines," *Kansas City Star*, March 12, 1919, 9.

[14] Otto P. Higgins, "Early Convoy for 35th," *Kansas City Times*, March 31, 1919, 2.

[15] Otto P. Higgins, "Football Title to 89th," *Kansas City Times,* March 31, 1919, 12.

[16] Colonel Warren W. Whiteside, Field Artillery, was commander of the 89th Division's 314th Train Headquarters and Military Police. He was awarded the French *Croix de Guerre.* In May 1919 during the occupation, his last duty station before sailing home was Kyllburg, Germany. George H. English, *History of the 89th Division, U.S.A.* (Denver, CO: The War Society of the 89th Division), 1920, 392, 483, 495 and 511.

[17] "As an 89th Division Artist Sees It," *Kansas City Star,* Monday, March 3, 1919, 3.

[18] 1st Lt. William E. Scott, originally with Company A, 3rd Missouri Infantry, was later assigned to Company E, 140th Infantry Regiment, 35th Division. He was born in Manhattan, Kansas, on November 26, 1895, and resided at 3778 Prospect, Kansas City, Missouri, when his unit was inducted into the 140th Infantry on August 5, 1917. He served overseas from April 25, 1918, until

September 30, 1918, when he was killed in action on the fourth day of the
Battle of the Meuse Argonne. His wife, Elinore Frances Scott, was notified as
next of kin. See Missouri Digital Heritage Soldiers' Records: id=A115837.
"Scott, cited for bravery, was a fine young officer from Kansas City. He had a
wonderful faculty for keeping cheerful under all discouragements, and his
courage was as fine as his spirit. No man had more friends, and no man
deserved them more. Until he was killed he gave an example of courage to his
men." See Evan Alexander Edwards, *From Doniphan to Verdun: The Official
History of the 140th Infantry* (Lawrence, KS: The World Company, 1920), 81.
Lt. Scott was awarded the Silver Star and is buried at the American Cemetery in
Romagne, France. "First Lieutenant Scott distinguished himself by gallantry in
action while serving with the 140th Infantry Regiment 35th Division, American
Expeditionary Forces, in action near Chaudron Farm, France, 26-28 September
1918, in brilliantly leading his platoon in an assault on an enemy machine gun
nest." See GHQ, American Expeditionary Forces, Citation Orders No. 4 (June
3, 1919). Valor.militarytimes.com/recipient.php?recipientid=83334

[19] Cpt. Jacob L. Milligan, who was born in Richmond, Missouri, on March 9,
1889, commanded Company G, 6th Missouri National Guard, which was
inducted into the 140th Infantry, 35th Division, on August 5, 1917. He served
overseas from April 25, 1918, until April 28, 1919. See Missouri Digital
Heritage Soldiers' Records: id=A89266. At Exermont, on September 29, 1918,
the fourth day of the Battle of the Meuse Argonne, "G Company with Milligan
were in the thick of it, and G Company lost heavily that day. He was gassed but
refused to leave. His company went in with 224 men and came out with 90.
Milligan wrote a great record that day." See Evan Alexander Edwards, 81,
255. Cpt. Milligan was awarded the Silver Star "for gallantry in action," and
his citation reflected that "although badly gassed he remained on duty with his
company until the division was relieved." See GHQ, American Expeditionary
Forces, Citation Orders No. 3. (June 3, 1919)
valorlmilitarytimes.com/recipient.php?recipientid=82627

[20] Maj. Murray Davis, who was born on September 24, 1889, in Burlingame,
Kansas, lived at 28 East Concord, Kansas City, Missouri, and commanded
Company L, 3rd Infantry, Missouri National Guard, which was inducted into the
140th Infantry on August 5, 1917. He was overseas from May 3, 1918, until
September 29, 1918, when he was killed in action a few hundred yards
southeast of Exermont during the Battle of the Meuse Argonne. See his service
record at Missouri Digital Heritage Soldiers' Records: id=A29898. Seriously
wounded already, he refused to have his wound dressed in the rear and
continued to lead his men until he was struck with enemy machine gun fire.
Realizing that he had been mortally wounded, he turned to Lt. Harry
Whitthorne, who was standing next to him and who had also been hit and
whispered, ""Take care of my men." For a biographical sketch of Murray
Davis and a description of the monument dedicated to him in Kansas City, see
James J. Heiman, *Voices in Bronze and Stone: Kansas City's World War I
Monuments and Memorials* (Kansas City, MO: Kansas City Star Books, 2013),
178-183. Also see Evan Alexander Edwards, 80-83, for a personal tribute.

Major Davis was awarded the Distinguished Service Cross. For his citation, see valor.militarytimes.com/recipient.php?recipientid=11503.

[21] Otto P. Higgins, "Find Graves of Friends," *Kansas City Star,* April 2, 1919, 6.

[22] Chaplain Evan Edwards told the following story about Cpt. Ralph Truman: "Our Intelligence Officer was then a Captain, although afterwards he won a Major's leaves. He had auburn hair. There is a certain disposition popularly supposed to accompany this complexion. In this instance it did. The officer had one pet aversion. He is strong in his likes and dislikes, but his strongest dislike is one of aviators. This attitude had been strengthened by our unfortunate lack of fliers in the Argonne. He has also a remarkable gift of expression. He can put matters so that no one could mistake his meaning. Positively no one! His motorcycle broke down on the long hike. For an hour he had been working in the mud and rain, and his disposition had almost reached the breaking point. He wore a regulation helmet, and a rain coat which concealed his Captain's bars. Just at that inauspicious moment a limousine rolled by. In it a spick and span second lieutenant, Aviation, lolled on along the road until it stood opposite the damaged motorcycle and the already furious captain. The door opened and from the interior came these words, 'My good man don't you know enough to salute an officer?' Then *****.'" (Evan Alexander Evans, 119-120). Ralph Emerson Truman was born in Kansas City on May 10, 1880, and for a time lived with his cousin Harry S. Truman's family, when Ralph's father, William Truman was in Texas. (Ralph had known Harry since Ralph was 7 years old). Ralph E. Truman had joined the 3rd Infantry, Missouri National Guard and served in Cuba during the Spanish American War, where he was seriously wounded. (See D. M. Giangreco, *The Soldier from Independence: A Military Biography of Harry Truman* (Minneapolis, MN: Zenith Press, 2009), 9. Also see Merle Miller, *Plain Speaking: An Oral Biography of Harry S. Truman* (New York: Barkley Publishing Co., 1974), 174.). As a 2nd Lieutenant, he served with the 3rd Missouri Infantry Machine Gun Company and later became intelligence officer for the 140th Infantry Regiment, serving overseas from April 24, 1918, to April 28, 1919. He received a field promotion to Major and continued to rise in rank until he reached the rank of Major General in command of the 35th Division, 1940-1941. He died at the age of 81 on April 30, 1962, and is buried in the National Cemetery, Springfield, Missouri. See Missouri Digital Heritage Soldiers' Records: id=A131448. For more details about Major General Ralph E. Truman see Springfield-Greene County Library, at thelibrary.org/blog/article.cfm?aid=1589.

[23] Regular Army Colonel Alonzo Gray relieved Col. C. E. Delaplane and served as commanding officer of the 140th Infantry Regiment from October 16, 1918, to January 3, 1919. Chaplain Edwards offered this assessment: "Col. Gray was an older man and familiar with the best traditions of the old army. He worked hard with the regiment, commanding it during a most trying period. He had a sense of humor and possessed that rare quality of enjoying a joke even when he was the subject. He possessed another rare quality. He was almost the only

regular officer we met overseas who could make a mistake about anything."
Evan Alexander Edwards, 119,148.

[24]The 140th Infantry Regiment's unit history remembered the November 5th reconnaissance: "They passed through a series of interesting and dangerous adventures and their work received the highest commendation. Upon their return, however, they simply reported that they had 'established contact with the enemy.'" See Evan Alexander Edwards, 120.

[25] Otto P. Higgins, "Two Days in Hun Lines," *Kansas City Star,* March 12, 1919, 9.

[26] George M. "Potsy" Clark was born on March 30, 1894, in Carthage, Illinois. At the age of six, he was nicknamed "Potsy" by a local veterinarian, and the name stuck for the rest of his life. He entered the University of Illinois in 1914 and as quarterback helped the Illinii go undefeated the next two seasons. He graduated in 1916 and in the fall of that year signed on as an assistant coach at the University of Kansas for $1,400, the highest first-year salary for any coach up to that time. In May 1917, he began officer training at Fort Riley, Kansas, and was commissioned a 2nd Lieutenant, Artillery, on August 15, 1917. While at Camp Funston, he organized softball competition and, with Grover Cleveland Alexander, coached the baseball team. In July 1918, he shipped to England with the 89th Division and saw combat during the Battle of the Meuse Argonne. After the Armistice, he led the 89th Division to the American Expeditionary Forces football championship and returned to the U.S. in June 1919. Captain Paul C. Withington was coach of that team. (See Chapter 11 endnotes). Clark became head coach at Michigan Agricultural College (now Michigan State) in 1920, the University of Kansas (1921-25), Butler University (1927-1829), and the University of Nebraska—Lincoln in 1945 and 1948. His cumulative college football record stood at 40-45-7. On the professional side, Clark led the Detroit Lions to the NFL Championship in 1935 and coached a number of other teams for a total NFL record of 64-42-12. From 1945 to 1953, he was Athletic Director at Nebraska. After serving in both WWI and WWII and coaching in both college and the NFL, Potsy Clark died at the age of 78 on November 8, 1972, in La Jolla, California. See Pat Carroll, "Potsy Clark: A Success Story," *The Coffin Corner,* Vol. 7, No. 2 (1985) at profootballresearchers.com/archives/Website_Files/Coffin_/Corner/07-02-218.pdf.

[27] Otto P. Higgins, "Football Title to 89th," *Kansas City Times,* March 31, 1919, 12.

Chapter 14: On the Way Home—April 1919

[1] Otto P. Higgins, "But This Is Home," *Kansas City Times*, April 21, 1919, 1.

[2] Benedict Crowell and Robert Forrest Wilson, *The Road To France II: The Transportation of Troops and Military Supplies 1917-1918* (New Haven: Yale University Press, 1921), 342. 395, 564.

[3] I am indebted to Blair Tarr, Director of the Kansas State Historical Society Museum, for remembering that another journalist familiar to *Kansas City Star* readers had also used the narrative device of a fictional romance to tell a factual

war story. Higgins may well have taken his cue from William Allen White, who, earlier in 1918, had published the story of his and *Wichita Beacon* editor, 35th Division YMCA Director and later Kansas Governor, Henry J. Allen's 1917 trip into the war zone as inspectors for the Red Cross. White alluded to using a romance story to add interest to the memoir. See William Allen White, *The Autobiography of William Allen White* (New York: The Macmillan company, 1946), 535, and William Allen White, *The Martial Adventures of Henry and Me* (New York: Macmillan, 1918).

[4] Otto P. Higgins, "Winning the D.S.C. and Her," *Kansas City Star*, April 27, 1919, 28C – 30 C.

[5] The inclusion of the detail that the two reporters and Mrs. Higgins were the only other representatives of Kansas City was justified as newsworthy because for some days prior to Alderman Griffin's arrival, the women's committee in Kansas City had petitioned Major Cowgill for funds to send a Kansas City delegation to greet the homeboys when they arrived from France. Cowgill refused to appropriate funds from city coffers, but he did contribute $100 of his own money, and his donation was matched by $100 from Senator James A. Reed, $100 from the 140[th] Infantry Auxiliary and $100 from Griffin himself. The $400 enabled Griffin to set out for New York, but the amount was apparently not enough to cover expenses for additional city representatives. "Failure to send a representative would leave the task of extending the glad hand to the *Star's* four correspondents at New York and two at Newport News," the paper warned. "Greet Men Despite Mayor," *Kansas City Star,* April 21, 1919, 1.

[6] "Some Fighters of the 140th," *Kansas City Times,* April 29, 1919, 2.

[7] "When Otto got back to New York he was so eager to see his wife that he maneuvered somehow to dodge the 'delousing station'. This was the place where all the soldiers were detained until they were free from the lice most of them brought back," 21, "O.P.H.," Jill Carter (Demchak), from an interview with her grandmother Elizabeth Higgins; personal communication from Sheila Scott, December 23, 2010.

[8] Otto P. Higgins, "Marched Armed in Berlin," *Kansas City Times*, April 22, 1919, 1. Picture from "He Went 'On to Berlin,'" *Kansas City Times*, April 29, 1919, 10.

[9] Otto P. Higgins, "Linxwiler with 70th," *Kansas City Times*, April 22, 1919, 2.

[10] James J. Heiman, *Voices in Bronze and Stone: Kansas City's World War I Monuments and Memorials* (Kansas City, MO: Kansas City Star Books, 2013), 115. See page 114 for a description of how General Pershing was selected over General Wood.

[11] Otto P. Higgins, "A.E.F. A Political Teapot," *Kansas City Times*, April 23, 1919, 1-2.

[12] Otto P. Higgins, "A.E.F. A Political Teapot."

[13] Benedict Crowell and Robert Forrest Wilson, 573.

[14] Otto P. Higgins, "When the Mobile Docked," *Kansas City Times*, April 24, 1919, 1-2.

[15] Charles B. Hoyt, *Heroes of the Argonne: An Authentic History of the Thirty-fifth Division* (Kansas City, MO: Franklin Hudson Publishing Company, 1919), 232,

[16] Otto P. Higgins, "When the Mobile Docked."

[17] Otto P. Higgins, "When the Mobile Docked." For another story about a famous WWI dog, see Ann Bausum, *Sergeant Stubby: How a Stray Dog and His Best Friend Helped Win World War I and Stole the Heart of a Nation* (Washington, D.C.: National Geographic Society, 2014). For stories about the roles dogs have played in the American military since the Great War, see Maria Goodavage, *The Untold Story of America's Canine Heroes* (New York: Dutton, 2012).

[18] Otto P. Higgins, "Home Towns to see 35th," *Kansas City Times*, April 25, 1919, 8.

[19] Otto P. Higgins, "The 129th Has Its Orders, *Kansas City Times,* April 29, 1919, 1.

[20] Otto P. Higgins, "Great Record for the 137th," *Kansas City Star*, April 24, 1919, 2.

[21] Otto P. Higgins, "Col. Garrett is Home," *Kansas City Star*, April 26, 1919, p. 2. Also see Lieutenant Colonel Ruby D. Garrett, "The 117th Field Signal Battalion," Chapter XI in *History of the Missouri National Guard* (Jefferson City, MO: Military Council, Missouri National Guard, 1934), 251.

[22] Otto P. Higgins, "Garrett's Men In," *The Kansas City Times*, April 28, 1919, 1-3. OPH dates the *President Grant's* sailing to October 3, 1917. Crowell and Wilson (417 & 604) indicate that the *President Grant* joined the troop transport fleet on December 26, 1917, suggesting that the *President Grant* was not part of a convoy when the 117th Field Signal Battalion set sail on her in October of that year. In a history of the 117th, however, Lt. Col. Ruby D. Garrett noted that "on October 18, 1917, the Battalion embarked with other Divisional units on the "President Grant," an interned German liner." Five days out to sea, "three of the ship's four boilers became disabled because of 'jokes' played by the Germans before the ship was interned." As a result, the ship "reluctantly turned its heels on the convoy and limped back alone to New York." Lt. Col. Ruby D. Garrett, "The 117th Field Signal Battalion," Chapter XI in *History of the Missouri National Guard* (Jefferson City, MO: Missouri National Guard, 1934), 244.

[23] "List of Passengers, S. S. 'Lapland,' White Star Line, New York – Liverpool," Saturday, April 6, 1918. Courtesy of OPH's granddaughter, Sheila Scott.

[24] Otto P. Higgins, "First Off, First Married," *Kansas City Times,* April 28, 1919, 2.

[25] Otto P. Higgins, "The Old 3rd Lands," *Kansas City Star*, April 28, 1919, 1. F. F. Cowherd is actually F. F. Hoard, and Pvt. Edgar F. Cowherd is actually Pvt. Edgar F. Hoard, the phonetic similarities being a good example of how names could sometimes be mistaken when transmitted orally and then into print.

[26] Otto P. Higgins, "Avenged His Boy's Death," *Kansas City Times*, Wednesday, April 30, 1919, 5. Also see the original report, where the censorship at the time precluded the identification of the names of officers and units. Otto P. Higgins,

"Our Men Whip the Best," *Kansas City Star*, October 27, 1918, Want Ad Section, 1B. In the original article, OPH reported the Major's age as 68; in the April 30, 1919, version the Major is 64. The Missouri Digital Soldiers and Sailors' Database indicates that Clay C. MacDonald, 2509 Faraon Street, St. Joseph, MO., was born 5 June 1857. That would make him 61 years, years, 3 months, 22 days, when his son was killed on September 27, 1918. See Lt. Col. Clay C. MacDonald's service record at Missouri Digital Heritage Soldiers Records: id=A79910 and Lt. Donald M. MacDonald's service record at Missouri Digital Heritage Soldiers Records: id=A79914. Whatever the discrepancy, the point is that Major MacDonald was well over 60 years of age and in spite of his age had responded courageously at the news of his son's death.

[27] Otto P. Higgins, "They are Martin's 'Boys,'" *Kansas City Times*, April 30, 1919, 6.

[28] Otto P. Higgins, "A Reunion at Camp Stuart," *Kansas City Star*, April 29, 1919, 2.

[29] Otto P. Higgins, "A Requiem Mass in France for the Dead of the 137th Infantry," *The Kansas City Times,* April 30, 1919, 5.

[30] Charles B. Hoyt, *Heroes of the Argonne: An Authentic History of the 35th Division,* 73.

[31] For the story of Vauquois Hill, see Chapter 13, "Vauquois Taken—the 138th Before Cheppy, in Clair Kenamore, *From Vauquois Hill to Exermont* (St. Louis, MO: Guard Publishing Company, 1919), pp 93-97. See also Otto P. Higgins, "Seven Days of Hell," *Kansas City Star,* November 1, 1918, 1. Figures 1 and 2 are maps showing the location of Vauquois Hill, Cheppy and Charpentry.

[32] Lt. Donald Malcolm MacDonald was born in August 1892 in St. Joseph, Missouri, and received his commission as a 2nd Lieutenant in the 4th Missouri Infantry on June 15, 1909. By May 1915, he had become the battalion adjutant of the 4th Infantry, and served in that capacity on the Mexican Border from June 27, 1916, to February 28, 1917. He lived at 2509 Faraon Street, St. Joseph, Missouri when the 4th Infantry, Missouri National Guard, was federalized into national service on August 5, 1917. As 1st Lieutenant with Company G, 139th Infantry, he led that regiment's charge at Vauquois Hill and was killed in action on September 27, 1918. His wife, Tessie MacDonald, was notified as next of kin. See Ancestry.com, *U.S. Adjutant General Military Records 1631-1976* [database on-line]. Provo, UT, USA: Ancestry.com Operations, Inc., 2011 and Missouri Digital Heritage, Soldiers' Records: id=A79941.

[33] Col. Hamilton S. Hawkins was Chief of Staff on the morning of the Argonne Battle. See Clair Kenamore, *From Vauquois Hill to Exermont,* 261.

[34] Otto P. Higgins, "Our Men Whip the Best," written on September 30, 1918, appeared in the *Kansas City Star,* October 1, 1918, 1B. See Chapter 7, "At St. Mihiel and in the Argonne—September 1918."

[35] Lt. Col. Clay Campbell MacDonald also served with the 338th Infantry and was overseas from May 19, 1918, until April 2, 1919. Lt. Col. MacDonald died in

1925 and is buried at Mount Mora Cemetery, St. Joseph, Missouri (Find A Grave memorial 364755589).

[36] Otto P. Higgins, "Avenged His Boy's Death," *Kansas City Times,* Wednesday, April 30, 1919, 5.

Chapter 15: Into Kansas City—May 1919

[1] "Now for the 89th!" *Kansas City Star*, May 21, 1919, p. 1.

[2] "Now for the 89th!"

[3] Otto P. Higgins, "Coin of a Real Realm," *Kansas City Star*, May 1, 1919, 7.

[4] Otto P. Higgins, "Greetings to the 140th," *Kansas City Star*, May 1, 1919, 16.

[5] Otto P. Higgins, "Greetings to the 140th."

[6] Otto P. Higgins, "Greetings to the 140th."

[7] Otto P. Higgins, "Greetings to the 140th."

[8] "They Don't Want Traub," *Kansas City Star*, May 2, 1919, 1.

[9] Otto P. Higgins, "Reorganizing Old Guard," *Kansas City*, May 7, 1919, 2.

[10] "Ristine Held at Funston," *Kansas City Star,* May 7, 1919, 3.

[11] Otto P. Higgins, "Sent 35th Poor Officers," *Kansas City Star*, May 19, 1919, 11.

[12] Otto P. Higgins, "Sent 35th Poor Officers."

[13] Otto P. Higgins, "Reflects on the Staff," *Kansas City Star*, May 19, 1919, 1, 11.

[14] Otto P. Higgins, "Reflects on the Staff."

[15] Otto P. Higgins, "Reflects on the Staff."

[16] "They Don't Want Traub," *Kansas City Times*, May 1, 1919, 1. For a more detailed account of the effect of Major General Traub's subsequent statements about the actions of National Guard units in the early days of the Meuse Argonne fight, see D. M. Giangreco, *The Soldier from Independence: A Military Biography of Harry Truman* (Minneapolis, MN: Zenith Press, 2009), 203-204.

[17] Otto P. Higgins, "'O. P. H.' Sees 'Em Again," *Kansas City Times*, May 10, 1919, 2.

[18] "The Boys are Hurrying," *Kansas City Times*, May 10, 1919, 2.

[19] "The Boys are Hurrying."

[20] Otto P. Higgins, "Soldiers Not for League, *Kansas City Star*, May 16, 1919, 11, and Otto P. Higgins, "Sent 35th Poor Officers, *Kansas City Star*, May 19, 1919, 11.

[21] Otto P. Higgins, "First of 89th in Today," *Kansas City Times,* May 22, 1919, 1.

[22] Otto P. Higgins, "First of 89th in Today."

[23] Otto P. Higgins, "Home for the 89th," *Kansas City Times*, May 23, 1919, 1.

[24] Otto P. Higgins, "Home for the 89th."

[25] Otto P. Higgins, "Home for the 89th."

[26] Otto P. Higgins, "Fine Record is 353rd's," *Kansas City Times*, May 23, 1919, 1 and Otto P. Higgins, "Nebraskans Made Fur Fly," *Kansas City Times*, May 24, 1919, 3.

[27] Otto P. Higgins, "May Hold 89th, is Rumor," *Kansas City Times,* May 24, 1919, 1.

[28] Otto P. Higgins, "May Hold 89th, is Rumor."

[29] Otto P. Higgins, "Parade Plans for the 89th," *Kansas City Times,* May 27, 1919, 2.

[30] Otto P. Higgins, "'Who Me" No! Hero Says," *Kansas City Star*, May 24, 1919, 2.

[31] Otto P. Higgins, "The Ambulance Men Land," *Kansas City Star*, May 25, 1919, 2A.

[32] Otto P. Higgins, "Laurels to Litter Bearers," *Kansas City Star*, May 25, 1919, 2A.

[33] Otto P. Higgins, "Unsung Heroes of the 356th," *Kansas City Times,* May 29, 1919, 2.

[34] Otto P. Higgins, "Unsung Heroes of the 356th."

[35] Otto P. Higgins, "The Silent Heroes There," *Kansas City Times,* May 31, 1919, 3.

[36] Col. Philip Joseph Kealy became president of the Kansas City's Metropolitan Street Railway Company in 1916. Just prior to that, in November 1915, Kealy had been elected Lieutenant Colonel of the 3rd Infantry Regiment, Missouri National Guard. On August 5, 1918, he was forced to take a leave of absence from the rail company when he was called to active duty, as commander of his regiment, which had quickly been federalized into the 138th Infantry. Five months later, Col Kealy was discharged from active service for physical disabilities, but during his absence from Kansas City Railways, the employees had unionized and walked out in a sympathy strike in support of local laundrymen. Col. Kealy found himself dealing with a strike that lasted from December 1918 to May 1919 and "almost developed into open warfare. More than seventy-five of the company's cars were attacked and wrecked by dynamite or rocks or other projectiles. Not only did its property loss run high, but the loss in riding was terrific." Kealy made immediate use of his military experience, however, and dealt with the labor and property damage issues in large part by going to Camp Funston and recruiting men who had just demobilized from military service. "The boys came in their uniforms and ran the cars. They liked the excitement. It made up in some small part for the big fight that they had missed overseas. And when two of them would bring a badly smashed car into the car-house one of them would be sure to say to the depot supervisor: 'A bit of bad luck, boss. Give us another and we'll see if we can't do better with her.'" The labor loss and property threats at Kansas City Railways may explain, in part, why Col. Kealy was especially eager to serve as chair of the Kansas City delegation on welcoming combat-hardened troops back home. See Edward Hungerford, "Philip J. Kealy of Kansas City—and His Job," in *Electric Railway Journal*, Volume 55, No. 18, May 1, 1920, 887-888, and Soldiers' Records: War of 1812 – World War I, Missouri Digital Heritage Soldiers Records: id=A68341. Also see, Sara Mullin Baldwin, Ed, *Who's Who in Kansas City 1930: Biographical Sketches of Men and Women of Achievement* (Hebron, NE, Robert M. Baldwin Corporation, 1930), 103; "Philip J. Kealy" in Katherine Baxter, Ed., *Notable Kansas Citians of 1915-1916-1917-1918* (Kansas City, MO: Kellog-Baxter Printing Co., 1925), 103-104.

[37] Judge Andrew F. Evans arrived in Kansas City in 1887, practiced law and was elected as Judge of the Circuit Court in 1902 See George Creel & John Slavens, *Men Who Are Making Kansas City: A Biographical Directory* (Kansas City: Hudson-Kimberly, 1902).

[38] John Augustine Eames had been living in Kansas City and working as a traveling salesman, professional stenographer and real estate agent. By 1920, he was serving as Mayor James Cowgill's personal secretary. After Mayor Cowgill died in 1922, Eames returned to real estate and eventually operated his own agency. See U.S. Federal Census records, 1900 – 1930; and city directories from 1884 to 1935.

[39] Mayor James Cowgill moved to Kansas City, Missouri, in 1893 and served as city treasurer in 1900. He then became Missouri State Treasurer (1909-1913). As president of the Pioneer Life Insurance Company, he returned to Kansas City in 1913, was Chair of the Democratic State Central Committee in 1916, and became a member of the Kansas City Board of Elections in 1917 before being elected mayor in 1918. He died while working at his desk on January 20, 1922, and is buried in Elmwood Cemetery, Kansas City, Missouri. See https://en.wikipedia.org/wiki/James_Cowgill; George Fuller Green, *A Condensed History of the Kansas City Area: Its Mayors and Some V.I.P.s* (Missouri Valley Room, Kansas City, Missouri Public Library, 1968); Find-a-Grave Memorial #6305186.

[40] Alderman William F. Fleming was speaker of the lower house of the City Council of Kansas City. See "Fleming Had Private Reasons," *Kansas City Times*, April 22, 1921, 1.

[41] Colonel Bennett Champ Clark (1890-1954).

[42] Otto P. Higgins, "'O.P.H' Sees 'em Again," *Kansas City Times,* May 10, 1919, 2.

[43] Lina K. Fitzgerald was born Lina Kelly on January 28, 1869, in Penn Yan, New York, and volunteered for military service with the Y.M.C.A. She was the widow of Frank T. Fitzgerald, a circuit judge in Manhattan (1905). Lina sailed for France on January 23, 1918, on board the *La Tourraine*, arriving on January 29, 1918. She returned to New York on July 22, 1919. See The University of Minnesota, Kautz Family Y.M.C.A. Archive, Minneapolis and U.S. Passport, Department of State, January 24, 1918, No. 1571.

[44] Maude Radford Warren was a Y.M.C.A. secretary and a writer for the *Saturday Evening Post.* A graduate of the University of Chicago, she was fluent in French and had already been abroad in 1916, visiting England, Ireland, Holland, France and Italy as a special correspondent for *Harper's Magazine.* As a Y.M.C.A. worker, she left for France in April, 1918, returned to New York in March, 1919, and went back to France again in June 1919 to work in the publicity section of the A.E.F. While in France on her first stint with the Y.M.C.A., she was posted to La Ferte, Château-Thierry and Saint Mihiel. "Once she walked nine miles," a post-war account related, "carrying on her back forty pounds of tobacco to a company in a front-line trench that had been without tobacco for sixteen days. Not only was the trench itself under fire at the time, but so, also, was all her road thither." At Saint Mihiel, "she was actually making chocolate

432

on the new front twenty-four hours before the arrival of the Army rolling kitchens. In the first five days of the drive, single handed, she served eight thousand cups of chocolate in the field. And for five days she made chocolate in Beney under the Boche guns. Twice she was struck by shrapnel. But the woman was absolutely intrepid, never spared herself any risk, never turned aside while work remained to do. And she never could see a limit to what she would undertake or endure to help an American Soldier." (See Katherine Mayo, *That Damn Y: A Record of Overseas Service* (Boston: Houghton Mifflin Company, 1920), 134-135). She was made an honorary Major and was cited for bravery on November 13, 1918. OPH knew Maude Radford Warren and had a high regard for her writing: "Maude Radford Warren of the same publication [*Saturday Evening Post*] lived with the troops all the time as a Y.M.C.A. secretary, so she could get first-hand information and plenty of 'atmosphere.'" She "probably saw," he said, "more actual war than any other American woman in France, just so she could write intelligently about it." (See Otto P. Higgins, "That Job of 'Writing Up' the War: O.P.H. Tells How Correspondents Worked in France," *Kansas City Star,* Sunday, June 8, 1919, 15C). For biographical detail about Warren's Y.M.C.A. service, see "United States YMCA World War I Service Cards, 1917-1919," database with images, *FamilySearch* (https://familysearch.org/ark61903/3:1:3Q9M-CSMB--GQX5-9?cc=2513098&wc=7STG-4WL%3A1589532034: 1 March 2017, Wachs-Wilson > image 352 of 1583; citing The University of Minnesota, Kautz Family YMCA Archive, Minneapolis); 1916 U.S. Passport Application 32368, August 23, 1916, and 1918 U.S. Passport Application 38, Special Services, May 14, 1918).

[45] Otto P. Higgins, "Laurels to Litter Bearers," *Kansas City Star*, Sunday, May 25, 1919, 2A.

Chapter 16: "From the Notebook of O.P.H."—June 1919

[1] Otto P. Higgins, "That Job of 'Writing Up the War': O.P.H. Tells How Correspondents Worked in France," *Kansas City Star*, June 8, 1919, 15C. Because this piece is in Higgins's own voice and offers such a comprehensive picture of what newspaper work entailed during the war, almost all of the piece is included in Chapter 1, "OPH: The *Star's* "Own Correspondent." The authenticity of the piece was especially recognized by the appearance of a substantial portion of it in a national magazine, with attribution to the *Kansas City Star,* but not to Higgins individually. See "A War-Correspondent's Job Was Not a Soft Snap," *The Literary Digest,* July 1919, 67-70. "One of these correspondents in an article in the Kansas City *Star* tells something of the job of 'writing up the war.' He says that all classes of writers were represented with the American Army at all times—" In the case of *The Literary Digest,* the "class" of writer being re-presented was, in fact, Otto P. Higgins.

[2] Otto P. Higgins, "'Getting By' the Censor," *Kansas City Star*, June 22, 1919, 20C. OPH's article on censorship is reprinted in the prologue, "The Style Sheet, The *Star* Man, and the Censor

[3] Otto P. Higgins, "From the Notebook of O.P.H.," *Kansas City Star*, June 22, 1919, 13A. This story is also included in Chapter 1.

[4] Otto P. Higgins, "From the Notebook of O.P.H.," *Kansas City Star*, June 17, 1919, 5.

[5] Otto P. Higgins, "From the Notebook of O.P.H.," *Kansas City Star*, June 13, 1919, 8.

[6] Otto P. Higgins, "From the Notebook of O.P.H.," *Kansas City Star*, June 24, 1919, 7.

[7] Otto P. Higgins, "From the Notebook of O.P.H.," *Kansas City Star*, June 17, 1919, 10.

[8] Otto P. Higgins, "From the Notebook of O.P.H.," *Kansas City Star*, June 29, 1919, 8A.

[9] Otto P. Higgins, "From the Notebook of O.P.H.," *Kansas City Star*, June 11, 1919, 14. After the war, Alfa Miller returned to Kansas and worked at the University of Kansas as a librarian. (See *1920 United States Federal Census* Roll T625_531, 8A, Ed 79, Image 464, January 24, 1920. Ancestry.com Operations, Inc., 2010).

[10] Otto P. Higgins, "From the Notebook of O.P.H.," *Kansas City Star*, June 19, 1919, 15.

[11] Otto P. Higgins, "From the Notebook of O.P.H.," *Kansas City Star*, June 26, 1919, 7.

[12] Otto P. Higgins, "From the Notebook of O.P.H.," *Kansas City Star*, June 26, 1919, 7.

[13] Otto P. Higgins, "From the Notebook of O.P.H.," *Kansas City Star*, June 23, 1919, 6.

[14] Otto P. Higgins, "From the Notebook of O.P.H.," *Kansas City Star*, June 22, 1919, 20C.

[15] Otto P. Higgins, "From the Notebook of O.P.H.," *Kansas City Star*, June 15, 1919, 13A.

[16] Otto P. Higgins, "From the Notebook of O.P.H.," *Kansas City Star*, June 24, 1919, 7.

[17] Ib Otto P. Higgins, "From the Notebook of O.P.H.," *Kansas City Star*, June 24, 1919, 7.

[18] Otto P. Higgins, "From the Notebook of O.P.H.," *Kansas City Star*, June 24, 1919, 7.

[19] Otto P. Higgins, "From the Notebook of O.P.H.," *Kansas City Star*, June 24, 1919, 7.

[20] Otto P. Higgins, "From the Notebook of O.P.H.," *Kansas City Star*, June 20, 1919, 5.

[21] Otto P. Higgins, "From the Notebook of O.P.H.," *Kansas City Star*, June 20, 1919, 5.

[22] Otto P. Higgins, "From the Notebook of O.P.H.," *Kansas City Star,* Friday, June 13, 1919, 8.

[23] Lt. Col. Ruby D. Garrett commanded the 117th Field Signal Battalion and was the Chief Signal Officer for the 42nd "Rainbow Division."

[24] "Bill" is William Slavens Mcnutt, war correspondent for *Collier's*.

[25] Mersch, District Luxembourg, is in the center of the country. Although the Treaty of London in 1867 had established the Grand Duchy of Luxembourg as a neutral and unarmed state, the German army nevertheless occupied the country in 1914, despite its protest. Grand Duchess Marie-Adélaïde (1894-1924) remained in power. After the Armistice, Marie-Adélaïde was accused of collaborating with the Germans and was forced to abdicate in January 1919 in favor of her sister Charlotte. See Information and Press Service of the Luxembourg Government Publishing Department, *Everything you need to know about the Grand Duchy of Luxembourg,* "History," April 2010. At *https://www.gouverement.lu/1829965/Tout_savoir-EN.pdf Accessed October 21, 2017.*

[26]The term, "Beau Brummell," (after George Bryan Brummell (1778-1840), "an English gentleman famous for his fashionable dress and manners"—*Webster's Dictionary*), was applied to a gentleman who dressed in style.

[27]On August 26, 1918, the Grand Duchess's sister, Princess Antonia, was engaged to Crown Prince Rupprecht of Bavaria, a *Generalfeldmarschall* in the German Army.

[28] Although OPH does not state specifically when he, McNutt and Lt. Col. Garrett visited the count and countess, judging from Lt. Col. Garrett's scheduled movement with the 42nd Division after the Armistice and OPH's report of the reaction of the people to the preferential treatment the count and countess had received from their collaboration with the Germans, it would seem that the Grand Duchess Marie-Adélaïde Hilda Antoinette Wilhelmine von Nassau-Weilburg was the countess named in the piece. However, she never married. Her sister Charlotte didn't marry Prince Felix of Bourbon-Parma until November 6, 1919, and their six children followed after that. So, although the political facts match the OPH narrative, the biographical facts are less compatible, and it is not completely clear, who, in fact, OPH, William Slavens McNutt and Lt. Col. Ruby D. Garrett did visit in the schloss near Mersch, Grand Duchy of Luxembourg, in 1919.

[29] Otto P. Higgins, "From the Notebook of O.P.H.," *Kansas City Star*, June 19, 1919, 15.

[30] Luxembourg Gardens refers to the gardens surrounding the Palais du Luxembourg, 6th arrondissement, 15 rue de Vaugiraud. The gardens are on the border between Saint-Germain-des-Prés and the Latin Quarter.

[31] *"Le Furet"* is the French word for "ferret." Figuratively, "a curious individual". A secondary definition refers to the name of a game in which an object is passed from one hand to the other while an observer tries to guess in which hand the object can be found. ("Jeu consistant à passer un objet de main en main tandis qu'un joueur s'efforce de deviner dans quelle main il se trouve." *Dictionnaire Usuel Quillet Flammarion Par le Texte et Par l'Image,* Pierre Gioan ed. (Paris: Quillet-Flammarion, 1957), 562). With tongue in cheek, OPH claims not to know why the café is so named, but by the end of the story the two American reporters seemed to have demonstrated the reason. The French have been wise to the game all along and did not need to guess what it was that the Americans had in their hands, while it was the Americans who

were left guessing until they, too, discovered the true character of French raw onions.

[32] Otto P. Higgins, "From the Notebook of O.P.H.," *Kansas City Star,* June 29, 1919, 8A.

[33] Lt. Col. Ruby D. Garrett commanded the 117th Field Signal Battalion, 42nd Division.

[34] Adam Breede, owner of and war correspondent for the *Hastings Daily Tribune,* Hastings, Nebraska.

[35] General Douglas MacArthur also figures in another OPH story involving the 117th Field Signal Battalion. See Ch 10, Otto P. Higgins, "Signal Men's Losses Few," composed on December 24, 1918 and printed in the *Kansas City Star,* January 17, 1919, 8.

[36] A "rod" is a unit of measure often used by surveyors or contained in legal descriptions of land. A "rod" is equal to 16½ feet or 5½ yards.

[37] "Out in sap" is a reference to a technique used in trench warfare wherein a short trench, or "sap," is dug across No Man's Land towards the enemy position. The sap is joined at the far ends "to create a new, unbroken frontline trench, which was completed and fortified before the process was repeated. Involving thousands of yards of excavation for small territorial gains, sapping was slow and grueling work . . . but was reliable and entailed relatively light casualties." Stephen Pope & Elizabeth-Anne Wheal, *Dictionary of the First World War* (S. Yorkshire: UK: Pen and Sword Military Classics, 2003), 420.

Chapter 17: At the End—July 1919

[1] "*Alsacienne et Lorainne,*" Carte Postale, circa 1918. This postcard depicts two young women, perhaps sisters, in traditional costume, next to a spinning wheel, the ancient symbol of the distaff, from which springs the French tri-color ribbon, wrapping furled strands of thread. In the traditional bonnets of their regions, each girl wears a tri-color rosette, symbolizing by birthright their allegiance to France. From the author's collection.

[2] *Poilu* is the French term for a French infantryman, 1915-1918. The term connotes manliness: "hairy," "shaggy," and therefore "strong" and "brave." See Ernest A. Baker & J. L. Manchon (Rev), *Cassell's French-English English-French Dictionary* (New York: Funk & Wagnalls, 1951), 550.

[3] See typewritten manuscript in "Otto P. Higgins, *Kansas City Star,*" Archival Box 2010-145, Edward Jones Research Center, National World War I Museum and Memorial.

[4] Otto P. Higgins, "Sun on Lusitania Graves: Clon Mell One of the Highest Spots Near Queenstown," *Kansas City Star*, May 20, 1918, 5.

[5] This unpublished, typed manuscript is also untitled, but Higgins' name as the author appears twice, once before and once after the text. In lieu of a title from OPH, I have supplied in its place the title, "*Mon Enfant,*" because the phrase occurs at a significant point in the story and is repeated twice by the main character, Pierre, whose grief over his missing child is the focus of the story. National World War I Museum and Memorial, Edward Jones Research Center, Archival Box Accession No. 2010.145.

[6] William Moore and James C. Russell, *U.S. Official Pictures of the World War* (Washington, D.C.: Pictorial Bureau, 1920), 186.

[7] A. Périchon, éditeur, "St. Mihiel – Rue Général Pershing (St. Mihiel, France: A. Périchon , c. 1918), postcard, from the author's collection.

[8] *"Permission"* is the French term for military leave.

[9] William Moore and James C. Russell, 186.

[10] William Moore and James C. Russell.

[11] Otto P. Higgins, "From the Notebook of O.P.H.," *Kansas City Star,* July 2, 1919, 17.

Epilogue: Remembering the War—Spring 1920 - June 1965

[1] "Kansas City School of Law, Examination in Statutory Rights and Remedies, Mr. E.D. Ellison and Mr. W. R. Moore, November 26, 1912." Also, "Kansas City School of Law, Final Examination, Domestic Relations," Wednesday, April 23, 1913, Mr. E. N. Powell, Mr. Frank C. Wilkinson, 20 question printed examination with OPH notes "Husband & Wife, Parent & Child, Infancy, Master & Servant, Guardian & Ward." Both examinations are in the collection of OPH Kansas City Law School artifacts, courtesy of Sheila Scott.

[2] D. G. Michalpopoulos, Harry Hayward, W. I. Fray, Otto P. Higgins, E. B. Sanders, Edwin O. Koch, and L. M. Turner, *The Pandex* (Kansas City, Missouri: Senior Class, Kansas City School of Law, 1920), 70.

[3] Otto P. Higgins, "Military History" *The Pandex* (Kansas City, Missouri: Senior Class, Kansas City School of Law, 1920), 67.

[4] Otto P. Higgins, "Our Soldiers," *The Pandex*, 66.

[5] Otto P. Higgins, "Our Soldiers," *The Pandex*, 66. (Photo, 10).

[6] Harry S. Truman to Bess Wallace, November 1, 1918, Truman Papers—Family, Business and Personal Affairs Papers, Harry S. Truman Presidential Library and Museum.

[7] Otto P. Higgins, "Romped 8 Miles in a Day," composed on September 16, 1918, and published in the *Kansas City Star,* Thursday, October 31, 1918, p. 10. See Chapter 7, "At St. Mihiel and in the Argonne—September 1918."

[8] "Unique Log Cabin for Kansas City Attorney," *Lake News*, Lake Lotawana, Missouri, November 25, 1919, Vol. 2. No. 8, 2.

[9] Otto P. Higgins, "O.P.H. in a French Village," *Kansas City Star*, October 2, 1918, 2.

[10] Lt. Col. Ruby D. Garrett, "With O.P.H. at the Front*," Kansas City Star,* December 23, 1918, 12.

[11] Jill Carter (Demchak), in personal communication from Sheila Scott, December 23, 2010, taken from notes originally written by Eleanor Carter and taped to the back of the wooden box holding the crucifix. Referring to the crucifix some forty years later, OPH's granddaughter commented in a school report that "It is very beautiful and valuable, and we have it in our home." Pictures of crucifix and notes from Vick Viquesney's CD.

[12] Emmet Crozier, *American Reporters on the Western Front 1914-1918* (New York: Oxford University Press, 1959), 271.

[13] Rudolph H. Hartmann, *The Kansas City Investigation: Pendergast's Downfall 1938-1939* (Columbia, MO: University of Missouri Press, 1999), 133.

[14] Otto P. Higgins, Lawyer, 613 Scarritt Bldg, Telephone: Harrison 6671, Bell Main, 6671; residence 3221 E. 32nd Street, Telephone Elmridge 2072, Bell Elmridge 2972. *City Directories of the US.,Segment IV, 1902-1939*, 1361, Microfilm.

[15] "Dies in Phoenix at 75," *Kansas City Star*, June 15, 1965, 3.

[16] Jerry N. Hess, "Oral History Interview with Stanley R. Fike," (Jackson County, Missouri, journalist and friend of Harry S. Truman), May 10, 1972, 9. Harry S. Truman Presidential Library, Independence, Missouri.

[17] Rudolph H. Hartmann, 132.

[18] "1939: Kansas City Political Machine," p. 2. http://www.kcfop.org/history/art/encarta- 1939kcmachine.htm, accessed by the author July 9, 2008.

[19] Rudolph H. Hartmann, 134.

[20] "Dies in Phoenix at 75," *The Kansas City Star*.

[21] "Inter-City Press Sold," undated newspaper article archived on CD by Vick Viquesney, courtesy of Sheila Scott.

[22] Emmet Crozier, *Yankee Reporters: 1861-1865* (New York: Oxford University Press, 1956).

[23] Emmet Crozier, *American Reporters on the Western Front 1914-1918* (New York: Oxford University Press, 1959), viii-ix.

[24] Crozier, *American Reporters on the Western Front 1914-1918*, x.

[25] Members of the Staff of *The Kansas City Star*, *William Rockhill Nelson: The Story of a Man, a Newspaper, and a City* (Cambridge: The Riverside Press, 1915), 127.

[26] Chris Dubbs, *American Journalists in the Great War: Rewriting the Rules of Reporting*, (Lincoln, NE: University of Nebraska Press, 2017), 278.

[27] The old trunk remained in storage for a while at the home on 5424 Harrison, Kansas City, Missouri. After that property was sold, the trunk then moved to Pierce City, Missouri, under the care of daughter Carol Larkin, before its contents came into the care of OPH's granddaughter, Sheila Scott, who then offered them to the Edward Jones Research Center at the National World War I Museum and Memorial in November, 2010.

INDEX

446